Experiencing Liveness in Contemporary Performance

Promotional slogan, mystical evocation, or marker of ontological difference? 'Liveness' in performance is a highly contested term.

Experiencing Liveness in Contemporary Performance moves beyond debates about the relationship between the live and the mediated to consider the processes of making and experiencing live performance. Drawing together contributions from theatre, music, dance, and performance art, it takes an interdisciplinary approach in asking not what liveness is, but how it matters and to whom.

This stunning collection invites readers to consider how liveness is produced through spectatorship, and how it becomes materialized in acts of performance, making, archiving, and remembering. Theoretical chapters and practice-based reflections explore a range of topics such as affect, documentation, embodiment, fandom, and temporality, to demonstrate the multiplicity of relationships between audience and event.

An illuminating new look at the concept of liveness, *Experiencing Liveness in Contemporary Performance* will be of interest across performance, audience and cultural studies, visual arts, cinema, and sound technologies.

Matthew Reason is Professor of Theatre and Performance at York St. John University, UK.

Anja Mølle Lindelof is Associate Professor of Performance Design at Roskilde University, Denmark.

Routledge Advances in Theatre and Performance Studies

For a full list of titles in this series, please visit www.routledge.com

39 **Play, Performance, and Identity**
How Institutions Structure Ludic Spaces
Edited by Matt Omasta and Drew Chappell

40 **Performance and Phenomenology**
Traditions and Transformations
Edited by Maaike Bleeker, Jon Foley Sherman, and Eirini Nedelkopoulou

41 **Historical Affects and the Early Modern Theater**
Edited by Ronda Arab, Michelle M. Dowd, and Adam Zucker

42 **Food and Theatre on the World Stage**
Edited by Dorothy Chansky and Ann Folino White

43 **Global Insights on Theatre Censorship**
Edited by Catherine O'Leary, Diego Santos Sánchez & Michael Thompson

44 **Mainstream AIDS Theatre, the Media, and Gay Civil Rights**
Making the Radical Palatable
Jacob Juntunen

45 **Rewriting Narratives in Egyptian Theatre**
Translation, Performance, Politics
Edited by Sirkku Aaltonen and Areeg Ibrahim

46 **Theatre, Exhibition, and Curation**
Displayed and Performed
Georgina Guy

47 **Experiencing Liveness in Contemporary Performance**
Interdisciplinary Perspectives
Edited by Matthew Reason and Anja Mølle Lindelof

Experiencing Liveness in Contemporary Performance
Interdisciplinary Perspectives

Edited by Matthew Reason
and Anja Mølle Lindelof

NEW YORK AND LONDON

First published 2016
by Routledge
711 Third Avenue, New York, NY 10017

and by Routledge
2 Park Square, Milton Park, Abingdon, Oxon OX14 4RN

Routledge is an imprint of the Taylor & Francis Group, an informa business

© 2017 Matthew Reason and Anja Molle Lindelof

The right of the editor to be identified as the author of the editorial
material, and of the authors for their individual chapters, has been asserted
in accordance with sections 77 and 78 of the Copyright, Designs and
Patents Act 1988.

All rights reserved. No part of this book may be reprinted or reproduced or
utilised in any form or by any electronic, mechanical, or other means, now
known or hereafter invented, including photocopying and recording, or in
any information storage or retrieval system, without permission in writing
from the publishers.

Trademark notice: Product or corporate names may be trademarks or
registered trademarks, and are used only for identification and explanation
without intent to infringe.

British Library Cataloguing-in-Publication Data
A catalogue record for this book is available from the British Library

Library of Congress Cataloguing-in-Publication Data
A catalog record for this book has been requested

ISBN: 9781138961593 (hbk)
ISBN: 9781315659701 (ebk)

Typeset in Bembo
by Apex CoVantage, LLC

Contents

List of Illustrations	ix
Notes on Contributors	xi

Introduction: Experiencing Liveness in Contemporary Performance 1
MATTHEW REASON AND ANJA MØLLE LINDELOF

PART 1
Audiencing: Introduction 17
MATTHEW REASON AND ANJA MØLLE LINDELOF

1 **Coming a(live): A Prolegomenon to any Future Research on 'Liveness'** 21
MARTIN BARKER

2 **Orange Dogs and Memory Responses: Creativity in Spectating and Remembering** 34
KATJA HILEVAARA

3 **Fandom, Liveness and Technology at Tori Amos Music Concerts: Examining the Movement of Meaning within Social Media Use** 48
LUCY BENNETT

4 **Social and Online Experiences: Shaping Live Listening Expectations in Classical Music** 60
STEPHANIE E. PITTS

5 **The Meaning of Lived Experience** 73
PADDY SCANNELL

vi *Contents*

6 Affect and Experience 83
MATTHEW REASON

Shorts 97

1 Live Art, Death Threats: The Theatrical Antagonism of *First Night* 99
ALEXIS SOLOSKI

2 Attention as a Tension: Affective Experience between Performer and Audience in the Live Encounter 104
VICTORIA GRAY

3 Empathy and Resonant Relationships in Performance Art 109
LYNN LU

4 Embodied Traces: Co-presence, Kinaesthesia and Bodily Inscription 117
IMOGENE NEWLAND

5 An Experience of Becoming: *Wearing a Tail and Alpine Walking* 124
CATHERINE BAGNALL

6 Sisters Academy: Radical Live Intervention into the Educational System 130
GRY WORRE HALBERG

7 One-to-One Performance: Who's in Charge? 137
SARAH HOGARTH AND EMMA BRAMLEY

8 A Performatic Archive 143
KERRIE READING

9 Theatre of Bone 149
REBECCA SCHNEIDER

Contents vii

PART 2

Materialising: Introduction 157
MATTHEW REASON AND ANJA MØLLE LINDELOF

7 **What is a Live Event?** 163
GARY PETERS

8 **Improvising Music Experience: The Eternal
Ex-temporisation of Music Made Live** 178
STEVE TROMANS

9 **The Place of Performance: A Critical
Historiography on the Topos of Time** 188
JONAH WESTERMAN

10 **Objectifying Liveness: Labour, Agency and the
Body in the *11 Rooms* Exhibition** 201
LISA NEWMAN

11 **Reconsidering Liveness in the Age of
Digital Implication** 215
EIRINI NEDELKOPOULOU

12 **Environmental Performance: Framing Time** 229
ANJA MØLLE LINDELOF, ULRIK SCHMIDT AND CONNIE SVABO

Shorts 241

10 *Three Performances*: **A Virtual (Musical)
Improvisation** 243
MATHIAS MASCHAT AND CHRISTOPHER WILLIAMS

11 **Chronography** 254
CRAIG DWORKIN

12 **Memory, Time and Self: A Text Work based
on a Conceptual Performance** 259
PAUL FORTE

viii *Contents*

13 Broken Magic: The Liveness of Loudspeakers 266
DUGAL MCKINNON

**14 Managing Live Audience Attention in the Age
of Digital Mediation:** *The Good, The God and*
The Guillotine 272
MARTIN BLAIN

15 Enlivened Serendipity 279
ALLEN S. WEISS

16 National Theatre Wales's *Coriolan/us*: **A 'Live Film'** 284
MIKE PEARSON

**17 Machines in Queer Gardens: Performance
as Mixed Surreality** 289
JUDD MORRISSEY AND MARK JEFFERY

**Afterword: So Close and Yet So Far Away: The
Proxemics of Liveness** 295
PHILIP AUSLANDER

Index 299

Illustrations

2.1	Still image from *Icebreaker*, Katja Hilevaara, 2013. Video by Sebastian and Salla Östman, edited by Abigail Conway.	43
3.1	*Strawberrymilkbath*, Lynn Lu, 2002. Photography Rob Schroeder.	112
3.2	*Walking a Mile*, Lynn Lu, 2005. Photography Kai Lam.	113
4.1	*Woman=Music=Desire*, Imogene Newland, 2010. Performed by Sheena Kelly. Photography Chris Parker	120
5.1	Julian with Pink Lined Black Ears, Catherine Bagnall, 2013. Photography Wilkins/Austin.	126
6.1	Gry Worre Hallberg Embodying the Headmistress at Sisters Academy #1, Odense, Denmark, 2014. Photography Diana Lindhardt.	130
6.2	Grand ceremony on the last day of Sisters Academy #1, Odense, Denmark, 2014. Photography Diana Lindhardt.	134
8.1	Chapter Arts Centre, Cardiff, Archives. Photography Kerrie Reading.	144
8.2	*Playing (at) Woyzeck*, Kerrie Reading, Chapter Arts Centre, Cardiff, 2013. Photography Warren Orchard.	146
9.1	Roman Gaming piece, 1st century CE. Bone. Diameter 3.2 cm. Photography Erik Gould. Courtesy of the Museum of Art, Rhode Island School of Design, Providence.	150
11.1	Technical Trial of 'Assembly' in *Rien à Cacher, Rien à Craindre*, 2011. Courtesy of Alexandros Tsolakis (UVA).	219
11.2	'Room 101' in *Rien à Cacher, Rien à Craindre*, 2011. Courtesy of Alexandros Tsolakis (UVA).	221
10.1–4	*Three Performances*: Musical Score.	245–51
12.1	*Time Table*, Paul Forte, San Jose State University, San Jose, 1977.	264–5
13.1	Gerriet K. Sharma performs using the ICO (icosahedral) loudspeaker developed by Franz Zotter (IEM, Austria). Izlog Festival, Zagreb, 2015. Photography Kristijan Smok	269
14.1	*The Good, The God, and The Guillotine*. 2011–13. Photography Jonas Hummel.	276

x *Illustrations*

15.1 *Theater of the Ears.* Photography courtesy of Allen S. Weiss. 281
16.1 *Coriolan/us*, 2012. Photography Mark Douet / National Theatre Wales. 286
17.1 *Kjell Theøry: A Prologue* by ATOM-r. Performed at Rapid Pulse Performance Art Festival, Chicago, 2015. Photography Arjuna Capulong. 294

Contributors

Philip Auslander is a Professor in the School of Literature, Media, and Communication of the Georgia Institute of Technology. He writes on performance, popular music, media, and visual art. Books include: *Presence and Resistance: Postmodernism and Cultural Politics in Contemporary American Performance* (University of Michigan Press, 1992), *From Acting to Performance: Essays in Modernism and Postmodernism* (Routledge, 1997), *Liveness: Performance in a Mediatized Culture* (Routledge, 1999, second edition 2008), for which he received the prestigious Callaway Prize, and *Performing Glam Rock: Gender and Theatricality in Popular Music* (University of Michigan Press, 2006). Auslander is also a working screen actor.

Catherine Bagnall is an artist whose work focuses on performance practices and its intersection with dress by exploring clothing's ability to transcend and transform the wearer, predominantly as 'other' in 'wilderness' sites. Using the distinctively cultural form of clothing to explore the human non-human animal divide Catherine's work puts into practice theories of 'becoming other' as a transformational strategy to shift our relationship to our environment and our fellow non-human creatures. Catherine is a lecturer at Massey University, College of Creative Arts, Aotearoa.

Martin Barker is Emeritus Professor at Aberystwyth University. His research has covered a wide range of topics, including racism, children's comics, moral controversies over the media and methods of film analysis. For the last twenty years he has focused on audience research. His work has included the huge international *Lord of the Rings* project (exploring the meanings of 'fantasy' across the world), and also contracted research for the British Board of Film Classification (looking at audience responses to screened sexual violence).

Lucy Bennett completed her PhD in online fandom at JOMEC, Cardiff University. Her work on digital culture and fandom appears in journals such as *New Media & Society, Journal of Fandom Studies, Transformative Works and Cultures, Social Semiotics, Continuum, Cinema Journal, Celebrity Studies* and *Participations*. She is the co-founder and co-chair of the Fan Studies Network and is currently co-editing a special issue of *New Media & Society* and a collection for Peter Lang on crowdfunding.

xii *Contributors*

Martin Blain is Senior Research Fellow at Manchester Metropolitan University. He is a composer and performer and is the Musical Director of MMUle (Manchester Metropolitan University laptop ensemble). In addition to working as Music Director for MMUle, he also works with a variety of leading contemporary music ensembles such as Apollo Saxophone Quartet, BackBeat Percussion Ensemble, and Equivox. Martin has published on collaboration, liveness and laptop performance practice in *Music Performance Research* and the *Journal of Music, Technology and Education*.

Craig Dworkin is the author of five books of poetry, including *Alkali* (Counterpath Press, 2015), *Chapter XXIV* (Red Butte Press, 2013), *The Perverse Library* (Information As Material, 2010), and *Motes* (Roof, 2011). He is also the author of *No Medium* (MIT, 2013) and *Reading the Illegible* (Northwestern, 2003) and co-editor of *Against Expression: An Anthology of Conceptual Writing* (Northwestern, 2011). He teaches at the University of Utah and serves as Senior Editor to Eclipse (eclipsearchive.org).

Paul Forte began his career in the San Francisco Bay Area in the 1970s. He has worked in a variety of media over the years and is included in the Sol Lewitt Collection; the Museum of Modern Art (artist's books); and the Yale University Art Gallery, among others. Forte has lectured on his work at The University of California, Berkeley; The Rhode Island School of Design; Brown University; and Pratt Institute. Paul Forte is a past recipient of a National Endowment for the Arts, Artist Fellowship (1978), and a Pollack-Krasner Foundation Fellowship (1990).

Victoria Gray is a performance artist and writer who has presented work nationally and internationally. Her practice-led research has been published and presented in peer-reviewed journals, edited books and conferences in the field of performance. Recent publications include articles in *Journal of Dance & Somatic Practice* (2012); *Kinesthetic Empathy in Creative & Cultural Practices* (2012), and *Choreographic Practices* (2013). Currently she is a PhD candidate at Chelsea College of Art and Design, University of the Arts, London.

Gry Worre Hallberg is a performance artist and curator operating in the intersection of art, research and activism. She is the co-founder of a range of organizations and movements among them Sisters Hope, Fiction Pimps, Club de la Faye, Staging Transitions and The Poetic Revolution. Besides her performance art practice, she is a visiting lecturer at Performance Design, Roskilde University, curates the performance-art program at the Roskilde festival and is the artistic director of the Dome of Visions.

Katja Hilevaara is an artist, teacher and researcher. She gained her PhD on performance and memory at Queen Mary University of London, where she is a teaching associate. Further information and images of her artwork can be found at www.katjahilevaara.com.

Contributors xiii

Sarah Hogarth is a lecturer at Liverpool John Moores University and **Emma Bramley** is a lecturer at Liverpool Institute of Performing Arts; they both specialize in Contemporary Performance and Applied Drama. In 2013 they formed All Things Considered Theatre. Their work explores the role of the audience as participant, and they are particularly interested in creating work that allows the spectator to take on the role of the unrehearsed performer.

Mark Jeffery is an Associate Professor in Performance at the School of the Art Institute of Chicago. He was a member of the internationally renowned Goat Island Performance group and co-founded ATOM-r, a performance technology collective, in 2012. Mark also organises the Chicago Biennial Performance Festival IN>TIME.

Anja Mølle Lindelof, Ulrik Schmidt and **Connie Svabo** are colleagues in Performance Design at Roskilde University, Denmark. Anja Mølle Lindelof is Associate Professor and she researches performance across the areas of music, popular culture and theatre with a specific interest in mediation of live performance and audience research. Ulrik Schmidt, Assistant Professor, is working with the role of audiovisual media and spatial design in art and everyday life. His recent book *The Ambient* (2013, in Danish) explores the ambient as a leading aesthetic principle in modern culture from 1800 to the present. Connie Svabo is Associate Professor and Head of Studies. Her research on experience, design and mediation focuses on environments such as exhibitions, immersive performance spaces, installations and interiors.

Lynn Lu is a visual artist from Singapore. She exhibits, performs and lectures extensively throughout Asia, Oceania, Europe and the Americas. Recent venues include the Perth Institute of Contemporary Arts; School of the Museum of Fine Arts, Boston; Singapore Art Museum; Tate Modern and 798 Art Zone in Beijing. She lives and works in London where she is Associate Lecturer at Southampton Solent University, Associate Artist at] performance s p a c e [, and curator of live art events at Solent.

Judd Morrissey is a writer and code artist who creates poetic systems across a range of platforms incorporating computational text, internet art, live performance and augmented reality. He is co-founder of Anatomical Theatres of Mixed Reality (ATOM-r) and Assistant Professor in Art & Technology Studies at the School of the Art Institute of Chicago.

Mathias Maschat studied 'Kulturwissenschaften und ästhetische Praxis' with a focus in music in Hildesheim. Currently, he is working on a PhD project about the performative aesthetics of musical improvisation. For this he was also a scholarship holder of 'Erinnerung—Wahrnehmung—Bedeutung. Musikwissenschaft als Geisteswissenschaft' at the University of Osnabrück. He lives in Berlin and works as author, concert organizer, musician and piano teacher.

Dugal McKinnon is a composer and sound artist whose creative output encompasses acoustic, electronic and text media, and the intersection of these, often in collaborative multimedia contexts. He is a writer on sonic art and contemporary music, with a particular interest in the mesh of sound, technology and ecology. He teaches at Te Koki New Zealand School of Music, where he is Programme Leader for Composition and Director of the Lilburn Electroacoustic Music Studios.

Eirini Nedelkopoulou is a Lecturer in Theatre at York St John University. She has published on interactive performance, participation, digital media arts and phenomenology. She is co-editor of *Performance & Phenomenology: Traditions and Transformations* (Routledge, 2015) and of the special issue 'Hybridity: The Intersections between Performance and Science' (*International Journal of Performance Arts & Digital Media*, Taylor & Francis). She is co-convenor of TaPRA's Performance and New Technologies Working Group.

Imogene Newland is a British researcher/practitioner specialising in interdisciplinary performance. Originally trained as a pianist, Imogene became interested in the intersection between choreographic practices and musical gesture in 2003. She has subsequently formed a series of practice-led works that address the intimate and intensely physical relationship between music and the body. In 2011 Imogene completed her practice-led PhD at the Sonic Arts Research Centre, Belfast. She has presented her original performances throughout the UK and Europe.

Lisa Newman is an intermedia artist and co-director/ founder of 2 Gyrlz Performative Arts, an artist-led presenting organization. She completed a PhD at the University of Manchester in 2014. Her current research explores the economic and social value of the body in performance and live art within contemporary art markets.

Mike Pearson is Emeritus Professor of Performance Studies in the Department of Theatre, Film and Television Studies, Aberystwyth University. He makes performance as a solo artist in collaboration with artist/designer Mike Brookes as Pearson/Brookes and with National Theatre Wales. He is co-author with Michael Shanks of *Theatre/Archaeology* (2001) and author of *In Comes I: Performance, Memory and Landscape* (2006), *Site-Specific Performance* (2010), *The Mickery Theater: An Imperfect Archaeology* (2011) and *Marking Time: Performance, Archaeology and the City* (2013).

Gary Peters is Professor of Critical and Cultural Theory at York St John University. He has written widely on continental philosophy, aesthetics and pedagogy with a book *Irony and Singularity: Aesthetic Education from Kant to Levinas* (Ashgate) published in 2005. His second book: *The Philosophy of Improvisation* (Chicago University Press) came out in May 2009. He is currently working on a book entitled *Improvisations on Improvisation* to be published in 2017.

Stephanie Pitts is Professor of Music Education at the University of Sheffield, with research interests in musical participation, arts audiences and lifelong learning. She is the author of *Valuing Musical Participation* (Ashgate, 2005), *Chances and Choices: Exploring the Impact of Music Education* (OUP, 2012) and, with Eric Clarke and Nicola Dibben, *Music and Mind in Everyday Life* (OUP, 2010). An edited book on audiences, *Coughing and Clapping* (with Karen Burland), was published by Ashgate in 2014.

Kerrie Reading is an AHRC funded practice as research PhD candidate working in collaboration with Chapter Arts Centre in Cardiff. Her work is looking at strategies of reconstituting archival material for a contemporary audience. Since 2008 Kerrie worked with self-founded theatre company, *Needless Allies*, creating site-specific performances. She has worked with theatre companies *Stan's Cafe* and *Talking Birds*. Many of her projects have focused on audience engagement leading to her current research enquiry at Aberystwyth.

Matthew Reason is Professor of Theatre and Performance at York St John University, UK. Publications include *Documentation, Disappearance and the Representation of Live Performance* (Palgrave 2006), *The Young Audience: Exploring and Enhancing Children's Experiences of Theatre* (Trentham 2010) and, co-edited with Dee Reynolds, *Kinesthetic Empathy in Creative and Cultural Contexts* (Intellect 2012). www.matthewreason.com

Paddy Scannell moved to the Department of Communication Studies at the University of Michigan in 2006 after many years at the University of Westminster, UK. In 1975 he and his colleagues launched the first undergraduate degree course in Media Studies in the UK. He is a founding editor of *Media, Culture & Society* which began in 1979. His research interests include broadcasting history and historiography, the analysis of talk, the phenomenology of communication and media and communication in Africa. He is currently working on a trilogy: *Media and Communication* (Sage 2007); *Television and the Meaning of 'Live'* (Polity Press 2014) and *Love and Communication* (in preparation).

Steve Tromans is a pianist and composer working in the fields of jazz and improvised music. He is currently a postdoctoral researcher at Birmingham City University, undertaking philosophical investigation via the modes of music performance in jazz and improvising music. www.steve-tromans.co.uk

Rebecca Schneider is a Professor in the Department of Theatre Arts and Performance Studies at Brown University. She is the author of *The Explicit Body in Performance* (Routledge, 1997), *Performing Remains: Art and War in Times of Theatrical Reenactment* (Routledge, 2011) and *Theatre and History* (Palgrave, 2014). She has authored numerous essays and edited collections on theatre, performance-based art and visual arts in intermedial exchange.

Alexis Soloski received her doctorate in theatre from Columbia University where she completed a post-doctoral fellowship in the humanities. Her

xvi *Contributors*

work has recently appeared in *Modern Drama, Theater,* and *Theater Journal.* A theatre critic for the *New York Times,* she also contributes frequently to *The New Yorker* and *The Guardian.*

Jonah Westerman is Assistant Professor of Art History at Purchase College, State University of New York. He received his PhD in Art History from The Graduate Center, City University of New York in 2014 and has worked as a Postdoctoral Research Associate at Tate in London. He is currently Chester Dale Senior Fellow in Art History at The Metropolitan Museum of Art in New York and is co-editing a volume of interviews and essays focusing on institutional histories of performance at field-defining museums and galleries.

Allen S. Weiss is a writer, translator, curator and playwright, and is the author and editor of over forty books in the fields of performance theory, landscape architecture, gastronomy, sound art and experimental theater, as well as fiction and radiophonic productions. His most recent works are *Métaphysique de la miette* (Argol), *Zen Gardens* (Reaktion), and *Radio Gidayū,* a soundscape of Kyoto (Deutschlandradio Kultur). He teaches in the Departments of Performance Studies and Cinema Studies at New York University.

Christopher Williams is a wayfarer on the body-mind continuum. His medium is music. He has a B.A., University of California, San Diego; and is a PhD candidate, University of Leiden. He has collaborated as a composer and contrabassist with Derek Bailey, LaMonte Young's Theatre of Eternal Music, Maulwerker, Charlie Morrow, Robin Hayward and dancer Martin Sonderkamp. Artistic research has been published in *Open Space Magazine* and *Critical Studies in Improvisation,* and he has frequently presented at international conferences. He co-curates *Certain Sundays,* an experimental music and sound salon in Berlin.

Introduction

Experiencing Liveness in Contemporary Performance

Matthew Reason and Anja Mølle Lindelof

That dance, music and theatre, along with live and performance art, are experienced *live* is something that is valued and celebrated by audiences and practitioners alike. Yet the status and significance of the live in contemporary performance has become contested: perceived as variously as a marker of ontological difference, a promotional slogan or a mystical evocation of cultural value. From something that might have been considered straightforward—what could be simpler than being live?—the exact nature, the ontology, of the live has become a recurring concern across a range of disciplines and contexts. Moving beyond debates about the relationship between the live and the mediated, this collection sets out to interrogate how liveness is produced through processes of *audiencing*—as spectators bring qualities of (a)liveness into being through the nature of their attention—and processes of *materializing* in acts of performance, acts of making, acts of archiving and acts of remembering.

Drawing together contributions from across dance, music, theatre and performance art, this collection asks less what liveness is, but rather *how* it matters? And to whom?

Liveness or Deadliness

To answer this let's start somewhere else: if something is not live, then what is it? Historically, the answer to this might have been that something that was not live was recorded, mediated in some form or another. This distinction, however, becomes less categorical—and, more crucially, less useful—in a world in which live and mediated have become interwoven.

Instead, perhaps the opposite of liveness is *deadliness*.

Often the word live appears to function as a near synonym for judgments of quality or worth. This is partly in terms of assertions of cultural value, in which the live is automatically considered to be superior or have more cachet than the non-live. Beyond this, however, there is a recurring linguistic construction of live as a marker of various qualities of vibrancy, immediacy, relevancy, realness. This is present in familiar phrases such as Keep Music Live, Coming to You Live

or You'll Love it Live; and equally in broader cultural and audience conversations, where assertions of something being live frequently becomes equated to being 'real' or being 'good' (Barker 2003; Reason 2006).

Yet we know, to our cost as spectators and performance makers, that not all live performances are good performances. Not all live experiences are vibrant experiences. Instead sometimes—often even—they are routine, mundane, disappointing—not to mention the occasions when they are actively bad. Sometimes, they are deadly. And tellingly in his construction of deadly theatre, Peter Brook describes deadliness as something that can infect and inhabit performances that are otherwise and ostensibly very live.

Brook writes that deadly theatre is 'the form of theatre we see most often' (1972, 11). And it is probably fair, unfortunately, to say that this is still the case. Mirroring the association of liveness with quality, for Brook deadly theatre is firstly bad theatre. However, his construction of deadliness is more nuanced than this, the deadly performance is bad, but not simply because it is not good. Indeed, Brook suggests that deadly theatre can involve good plays performed by good actors in 'lively', 'proper' and 'colourful' ways, but that at the same time it remains excruciatingly boring (1972, 12). Deadliness, Brook suggests, is not the result of any particular form, content or genre. Nor is deadliness even particularly the result of something we might term quality. Rather, deadliness is the product of a failed relationship between performance and audience. From the specific context of theatre we would like to expand this concept of deadliness across dance, music and performance art and consider that what is important about liveness—how and why it matters—resides not in some essential or ontological characteristic of the performance itself, but precisely in the relationship between performance and audience.

In order to make our own terrain more visible, it is useful to borrow from another discipline. Writing about the philosophy of education, Martin Buber states that a 'real lesson' should be 'neither a routine repetition nor a lesson whose findings the teacher knows before he starts, but one which develops in mutual surprises':

> In a real conversation (that is, not one whose individual parts have been preconcerted, but one which is completely spontaneous, in which each speaks directly to his partner and calls forth his unpredictable reply), a real lesson (that is, neither a routine repetition nor a lesson whose findings the teacher knows before he starts, but one which develops in mutual surprises), a real embrace and not one of mere habit, a real duel and not a mere game.
>
> (2002, 241)

The notion of *mutual surprises* is compelling: both parties within the encounter allowing themselves to be caught out, to be affected, to be relocated and transported. 'Surprise', writes education researcher Julian Stern, 'is the sign that genuine dialogue is happening' (2013, 45). The mutuality of surprise mirrors

Introduction 3

the mutuality of co-presence, the mutuality of the gaze, the mutuality of liveness. Buber continues:

> in all these what is essential does not take place in each of the participants or in a neutral world which includes the two and all other things; but it takes place between them in the most precise sense, as it were in a dimension which is accessible only to them both.
>
> (2002, 241–2)

We might add to this a 'real' encounter within live performance, whereby both the audience and the performer experience something that takes place between them, includes both, is accessible only to them and leaves them both changed—even if only fleetingly. The description, in other words, is not of the live as something uni-polar, nor something that is defined in opposition to mediatisation, but rather something that only exists in resonance between performance and audience.

From Liveness to Experiencing Live

A pseudo-neutral description of live performance seems almost automatically to reach for ontology: that is, a description of a state of being or a set of fundamental properties essential to the nature of liveness. One example of this might be Bernard Beckerman's assertion of the ontology of theatre as being immediate presence in space and time: 'Eliminate the actuality of man and eliminate theatre' (1979, 7). Or we might consider Peggy Phelan's much repeated ontological statement that performance 'becomes itself through disappearance' (1993, 146).

These can be described as essentialist positions, whereby live performance is defined as the product of spatiotemporal presence: the spectator and the performer co-present in the same time and place. In the here and now. In that auditorium, in that concert hall, in that performance time/space whether it be gallery, post-industrial ruin, studio, field or barn. There is a deterministic quality to such descriptions and, in an ontological narrative of live performance, such spatiotemporal presence is the beginning and end of liveness. There is purity to this presence, an undilutable quality. To dilute presence, to dilute the actuality of man, would be to shatter the absolutism of essentialism.

Tellingly, Beckerman's definition of theatre rests upon an opposition between the live and the mediated, as he compares the difference between watching action on screen and on stage: 'The experience of seeing human beings battle time and space cannot be the same as seeing visual images upon a screen' (1979, 7). The trouble is that even if we believe this ontologically, it is much more difficult to identify the difference experientially. That it '*cannot* be the same' is an essentialist declaration, rather than an experiential deduction. It ignores the possibility for a failed relationship between performance and spectator, the possibility of deadliness.

We have, moreover, learnt to go in fear of essentialisms. The 'we' in this sentence being contemporary scholars and thinkers in performance studies, music and art. Our impulse is to question universalist arguments that ignore the ideologically and historically contingent position of the speaker. In the context of live performance we have become particularly aware of the technological contingency of the here and now, not least after Auslander's radical reading of Baudrillard's simulacra (1998) onto questions of liveness. The here and now, we have come to realise, is always already infected by the there and then. It is not for nothing that a key section of Auslander's book *Liveness*, is titled 'Against Ontology', his central argument that discussions of liveness must be articulated through particular cases and not '*a priori* as a relation of essential opposition' (1999, 54).

The fraying of belief in undilutable presence has many historical echoes. It is present in Pirandello's evocative description of the silent film actors, who must appear divorced from the full reality of their physicality. On screen, Pirandello bemoaned, the actor 'loses his corporeality, it evaporates, it is deprived of reality, life, voice and the noises caused by moving about' (cited in Benjamin 1970, 223). This dilution of presence experienced by Pirandello is the particular product of the technology of film production in the early twentieth century; today the mute and distant silent screen actor is a world away from the sensorium of our own screen experiences. In the language of Baudrillard, screen presence today presents us with a hyperreality of presence, that is not only confused with the real but is at times more real than the real. In this light, clinging to a purity of absolute presence seems as nostalgic as ancient Greeks mourning how writing had supplanted the presence of live speech.

The particular impact of Auslander's publication *Liveness* was to challenge the 'unreflective assumptions' that he perceived as underpinning value judgments based upon liveness (1999, 2). Such assumptions might include ideas of an 'energy that supposedly exists between performers and spectators', that live performance automatically establishes a 'community' either within the audience or between spectators and performers, and that of a cultural value to authenticity that is associated with having been in the presence of the performer. This is not to deny that we might attend a performance in which we experience something that is best described in one or all of these manners. Vitally, however, Auslander explored how our understanding of temporal simultaneity and spatial co-presence can be considered in the light of Baudrillard's concept of simulacra. If we recognize that our very understanding of live performance is significantly produced by mediatisation, and is constantly changing in response to changing technological innovations, then any automatic value judgments based upon an ontology of liveness become indefensible. The simple declaration of essentialism goes against our lived experiences, which include charged, human and ever so very real encounters with human presence and liveness through digital, screen, recordings and other media. The focus, therefore, needs to shift away from locating liveness within performance a priori (within an ontology of liveness) and instead to careful consideration of the particular and

contingent relationships between performance and audience. Away from liveness and towards experiencing live.

Let us illustrate with an anecdote, from a project designed to investigate how young audiences might become engaged with contemporary theatre (described in Forsare and Lindelof, 2013). One of the young participants spontaneously addressed the theatre director, commenting on what he obviously felt to be a strange and contradictory part of the project: 'Why do you keep emphasizing that what you do is *live* when you don't even notice us when we are here?' Put like this, the performance might have been ontologically live, but experientially liveness ceased to matter.

A different time, a different place and a sixteen-year-old girl attempts to articulate the importance of her experience of the actors performing in front of her:

> I like how there's actual people on stage. I like going to the pictures and that, but that's, that's on the screen. But this is like the actual proper people on stage, acting and that. Which I think it's like, brings it more into the audience, I think. Makes it more live.
>
> (cited in Reason 2006, 231)

Of course, there is something here—*actual* people; *actuality* of man—that echoes Beckerman's ontology of theatre. However, on this occasion the particularity of this relationship between spectator and performance is noted because it left a visceral, emotional imprint upon the spectators' memory and not as an abstracted statement. The experience took place between performer and spectator in a manner that is evocative of Buber's 'real conversation'—its liveness *mattered*. In his chapter in this collection, Martin Barker utilizes the phrase 'comes alive' to describe this active, dynamic relationship between individual and experience. In the two encounters described here, it is clear that one came alive to the spectator in a manner very different to the ostensibly equally live experience of the other.

The implications of having the 'actual' people there in front of you are a recurring image in discourses about the importance of liveness. It presupposes a spatial specificity to the live experience. Another common presumption is how the live encounter unfolds in time. That is, it has a temporal specificity. As spectators *and* as performers, those involved in a live performance are required to invest in this specificity, whether in terms of our time, our minds or our bodies. We are all required to invest. As Brook writes, 'If good theatre depends on a good audience, then every audience has the theatre it deserves. Yet it must be very hard for spectator to be told of an audience's responsibility' (1972, 24–5). Yet sometimes it seems entirely valid to ask: 'Why do you keep emphasizing that what you do is *live* when you don't even notice us when we are here?'

The vital questioning of an essentialist understanding of liveness shifts our focus to relative and nuanced experiences of the live. In the shift from liveness to experiencing live the most vital question becomes the diverse ways (an important plurality) in which live performance matters and means to audiences

and practitioners. Of course, live performance itself has not been erased: individually and collectively audiences continue to encounter performers in proximity, in temporal simultaneity, in co-presence, in participation, in community, in various degree of multiple and shifting liveness-es. To add a plural to the neologism may be unpardonable, but the very grammatical awkwardness serves to stress that this is a matter of multiplicity and specificity.

Liveness-es

If we consider liveness across different disciplinary contexts, then its meanings have always been multiple. Although most prominent within performance studies, liveness has accrued particular discourses and meanings across disciplines including music, film and media studies. Audience researcher Martin Barker explicitly notes the many meanings of liveness, pointing out that while discourses might focus around a similar set of ideas—which he lists as simultaneity, bodily co-presence, eventness, experienced risk, immediacy and a sense of place (2013, 57)—these are constructed and valued very differently in different contexts. With this book particularly interested in interdisciplinary readings, it is valuable to map out some of these particular manifestations of liveness that often seem remarkably unaware of one another.

Firstly, in performance studies, which have taken liveness as its specific domain. In this context, liveness carries meaning in relation to processes of production, of marketing and of experience. Within performance studies, liveness is often discussed with regard to the ephemerality of performance and from the perspective of production in which the work is re-made anew on each re-presentation.

The emphasis here is on a continual fabrication of the newness of the event and the fact that what is happening might go wrong: the dancer might fall, the equipment might fail and the actor might miss a line. Often this is hypothetical, a stress on the *potential* for difference rather than analysis of the impact of actual differences as asserted by in phrases like: 'what's interesting with dance is that you never know what is going to happen', or 'with music it all depends on the day you are there.' The notion of live performance, therefore, is defined through such subtle, spatiotemporal interactions, epitomized by Erica Fischer-Lichte: 'Whatever the actors do elicits a response from the spectators, which impacts on the entire performance. In this sense, performances are generated and determined by a self-referential and ever-changing feed-back loop' (2008, 38).

That 'a performance is never the same' or 'the audience is different each time' might be right—even if only in small, subtle and perhaps even insignificant ways—but it is worth pointing out that this is from the perspective of the production and the performers. It is a different relationship for audiences, most of whom only experience a performance once. Indeed, it is for this reason that Barker dismisses the perception of each performance being unique as a 'strange notion', pointing out that most spectators are unable to truly know in what ways a performance might have changed in their presence

alone (2013, 44). The point, however, has different resonance if considered in terms of experience.

Audience research suggests that audiences invest meaning and value in the *possibility* of change, of risk, of mistakes, even in the absence of them actually occurring. Indeed, perhaps specifically *because* of the absence of them occurring, with the ability to pull something off live producing an admiration of virtuosity and an appreciation of the skill and craft of the performer. As one spectator to a dance performance commented, 'I was looking for her to make a mistake but she didn't' (cited in Reason and Reynolds 2010). For audiences, therefore, interest and tension aren't dependent on something actually going wrong, but the awareness of that possibility. That most performances are pretty much exactly the same every night, and that most audiences only see a performance once, doesn't matter. What does matter is that there is a pleasure in experiencing people doing things in real time. Although with different inflections in different disciplines, this experiential admiration of virtuosity when watching live performance is a frequent occurrence.

Such debates can be pursued, although what is worth emphasizing here is the difference between a focus on ontology (liveness as an essential property of live performance) to a focus on experience (particular kinds of experiences, constituted by audiences in relationship with particular performances). The shift might be articulated as one from essentialism to relativism, from production to reception, from an objectivist understanding of art to an interactionist understanding, from liveness to experiencing live. First, however, it is worth acknowledging that liveness is constituted differently in different contexts.

For example, while bodily co-presence between audience and performers is central to performance studies, it is not an issue in sports studies, which instead focuses on the importance of co-presence between spectators. Consequently, fans may move their sports watching from the venue to other locations because of the continuously stronger regulations of what counts as accepted viewer behaviour in stadiums (Barker 2013, 55). In other words, the occasion, the sociability of the event, is emphasized above other factors such as performer presence.

Music studies have typically engaged with liveness in relation to recording techniques and sound ideals, considering, for example, the potential for recordings to communicate not disembodied music but the sound of liveness. While this might most obviously be the case with the live concert recording, it can also be considered in other instances. The close microphone set-up used by Glenn Gould being designed to allow the listener to hear every single note more distinctly and also capture the sounds of the performance: the performer's breath, his quirky chair. According to Paul Sanden in his comprehensive study of liveness in modern music, such techniques resulted in an 'increased communication of the corporeal—and thus human—significance' (2013, 64). Within music, therefore, liveness is about performance rather than about the spatiotemporal encounter. As Simon Frith writes, 'For me, to hear music is to see it performed, on stage, with all its trappings' (1996, 211).

Certainly the way we think of music—what is music!?—has changed during the last 100 years exactly because of technology and media, from scores and/or live performance as the only ways of encountering music to the 'ubiquitous music' (Kassabian 2013) that enters into our lives unbidden. Any essential narrative of music—the production of sound by or through the human body—has been exploded continuously outwards, making it increasingly redundant to think of music ontologically rather than as an activity—as musicking (Small 1998)—producing ever more layers of experience.

Within media studies liveness has been discussed in relation to transmission technology and specific programme formats (most frequently news and sports). Even as recently as 2012, Andrew Crisell devoted a full book, *Liveness and Recording in the Media*, to discuss the 'many desirable features' of liveness in broadcast media. Crisell's main concern is to question why radio and television carry so much recorded material, despite the fact that they are basically *live media*. What is striking in his argument is how the construction of the dichotomy between live and recorded (often live *versus* recorded) quickly becomes a quagmire from which it is almost impossible to emerge.

Often the shift toward close consideration of experiences of liveness has been the result of a developing focus on empirical audience research, which naturally gravitates towards uncovering lived experiences rather than ontological statements. This is particularly the case in media studies, where, as already mentioned, Barker discusses the many meanings of liveness in his book on livecasting, *Live to Your Local Cinema* (2013), which addresses the sociability of the event as a combination of aesthetic, commercial and social interests. In his book *Television and the Meaning of Live* (2013), Paddy Scannell discusses liveness in terms of the ordinary, everyday experience of television rather than media specific technology or related to particular television genres. With reference to Heidegger's phenomenological thinking about 'being and time', he suggests that the meaning of live lies in our engagement with television as a way of engaging with life.

Although this is by no means a complete literature review—which in an evolving field would be redundant as soon as it was produced—we hope it will serve as an introduction to the value of cross-disciplinary reading in the subject of liveness. As such it is an illustrative mapping of the plurality of approaches to liveness and in particular the turn towards a phenomenological understanding of experiencing live.

A Phenomenology of Experiencing Live

A focus on experience is the prerequisite of phenomenological understandings of our engagement with the world, and here more specifically our engagement with art and culture. As Wolfgang Iser writes, in terms of readers but the consideration might equally be of viewers, listeners, spectators or audiences:

> the phenomenological theory of art lays full stress on the idea that, in considering a literary work, one must take into account not only the actual

Introduction 9

text but also, and in equal measure, the actions involved in responding to that text

(1974, 274)

A phenomenological approach to live performance inevitably disallows consideration of liveness as something that might be objectively described and measured in a manner divorced from its relationship to experience. Instead it invites consideration of a *thickening* of our understanding of the experience of live performance.

The particular tools of phenomenology are conceptual ideas that inform methodological approaches. These include the articulation of perception as embedded in embodied operations, an interest in the relationship between subjectivity and the intersubjective (or after Laing we might say between the experience and the inter-experience, 1967, 17–8) and the importance of affect. Vivian Sobchack, for example, presents a phenomenological understanding of film as encountered through the eyes and ears but *experienced* within the sensorium of our bodies. Sobchack writes that as humans our experience of the world:

necessarily entails both the body and consciousness, objectivity and subjectivity, in an *irreducible ensemble*. Thus we both matter and mean through processes and logics of sense-making that owe as much to our carnal existence as they do to our conscious thought.

(2004, 4)

This notion of how we both matter and mean is echoed later in her book when Sobchack writes that we are 'embodied and conscious subjects who both "have" and "make" sense *simultaneously*' (2004, 75). To make sense is to engage in sense-making: processes of conscious interpretation, of socially constructed meaning making, of enduring reflection, of analogy, comparison and memory recall. To have sense is to participate in an immediate reflective experience that impinges upon us materially, upon us as bodily (carnal) matter, before the activation of conscious thought. Making sense in this context might be aligned to Roland Barthes' description of meaning as sensually produced, as well as to the contesting of the mind/body nexus that has prevailed in much western thought.

Crucially, Sobchack suggests that having sense and making sense emerge simultaneously and inform and infect each other. A phenomenology of experiencing live, therefore, needs to consider experience as a set of dynamic and particular relationships—the most crucial of these being the active or interactive relationship between the art work and the spectator.

In his writings Maurice Merleau-Ponty examines the interrelationship between embodied perception and the world as experienced. Importantly, this is not positioned as a one-way relationship, but rather a system of exchanges that occur through correspondences between the act of perception and the

object in the world. In the case of paintings, for example, Merleau-Ponty suggests that 'Quality, light, colour, depth, which are there before us, are there only because they awaken an echo in our bodies and because the body welcomes them' (1993, 125). A particularly evocative echo of this in relation to music is presented by Thomas Clifton:

> The sound produced by an oboe in its middle register is usually described as somewhat thin, nasal, rough and slightly hollow. But this is not altogether accurate. Rather, these words are descriptive of our bodily behaviour: we have adopted an attitude of hollowness, thinness etc.
>
> (1983, 63)

Within the cognitive sciences this understanding of the world is described as 'interactionist'. For example, Reber, Schwarz and Winkielman describe how while an objectivist understanding of art would see aesthetics as intrinsic and a matter of essences—and a subjectivist view would see aesthetic taste as entirely personal and idiosyncratic—an interactionist view constructs aesthetic experience which 'emerges from the patterns in the way people and objects relate' (Reber et al. 2004, 365). Or, returning to performance studies, Peggy Phelan describes the creation of co-presence as an 'interactive exchange between art object and the viewer' (1993, 146).

The use of 'co-presence' here is particularly provocative, for it is co-presence that is held up as the very particular nature of the live encounter. Barker, for example, describes an emphasis on co-presence as 'the sine qua non for theatre and performance studies' (2013, 57). In an echo of Buber's notion of 'mutual surprise', discussed earlier, this is a description of a kind of mutuality, an awareness or active going between performance and audience that produces particular affects. The provocation, however, is the realization that co-presence—that mutuality, that (a)liveness—is not simply a result of proximity in time and space but rather a quality that describes particular kinds of experiences.

This is surely the question: how to bring a performance into a tight unity of a real conversation? How to generate the experience of mutuality? If we were striving for a grand narrative, we might suggest that much contemporary performance seeks to activate the potential of the audience's live attention—that is to activate the potentiality of co-presence and realise that moment of mutual surprise or mutual affect. We might consider this in terms of Brook's notion of the 'responsibility' of the audience, or Jacques Rancière's description of an emancipated spectator being one who is empowered to produced their own interpretations, 'to compose her own poem with elements of the poem before her' (2011, 13).

What has been termed postdramatic performance (Lehmann 2006) seeks to assert the mutuality of performance and audience through multiple devices such as direct address of the spectator as a spectator, exposing the processes of composition, through *being* on stage rather than seeming, presenting the performance as process rather than product. Interactive and participatory practices

have sought to emphasize mutuality by asserting the integrity of the audience as co-authors who shape the performance as it is made. These range from one-to-one performances where co-presence is intimate and intense, to dispersed encounters that operate through social media and cyberspace. Immersive and site-specific practices assert mutuality through emphasis on the particularity of the shared space, and the absolute embodied experience of that space. Improvisational and durational practices assert the importance of co-presence through an emphasis on the mutuality of time.

In these different ways each of these practices seeks to assert and underline to the spectator that yes, your investment matters. They seek to answer the question posed by the young spectator—Does it matter to you if I am not there?—and equally its implied reverse—Does it matter to me if *you're* not there? The particular answer is embedded within the content, structure, form and what we are terming the *materiality* of the work itself. Both spectator and practitioner are striving for a more affective relationship, desiring liveness rather than deadliness.

Liveness, therefore, is not just a matter of the individual capability of the artist, the performer or the audience. Rather the live experience calls forth a specific blending of occasion and reflexivity (Carlson 2003, 196). It is partly through cultural activity, through the process of aesthetic participation, that we know ourselves and fully engage with our encounters with the world. For John Dewey it is only through processes of self-reflective actualization that experiences are constructed *as experiences*, with their own 'individualising quality and self-sufficiency' (1934, 35). And interestingly, one of the most pertinent insights of empirical audience research has been the repeated assertion by spectators of the importance of sharing and discussing their experience with others. This means that the act of live participation is connected not just to the sense of occasion or the private bodily experience, but to the way in which this presence is recognized and valued by oneself and others. The live experience matters and means, we would argue, because of this double consciousness that allows play with identities, prejudices and taboos. It entertains and enjoys as it creates a space for potential transformations of perception and attitude.

One consequence of this is a growing recognition that experiences of live performance need to be considered *beyond* the specific or singular moment of the live encounter. Considered from the perspective of the producer of the work it is perhaps natural to conceive of each experience as discrete and bound by the confines of the work. This, after all, is what producers of work have control over. Considered from the perspective of the audience these boundaries remain important but are not limits or endpoints. Rather than experiencing individual works in isolation, audiences engage with multitudes of experiences over an ever evolving time period. This notion of a 'longer experience' (Barba 1990; Barker 2006; Reason 2010) expands in both directions in time to embrace both anticipation/expectation and recollection/memory, including the mutations, transformation, misrecollections of live memory that might be considered as a continuation of the liveness as an ongoing creative process.

If liveness is the opposite of deadliness, then it is not the product of the performance alone. Nor does it simply rest in that ontology of simultaneity in time and space. Rather, if liveness is the opposite of deadliness, then it is the product of the particular encounter between spectator and performance. Deadliness can and often does reside in the live encounter—the live encounter that is ontologically, essentially live, but which is deadly, irrelevant, forceless and spent. The payoff of co-presence is only a *potential*, not the inevitable result of a live ontology, but rather the potential result of a live experience. Deadly performances are those that fail to produce a live attention, a live sociability, a live encounter with their audiences. They fail to produce Buber's mutual surprises, Brook's quality of attention, Fisher-Licht's feedback loop or Rancière's 'emancipated spectator.' To talk about 'experiencing live' is to emphasize particular kinds of engagement, particular kinds of experiences, in which mutuality matters. To me. To us. To the performance. Maybe to our future engagement with the world.

This book is not an instruction manual, it will not provide answers as to *how to* but rather analysis of *how do*—how do performances and audiences interact to construct a live experience. Vitally, the particular dynamic, the particular experiential qualities of these performances, needs to be considered in their own right rather than asserted as the product of ontology. Not least because there can be a thin line between charisma and demagoguery, between immersion and passivity, between participation and manipulation, between spectacle and, well, empty spectacle.

The live experience is a real embrace. It is something that escapes from mere habit and, instead of routine consumption within an experience economy, becomes creative co-production.

Why this book now, why in this form?

We propose that there is a need to take the discussion further after Auslander. A need to enact a shift of focus from *liveness*, which seems to automatically keep us within a framework of ontology, to that of *experiencing liveness*. The challenge of engaging with, understanding and mapping experience seems fundamentally more vital than that of searching after an ontology. There are key texts within the discourses of liveness, central amongst which are those of Auslander and Phelan, but it is noticeable that, while frequently acknowledged as starting points, the contributions to this collection are rarely orientated exclusively around such texts. Rather they take standpoints beyond this dispute, engaging with questions of audience experiences and material processes which form the structure for this collection.

As editors, this book emerges from our own research, our own interests and sense of the developing discourses in the field. Both of us have at various points engaged in what is sometimes still called interdisciplinary research—performance studies borrowing from the cognitive sciences, music borrowing from social studies—but which should probably simply be termed research. In such practices we have become aware that similar conversations are taking place

in different locations, from different perspectives. There may be different inflections, according to dialect and culture, which result in reference to different theoretical thinkers and different key practices, but nonetheless these discourses are engaging in fundamentally the same issues. As editors we are interested in an interdisciplinarity that 'springs from a self-conscious dialogue with, criticism of, or opposition to, the intellectual, aesthetic, ethical or political limits of established disciplines' (Born 2010, 8). As new kinds of research questions emerge from the interdisciplinary engagement with experiencing live, it becomes increasingly difficult to return to any fixed differentiations between distinct disciplines. Equally, these new kinds of questions require inter-methodological approaches, which allow different ways of thinking and researching, including the empirical and the philosophical, to sit alongside each other without requiring either narrow synthesis or hierarchical subordination.

We want this book to enact a 'real conversation', drawing together different dialects and cultures from across various disciplines. If liveness does not reside solely in the ontological manifestation of performance but is rather related to the particular qualities of the spectators' attention and the specific qualities of the materialization of the work, we need to approach these liveness-es differently. We need to investigate the pluralities of experiencing live through interdisciplinary approaches, forcing us to relocate our attention towards matters that become apparent across disciplines.

This book therefore brings together current and dynamic perspectives on the question of experiencing live. It does so across disciplines (principally theatre, dance, music and live art, but also sound art, writing and other practices) and through incorporating both full-length theoretical chapters and what we have termed 'shorts'.

In a much repeated declaration, Edgar Allen Poe described the short story as something that might be 'read at one sitting'. For Poe it was this, along with a 'unity of effect', that made the short story superior to the novel. At around 2,500 words in length, all the shorts in this collection have these attributes of brevity and unity. The subsequent ability to read them at one sitting invites readers to engage or indulge in various acts of traversing. To follow the labour of a full length chapter with the refreshing joy of a short; or to read one in the immediate light of another. These shorter texts are not necessarily any less 'academic', but often have a different kind of tone, are frequently orientated around practice and are designed to allow greater diversity of material and voice, both crucial given the interdisciplinary nature of the book.

Across these contributions we have divided the book into two parts— *Audiencing* and *Materialising*—which consciously avoid the trap of reification as well as divisions that might be based upon either discipline or methodology. We say more about the thinking behind this structure in the two section introductions, where we also briefly introduce each contribution and its relationship to the collection as a whole. Appropriately, given the starting point for much of this debate, the collection is concluded with an afterword from Philip Auslander.

14 *Matthew Reason and Anja Mølle Lindelof*

While divided into sections, we invite readers to navigate crab-wise: reading concepts and ideas between theory and practice; between disciplines; between processes of audiencing and processes of materializing; between narratives of making and narratives of experiencing; between methodological approaches that result from different ways of knowing. The ambition of all these forms of knowing—and the ambition of this book—is to know something about the live experience and consider the particular ways in which it matters and means to different audiences, in different times and different contexts. To invite all of us to elaborate on the possible answers when we ask:

What are the particularities of live experiences?
Does liveness matter?

References

Auslander, Philip. 1999. *Liveness: Performance in a Mediated Culture*. London: Routledge.
Barba, Eugenio. 1990. 'Four Spectators.' *The Drama Review* 34: 96–100.
Barker, Martin. 2003. 'CRASH, Theatre, Audiences, and the Idea of "Liveness".' *Studies in Theatre and Performance* 23 (1): 21–40.
Barker, Martin. 2006. 'I have seen the Future and it is not here yet . . .; Or, on being Ambitious for Audience Research.' *The Communication Review* 9: 123–141.
Barker, Martin. 2013. *Live to Your Local Cinema: The Remarkable Rise of Livecasting*. Basinstoke: Palgrave Macmillan.
Baudrillard, Jean. 1988. 'Simulacra and Simulations' from *Selected Writings*. Cambridge: Polity Press.
Beckerman, Bernard. 1979. *Dynamics of Drama*. New York: Drama Books.
Benjamin, Walter. 1970. 'The work of art in the age of mechanical reproduction.' In *Illuminations*, edited by H. Arendt, 211–44. Glasgow: Fontana.
Born, Georgina. 2010. 'For a Relational Musicology: Music and Interdisciplinarity, Beyond the Practice Turn.' *Journal of the Royal Musical Association* 135 (2): 205–243.
Brook, Peter. 1972. *The Empty Space*. London: Penguin.
Buber, Martin. 2002. *Between Man and Man*. London: Routledge.
Carlson, Marvin. 2003. *Performance: A Critical Introduction*. New York: Routledge.
Clifton, Thomas. 1983. *Music as Heard: A Study of Applied Phenomenology*. New Haven: Yale University Press.
Crisell, Andrew. 2012. *Liveness and Recording in the Media*. Basingstoke: Palgrave.
Dewey, John. 1934. *Art as Experience*. New York: Minton, Blach and Co.
Fischer-Lichte, Erika. 2008. *The Transformative Power of Performance: A New Aesthetics*. Abingdon: Routledge.
Forsare, Malena & Anja Mølle Lindelof. 2013. *Publik i Perspektiv* [Audience in Perspective, in Danish and Swedish]. Lund: Makadams Forlag.
Frith, Simon. 1996: *Performing Rites. On the Value of Popular Music*. New York: Harvard University Press.
Kassabian, Anahid. 2013: *Ubiquitous Listening*. California: University of California Press
Iser, Wolfgang. 1974. *The Act of Reading. A Theory of Aesthetic Response*. Baltimore: Johns Hopkins University Press.
Laing, R.D. 1967. *The Politics of Experience*. New York: Pantheon Books.

Lehmann, Hans-Thies. 2006. *Postdramatic Theatre*. London: Routledge.

Merleau-Ponty, Maurice. 1993. 'Eye and Mind.' In *The Merleau-Ponty Aesthetics Reader*, edited by G. Johnson, 121–149. Evanston, IL: Northwestern University Press.

Phelan, Peggy. 1993. *Unmarked: The Politics of Performance*. London: Routledge.

Rancière, Jacques. 2011. *The Emancipated Spectator*. London: Verso.

Reason, Matthew. 2006. 'Young Audiences and Live Theatre, Part 2: Perceptions of Liveness in Performance.' *Studies in Theatre and Performance* 26 (3): 221–241.

Reason, Matthew. 2010. 'Asking the Audience: Audience Research and the Experience of Theatre.' *About Performance*, 10: 15–34.

Reason, Matthew & Dee Reynolds. 2010. 'Kinethesia, Empathy and Related Pleasures: An Inquiry in to Audiences Experiences of Watching Dance.' *Dance Research Journal* 42 (2): 49–75.

Reber, Rolf, Norbert Schwarz & Piotr Winkielman. 2004. 'Processing Fluency and Aesthetic Pleasure: Is Beauty in the Perceiver's Processing Experience?' *Personality and Social Psychology Review* 8 (4): 364–382.

Sanden, Paul. 2013. *Liveness in Modern Music*. New York: Routledge

Scannell, Paddy. 2013. *Television and the Meaning of Live*. Cambridge: Polity Books.

Small, Christopher. 1998. *Musicking: The Meanings of Performing and Listening*. London: Wesleyan University Press.

Sobchack, Vivian. 2004. *Carnal Thoughts: Embodiment and Moving Image Culture*. Berkley: University of California Press.

Stern, Julian. 2013. 'Surprise in Schools: Martin Buber and Dialogic Schooling.' *Forum* 55 (1): 45–58.

Part 1

Audiencing

Introduction

Matthew Reason and Anja Mølle Lindelof

'Audiencing' describes the work of the spectator. It describes acts of attention, of affect, of meaning-making, of memory, of community. A focus on audiencing recognizes that attention is a constructive or performative act, that spectators bring performances into being through the nature of their variously active, distractive or contested attention. In a volume that focuses upon experiencing live, this is central. Consisting of six full length chapters and eight 'shorts', the contributions in this section consider the work of the spectator in relation to experiencing liveness.

Threaded through all of the chapters in this section is a concern with how we experience live performance. What kinds of consequences, investments and relationships are prompted for spectators by the experiences of liveness? The first chapter in this section is sub-titled a 'prolegomenon', and it does indeed serve as an appropriate introduction to the collection as a whole. **Martin Barker** opens his discussion with a series of descriptions of vibrant, visceral and enduring experiences—of a church service, a film, a concert—only some of which might be described as formally live but all of which 'achieved a form of liveness' as a consequence of his investment into the experience. Barker arrives in this discourse from the perspective of film and media studies, with a particular focus on audience research, and therefore has a degree of distance from and insight into the discourses around liveness that have been flowing through performance studies. This chapter in part maps Barker's intervention into this debate to propose that the vital and meaningful quality of any cultural encounter is its transformative potential: how does it impact upon and change spectators? In rethinking liveness as 'aliveness', Barker describes (a)live experiences as emergent, 'that is, as they are experienced they are felt to grow, to integrate, and to open up new possibilities.'

If Barker opens with some brief anecdotal accounts of moments when an experience came *alive* to him, **Katja Hilevaara**'s chapter, 'Orange Dogs and Memory Responses', takes the extended memorial response to performance as its central motif. Images of disappearance, transience and ephemerality have long been central to evocations of liveness, a discourse that Hilevaara describes as producing 'eulogy writing'. Hilevaara follows the vital counternarrative of considering what does remain, not least in spectators' memories. Of course,

memory is marked by its fallibility, represented here by the misremembering of an orange dog in a Laurie Anderson performance, but Hilevaara asks us to consider the conceptual and philosophical implications of placing positive value on the translations and mutations of memory. Instead of mourning (another deadliness) Hilevaara draws upon Henri Bergson's discussions on memory as an act of becoming to construct a playful memory response approach through which spectators can actively engage in creatively responding to their performance experiences. Reading across these two chapters, we might consider how through such active misrememberings the experience comes (a)live.

The following two chapters in this section can also be read as companion pieces, as both engage in considering how spectators' responses to live music have been shaped by changing technology. What is striking is that neither chapter—**Lucy Bennett**'s 'Fandom, Liveness and Technology at Tori Amos Music Concerts' or **Stephanie Pitt**'s 'Social and Online Experiences: Shaping Live Listening Experience in Classical Music'—construct the relationship between the live and the technological as oppositional. Indeed, the irrelevance of such a construction becomes apparent precisely through both authors' careful mapping of the interrelationships (or as Bennett puts it 'entanglements') between spectators' live, mediatized, online and technological engagement with music. From within different music genres, both Bennett and Pitts utilize empirical audience research in order to provide grounded and evidenced discussion of how audiences construct and use technology in relation to performance experiences. Bennett considers how social media enables live sociability to extend beyond those actually present at the concert, while Pitts examines how the interrelationship of live and recorded classical music as well as the social circumstances of listening informs audiences' musical lives. Framed by a contemporary concern in arts organisations for the status of classical music, Pitts argues for a more informal public discourse that acknowledges the experiential qualities of live music listening often emphasized in qualitative audience research.

It is not just within arts institutions that lived experience has long been an uncomfortable notion. In the new critical paradigm of cultural theory in the 1970s and 1980s, experience became a contested term, dismissed as a theoretical abstraction or as pure subjectivity. In his chapter, 'The Meaning of Lived Experience', **Paddy Scannell** plays with Martin Heidigger's phenomenological thoughts on 'being' and 'time' in order to explain why and how experience is fundamental to human existence. Departing from a brief introduction to various kinds of experiences, the chapter introduces the concepts of 'care structure' and 'mood' to examine how such 'events as occasions' are organized, planned and invested with hopes and expectations. 'To own an experience (to possess it) is to have been possessed by it', Scannell suggests and while such occasions might be 'uselessness', non-utilizable, they offer distinct moments in time, moments out of time, moments that are deathless.

Finally, in this section **Matthew Reason**'s chapter on 'Affect and Experience' addresses a crucial dilemma in talking (and writing) about the experience of live performance. If the live experience is best described as something that

has impact upon us, but yet simultaneously escapes us, then how can we—as audience as well as researchers—engage with it, the experience and its impact, in post-performance situations in any meaningful way? Informed by the 'affective turn' and by contestations within affect theory, the inadequacy of language is discussed through an engagement with the words of audiences watching dance and the writings of Brian Massumi, Margaret Wetherell and Ruth Leys to examine the relationships between affect, emotion and meaning making. Experiencing live, Reason argues, is a dynamic relationship between having sense and making sense, a co-constructive process in which the non-conscious and the intentional intersect and allow 'affect to infect our ongoing lived experience of the world'.

<p style="text-align:center">★ ★ ★</p>

Following on from the chapters, the shorts in this section engage with the question of audiencing in a variety of manners and from a diversity of perspectives. They present careful considerations of particular relationships, engaging with experience, with encounter, with affect and with empathy.

The first two shorts, by **Alexis Soloski** and **Victoria Gray**, both engage with affective encounters between audience and performer, although from diametrically opposing perspectives. Drawing on her experiences as a critic, Soloski describes the sometimes numbing experience of sitting in the auditorium and recognizing that 'as much as I want to believe that theatre demands the real-time interaction of actor and audience, it isn't always true.' She then recounts one particular experience, of Forced Entertainment's *First Night*, that made her sit up, pay attention and recognize the centrality of her presence. Gray also presents a particular performance/audience encounter, but this time from the perspective of the performer. Her short presents parallel accounts—one a visceral 'in the moment' steam of embodied consciousness, the other a reflective analysis—of her experience of audience members photographing her in performance against her wishes. Both these chapters share an attention to the fine grain of the experiential encounter, its particularities and its embodiedness.

The experiential encounter between audience and performer is continued in the next two shorts, with **Lynn Lu** and **Imogene Newland** both explicitly engaging with questions of empathy. In the different contexts of live art and dance, Lu and Newland consider ways in which the audience experiences might be felt, inscribed on and remembered through the body. Echoing Hilevaara's engagement with audiences' ongoing memorial responses, Newland works to construct a '"liveness" that does not merely pass into "gone-ness" or "lost-ness" but rather is a living process.' For Lu the dynamic between artist and live audience is an 'inextricable and critical' element of her work. Whether she asks spectators to swap clothes with her, or drink her bath water, or witness her exposure to shark infested waters, there is an interest in the consequences of the human-to-human encounter: a coming alive between performer and audience that represents a genuine opportunity for mutual surprise.

The opportunity to discover synergies across extremely different contexts is presented again in the next two contributions: **Catherine Bagnall** writing about participatory mountain walking while wearing the handmade ears and tails of animals; and **Gry Worre Halberg** on the Sisters Academy's radical interventions into Danish secondary schools, designed to enable sensuous and poetic modes of being. The connections between the pieces are in fact significant, most noticeably a concern to develop alternative, more connected, modes of being with ourselves, other people and the world around us. And, moreover, to do so through performance experiments which re-orientate our aesthetic sensibility and, in the words of the Sisters Academy involve 'putting our flesh into the idea'. In relation to experiencing liveness, both describe audience/participant *becomings*—moments of acting, transformation, ongoing immersion. Moments in which co-presence both matters and means.

In their contribution **Sarah Hogarth and Emma Bramley** also deal with a kind of immersion, on this occasion in the context of one-to-one performances. The authors draw on their curation of a 2014 festival of one-to-one performance, in Liverpool, which focused on motifs of control and authorship. Often seeking to stage moments of face-to-face encounter, where the I of myself recognizes the I of another, the one-to-one performance is an exemplar of the careful curation of the relationship between audience and performer. Hogarth and Bramley's discussion suggests that more participation in and of itself does not always result in greater impact or greater sense of live co-creation, instead accounting of the powerful affect of a decision *not* to speak.

Finally in this section on audiencing, **Kerrie Reading** and **Rebecca Schneider** engage with different kinds of performance remains and consider how the process of engaging with such archival and indeed archaeological traces can become a form of audiencing of past performances, experiences, encounters and livenesses. Reading's account is of a practice-based intervention into, and re-staging of, the archive of Chapter Arts Centre, Cardiff. She uses the phrase 'performatic archive' to argue that 'the archival document can be approached in an embodied way that is able to make it (a)live.' In her contribution, Schneider travels further back in time, using her encounter with the face of a Roman actor on a small bone disk or token to consider a 'strange question' and 'ask whether I am experiencing the object live?' Vitally, the question is not is this object live, but am I experiencing it live? And this, of course, is the question that underpins all the contributions in this collection with the variety of ways in which it is answered and addressed demonstrating the complexity—but also vibrancy—of the issue.

1 Coming a(live)

A Prolegomenon to any Future Research on 'Liveness'

Martin Barker

When I was 13 years old, I used to accompany my parents to our local church. One Sunday, to their consternation, the preacher was an evangelical. He strode around, roused, urged, cajoled—and then called on all the young ones who felt The Call to come forward. I was hooked. I really wanted to go, but didn't— I have no idea why. That night, I talked to my mum, who was very clear: if I really believed what I had heard I should 'come forward.' That experience and that conversation set in train a year-long process of thinking which I've never forgotten.

When I was 22, I went to see *If*, Lindsay Anderson's (1968) film about a rebellious boy at a British 'public' school. I found it deeply arousing: first, for its general portrayal of the school's viciousness—like an extreme version of my own; second, for a pivotal fantasy sex scene, in which Malcolm McDo-wall writhes on the floor with a beautiful naked motorbiking girl; third, for its denouement, in which the pair machine-gun teachers and boys from the roof of the school and themselves go down in a hail of bullets. As I watched, I cheered inside, and I've never forgotten it.

When I was 42, my wife took me for my birthday to a live concert of my long-time favourite piece of music, Mahler's Second Symphony. We arrived quite late and had to take seats right behind the brass section. There is one moment in the symphony which always catches me: the end of the first movement, where the orchestra descends in arrhythmia across many bars, which then resolve suddenly. But I have never reacted so strongly as this time: at the moment of resolution I lurched forward almost convulsingly. I've never forgotten it.

Three moments of complete absorption, each of which by dint of its force contributed to making me what I am. But each worked differently. The first certainly depended upon my being there and feeling caught up in the preacher's 'performance.' But its effect found shape through what happened afterwards. Thinking about it, it lost its 'liveness' as I began to think about how manufactured it was, and how its artificiality ran counter to thinking about the issues it claimed to address. That led to me becoming an atheist, after a year of thinking. The second was from the outset wholly mediated, and I knew it was, but it *felt* as if I was (re)living my own unpleasant, bullying, hierarchical school. It took

22 Martin Barker

me on a journey towards becoming a socialist (as I came to see in myself, partly through that film, a horrible assumed superiority that I needed to shuck off). That *lived with me* for many years—and I intend that both literally and metaphorically. The Mahlerian third was without doubt live in the traditional sense. But its force came from me knowing the music beforehand and being primed to respond to my favourite moment, but getting an experiential *excess*, because of those local circumstances. The memory of my response led me to reflect on what I love in all forms of art: 'moments' where form is *visible but stressed*. That has informed my choices on many occasions since. All three were, and in some ways still are, magically 'alive' to me.

This chapter addresses the topic of what is going on when culture most matters to people—when it *comes alive* for them. It is about the capacity of media and cultural forms and products to change lives. We know very well that most of the time no such thing happens. We note, we enjoy, we evaluate, we criticise and we consign to appropriate places in our repertoire of bits of memory—or simply forget. But once in a while, something different occurs. This chapter is about the processes that are triggered. And it is, tentatively, about how perhaps we might research this largely ignored phenomenon.

This chapter is intended as a contribution to ongoing debates about 'liveness' as a factor in the reception of media and cultural materials. Yet its evidence is drawn primarily from a field that is synonymous with the non-live: cinema. And I am not addressing any of the features traditionally said to characterise 'liveness': simultaneity, co-presence, performers' interaction with audiences, and so on. In a previous study (Barker 2013a and 2013b), I compared approaches to liveness across a series of fields of study: theatre and performance, television, film and cinema, comedy, music (especially opera), radio, sport and virtual presence. That study was prompted by the rise of the phenomenon of simulcasting of theatre, opera and other events into cinemas—events that stress their 'liveness,' but are clearly not live in many of the traditional senses. Trying to make sense of these and how audiences described their reactions to them, I came to realise that there are many competing ways of thinking, valuing, and theorising 'liveness.' A survey of the main traditions within these fields revealed a host of contradictions—yet mainly hermetically sealed approaches.

Probing the literature revealed that there are at least nine working notions of what makes up 'liveness'. The first four—*co-presence* (performer and audience are both there), *simultaneity* (the performance is happening at that moment), *risk* (the outcome is not guaranteed—the event has still to happen) and *audience-impact* (the audience's reactions [laughter, applause, etc.] might affect how the event goes)—are particularly stressed by theatre and performance scholars (where, prompted by scholars like Peggy Phelan (1993) and Philip Auslander (1999, 2008), the most serious attempts have been made to theorise the issues). Some of these, however, are either impossible or irrelevant to other approaches. For instance, music scholars generally have no problem with recordings—as long as these capture the *grain* and perhaps *virtuosity* of a performance. Then, recordings can count as 'captured liveness.' In another direction,

some opera scholars, de-emphasising risk (the last thing wanted), have stressed the importance of creating a *sense of community*, which could involve the use of technological relays. Comedy scholars, meanwhile, knowing well that touring comedians use a script (and, of course, are generally understood by audiences to do so), argue for the importance of the *local colour* that will be added to ground an otherwise standard routine. Sports scholars—just about the only group actually to include studies of their audiences—have played up the importance of *created communities* (e.g., at pub football screenings, where fans dress up, sing and perform their fandom). Finally, virtual performance scholars are essentially interested in how audiences can be *persuaded* that what they are doing is 'live,' by techniques which generate immersion and closeness to avatars, for instance. Film and television studies, meanwhile, are largely suspicious, seeing *claims to liveness* as part of commercial or ideological devices.

Not only are these very varied, but there are substantial conflicts among them. And overwhelmingly lacking is research on the meaning and value of 'liveness' to actual audiences. In a small study of audiences for simulcast events, I found instead that many people—even while they might acknowledge in theory that they were losing something by 'not being there'—in practice loved the events, often felt they got more out of them, and even felt they gained privileged access to aspects of it that were invisible to direct attenders. In short, they *achieved a form of liveness*. As two of my respondents put it: 'naturally the experience of actually being in the opera house with all the buzz and excitement cannot be reproduced. That apart, it was better than a live performance in two respects. Having close-ups of the singers was better than using opera glasses. Secondly, having cameras behind the stage in the interval was fascinating.' 'Larger than life. . . . surprisingly intimate, great visibility, and interesting introductions.' Being surprised by how intimate and involving simulcasts could be was one discovery of the project. It suggested that for audiences the dynamics of the 'live' are more complex than our current theories will allow for. I want therefore to propose a new way of thinking about 'liveness,' one that builds on pieces of evidence that have emerged in a series of audience research projects.

My proposition runs in the opposite direction from the field of fan studies which, for more than twenty years now and with an accelerating body of work, has been exploring very effectively the operation of a whole series of important qualities in audiences: community development, corporate resistance, knowledge-creation, world-extension and playfulness. Forged out of a rejection of models of fans' 'obsessiveness,'[1] these very valuable investigations have hugely expanded our understanding of the many ways in which fans claim ownership of circulating mass products (films, television series, comic books, etc.), and formed collectivities within which they share their own creations, of many different kinds. But they have left a significant flipside underconsidered: the 'moment' when audiences find themselves moved, aroused, excited and overwhelmed by the cultural and media materials that they love. If fan studies have shown particular interest in, to borrow a striking phrase

from Matt Hills, the 'endlessly deferred narrative,' what should we say about people sinking themselves in richly lived moments and declining to defer at all?[2] I am not alone in believing that attention to these could allow us to think about the role that cultural materials may play in changing individuals and prompting wider social changes. The earliest sign that I have identified was the quirky and sadly ignored work of Victor Nell (1988) who explored the brain and psychological processes of engrossment in reading. More recently, Tomas Axelson (2008, 2014) has begun exploring the near-religious dimensions of audiences' pleasures in films; Alf Gabrielsson (2011) has gathered a remarkable body of audience talk about the transformative effects of music; and Claudio Benzecry (2011) has explored the complex relations of a group of Argentinian opera fanatics to their chosen music. In other fields occasional works have also explored people's complete devotion to an activity: Mark Stranger's account of Australians' dedication to surfing catches this well (2011). Some earlier work of my own (e.g., 2009) has broached the topic less systematically. This eclectic scatter of interest and research suggests an emergent field, not yet integrated.

A Sketch of the History of Thinking about Cultural Transformations

There is, inevitably, a long history of thinking about the ways in which 'culture,' and especially popular culture (variously defined and understood), might be capable of forming and changing people (as against, for instance, providing them with expressive outlets, pleasures, entertainment and escape). A great deal of that history has been dominated by cultural critics expressing fears about audience engrossment. From Plato onwards, a chorus of lament has worried, variously, about shadows in the cave, weak and immature minds and ideological subordination. Celebration has been much rarer.

The first wave of serious thinking came in the eighteenth century, with the rise of theories of the 'sublime.' Scholars (e.g., Monk 1960; Ashfield and deBolla 1996; Clewis 2009) have devoted a great deal of attention to this phenomenon and its variants (from Edmund Burke's 'sublime terror' to Immanuel Kant's 'rational sublime'). Burke wrote that 'whatever is fitted in any sort to excite the ideas of pain and danger, that is to say whatever is in any sort terrible, or is conversant about terrible objects, or operates in a manner analogous to terror, is a source of the sublime; that is, it is productive of the strongest emotion which the mind is capable of feeling' (2008 [1757], 499). The period's fascination with 'pleasure' for its own sake and what that might signify and achieve, was clearly connected to the emergence of a consumer society, to rising (if wildly unequally distributed) wealth, to mercantilism and inflow to Europe of new goods, experiences, and ideas—and of course (on the underside but equally formative) to the slave trade and its increasingly rigid hierarchisation of superior and inferior beings.[3] It was also connected to the rise of a grandiloquent concept of 'nature' as spectacle: awe-inspiring mountain

Coming a(live) 25

ranges, for instance, to be sought out on Grand Tours of Europe. These were experiences to *aspire* to and failure to have them marked one as lesser, of the middle order. To attain sublimity was to be a better human being, to be capable of true philanthropy, or (in one striking phrase) experiencing 'the luxury of doing good' (Anon., the Royal Humane Society, 1796). For Kant, the last (and most powerful) theoriser, the sublime was linked to his transcendent category, 'Reason.'

This was a *performative* category, expressing experiences one *ought* to have and needed to show others that one had. It is what gentlemen (and occasionally ladies) did to prove their right to ascendancy. The category dissolved, at speed, under the impact of the French Revolution—now the notion that anything leading to a sense of 'Terror' is a source of Delight (Burke) became not a little challenging![4] And indeed the nineteenth century is then dominated by two linked processes: the drive to demarcate 'proper culture' from mass culture and the culture of the masses;[5] and the increasing policing of working class media and cultural pleasures as 'dangerous' and 'corrupting.'[6]

The next substantial theorisation of rich experiences had to wait until after the Second World War. Originally published in 1954, Abraham Maslow's *Motivation and Personality* (1987) builds a strongly normative hierarchical model of personality types heading towards 'health' and 'self-actualisation.' He divides human needs across five levels: physiological, safety, belonging (so-called 'deficiency' needs), esteem and self-actualisation ('growth' needs). His most significant type then divides into the real high achievers, the 'peakers,' and their middlebrow associates, the 'non-peakers.' The latter are still missing something. This is part of his ('humanistic') Third Way in psychology, emerging in the 1950s in opposition to both behaviourism and psychoanalysis, built out of his encounters with Ruth Benedict and Max Wertheimer who provided him with intellectual paradigms of ideal ('healthy') people:

> These self-actualising people tend to be good animals, hearty in their appetites and enjoying themselves without regret or shame or apology [. . .] What healthy people *do* feel guilty about (or ashamed, anxious, sad, or regretful) are (1) improvable shortcomings [. . .]; (2) stubborn remnants of psychological ill-health [. . .]; (3) habits which, though relatively independent of character structure, may yet be very strong; or (4) shortcomings of the species or the culture or the group with which they have been identified.
>
> (1987, 131)

Yet at the same time, he is sufficiently concerned with pleasure for its own sake that he distinguishes (approved) Apollonian and (disapproved) Dionysian ways of enjoying.

What characterise these 'healthy' folk are *spontaneity, fresh appreciation* and *peak experiences*: 'peak experiences are characterised by feeling [. . .] simultaneously more powerful and also more helpless, of great ecstasy and wonder and awe, the

loss of placing in time and space with, finally, the conviction that something extremely important and valuable had happened' (177). And: 'peakers [. . .] live in the realm of Being, of poetry, aesthetics, symbols, transcendence, "religion" of the mystical, personal, non-institutional sort, and of end experiences' (138). But Maslow is very positive that peakers are *not* rebels. He is confident that his theory is compatible with business applications (and indeed his work has been widely taken up within marketing).

There have been many critiques of Maslow's work for its lack of attention to gender, class or race dimensions and for its hierarchical theory of needs. But perhaps the predominant problem with Maslow's work is simply its close connection with business motivational psychology: this is a theory tailored to getting more out of higher-ranked employees. Manual and administrative workers, the self-employed and so on do not feature—they simply won't reach his Level 5. This reads like an early version of Richard Florida's (2002) hyperbolic 'creative class' argument, coupled awkwardly with culture-status (serious vs middle-brow) theorisations.

More recently, in particular fields, claims have been laid down—sometimes influentially—for the ability of cultural forms to change people. Perhaps most notably Charles Jencks' (1999) celebratory account of architecture's 'ecstatic' potential has resonated widely. Borrowing heavily from the work of Jean Baudrillard and theories of the 'postmodern,' Toy and Jencks (1999) write of architecture as potentially 'stimulating, holistic and overpowering': the words, of course, recalling the claims about 'sublimity.' In their ways of talking buildings do seem to take on a life, come alive in significant ways. The problem is the severe lack of evidence that anybody other than the *creators* and *owners* of such prestige buildings feel stimulated and expanded in the suggested ways. The risk of theorisations of this kind is that they sound like the blurbs in sales brochures for rebranding urban areas and selling luxury properties.

These attempts to theorise people's 'high value' experiences are rare, scattered and context-specific. They are also, it seems to me, class-specific in all cases and horribly lacking in an evidential base. If theories of 'liveness' are mutually contradictory, and the few attempts to produce theories of ideal transformative experiences markedly display their class and status origins, I want to argue the need to begin again, from a very different angle.

Behind and alongside all these is the continuing tradition of fears about audience 'vulnerability': that powerful engagement and extreme emotions are dangerous, that repeated encounters implies increased 'effect' and indicates loss of self in their face, that therefore deeply engaged viewers (and it usually is visual materials that generate these fears the most) are likely to be absorbing the 'messages' which concerned critics identify. This panoply of concerns has its popular versions but has also its 'scientific' version in the mass communications research tradition. The assumption in all such work is that deeply engaged experiences of films, games and other popular media are simple, unreflective and unproductive. They involve *identification, loss of self, absorption*. This is a double assault: on the *wrong people* engaging deeply with the *wrong materials*. One of my ambitions is to reclaim popular media as also potentially transformative,

yielding rich experiences for people and providing the resources for thinking about self, the world and the future. This happens, I believe, when these media *come alive* for their audiences.

Some Evidence from the *Lord of the Rings* Project

I want in this section to draw on fragments of the evidence gathered in the course of the international *Lord of the Rings* reception project. Conducted in 2003–04, this project (which brought together researchers in 18 countries) managed to gather almost 25,000 responses to a common questionnaire. This questionnaire combined quantitative measures (capturing demographic and orientation factors) with qualitative accounts. Designed for quite other purposes (the project aimed to explore how a very English story, made into a Hollywood film, was received and understood around the world), the project threw up some startling results that are relevant here. Most immediately relevant was the discovery that, across the world, people who gave the highest ratings for both pleasure and importance to the films were likely to label them a 'Spiritual Journey'; that is, a 'story in which people discover inner truths about themselves.' It is among the qualitative responses of a good number of these people that we find evidence relevant to this chapter.

The first marker of this is the frequent use of expressions such as 'brought to life.' Here are some representative examples:

> It was completely amazing! I am not a moviegoer, in fact up till the release of *Fellowship of the Ring* I had not gone to movies in about 7 years. It has brought to life all of my childhood dreams and has given them a real face to look upon.

> The best movie experience I ever had. Almost miraculously Peter Jackson brought to life my imagination of what Middle-earth should look like feel like and sound like.

> I have loved these books for 20 years now and it was a thrill to see them brought to life on the big screen. The movies stayed true to the heart of the story which is about friendship and loyalty and doing the right thing though no one may ever know of it. It is about the little person who overcomes all odds and makes the biggest difference of all.

These quotations, between them, hint at many things. First, that bringing to life can be an intensely *emotional* process. Second, that film is not experienced (as so much film theory has suggested) primarily as a visual medium, but also as a creation of sound. Third, that in being powerful and emotional, films such as this can enact and embody major human themes, by making them 'real.' Finally, that in doing this, a substantial part of the value comes from *making this public*, shareable with everyone. This last becomes even more important when we consider how participants in the *Rings* project (including a number of those

28 Martin Barker

who talked of 'bringing to life') then talk about the effects on them; the films *changed* them:

> I have never had a film experience that literally changed my life and the way I look at things. This trilogy could be a religion.

> It has changed my life. I had not read the books before the TTT. Now I have read them four times. Now I live by daily quotes from the books and my fitness goals are tied to them as well. This would not have happened without the movies. The movies gave me mental images to have in my mind when I read the books making them much more real and exciting.

> These movies have changed my life and have given me hope that the little things that I do in my life can incur great change in the world.

Again, these quotations hint at broader themes: a near-equivalence with religion, in its import; being a source for day-to-day decisions and struggles; against powerlessness in the contemporary world; that other people who share the love of these films may share similar ideas about the world. There is, of course, always the problem that such exclamations can be momentary outpourings, performances of excitement that fade quickly. But we cannot assume this to be always the case. The last quotation even hints at a self-monitoring for changes not yet grasped by the person. It is also possible that some of these enthusiasms, even if long-lasting, simply revolve around repeated returns to the films. But again, we must not rule out the likelihood that some people expressing these sorts of views do go on to behave differently, seeing and acting on the wider world in new ways.

Simply, then, for people like this, in so many (greatly valued) ways, the films of *The Lord of the Rings* came *fully alive* for them. How do they do this? I am not certain but certain features emerge which I tentatively offer. They turn around the search for and experience of 'completeness':

> For once a fantasy movie comes out that has taste, unbelievable richness, real epic proportions and believability in plot and visuals. A complete world built on screen—can't get much better than that.

> Amazed humbled scarified moved astounded grateful tired completed happy sad blissful agony.

> You can always shut your eyes and see your own sort of place, but to see it in front of you, then you're getting the complete experience of it. There is some bits in the book that I can imagine more vividly than others, and there are some bits that you sort of skim by now, and then to see them sort of placed, things like Minas Morgul, that was really good to see somebody else's interpretation. I think it's quite important to be able to see it and then visualise it, and especially the sound, the sound's the most important thing, cos that sort of completes the entire experience.[7]

Coming a(live) 29

In these quotations a series of qualities show. There is, first, a sense of welcomed extravagance: the experience outruns almost anything previously experienced. This shows in various ways: sometimes by direct assertion, in others by offering an almost never-ending list of responses. This in turn leads to a sense of crossing between levels and modes of experiencing. That remarkable slide in the last quotation between 'visualisation' and 'especially the sound' captures this very well. Out of this a sense of 'completeness' (a repeated term), a wholeness, is achieved. And finally, there develops an awareness of the place of this experience within a person's ongoing history, but that this in some way redirects that history. People believe that they will never be quite the same person hereafter. These are, I would argue, the conditions required for an experience like this to become transformative.

Rethinking 'Liveness' as 'Aliveness'

My proposal is that we should understand 'alive' experiences as *emergent*: that is, as they are experienced they are felt to grow, to integrate, and to open up new possibilities. This is the sense and the way in which they are transformative. They appear to be characterised by a number of dimensions. I am tentatively modelling six that can be co-present. But because this is an emergent process, the more they are present and, the greater their interconnection, the greater the potential for transformation:

1 The achievement of 'aliveness' will be experienced to some degree as a *surprise*: however much a person may plan towards, and hope for, something special from an encounter, something more than we bargained for happens; at least for a while it is taken out of our control.
2 The conditions for the reception of the experiences will be managed and important to the outcome: in 'alive mode,' people look for ideal conditions. This does not necessarily mean isolation; it is about the conditions that allow the kind of concentration required. Paradoxically, the closer they *manage* these, the greater their chance of *surprise*.[8] This will incline people to *want to search* for the right, often new terms to encapsulate their experiences.
3 Experiences will often be cross-sensory: in 'alive mode,' a media or cultural presentation will tend to be experienced in a whole-body way. A poem off the page could be heard, could colour the world, could induce shivers. A painting could elicit a sense of sounds. Music could conjure up visual impressions. As importantly, even if a person can talk about them separately, the various senses will be experienced as integrated. Languages for talking about them will therefore tend to cross between the senses. I am not sure, yet, how to think about the relations of this to the more specific and rare experience of synaesthesia, but it certainly shares some characteristics with that.
4 Experiences will attain a rhythm: in 'alive mode,' experiences will become quite structured, with a sense of the pacing of both presentation and experience, leading to identification of necessary highs and lows, critical points

30 *Martin Barker*

and relaxations. A person reporting on their experience is likely to be able to express a great deal of the *whole* through an account of a critical *part*.

5 Experiences will be simultaneously sensuous and intelligible: in 'alive mode,' audiences will use imaginative, remembering and critical/evaluative faculties *more*. It will not be a choice between sensuous depth and rational evaluation but heightened combinations of all responsive capacities. This will show in, among other things, the ability to recount particular parts in detail, weighing what these achieve and how they function within the whole.

6 Experiences will combine and command both form and content: in 'alive mode,' it will be meaningless to distinguish (as much critical research does) the message (what will potentially influence a person by becoming a residue within them) and the medium (what enables that message and works persuasively on a person). People will be intensely aware of the *ways* things are done and this will be operative within their senses of the emergent whole. This will show in the manner of their retelling of particular aspects or moments, which will tend to reveal awareness of their constructedness.

From these, to the degree that they function within audiences, the materials presented will attain increased meaningfulness. They will find and build linkages with other aspects of a person's life, understandings, hopes, fears and ambitions. The experience itself will be measured by notions of 'completeness,' which will be more than ideas of closure or ending. A 'whole' will be felt to have emerged.

The concept of 'wholes' on its own invites connections to be made with a tradition of thought and research that has much fallen out of favour since the 1970s. This is the tradition of exploring the nature and role of 'totalities' in culture, a concern that motivated several generations of Marxist cultural theorists (see Jay 1992). But I am thinking in particular of the work of Lucien Goldmann who, in particular through his study of seventeenth century French Jansenism *The Hidden God* (1976), argues that emergent social groups are capable of generating 'world-visions,' complex wholes spanning different fields of experience (in the Jansenist case particularly drama and philosophy) which establish fields of possibility of social action. But while Goldmann sees the number of possibilities and situations where this might happen to be quite limited, I see no reason to set such limits ahead of doing actual research. *Fragments* of world-visions could be significant markers of ideas, attitudes and groups seeking to find modes of expression (see my 2006 essay on this).

A New Research Agenda

How then might we most effectively research 'aliveness,' understood in these ways? Clearly, scholars like Gabrielsson and Axelson have made valuable starts in gathering and thinking about bodies of illustrative evidence. To go further we need, I would argue, to put some complicated questions at the heart of any research design. As a first stab at these I would propose the following:

1 When and under what circumstances are such 'aliveness' experiences encountered? At what stages of a person's life? How well do these map onto psychological researchers' claims of 'latency' periods (where key memories, inclinations and senses of identity are laid down) in early adulthood?
2 Over what length of time can the influence of such experiences typically be traced? What do they interact with? What facets of the experiences are noticed and built into wider beliefs, understandings and purposes?
3 Is there evidence that the kinds of materials inducing these experiences are generationally linked? How do different media fare at different times? Are there 'high points' where a new medium or particular products provoke these experiences?
4 How do people characterise in talk the nature of these experiences? From where do they borrow the languages to describe exceptional moments? How continuous or varied are these languages over time and space? What research techniques might assist us when people *run out of words* to express their feelings, perhaps because they are in process of formation?
5 What kinds of wider life-decisions, associations and behaviours flow from such experiences? When and how do these transcend being purely individual and become the source of combined social actions? Can we trace moments when such experiences begin to play a role in social and political life?
6 What combinations of psychological, sociological and cultural theories could best help us design the research and analyse the results for these sorts of experience?

These questions suggest a complex life-history mode of research. Particular *parts* of this agenda could well be lifted out for separate treatment. But I would argue that such limited researches need to be thought of in terms of their potential placement within these wider frames, even if these remain beyond our research reach.

All this is very tentative and, in the full meaning of the term, a prolegomenon. I doubt I will ever be able to do this research, but I hope very much someone does, and almost certainly corrects much that is in here, in the course of doing so.

Notes

1 See Lewis (1992) and especially the essay by Joli Jensen.
2 There is a curious irony in the fact that one of the major sites for publishing works in this field is the online journal *Transformative Works and Cultures* which has, since 2008, published a wide range of essays on diverse aspects of fan engagements. Yet arguably the title belies—with certain exceptions (e.g., Henry Jenkins' striking [2012] study of fan activism) the predominant interests of researchers are in fans' creativity, community and identity.
3 For a wide-ranging introduction to this topic, see Porter and Mulvey Roberts (1986).
4 Something of this process is brilliantly captured in James H. Johnson's *Listening in Paris* (1996).
5 See for instance Levine (1990) and Storey (2006). See also Schiach (1989).

32 Martin Barker

6 See for instance Pearson (1983 and 1984). Richard Altick's *The English Common Reader* (1957) presents an excellent overview of both the debates about the dangers of the 'common folk' getting above themselves by attaining literacy, and of the importance of that literacy to rising working class movements and demands.

7 The first two quotations are taken from the *Lord of the Rings* research database. The last comes from a follow-up interview in the UK, and is shortened from the version used in an earlier related discussion. See Martin Barker (2006).

8 In saying this, I recall in particular one interview from the *Rings* project, in which a woman told us how she had watched the final film. She had gone, first with several friends, to enjoy it communally. But she had then gone again, alone, in order to allow herself to let go into it, with the outcome that 'I remain a bit taken aback by how much I really did sort of feel a very strong emotional reaction to it all.' I analyse this interview in some detail in Barker (2009).

References

Altick, Richard. 1957. *The English Common Reader*. Chicago: University of Chicago Press.

Ashfield, Andrew & Peter de Bolla, eds. 1996. *The Sublime: A Reader in 18th Century Aesthetic Theory*. Cambridge University Press.

Auslander, Philip. [1999] 2008. *Liveness: Performance in a Mediatized Culture*. Revised, London: Routledge.

Axelson, Tomas. 2008. 'Movies and Meaning: Studying Audience, Fiction Film and Existential Matters.' *Participations* 5 (1).

Axelson, Tomas. 2014. *Förtätade filmögonblick: den rörliga bildens förmåga att beröra [Intense Film Moments: The Moving Image's Ability to Touch]*. Stockholm: Liber.

Barker, Martin. 2006. 'Envisaging "Visualisation": Some Challenges from the International Lord of the Rings Audience Project.' *Film-Philosophy* 10 (3): 1–25.

Barker, Martin. 2009. 'Changing Lives, Challenging Concepts: Some Findings and Lessons from the Lord of the Rings Project.' *International Journal of Cultural Studies* 12 (4): 375–94.

Barker, Martin. 2013a. *Live to Your Local Cinema: The Remarkable Rise of Livecasting*. Basingstoke: Palgrave.

Barker, Martin. 2013b. 'Live at a Cinema Near You: How Audiences Respond to Digital Streaming of the Arts.' In *The Audience Experience: A Critical Analysis of Audiences in the Performing Arts*, edited by Jennifer Radbourne, Hilary Glow and Katya Johanson, 15–34. Bristol: Intellect.

Benzecry, Claudio. 2011. *The Opera Fanatic: Ethnography of an Obsession*. Chicago: University of Chicago Press.

Burke, Edmund. (1757) 2008. *A Philosophical Enquiry into the Origin of Our Ideas of the Sublime and the Beautiful*. Reprint, Oxford: Oxford World's Classics.

Clewis, Robert R. 2009. *The Kantian Sublime and the Revelation of Freedom*. Cambridge: Cambridge University Press.

Florida, Richard. 2002. *The Rise of the Creative Class: And How its Transforming Work, Leisure, Communities and Everyday Life*. New York: Basic Books.

Gabrielsson, Alf. 2011. *Strong Experiences with Music*. Oxford: Oxford University Press.

Goldmann, Lucien. 1976. *The Hidden God*. London: Routledge.

Jay, Martin. 1992. *Marxism and Totality: The Adventures of a Concept from Lukács to Habermas*. Berkeley: University of California Press.

Jenkins, Henry. 2012. 'Cultural Acupuncture: Fan Activism and the Harry Potter Alliance.' *Transformative Works and Cultures* 10.

Johnson, James H. 1996. *Listening In Paris: A Cultural History*. Berkeley: University of California Press.

Levine, Lawrence.1990. *Highbrow/Lowbrow: The Emergence of Cultural Hierarchy in America*. Cambridge, MA: Harvard University Press.

Lewis, Lisa A. ed. 1992. *The Adoring Audience: Fan Culture and Popular Media*. London: Routledge.

Maslow, Abraham. (1957) 1987. *Motivation and Personality*. 3rd Edition. Reading, Pa: Addison-Wesley.

Monk, Samuel H. 1960. *The Sublime: A Study of Critical Theories in XVIII-Century England*. Michigan: Ann Arbor Paperbacks.

Nell, Victor. 1988. *Lost in a Book: The Psychology of Reading for Pleasure*. Cambridge, MA: Yale University Press.

Pearson, Geoff. 1983. *Hooligan: A History of Respectable Fears*. Basingstoke: Macmillan.

Pearson, Geoff. 1984. 'Falling Standards: A Short, Sharp History of Moral Decline.' In *The Video Nasties: Freedom and Censorship in the Arts*, edited by Martin Barker, 88–103. London: Pluto Press.

Porter, Roy & Marie Mulvey Roberts, eds. 1986. *Pleasure in the Eighteenth Century*. Basingstoke: Macmillan.

Phelan, Peggy. 1993. *Unmarked: The Politics of Performance*. London: Routledge.

Schiach, Morag. 1989. *Discourse on Popular Culture: Class, Gender, and History in Cultural Analysis, 1730 to the Present*. Palo Alto, CA: Stanford University Press.

Storey, John. 2006. 'Inventing Opera as Art in Nineteenth-Century Manchester.' *International Journal of Cultural Studies* 9 (4): 35–456.

Stranger, Mark. 2011. *Surfing Life: Surface, Substructure and the Commodification of the Sublime*. Burlington, VT: Ashgate Publishing.

Toy, Maggie & Charles Jencks. 1999. *Ecstatic Architecture*. Hoboken, MS: John Wiley.

2 Orange Dogs and Memory Responses

Creativity in Spectating and Remembering

Katja Hilevaara

I Remember Walking on Glass

It looks cold, metallic, dangerous, but it is mesmerising. I am drawn to the floor, knowing it is made of glass, wanting to test it, try it out, measure its keep. I step onto the floor and feel the cracking underfoot. It gives way, a gentle bounce underneath whilst it creaks and splinters. I am exhilarated, and I anticipate with trepidation, that the glass will break. I hear other steps around me breaking the glass floor slowly but inexorably and here, underneath my shoe, more glass breaks. But the softness surprises me—the layers of glass cushion the step and give it that bounce. It feels alive. It is matter stretched to its limit as its molecules hold onto each other under the pressure, under the duress. It finds its strength in the mass, each sheet of glass resting on another, resisting the weight that forces it, inevitably, to break. But still, shattered, crushed, it holds its shape and the weight of my feet. It is defiant, laughing at my feeble weight, ridiculing my initial fright.

This is the moment I remember of Brazilian artist Cildo Meireles's installation *Through* (2009), which I experienced at the Tate Modern in London, January 2009. This is also the moment that triggered *Icebreaker* (2013), a performed act of defiance by myself that took place off the coast of Espoo, Finland, in March 2013, and which now exists as a video of the same name. In this performed response to Meireles's work, I wanted to play with the delight and anticipation I had experienced in *Through* whilst walking across the bed of breaking glass. Instantly, I wanted to respond by jumping on the frozen sea ice. At the time of making the response, I didn't remember the name of the work or the name of the artist, but the memory of breaking glass was there immediately, vibrantly, dangerously. I went to the sea, walked on the thick ice with my sister, and her dog Luna, a mixed Jack Russell and Finnish Hound. I began to jump.

This remembered moment in *Through*, I now realise, never took place, not quite like I recalled it. The floor was not made of sheets of glass, giving way underfoot, cracking sheet by sheet, but was a bed of already broken glass. A minor slip, perhaps, but had I remembered correctly, would *Icebreaker* have been conceived? Would I have considered jumping on the frozen ice as a way to reflect on the original artwork? No, I don't think so. Yet, *Icebreaker* was conceived in response to *Through*, with an intention to creatively critique the

experience of Meireles's artwork. Does it then matter that what I remembered stretched the truth somewhat? Does it matter that in the process of responding to an artwork the memory had transformed the original? I think not. I propose that *Icebreaker*, its conception, my subsequent reflection of Meireles's original artwork in relation to the remembered moment and the performed response, all participate in a creative act of critique.

I here foreground the *creative* act of critique to draw attention to the transformation that takes place in memory, the memorial creations. When the original artwork is usurped by remembering (here incorrectly), what kinds of 'truth' claims can we make of it in the form of critique? What is the value of a response whose premise is defective, untrustworthy and not faithful in an art form that highly esteems authenticity? Or rather, if we as critics leave it to the fickleness of our memory to draw on the experience of an artwork, shouldn't we at least acknowledge, if not indeed honour, the transformations set in motion? In this chapter I want to foreground a memory of a performance and *re*-consider its unreliability to accurately return to the once experienced performance event. Given that a series of remembered moments is more often than not the thing that remains of a performance, could we perhaps begin to think about the 'possibility that there is more, rather than less, in memory' as Matthew Reason proposes (2006, 52)? Could we begin to interrogate what values, possibilities and new encounters are hidden in the remembered 'non-truths'? This would call for an understanding of memory not as a failure to reproduce what is already there, but as a creative enabler to generate new experiences and meanings, celebrating remembering for its inconsistencies, inaccuracies and innovations.

Tracing the Steps towards Memory

My enquiry began with a note I jotted on the margin of a photocopy of Peggy Phelan's chapter, 'The ontology of performance: representation without reproduction' in *Unmarked* (1993). It read: '*memory AS performance.*' Although Phelan's now infamous project in this text has been understood to claim that performance cannot be reproduced for its 'only life is in the present' (1993, 146), my attention was drawn towards her description of Sophie Calle's artwork *Last Seen* (1991) at the Isabella Stuart Gardner Museum in Boston. In this work Calle framed the *remembering* of an artwork as an artwork in its own right by asking some of the museum visitors and staff to describe, *from memory*, thirteen objects of art from the collection that had recently been stolen. Calle displayed these descriptions in place of the absent paintings, framing transcribed texts of the depictions alongside photos of the empty places in which the stolen works had been hung.

In this way, I thought, memory stood in place of the artwork and became anew, drawing attention to what had remained after an engagement with it. What was evoked was how the museum visitors and staff, in that particular time and place, remembered. Each individual memory was different, emphasising

and confirming the subjective experience inherent in viewing art. These memories are of course not complete, not 'accurate,' and certainly not reproductions of the artwork. Instead, by foregrounding these ordinary, arguably quotidian engagements with the works, Calle points towards our way of dealing with aesthetic experience. It does not only take place in the moment of its perception and in the act of viewing, but the experience continues and becomes part of us after the event. The transformation of the works in the memories of the museum visitors and staff led me to consider remembering art, and performance, as creative *processes*.

The description of *Last Seen* began the process of my enquiry into the remembering of artworks, and performance in particular. This potential for the spectator's memory to be a creative continuation of performance was confirmed by an anecdote by the American artist Laurie Anderson. She describes a conversation with an audience member who erroneously remembered an orange dog in one of her performances. Anderson writes how she had resisted photographs, film and video as a record of her work for years: 'I thought that since my performances were about memory, the best way to record them was in other people's memories' (Anderson, quoted in Jones 1998, 32). However, disturbed by the unleashed orange dog, Anderson said she no longer deemed memory an adequate form of storage for her performances, because 'other people [don't] remember them very well' (32). In order to preserve a 'better' record, she subsequently resorted to documenting her work. The appearance of the uninvited orange dog certainly demonstrates that human memory is an untrustworthy chronicler of events but it also, fruitfully, suggests memory's capacity for creation. Where *did* the dog come from? What in the performance, if anything, triggered the appearance of this creature? More importantly, what can it tell us about experiencing live performance? If the orange dog made its appearance to an audience member, shouldn't we be asking how this experience of the performance event could be *positively* valued instead of considering it inaccurate?

If Calle foregrounded the remembered, transformed artwork, and arguably celebrated the caprices of memory, Anderson's response was to salvage the original work from the shifts of undesirably erratic memory. Calle's approach deliberately and knowingly alters the form of the original work, merging it with the experience of the spectator. In contrast, Anderson's faith in reproducible documents fixes the original and thereby omits that spectator experience. Even so, the orange dog remains. In both these examples, my attention was drawn towards the new material provided by the processes of remembering, towards how the 'originals' shifted and changed. The remembered responses to these artworks generated something that had previously not been present. These apparently recurrent incidents of fabricated material produced by the spectators' memories seemed to me to warrant further investigation. In what way, if at all, could focusing on the depictions of those experiences expand and enrich our understanding of what it is to experience performance events, and how to meaningfully account for them and make them count?

Orange Dogs and Memory Responses 37

Critical responses to performance might be served positively by thinking beyond the 'presentness' of the event, because each attempt at responding to the event—in writing, discussion, thinking—is conditioned by remembering. We should revalue the event as one point of transfer for a thought-in-motion that leads to remembering and subsequent responses, instead of getting caught up in its liveness. Memory is the critic's starting point, even if that point has transformed into misrememberings and mistakes, banal everyday moments or fragments that taken out of context might not resemble the original event. As another point of transfer, I argue that those transformations reveal something of the process of our encounters with events. That which *is* remembered, that which re-emerges, demands to be paid attention to. In this chapter, following on Sophie Calle's footsteps, I experiment with memory's inherent creativity, its ability to distort, think anew and invent by paying attention to that which has remained. The glass breaking underfoot in Meireles's *Through* is harnessed here for an experiment that *begins* in that remembered moment.

Performance Disappears into Memory and Eulogy Writing

This enquiry into the afterlives of performances, and their transformation in the memories of their spectators, challenges a particularly persistent hold of liveness/disappearance discourse prevalent in performance studies. Although increasingly critics place importance on that which remains instead of what disappears of performance (e.g., Barba 1992; Reason 2006; Schneider 2011), the focus on the event's disappearance endures. Phelan's paradigm-shifting claims for performance over twenty years ago defined it as ephemeral, fleeting and intangible, and declared it impossible to reproduce into a commodity, because its 'only life is in the present' (1993, 146). Because Phelan's performance disappears into the unconscious 'where it eludes regulation and control' (148), its resistance to market forces is stubborn. This value attached to performance's irreproducibility is also rehearsed in Phelan's performative writing which 'restage[s] and restate[s]' (147) the loss of the work, its disappearance. She suggests that writing about performance should be '[t]he act of writing toward disappearance, rather than the act of writing toward preservation' (148).

Similar focus on loss can be identified in performance scholar Adrian Heathfield's notion of 'eventhood,' where the spectator is asked to be in the present moment which, as Heathfield suggests, is by its very nature paradoxical. He contemplates that 'eventhood allows spectators to live for a while in a paradox of two impossible desires: to be *present* in the moment, to savour it, and to *save* the moment, to still and preserve its power long after it is gone' (2004, 9, original emphasis). Here eventhood is fashioned as an enabler of a kind of out-of-body experience, in which the spectator is able to perceive themselves both within an event as well as removed from it, and Heathfield suggests that this kind of paradoxical duality functions as a reminder of the impossibility of presentness. The tension between the 'impossible desire' to grasp the present

38 *Katja Hilevaara*

moment yet never quite being able to do so reiterates the discourse of the live event's disappearance.

The upshot of such discourse is that all too often critics denounce the writing that comes afterwards as inadequate to account for the experience of performance. The critic's disclaimer positions his words as a poor substitute to the event that has vanished, apologising for being a 'hapless secondhand witness with a vulnerable voice' (Heathfield and Hsieh 2009, 11). The image of writers mourning the loss of the performance, weeping over their keyboards, eulogising the past event, is evoked by Phelan's 'act of writing toward disappearance' (1993, 148). The rhetoric of faithfulness, staying true to the event, finds writers constantly betraying the performance, always failing to do it justice. This tendency to 'eulogy writing' or what other critics have termed the 'theology of ephemerality' (Kershaw 2008, 42) or 'the current morbidity of performance studies' (Read 2008, 6) ignores the creative potential of remembering that, for instance, Sophie Calle's works point towards. The valorisation of the live event resonates in the way critics approach writing about performance.

Instead of mourning the inadequate memory of the original event, tending to its disappearance, I propose to use what the critic (or spectator) *does* remember as a starting point for a new creative act, even if the starting point is the orange dog that never featured in the original. What the focus on disappearance fails to take into account are the temporalities in which performance work is perceived. In glorifying the present and the inevitable loss of it, the artwork's 'user' experience is not considered and the memorial and imaginative revisits to the performance are ignored. I argue that the spectator's contribution and response are not fixed or completed at the time of the performance but take place in even more rich and disruptive ways *after* the event. Memory is the scene where we honour, play out and hold open the invitation extended by some performances, to contribute and to exceed the performance in our own imagination. Responses to the invitation could therefore speak for the varied encounters of each individual spectator, rather than being (failed) attempts at resuscitating the original performance. In place of reiterating what the performance 'did'—what concepts, themes and images it produced—I propose to begin from where those ideas have subsequently taken the critic's (or spectator's) thinking and follow that thought-in-motion.

Phelan's disappearance discourse has produced performative writing that I would say is about humility and the theorist's inadequacy to the plenitude of the event. Memory, as I will go on to argue, is about creativity, the plenitude of the response and a celebration of its excesses and inaccuracies. It is my intention to follow performance into the realm of memory, suggesting that rather than considering performance as something that disappears in the moment of its event-ness, its most vivid life might be in memory.

Remembering as a Process and as a Habit

Heathfield's argument that the present moment in performance produces a paradox of living and saving the event simultaneously, configures the live moment

as a particularly complex and tension-filled event. I see a clear link between this and philosopher Henri Bergson's contention that the present cannot be perceived because it is always understood through the past, or memory, and always projects towards the future as a movement, a process. This contemporaneity, or duration, configures the live moment less as a scene of loss and more as a movement during which what is perceived is understood *after* its occurrence. There is always a delay, however brief, in recognising the constellation of signs, associations and information that each lived moment is charged with. In other words, the present *is* not, but is constantly *becoming*. These 'zones of indetermination' (Bergson 1988, 32), the delays during which memory-images (our experiences) dart back and forth, provide us with a prospect of ever-expanding choice. There is nothing thin or depleted about memory; on the contrary, it is all made up of that which was striking, of collected vividnesses and things that resurface because they are contiguous to what goes on in the present. It is here that the possibility of unforeseen, undetermined responses opens up, paving a way to surprising connections; in a word, to creativity.

However, our tendency to rely on habitual responses—for their efficiency and speed to deal with the object of perception—foregrounds an obstacle for the emergence of innovation. As Bergson describes *habit memory*, it 'has retained from the past only the intelligently coordinated movements which represent the accumulated efforts of the past; it recovers those past efforts, not in the memory-images which recall them, but in the definite order and systematic character with which the actual movements take place' (82). Habit memory provides instant, effective and safe responses to situations. Habit memory repeats motor-sensory actions stimulated by varying different situations, and the tendency to act with the least effort can exclude other possible choices that might serve to create something new. Philosopher Dorothea Olkowski points to this fundamental problem in the potential for creativity in Bergson's description of memory. She states that 'swayed by habits, committed to constant action, we find ourselves trapped in an endless repetition in which each new situation foregoes its novelty and is merely repeated on the model of a previous bodily habit. Accordingly, in place of novelty, we produce representations' (Olkowski 1999, 116). Paradoxically, Olkowski unveils memory here as *not unreliable enough*, its habitual responses resistant to the production of the new. Accessing memory's creativity arguably requires a sharp turn around the obstacle of habit.

Memory Response and Playing Tricks

How can I then harness the production of the new implicit in memory and not be hindered by habit? How can I foster the vividness of the material that emerges from remembering and enable its 'becoming'? How do I ensure that the thought-in-motion, which was triggered at the initial performance and revived at the moment of remembering, continues and keeps transforming? How do I, as a critic, not compromise the creative drive inspired by the performance but enhance it in my response?

Icebreaker emerged from the experimental methodology that I configured to explore these questions and the memory of performance. 'Memory response' is a creative and critical method that engages with the afterlife of a performance. Its creative critical drive is based on a desire for equivalence—or to be 'somehow "like" the artwork' it responds to, following art critic and architectural historian Jane Rendell (2010, 7), and other innovative modes of creative critical enquiry (see, for example, Della Pollock in Phelan and Lane [1998]; Mieke Bal [2001]; Gavin Butt [2005]; Stephen Benson and Clare Connor [2014]; Manning and Massumi [2014]). In Rendell's model for criticism, the critic becomes an artist, who negotiates her tentative critical position through an act of creativity that 'intervene[s] in the critical act as the critic comes to understand and interpret the work by remaking it on his/her terms' (7). Memory response is therefore staged as a method of critique but not as a critique that judges, assesses, interprets, defines or confines the work. Instead, its aim is to elaborate the work, embellishing and reaching past it, augmenting what is already there. It foregrounds the processual nature of performance and its effects and affects in the world by continuing where the performance left off. In responding to the memory of performance, it constructs a framework within which another performative act is encouraged, making possible and visible the process of creation.

Memory response is an approach to critique that is partly modelled on a workshop exercise by the Chicago-based and now disbanded performance group Goat Island, termed 'creative response' which, in responding to a performance with another performance act, results in 'a work of art that could not have existed without the work it is responding to' (Bottoms and Goulish 2007, 211). Instead of uncovering problems in, or attempting an analysis of the performance, creative response encourages the observer to focus on the elements in the work that are 'exceptional and inspiring' (210–211). As a result both the critical and creative minds are engaged simultaneously because the emphasis is on that which is inspiring rather than that which needs fixing or interpreted, as Goat Island's Matthew Goulish suggests. The purpose is to acknowledge criticality in a creative act and develop a critical-creative practice 'that relies on another for inspiration and energy, both critically and creatively' (211). Goat Island's model of creative critique endows an artwork with critical agency, a concept mirrored by Mieke Bal's contention that artworks can be 'theoretical objects,' able to 'deploy their own artistic and [. . .] visual medium to offer and articulate thought about art' (2001, 5). Memory response, therefore, is a critical performance practice, which instead of writing in response to performance, engages in a process of making performance. The act that ensues, makes visible (literally) the thought-in-motion that has its roots in another performance.

Memory response was configured through experimenting how to generate conditions in which Bergson's 'zone of indetermination' could be extended. Harnessing one's memory for this work is perhaps about catching it unawares, jolting its forward-moving process and tricking it into delaying. I suggest that there needs to be a surprise, or a push and a shove that enables us to let go of what we feel we already know. Our habitual reactions need to be purposefully

Orange Dogs and Memory Responses 41

derailed. This derailment, or as philosopher Elizabeth Grosz suggests, 'division, bifurcation, dissociation—by difference, through sudden and unpredictable change, change which overtakes us with its surprise' (2005, 111) ruptures the process. In a way, it could be argued that the misremembering that occurred whilst thinking about *Through* caused the kind of bifurcation Grosz describes that enabled the generation of the new performance. Also, in light of performance scholar Sara Jane Bailes's 'poetics of failure,' where 'failure is intrinsically linked to the ability to see more and to the expansion of our understanding of an object's properties' (Bailes 2011, 11), misremembering can be seen to open possibilities rather than close them.

The crucial point is that a mistake is unpredictable and as such it may function against the habitual lines of thinking that memory response tries to challenge. In terms of the tricking that enables the bypassing of normative, habitual responses for the benefit of a creative memory response, making space for mistakes seems significant. I have here highlighted mistake as one sharp turn around the obstacle of habit, given the focus on misremembering in the memory response outlined in this chapter. It is not to say, however, that mistake is necessary or the only way to bypass habit for a creative response to a performance. What I propose, and go on to elaborate, is that staying with the remembered moment—however banal, however fragmentary it is—and following its transformation into a creative act, is key in factoring a space for unpredictability.

Memory Response and Following Rules

In order to experiment with my own memory of performance events, I devised a set of rules.

1 *Remember a performance moment that delights you.*
2 *Linger with the moment.*
3 *Make a short performance act in response to this moment using only your own personal experiences and everyday objects.*
4 *Document it.*

I wanted to begin from the thing that had remained—the delightful moment—which in this instance presented here was of walking on broken glass in Meireles's *Through*. I hoped that focusing solely on this moment, letting it linger in my mind as an inspiration for a performance act of my own, a creative (thought) process would be triggered. Following a set of rules imposes a structure, which outlines and limits the creative act, and potentially enables the disruption of habitual responses. Limitations narrow down the options but also focus the investigation. One is able to engage with something in great detail, as if with a microscope, focusing in on that which is magnified, making that the space to proliferate and ignoring what is outside of it.

Directives, rules and instructions can be considered as what performance scholar Laura Cull terms 'creative constraints,' which operate 'as means to

42 *Katja Hilevaara*

expose the ego of the author to the intervention of worldly forces into the art-making process' (2012, 49). The idea is that personal tastes, habits and tendencies that make up the ego are jolted into a collaboration with the rest of the world, where the 'author is no longer the sole arbiter of the work' (49). One example of this is John Cage's chance operations, which he described as having 'the effect of opening [him] to the possibilities [he] had not considered. Chance-determined answers will open the mind to the world around' (Cage, quoted in Cull, 49). A restraint of the artist's choices potentially assists in bringing something unforeseen to the world. Similarly, returning to Sophie Calle, whose 'rules of the game' delineate her projects, says that following rules is 'restful . . . [and] a way of not to have to think—just be trapped in a game and follow it' (2009). As such, Calle points towards the freedom that relinquishing one's own ideas to an imposed structure generates.

And so I did. I remembered a delightful moment in *Through* and then lingered on with that memory, thinking about my own performance act. I wrote my thoughts and ideas down and the experiment emerged with a two-fold focus: to practice critique with a creative critical method of memory response, and to pay attention to *how* the method works. As such, it first acted out 'immanent critique' (Deleuze 1997): critique that emerges whilst *doing* the remembering and thinking and making. The elaboration of the remembered moment, the thought-in-motion that lingers and then takes the form of a performed act, *is* the critique. It is critique which does not criticise, or analyse, or summarise, but is attentive to and honours the phases of transformation of the memory of the original artwork whilst conceiving a creative response that makes visible the thinking that emerges. It is rigorous in that it methodically follows a set of rules. The rules are self-imposed, yet they frame the experiment with memory as a critical act.

Secondly, the experiment is a record of putting the method of memory response into practice. In this sense its purpose is to elaborate on the *how* of the method. In other words, I have attended to the creative process that emerged from the remembered moment as a methodological enquiry. How does the method work, what characterises each particular experiment in terms of the concerns they raise?

Therefore, concluding this chapter, I will return to *Icebreaker* and the process that was set in motion when I remembered walking on the glass in Meireles's *Through*. The performance that I produced in response to the memory left of Meireles's work does not claim to explain or analyse or even reflect on the original work. It is a transformation, from *Through* to *Icebreaker*, via what was remembered. It is an experiment with memory's creativity and it honours and celebrates that which remains of a performance. *Icebreaker* stands in for an experience and it tends to the transformation triggered by *Through*. Its criticality is embedded in the foregrounding of the acts of defiance that walking on broken glass and jumping on ice may reveal.

In this chapter I have argued that we should begin to turn scholarly attention to not only those metamorphoses that take place during the event, but to those that reach into the performance's future iterations, in memory, and

in particular the transformed new connections the memory makes with its present. This would entail developing a scholarship that can allow for and chart transformation, in place of playing out a duty-bound attempt to limit thought to a precise consideration of the historical event that it thinks its subject should be. Instead of an obligation to remember accurately and always failing to do so,

Figure 2.1 Still image from *Icebreaker*, Katja Hilevaara, 2013. Video by Sebastian and Salla Östman, edited by Abigail Conway.

we should release ourselves to remember what actually stays with us, or what we create. Most of the time that which stays is far from complete, far from managed and fixed, but an elusive thing that remains with the spectator: the thing that touches, irritates and lingers on. We can begin to free ourselves up from the discourses valorising performance's ephemerality and the apparent impossibility of reproducing it if we engage with performance in such a way that we acknowledge its ontology as a process, as an event in-motion, an event that does not disappear but lingers on, multiplied, magnified and refracted by individual memories.

Walking on Glass, Jumping on Ice

It is a clear, crisp sunshine-filled late winter's day. I am here, outwards of the shores of Kivenlahti, Espoo, with my sister and a black and white and brown dog, and I want to do something which is not strictly speaking safe. The winter has been cold and snowy, the waters around the city still covered with a strong layer of ice. Behind me the ice-fishermen might show me that the thickness of the ice is some metre deep, and there is no evidence of these semi-professionals being faced by imminent danger. Mind you, they walk across the most precarious ice both sides of the winter, and in the middle of it, even if there have been periods of thaw. I approach the task with trepidation, but also with great excitement. This was fun back in the day and now, today, on the ice of the sea it again fills me with joy, firmly mixed with uneasiness.

JUMP. JUMP. JUMP.

It looks cold, metallic, dangerous, but it is mesmerising. I am drawn to the floor, knowing it is made of glass, wanting to test it, try it out, measure its keep.

JUMP. JUMP. JUMP.

I step onto the floor and feel the cracking under foot. It gives way, a gentle bounce underneath whilst it creaks and splinters.

JUMP. JUMP. JUMP.

Of course nothing happens as the ice is thick and the site is safe. The thick layer of snow between the ice and my bouncing feet compacts, I may imagine the layers of ice and snow tremble under my weight but truthfully speaking there is no effect of my jump. I hear the snow grate but the excitement is more about my imagination than real effects.

Orange Dogs and Memory Responses 45

JUMP. JUMP. JUMP.

But the softness surprises me—the layers of glass cushion the step and give it that bounce.

JUMP. JUMP. JUMP.

> *'I play with people's fears. Fear is the material of many of my works. When you have fear your senses become heightened, you become more attentive to your environment.'*
>
> *(Cildo Meireles quoted in Farmer 2000, 38)*

JUMP. JUMP. JUMP.

The artist defies us to take the risk and step onto the broken glass.

JUMP. JUMP. JUMP.

I am exhilarated, and I anticipate, with trepidation, that the glass will break.

JUMP. JUMP. JUMP.

I think about a childhood game Meireles recalls. It is a game he used to play with his friends when he was young. They were crossing a road in front of moving cars, dashing across to the other side as close to the car as possible. Speed was not of concern, it was the closest proximity to the car that declared the winner of the game, and 'the only criterion was space.' (Meireles quoted in Mosquera 2005, 475) These darts across cars bring to mind a certain sense of defiance—an overcoming of fear.

JUMP. JUMP. JUMP.

There is a Finnish saying that loosely means 'to recklessly try one's chances,' an expression translated word for word as trying the ice with a stick—to see how far one can go, challenging, defying, rebelling, resisting. I am defiant with the danger of the sea ice. I grew up by the sea, and the respect for 'weak ice' has been instilled in every Finnish child. Stories of frosty plunges through the always unpredictable, never-to-be-taken-for-granted ice sheets of the lakes and the sea live in my spine. Walking on ice can always be dangerous. Jumping on ice is only done when the ice is positively thick and hard. Or when it is a frozen puddle on the pavement or the school courtyard—the delight of jumping the ice and making it crack to discover the gush of water that spills from underneath stems from my childhood.

46 *Katja Hilevaara*

JUMP. JUMP. JUMP.

It feels alive. It is matter stretched to its limit as its molecules hold onto each other under the pressure, under the duress. It finds its strength in the mass, each sheet of glass resting on another, resisting the weight that forces it, inevitably, to break. But still, shattered, crushed, it holds its shape and the weight of my feet. It is defiant, laughing at my feeble weight, ridiculing my initial fright.

JUMP. JUMP. JUMP.

References

Bailes, Sara Jane. 2011. *Performance, Theatre and the Poetics of Failure: Forced Entertainment, Goat Island, Elevator Repair Service.* London: Routledge.

Bal, Mieke. 2001. *Louise Bourgeois' Spider: The Architecture of Art-Writing.* Chicago: University of Chicago Press.

Barba, Eugenio. 1992. 'Eftermaele: That which will be said Afterwards.' *TDR* 36 (2. T134): 77–80.

Benson, Stephen & Clare Connors, eds. 2014. *Creative Criticism: An Anthology and Guide.* Edinburgh: Edinburgh University Press.

Bergson, Henri. [1910] 1988. *Matter and Memory.* Translated by Nancy Margaret Paul and W. Scott Palmer. New York: Zone Books.

Bottoms, Stephen & Matthew Goulish, eds. 2007. *Small Acts of Repair: Performance, Ecology and Goat Island.* London: Routledge.

Butt, Gavin, ed. 2005. *After Criticism: New Responses to Art and Criticism.* Malden, MA: Blackwell.

Calle, Sophie. 2009. *Video Interview with Iwona Blazwick.* London: Whitechapel Gallery. YouTube. Accessed 21 July 2014 at http://www.youtube.com/watch?v=cRx7nFVuLwA

Cull, Laura. 2012. *Theatres of Immanence: Deleuze and the Ethics of Performance.* Basingstoke: Palgrave Macmillan.

Deleuze, Gilles. 1997. 'To Have Done With Judgement.' In *Essays Critical and Clinical*, Translated by Daniel W. Smith and Michael A. Greco, 126–135. Minneapolis: University of Minnesota Press.

Farmer, John Alan. 2000. 'Through the Labyrinth: An Interview with Cildo Meireles.' *Art Journal* 59 (3): 34–43.

Grosz, Elizabeth. 2005. *Time Travels: Feminism, Nature, Power.* Durham: Duke University Press.

Heathfield, Adrian, ed. 2004. *Live: Art and Performance.* London: Tate Publishing.

Heathfield, Adrian & Tehching Hsieh, eds. 2009. *Out of now: The Lifeworks of Tehching Hsieh.* London: Live Art Development Agency and MIT Press.

Jones, Amelia. 1998. 'Postmodernism, Subjectivity, and Body Art: A Trajectory.' In *Body Art: Performing the Subject.* Minneapolis: University of Minnesota Press.

Kershaw, Baz. 2008. 'Performance as Research: Live Events and Documents.' In *The Cambridge Companion to Performance Studies*, edited by Tracy C. Davis, 23–45. Cambridge: Cambridge University Press.

Manning, Erin & Brian Massumi. 2014. *Thought in the Act: Passages in the Ecology of Experience.* Minneapolis: University of Minnesota Press.

Meireles, Cildo. *Cildo Meireles* Exhibition at Tate Modern. London. 14 October 2008–11 January 2009.

Mosquera, Gerardo. 2005. 'In Conversation with Cildo Meireles, October, 1998, Rio de Janeiro.' Conceived and edited by Phaidon Editors. In *Pressplay: Contemporary Artists in Conversation*, 462–75. London and New York: Phaidon.

Olkowski, Dorothea. 1999. *Gilles Deleuze and the Ruin of Representation*. Berkeley, CA: University of California Press.

Phelan, Peggy. 1993. *Unmarked: The Politics of Performance*. London: Routledge.

Phelan, Peggy & Jill Lane, eds. 1998. *The Ends of Performance*. New York: New York University Press.

Read, Alan. 2008. *Theatre, Intimacy and Engagement: The Last Human Venue*. Basingstoke: Palgrave Macmillan.

Reason, Matthew. 2006. *Documentation, Disappearance and the Representation of Live Performance*. Basingstoke: Palgrave Macmillan.

Rendell, Jane. 2010. *Site-writing: The Architecture of Art Criticism*. London and New York: I.B. Tauris.

Schneider, Rebecca. 2011. *Performance Remains: Art and War in Times of Theatrical Reenactment*. London and New York: Routledge.

3 Fandom, Liveness and Technology at Tori Amos Music Concerts

Examining the Movement of Meaning within Social Media Use

Lucy Bennett

In recent years, the use of smart phones, mobile internet and social media platforms such as Twitter, Facebook and text messaging has altered live music experiences for some popular music fans and audiences quite sharply. Live music has been regarded as a powerful and integral element within popular music fandom, a space where fans can gather to 'enact the meaning of fandom' (Cavicchi 1998, 37) and as an event 'made distinctive by its listeners, as each person's connection with the event is shaped by expectations, prior experiences, mood and concentration.' (Burland and Pitts 2014, 1). The arrival of new technological tools has facilitated powerful interjections into the behaviour within this space, enabling music fans at the show to connect digitally with each other, to tweet and text concert photos, setlists and other information live and by allowing non-physically present fans around the world to feel part of and experience a sense of the event (Bennett 2012, 2014). In other words, the boundaries of live music events are being extended to include the remotely located audience and give them a *sense* of being there. Likewise, physically present concertgoers are also experiencing an extension of their experience, through the ability to capture and preserve moments of the show on video and photo through their mobile devices and connect with the remotely located fans as the show takes place. These possibilities can produce strong tensions for some fans who aim to remain engaged in the live show, yet feel a desire to use their technological devices to perform a valued service to non-physically present fans and also preserve moments of the event.

This chapter will examine further the technological processes of texting, tweeting and mobile phone use by live popular music concert attendees as they attempt to connect with and inform a non-physically present audience. Through empirical research, in the form of a survey conducted with fans of prolific touring artist Tori Amos, the impact of this practice on the physically and non-physically present audience will be explored, in an effort to understand and unravel the consequences of this process on their live music experiences. Building on work by Philip Auslander (2008) and Roger Silverstone (1999), this chapter will focus specifically on how technological use at music concerts can be understood through the lens of, and as a process of, liveness and mediation and how this can be, for some fans, entangled with changing notions

of experience, meaning and value. In other words, this study will examine 'the movement of meaning' and its 'constant transformation' (Silverstone 1999, 13) within this use of technological tools. It will examine how these circulated mediated meanings can complement, or collide with, fans' understanding of (1) the meaning making and presence of the non-physically present audience and (2) the entanglement of mediation and immersion in the live music event. Silverstone suggests that mediation essentially occurs within the discourses 'in which we as producers and consumers act and interact, urgently seeking to make sense of the world, the media world, the mediated world, the world of mediation' (1999, 13). Building on these observations, and those of Auslander (2008), I propose that similarly urgent interactions can be found within music fandom discourses surrounding live concerts, with fans, audience members and often the artists themselves, seeking to 'make sense' of these new technologies and the transformations of the live music space they wield upon audiences, present and non-present. Overall, I argue that although live technological connections and updates during music shows are considered an important and valued service by many Tori Amos fans, a practice which permits them to enact the values of their fandom on a collective level as they follow the updates from volunteer fans, meanings can also change and transform as fans collectively and personally seek to understand, negotiate and make sense of these emerging processes of mediation.

Liveness, Mediation and Live Music Fandom

The development of technology and mobile devices has seen an alteration and divergence in the practices and behaviour of some audience members within live music concerts. Whereas lighters used to be held aloft during certain songs, these have often been replaced by phones (Strauss 1998; Chesher 2007), which are being used to take photos, film videos, call friends physically present and absent, and also to update their presence at the show on social media platforms. The widespread appearance of these devices within concerts has been welcomed and incorporated into the shows of some artists (e.g., R.E.M. and U2); Richie Hawtin allows audience members to connect with him and the music through an interactive iPhone app during the show (Baym 2011). However, conversely, the technology has been rejected by others, such as the Yeah Yeah Yeahs, Wilco, Ryan Adams and Kate Bush, all of whom have personally requested that audience members refrain from using any technological devices or screens during their concerts. Debate has been sparked over the use of what some have deemed intrusive and disturbing technology (Lee 2013), and there have been efforts to quell the use of screens and bright lights within the concert space (Hann 2013).

One area that this technology use has infiltrated is music fandom, with it permitting fans physically present or remotely located to connect with each other during concerts, sending updates and constructing and preserving moments. In this sense, these practices of using technology are very much connected

50 *Lucy Bennett*

to notions of 'liveness,' which involves 'a relationship of simultaneity' (Auslander 2002, 210) between audience members and a live event as it unfolds. As Auslander observes, 'liveness' can also be understood as 'a moving target, a historically contingent concept whose meaning changes over time and is keyed to technological development' (2008, xii), a process which we are currently observing with not only live theatre broadcasts (Barker 2013) and sports attendance, but also within live music fans and audience members at shows and their use of mobile devices.

In addition to being connected to issues of 'liveness,' taking Auslander's (2008) observations further, I also want to underline in this chapter the extent to which mediation arises within these practices. Roger Silverstone, writing about news and media, approaches mediation as a process within which meaning moves between texts, discourses and events and fosters:

> the constant transformation of meanings, both large scale and small, significant and insignificant, as media texts and texts about media circulate in writing, in speech and audiovisual forms, and as we, individually and collectively [. . .] contribute to their production
>
> (1999, 13)

Although Silverstone was ruminating here on news and media, I would argue that these observations surrounding mediation can also be applied to live music concerts and fan/audience use of technological devices. In essence, through technological behaviour, the live concert is being mediatised, with its parts filtered through mobile devices, ready to be ingested by an online audience, or preserved as a memory of the show by the recorder (Long 2014). In this sense, and with the complicated and differing approaches between those who are physically there as audience members, those who are remotely located and the musicians themselves, there can seemingly be a constellation of different meanings surrounding the live event.

A Study of Tori Amos Fandom

In order to question and explore how some music fans are undertaking technological practices and using their devices to send live updates during concerts, I selected the fan community of American singer-songwriter Tori Amos as a case study that may offer rich insight into how meaning, mediatisation and liveness are perceived. Tori Amos is a prolific touring artist who changes her setlist nightly on tour (Amos and Powers 2005; Farrugia and Gobatto 2010), regularly includes improvisational songs and introductions, one-off cover versions and has a large fan base with many attending multiple shows each tour and others who discuss and preserve these performances at length online. The level of interest within her fan base surrounding these concerts is highlighted by the technological tactics that occur within each show and have done since the technology permitted. For example, at each concert

a fan volunteers to be the assigned texter or tweeter who relays information via their phone about the songs being performed, as they occur 'live,' to fans gathered online on Amos's fan forums, Facebook and Twitter. These online fans discuss the show, play the songs being performed and experience an event remotely, even though they are not physically present (Bennett 2012). Photographs and vines are often tweeted, as are sound check setlists, if fans overhear them from outside the venue, provoking further discussion and anticipation surrounding which of these songs would be performed during the concert. As a singer and pianist, Amos's musical structure of the tour often changes—her most recent tours have been solo but she has also performed with a three-piece band, a full orchestra and a string quartet. Her solo and orchestral concerts have primarily lent themselves to an audience that remains quiet throughout the performance, which is heightened by her often playing seated venues. In contrast, her concerts with the band can occur at standing, general admission venues and provoke a more physical and loud response from fans in attendance. Whatever venue and musical set-up, her concerts have been regarded as being 'intense' and 'intimate' (Jeckell 2005, 17) due to the personal nature of lyrics and strong focus on the audience, with Amos looking directly and pointedly at audience members.

Although Tori Amos has had a fairly large and active online fan base since the early 1990s, she had not maintained a strong (at least seemingly) personal presence on social media until 2014 and the release of the *Unrepentant Geraldines* album and its accompanying tour. During this time, Facebook, Twitter and Instagram were used in tandem surrounding the live shows. On Instagram an 'Unrepentant Selfie Tour Instagram Photo Contest' was launched where fans were encouraged to take selfies of themselves surrounding their attendance at a concert on the tour (showing themselves at a venue or with a ticket), using the hashtag #Unrepentantselfie and a specific hashtag for the city where they were attending the show. A selected fan in each 'tour market' could then win a tour programme autographed by Amos. The musician also took part in the hashtag herself, taking selfies in different locations and countries across the tour and posting them on Instagram under the hashtag. This process was also continued with two other forms of personal images that were posted across Twitter, Facebook and Instagram: selfies of Amos while backstage while she prepared to take the stage and photos of the setlist after the show, which featured on them her hand-written chords and last minute changes, and were surrounded by artefacts from her dressing room. Both types of pictures received much attention from the fan community, with fans sharing their anticipation for the show under the pre-concert selfies, attempting to predict the setlists and guessing the songs that would be played. The post-concert setlist pictures would then feature further reactions to what had been performed, even though many fans would already know the setlist (due to texting and tweeting). Thus, as her social media engagement also now demonstrates, live concerts within Tori Amos fandom could be viewed as powerful anchors and meeting spaces, imbued with meaning for those physically present, and those unable to attend,

52 Lucy Bennett

with the anticipation and unexpectedness surrounding setlists offering meaning for many within her fan community.

In order to ascertain how fans articulate and understand the use of smart/mobile phones, internet and texting during live concerts, I launched an anonymous online survey that focused on these issues and during October and November 2012 posted an invitation to participate on Unforumzed (unofficial fan forums), Twitter and a Facebook group for Tori Amos live concerts. The survey was comprised of both quantitative and qualitative questions and received 56 responses, with 44 of these declaring a willingness to take part in follow up interviews. In terms of demographics of the respondents to the questionnaire, 45% identified themselves as male, 55% as female. The survey received a considerably wide reaching range of ages: 3% were aged 18 and under; 32% were aged between 19 and 29; 61% were aged between 30 and 45; and 4% were aged between 45 and 65. Respondents came from 17 different countries, the USA and UK being the most dominantly represented. All responses are presented as verbatim and without any identifying demographical information.

However, it is also important to acknowledge the limitations of an online fan study of this nature. The sample focused specifically on online Tori Amos fans; fans that are not online were not accounted for. As a consequence, the findings of this survey and study do not claim to represent all Tori Amos fans, or all music audiences. However, as specific emerging practices of fan behaviour are being explored in this study, the relatively small sample was deemed sufficient enough to make some preliminary explorations into uses of technology during live music concerts and to identify pertinent questions and themes rising out of these practices.

Writing about the findings of this survey elsewhere (Bennett 2014), I focused on the tensions and confliction for some fans between a desire to provide an act of service to the collective fan community through texting and tweeting to non-physically present fans following via their computers, and a commitment to what they perceived as their own undisrupted engagement and submersion in the experience of the live concert. However, in this chapter I want to unravel understandings of these technological practices and attitudes further by focusing more closely on the intersection of mediation, meanings and a sense of liveness. To do this, I will explore and discuss in turn two, often interrelated, themes of fans' understandings: (1) the meaning making and presence of the non-physically present audience and (2) the entanglement of mediation and live music experience.

The Meaning Making and Presence of the Remotely Located Online Audience

When asked in the survey if they followed setlists and other updates live from tweeters and texters during Tori Amos concerts at which they were not physically present, the majority of respondents (57% or, 32 out of 56) stated they actively took part in this practice, whereas 39% (22 out of 56) said they currently

did not. Thus, this leads us into the first dominant theme, which focuses on the presence of the remotely located audience, who are following live updates on the shows as it unfolds.

Asked further how often they thought about the online audience when they were physically present themselves during the shows, 45% (25 out of 56) of respondents indicated they did not, whereas the majority (54% or, 30 out of 56) said they did. From those who claimed not to consider the online and physically absent audience during the show, a dominant pattern expressed within responses was that they were focused on and engaged in the music, so did not consider these individuals at all during the evening. Examples of this perspective included:

> Never. I try to focus on my own experience during the show (ha, that sounded so selfish!)

> I don't. I want to be as present in the moment as I can be.

> I'm too wrapped up in the musical experience to really think about that.

Thus, technological connections for some individuals are viewed as a disruption that could jeopardise their musical experience and concentration. Within these responses was a striking emphasis on the individual, and the Tori Amos music concert being a personal event that requires uninterrupted engagement and immersion. However, in contrast to this, others took a more collective approach and claimed to regularly think of the online fans that were following the live updates, especially during the performances of rare songs, where their reaction as they received the update was imagined:

> For Tori shows, I generally think about how the people reading the setlist are reacting when something very rare is played or when something is played for the first time that tour/ever. It adds a little bit of extra excitement to know that there are others out there enthused about what's being played.

> I think of them all of the time!!!! Often wishing they were there with me as a song gets played that I know they love and I feel sad knowing they are missing it by not being there, but then I feel glad that they at least get to know that the song is being played, right there and then at that moment.

For the above respondents, knowledge that non-present individuals were aware of the specific songs being played exactly as they happened delivered further meaning to their concert experience. More specifically, there is an interesting difference in these responses: the first fan talks about thinking of other fans ('people') in the wider community that seem to be unknown to him or her, whereas the second focuses on specific individuals, such as friends or family at

home. In both instances, an awareness of these individuals and bringing a sense of the live experience to them was hinged with emotion, such as excitement or sadness. Notions of excitement were expanded on by another fan:

> I support the idea (and I can say that from having experienced both sides of the coin as both the Texter/Tweeter and the rabid recipient!) For fans who are unable to be at the show and are at home either logged into an active discussion forum and/or logged into twitter, receiving real-time setlist information is hugely exciting and helps foster a sense of community amongst fellow fans as the lively discussion begins to unfold. People start to guess what song will be played next or create fantasy setlists and then compare them to the real thing. If a song is played with a new arrangement, with a unique improvised 'intro' or if the lyrics are forgotten or changed, it creates even more excitement and helps the fans at home feel like they are there in the concert hall too.

Thus, the remotely located fans are depicted as experiencing the event live, through their collective, collaborative and technologically mediated actions and thereby become another audience for the concert. Small details such as forgotten lyrics, new introductions and improvisations are thus also given high prominence by these practices. Although they may not be in the room where the event is taking place, they are engaging in their own meaning making through mediation. This occurs through the 'lively discussion,' judgment on songs being performed and predictions (for example, the creation of possible setlists). All of these activities could be viewed as the collective contribution to the 'transformations of meaning' within mediation as discussed by Silverstone (1999, 13). In these cases, Tori Amos fans that use technology to send and receive updates from the live concerts, and those who receive them, are anchoring this behaviour with significant meaning in the fan culture. As another respondent similarly highlights, due to these activities the physically absent audience has become an integral part of the concert experience for the present audience. In other words, they are an absence that has a presence:

> Yes I'd say I'm always aware of [online fans], as much as I am of the ambience in the venue itself actually.

For this fan, the non-present audience, linked through technology, becomes part of the ambiance and energy of the event. For another, predictions of how absent fans may be reacting negatively to certain songs being played factors in her experience during the show. In this sense, online reaction matters and is viewed as a collective that expresses fan community norms and values surrounding certain songs:

> I think about it a lot, as I pay attention to the online reaction to the shows prior to mine, so I can't help but think like 'Oh, they're going to roll their eyes when they read this song is on.' I think the shows are for the people

actually at them, but the Tori online fandom is a little different and so it's kind of like 'our' thing, even if we're not all there at every show.

However, while some of the above respondents appeared to be seemingly firm in their views, for others, the use and appearance of technology within the live music concerts proved a more complicated issue that brought forth contrasting meanings, as the next section will now move on to explore, in terms of how mediation can impact on immersion and engagement in the concerts.

The Entanglement of Mediation and Live Music Experience

In order to explore how Tori Amos fans articulate and negotiate the use of technology during her live music shows, and how mediation connects with their experience, I asked them to describe how they viewed the impact of technological devices and the practice of texting and tweeting updates during concerts. Within the responses there appeared a variety of different views and meanings articulated, which highlights the complexities of these processes and their appearance in the live music show space. For those who felt that engaging in this activity detracted from the experience of the physically present fans, the prospect of not being focused or engaged in the live moment and of missing key elements was frequently cited:

> People aren't as present. It's absolutely what I think. There are people who get so caught up in tweeting/texting every moment of a show—pictures, lyrics, updates, lighting changes, costume changes . . . they miss on being in the moment and being there.

> I think it takes the person out of the moment. They are connected to the fans at home, and it takes away from the experience as a whole. If they are looking at their phones, how can they be paying all of their attention on the show?

Another respondent mentioned the distraction they felt both being an audience member performing the texting/tweeting service, and also as one witnessing others using their devices to record elements of the show:

> I do think it is annoying to those who dont want bright lights in their face . . . honestly, I go to ALOT of different concerts and the most annoying thing in the world is to watch the show through the phone being held up by the dude in front of me . . . I've only blow by blow texted the entire set . . . once . . . and it takes away from being able to relax and enjoy the show. you miss out.

In this sense, these responses articulate meanings of 'missing out': of being physically present but absent from vital elements of the show due to their

preoccupation with their own media/technology use. In contrast to this, for other fans, technology has a different meaning, allowing them to improve their knowledge surrounding their own attendance at the shows, and indicating what to anticipate:

> Of course, it takes away some of the excitement for fans who don't want to spoil the surprise. But in a case like the recent Gold Dust Tour it can also be quite helpful to find out what staples will be played and whether or not there might be room for unexpected songs. Anyone is free to look at the tweets or ignore them. They changed my concert experience for the better.

Although this knowledge may remove some elements of surprise, as another fan expanded, experiencing the setlist and show information live through the updates made some want to attend more shows in person:

> At one time I thought it might be spoiling the element of surprise as maybe knowing what is coming makes you less interested, however this could be said for attending multiple shows on a tour ... knowing what Tori plays in a part of the world I can't easily get to is great—knowing what she plays down the road when I decided not to go ... well that's a risk I spend hours debating! Sometimes I make the right choice so looking at the setlist proves it, other times I get pangs of regret. In general the texting/tweeting makes me want to go to as many shows as I can—which friends and family do not understand! That's quite common I believe ...

For the following respondent, the complexities of these practices are highlighted. A distinction is made between technological practices, with texting and tweeting being viewed as a lesser disruption than filming or holding devices up in the air, a practice described as an inevitable part of contemporary concert going. However, the later benefits of putting up with technological use are also highlighted, through the enjoyment of rewatching the videos at a later date on YouTube:

> It is definitely changing the overall experience for fans. Although some will say texting and tweeting is disruptive, it's nothing on a par with people who film concerts on their phone or camera. It's almost impossible not to attend a concert now without seeing a sea of lit up phones and cameras scattered across the audience and although this can cause annoyance for people who are seated/standing nearby, we all appreciate the final result, once it is uploaded to Youtube! ... I feel that if it is done discreetly then the benefits far outweigh the negatives. We must remember that for every one person tweeting, texting or filming, there are probably 10 people talking loudly, drinking heavily, getting up to go to the toilet, or being violent or abusive, and I find this to be much more obnoxious than someone texting or tweeting.

This perspective then offers an observation that, from their experience at the concerts, some audience members can display disruptive and disengaged behaviour even without the use of technology. Ultimately, this fan sees value and meaning in the live texting and tweeting service, yet with the provision that it is conducted in a 'discreet' manner that does not disturb others.

Overall, these responses demonstrate how understandings of technological use during concerts can have differing meanings between fans that are not clear cut, but rather complicated and being regularly moved and transformed between individuals and their experiences.

Conclusion

This chapter has explored the use of technology by music fans, unravelling how processes of liveness and mediation are impacting upon their experiences of these events. I have argued that although live connections and updates during music shows are considered an important and valued service by many of the fans surveyed and are viewed as a practice which allows the meanings and values of their fandom to be enacted, meanings can also alter and transform as fans collectively and personally seek to make sense and negotiate these emerging processes of mediation.

Arising from these findings are two interrelated implications and areas for future research. Firstly, how meanings surrounding mediation may transform further as technological devices, practices and trends advance. The recent banning of the use of 'selfie sticks' during concerts (Cowler 2015) by major UK music venues London O2, SSE Wembley Arena and the O2 Academy Brixton, is evidence of the growing intersection between technology and concert-going and the efforts to curb it. As Silverstone argues, in order to understand how mediation operates, we need 'to understand how meanings emerge, where and with what consequences. We need to be able to identify those moments where the process appears to break down. Where it is distorted by technology or intention' (1999, 18). In this sense, perhaps 'selfie sticks' are the tipping point surrounding meaning and technology at these events, as seemingly an ultimate personal practice that focuses on self rather than collective experience. They could be viewed as disrupting the process of the live music concert, breaking down through mediation the meanings of being an attendee and drawing the non-physically present audience (who are the imagined viewers of the selfies) to the forefront. How meanings emerge, shift and are transformed as new devices advance, therefore, will be an area to explore within future audience studies.

Secondly, how younger fans that have grown up with these forms of technology may construct and ascribe meaning to their use is also an area for investigation. The Tori Amos fans surveyed in this chapter, as per her fan base, are predominantly aged between 19 and 45, thus would not have grown up with smartphones being used at concerts in such a manner. Perhaps younger, newer fans of the musician may have different meanings surrounding engagement,

58 Lucy Bennett

mediation and liveness, and thus how these notions collide between those who have grown up with the technology, and those who have witnessed the technological change over time, will be an area for future consideration.

Acknowledgments

The author would like to thank Iñaki Garcia-Blanco for his valuable comments and suggestions during the conducting of this research and Rachel King for her support and help with the survey dissemination.

References

Amos, Tori & Ann Powers. 2005. *Piece by Piece: A Portrait of the Artist*. London: Plexus.

Auslander, Philip. 2002. 'Live from Cyberspace or, I Was Sitting at My Computer This Guy Appeared He Thought I Was a Hot.' *PAJ: A Journal of Performance and Art* 24 (1): 16–21.

Auslander, Philip. 2008. *Liveness: Performance in a Mediatized Culture*. 2nd Edition. Oxon: Routledge.

Barker, Martin. 2013. *Live To Your Local Cinema: The Remarkable Rise of Livecasting*. Basingstoke: Palgrave.

Baym, Nancy. 2011. 'Nancy Baym: An interview with Richie Hawtin: Building Global Community.' *Midem Blog.* 23 February. Accessed 7 June 2015 at http://blog.midem.com/2011/02/nancy-baym-an-interview-with-richie-hawtin-building-global-community/

Bennett, Lucy. 2012. 'Patterns of Listening Through Social Media: Online Fan Engagement with the Live Music Experience.' *Social Semiotics* 22 (5): 545–557.

Bennett, Lucy. 2014. 'Texting and Tweeting at Live Music Concerts: Flow, Fandom and Connecting with Other Audiences through Mobile Phone Technology.' In *Coughing and Clapping: Investigating Audience Experience*, edited by Karen Burland and Stephanie Pitts, 89–99. Surrey: Ashgate Press.

Burland, Karen & Stephanie Pitts. 2014. 'Prelude.' In *Coughing and Clapping: Investigating Audience Experience*, edited by Karen Burland and Stephanie Pitts, 1–4. Surrey: Ashgate Press.

Cavicchi, Daniel. 1998. *Tramps Like Us: Music & Meaning among Springsteen Fans*. New York: Oxford University Press.

Chesher, Chris. 2007. 'Becoming the Milky Way: Mobile Phones and Actor Networks at a U2 Concert.' *Continuum* 21 (2): 217–225.

Cowler, Jasmine. 2015. 'Major UK Music Venues Ban "Perilous" Selfie Sticks From Gigs.' *Gigwise*, 16 January. Accessed 7 June 2015 at http://www.gigwise.com/news/97370/selfie-stacks-banned-by-a-number-of-uk-music-venues

Farrugia, Rebekah & Nancy Gobatto. 2010. 'Shopping for Legs and Boots: Tori Amos's Original Bootlegs, Fandom, and Subcultural Capital.' *Popular Music and Society* 33 (3): 357–375.

Hann, Michael. 2013. 'Yeah Yeah Yeahs Launch Pre-emptive Strike at Phone-wielding Gig-goers.' *The Guardian Blog*, 10 April. Accessed 7 June 2015 at http://www.guardian.co.uk/music/shortcuts/2013/apr/10/yeah-yeah-yeahs-phones-gigs

Jeckell, B.A., 2005. 'Amos Expresses Herself with New Album, Book', *Billboard*, 19 February 2005, p.13 and 17.

Lee, Dave. 2013. 'Should Music Fans Stop Filming Gigs on their Smartphones?' *BBC*, 12 April. Accessed 7 June 2015 at http://www.bbc.co.uk/news/technology-22113326

Long, Paul. 2014. 'Warts and All: Recording the Live Music Experience.' In *Coughing and Clapping: Investigating Audience Experience*, edited by Karen Burland and Stephanie Pitts, 147–158. Surrey: Ashgate Press.

Silverstone, Roger. 1999. *Why Study the Media?* London: Sage.

Strauss, Neil. 1998. 'A Concert Communion with Cell Phones; Press 1 to Share Song, 2 for Encore, 3 for Diversion, 4 to Schmooze.' *The New York Times*, 9 December. Accessed 7 June 2015 at http://www.nytimes.com/1998/12/09/arts/concert-communion-with-cell-phones-press-1-share-song-2-for-encore-3-for.html?pagewanted=all&src=pm

4 Social and Online Experiences

Shaping Live Listening Expectations in Classical Music

Stephanie E. Pitts

Introduction: Ways of Listening to Classical Music

'Classical music has people worried' (Kramer 2007, 1). So begins Lawrence Kramer's discussion of the changing role of classical music in contemporary society, in which he notes a decline in sales of symphonic recordings and concert tickets, and attributes this to 'the loss of a credible way to maintain that people *ought* to listen to this music, that the music is something that should not be missed' (3). Almost a decade later, it remains the case that classical music is both everywhere in contemporary Western culture, turning up as the soundtrack to adverts, films and grand public events, and yet nowhere, its role in music education substantially reduced and the numbers of young people learning the violin and flute surpassed for the first time by aspiring guitarists and drummers (ABRSM 2014). However, the loss of certainty over the status of classical music that Kramer asserts as a pressing social concern presents an interesting opportunity to examine prevalent assumptions about cultural value: 'Music's ability to unite people across space and time [. . .] is highly vulnerable to systemic changes, such as increasing consumerism, commodification, and competitiveness' (Hesmondhalgh 2013, 10).

Kramer's and Hesmondhalgh's commentaries about the place of music in society (see also Johnson [2002]) highlight a compulsion to explain and justify musical engagement, with those explanations themselves becoming part of musical identity formation at an individual and social level. Such advocacy for classical music can be seen as a timely response to its marginal role in contemporary consumption of the arts: the longest established classical music station in the UK, Radio 3, had a 1.1% audience share in 2014 (just under 2 million listeners), with its younger rival, Classic FM, claiming 3.6% of the national audience (a little over 5 million listeners) with its more populist presentation of classical repertoire (RAJAR 2014). Meanwhile, the peripheral position of classical music is corroborated by reports that concert audiences are also ageing and declining (Kolb 2001). While classical music listeners have consistently tended to be older than those of popular music and jazz (Hodgkins 2009), they are no longer being replaced by the next generation at an equivalent age, resulting in an estimated loss of 3.3 million American concert goers over a decade

(League of American Orchestras 2009, 11). Studies with teenagers also report low consumption of classical music (Lamont et al. 2003), as well as a perception that it is 'uncool' amongst peers and associated with seeking parent and teacher approval (North, Hargreaves and O'Neill 2000). An age-related disengagement with classical music therefore looks set to continue, unless addressed through intervention from arts promoters, music education or other sources.

These gloomy analyses are counteracted, however, by reports of the value of live listening experience for those who *do* engage with classical music. A growing body of research with concert audiences seeks to explore these listening encounters both in real time and retrospectively, in order to understand the factors that influence audience development and retention (see edited collections by Burland and Pitts [2014]; and Radbourne, Glow and Johanson [2013]). This chapter aims to explore how listener identities in classical music are formed through musical exposure and experience and through the institutional structures and social interactions that surround the activity of listening, including those that are increasingly situated online. Emphasis is placed upon the implications of such research for arts organisations, particularly for the ways that they communicate with their existing and potential audiences, and the ways in which their efforts to attract new audiences are mediated by listener expectations and prior experiences. Drawing upon empirical evidence from studies with new and established audience members at classical music events, some key questions to be addressed in the chapter include the following:

1 How are listening choices made, influenced and evaluated by new and established audience members?
2 How does music-related activity beyond the concert hall—including online—affect the live listening experience?
3 How do arts organisations communicate with their audiences and what effect does this have on the listening experience?

The empirical evidence that informs the first section of this chapter comes from a series of mainly qualitative studies carried out with audiences in Sheffield, Edinburgh, Oxford and Birmingham over the past ten years (see Pitts [2014a] for a summary), and from life history research undertaken with adults who are active amateur musicians or musical enthusiasts (Pitts 2012). These studies have explored different musical contexts and genres, from jazz clubs to chamber music festivals (Pitts and Spencer 2008; Pitts and Burland 2013), and from first-time opera goers to lifelong concert attenders (Pitts 2005). Throughout these different settings, there have been common threads of exploration, including people's routes into music listening, their sense of belonging within an audience, their choices of listening and the loyalties associated with those, and the extent to which their live and recorded listening habits bring distinctive experiences of personal, musical and social enjoyment. Inevitably, there has been much variation across the individual stories collected through this

62 Stephanie E. Pitts

research, and this chapter will illustrate some of those specific encounters with classical music, providing insight on the ways in which live and recorded listening intersect with people's engagement with classical music. At the same time, some consideration will be given to the broad trends of audience narratives and the extent to which these could inform the pressing concerns of arts promoters and music educators: namely, how to attract new audiences without disengaging existing ones.

Listening Choices and Their Challenges: What to Listen to, Where and When?

While hearing classical music is almost unavoidable in everyday life, becoming a classical music listener is a more deliberate act, requiring opportunity and, very often, encouragement, guidance and company. Adults looking back on their routes into concert listening as part of my musical life history study (Pitts 2012) mentioned influences including school visits to concert halls, parents who listened frequently to the gramophone or radio and older siblings who offered glimpses into current pop trends, so demonstrating the value of both role models and opportunities in first encounters with music. A few offered more idiosyncratic stories that were nevertheless illustrative of the emotional impact and immediacy of access to live music:

> In 1949 [. . .] I joined a one-lorry self-employed driver working between Hull and the far-flung wastes of East Yorkshire: the most unforgettable man I have ever met. [. . .] Walt would whistle, quite accurately, the most fabulous melodic lines I had ever heard: with my attuned but musically-ignorant ears I would ask, "What's that, Walt?" He would answer, "Oh, that's Beethoven's Pastoral Symphony" or "that's the end of Brahms's First Symphony" and so on. [. . .] No explanations other than the bald title, no attempt to educate me. He whistled. I listened. Then, sometime in early 1950, Walt tossed me a ticket for a Hull City Hall concert: the long-gone Yorkshire Symphony Orchestra were playing one of his favourites, the Emperor Concerto, and he thought I should hear it played properly. I sat by myself and it was an experience I shall never forget. I had intended to get the bus home, but I wanted to delay facing my disapproving father: instead I walked home with Beethoven rolling round and round my head. Totally unprepared for what I would hear, I never looked back.
>
> (RW, aged 74. In Pitts 2012, 232)

This somewhat idiosyncratic example illustrates a more general point, that decisions over what to listen to in the concert hall are often made (at least in the early stages of concert-going) by someone else. Parents' musical tastes and leisure habits, particularly mothers' (Gracia 2015), can have lifelong effects on their children's concert attendance (Kolb 2001), while couples' attendance is increased by the combined educational and cultural backgrounds of both partners (Upright

2004). In these circumstances, a trusted relative or friend who shares their own enjoyment of live listening can act as a guide into the mysteries of concert hall behaviour and audience interactions. It is likely though, that having passed the stage of entering a concert hall for the first time, listeners who continue their engagement with live music will need to begin making their own decisions about what to attend and how to listen. Studies with new audiences (e.g., Kolb 2000; Dobson and Pitts 2011) have consistently shown that this can be a bewildering process, with inexperienced listeners feeling that they needed to be prepared or educated in some way in order to make reliable selections. This too marks a generational change, with the teaching of classical repertoire having been displaced in the school music curriculum by a focus on acquiring creative skills, often through popular and world music (e.g., Rainbow and Cox 2006). While this is a largely positive step for enthusing young people about music in general, it risks leaving them less informed about concert repertoire than would have been the case for their parents and grandparents, and so gives arts organisations a greater challenge in drawing in new and younger audiences.

One logical solution to this challenge is for arts promoters and performers to provide an informative welcome about their events in other ways, and the websites of major orchestras and festivals demonstrate that this approach has been tackled imaginatively with new approaches to arts marketing. The City of Birmingham Symphony Orchestra (cbso.co.uk) is amongst those organisations who offer an online 'First timers' guide,' addressing such questions as 'How do I know whether I'll enjoy it?' through links to Spotify playlists, and highlighting strands of programming for those seeking different levels of musical challenge and emotional intensity: 'Classical music can evoke all kinds of feelings and emotions, so whether you want to relax and soothe your soul, feel your heart pounding and shivers running down your spine, or simply share a fun night out, we've got the performances for you' (CBSO website, January 2015). This appeal to emotional engagement, rather than repertoire knowledge, marks a shift in communication from traditionally 'information heavy' marketing materials aimed at established listeners. Just as well, perhaps, since an experimental study (Margulis 2010) demonstrating the limited effectiveness of written information in increasing listener enjoyment suggests that the tone of programme notes provided for audiences does indeed need to be reconsidered: less experienced listeners found analytical descriptions of musical sounds to be distracting rather than helpful, leading to the conclusion 'that conceptualization dampens musical enjoyment before it enhances it' (300). It is understandable that an uncertain listener faced with the erudite writing of an obviously more experienced music scholar could find this off-putting, feeling their own lack of knowledge to be reinforced rather than helped by such an intervention. And yet classical music listening retains the overtones of learning and personal development, with ethnographic research of the devoted audience in a Buenos Aires opera house finding that 'opera fans enjoy opera based on their belief that opera is something that needs to be learned about in order to be properly enjoyed' (Benzecry 2009, 131).

Setting aside for the moment the question of whether self-education through classical music is necessarily a helpful concept, a potentially more appealing route to this 'insider perspective' is increasingly being offered by arts organisations in the form of pre- or post-concert talks with performers, composers or other musical experts. Melissa Dobson and John Sloboda (2014) have investigated how the exchange of perspectives between musical creators and listeners can be mutually beneficial, though they acknowledge that achieving this communication demands new skills of both parties in articulating musical responses and intentions that are more often left unspoken. The pianist Susan Tomes (2012) is amongst those performers who have reflected on the 'vulnerability' of talking to the audience before and during concerts, and the distraction it can present, particularly to a performer about to play from memory. These personal connections with performers are welcomed by first-timers and regular audience members but need to be carefully managed in the new demands that they place on players' skills and powers of concentration.

These reflections on the listening choices surrounding live classical music highlight the various factors that promote or inhibit audience members' readiness to listen, and can be seen as being in direct contrast to the apparent spontaneity of the uses of recorded music in everyday life (DeNora 2000; Bull 2005). Listeners who make their own choices of music in the home, the car or elsewhere are able to match their listening experience to their mood, the level of concentration needed for any simultaneous activities and the connections they are seeking to make (or avoid) with the people around them (Sloboda, O'Neill and Ivaldi 2001). These choices draw upon past experience and knowledge just as much as in the live concert but the setting is generally relaxed, informal and relatively within the listener's control, so the learning goes unnoticed. Moreover, these musical decisions are private rather than communal, so not subject to comparison with choices or expectations of more experienced listeners. Listeners in the concert hall, by contrast, often make their musical choices some time before they hear them, and the matching of listening experience to internal mood therefore requires an accommodation that might not be so apparent when listening privately in the home.

Amongst the generational changes in audience membership could be an increasing expectation that live listening should be a mood-enhancing experience, since this is the everyday use of music that is most commonly reported in the young adult population (North, Hargreaves and Hargreaves 2004). Furthermore, since this mood enhancement is usually achieved through distracted listening while attending to other tasks, it is little wonder that the concentrated, reverential listening of the concert hall is increasingly remote from everyday life for new audience members. One student respondent in a recent study with first-time attenders asserted her 'right to daydream,' suggesting that distracted listening to live music was as legitimate a response to an arts event as concentrated attention (Pitts 2014b). For these young adult listeners, the live listening experience is qualitatively different from the engagement with recorded music that is a valued part of their musical engagement, and different again from the

concert-going expectations of the regular audience members who surround them in the concert hall. Being 'in the right place' for live listening, emotionally as well as physically, therefore presents more barriers to the next generation of potential audience members than are currently being addressed through ticket offers and attractive marketing. As in other aspects of live listening, those features of the concert experience that make it attractive to established audience members are less readily accessible to younger newcomers, creating a real challenge for arts organisations marketing to the audiences of the future.

Guaranteed Listening Pleasure? Live Music in the Digital Age

Having outlined some of the challenges of audience recruitment and retention in live classical music, and the contrasts between live listening and contemporary uses of recorded music, this section will consider how these two dimensions of current listening trends can intersect at an individual and organisational level. Relationships between listeners and arts organisations have historically been a one-way channel of communication as traditional forms of marketing, such as the distribution of season brochures or even the maintenance of a website, relied on audience members seeking out information and so knowing that they needed that information in the first place. These modes of communication are still relevant, particularly to established audience members, but the sense of 'not knowing what is going on' is a source of frustration to potential arts attenders as well as to the organisations who feel that their marketing is not being noticed by the 'millennial cultural consumers' they are trying to reach (Vaux Halliday and Astafyeva 2014).

Arts organisations' new uses of digital media, live streaming, performer blogging and so on, are of course being driven primarily by technological changes and a need to maintain audience share and attention when other similar organisations are making use of social media to attract and engage with their potential customers. Underlying these digital practices, however, are some largely unexamined assumptions about the type of interactions audience members will find attractive and that will ultimately lead them to buy tickets, attend more frequently or encourage friends to join them in their live arts attendance. This more visible and immediate relationship between arts organisations and their publics has altered the style of communication as well as its medium, such that whether a performer or arts provider is blogging, tweeting or following other instant communication trends, they are becoming more integrated in the everyday life experiences of those who receive and respond to their communications.

Whether audience members necessarily welcome this change in communication style remains open to question, since the limited evidence so far available is mixed. One case study of a symphony orchestra using a mobile phone app to recruit young adult audiences led to the accusation from one focus group member that 'they [the orchestra] want an app, cos it's just trendy' (Crawford et al. 2014, 1077). The student participants in that research sought limited

features from a mobile app to enhance their existing knowledge of classical music engagement, and doubted the potential of technology to recruit entirely new audiences. Indeed, during the course of the case study, 'most had not used the existing features, such as the sound clips and links to social networking sites, and certainly participants were against the idea that the app might operate as a concert companion during a live concert' (1082). However, ongoing research by Ben Walmsley (2015) suggests that provision of 'behind the scenes' insights through digital media can help increase the sense of anticipation before a performance, allowing new audience members to feel as prepared as their more experienced counterparts and so overcoming one of the recognised barriers to attendance.

The disjunction between the rarefied atmosphere of a classical concert hall in which using mobile phones, for example, does not form part of the accepted code of behaviour, is an obvious inhibitor to digital innovation, particularly when the opinions (and ticket purchasing habits) of regular audience members hold more sway than those of newcomers. As Alan Brown (2004) notes, 'emotions run high' in discussions of changing concert formats and new developments such as the visual presentation of classical music, or the provision of listening guides on surtitles or hand-held 'concert companions' gain mixed and not always predictable reviews: 'early indications are that the level of experience with classical music is less of an indicator than a desire to learn something new, a sort of gregariousness of mind and a willingness to entrust one's imagination to someone else's subjective view of what's going on in the music' (Brown 2004, 15).

Outside classical music, other studies have shown how communication between audience members can increase engagement and the sense of belonging that is known to contribute to audience satisfaction and repeat attendance (e.g., Pitts and Spencer 2008). Lucy Bennett's 2014 ethnography of texting and tweeting at Tori Amos concerts illustrates the responsibility that some pop music listeners feel to publish setlists and descriptions of the event they are attending, so allowing absent fans to 'live vicariously through others updating in real time' (2014, 93). Bennett's respondents spoke about their online practices as fostering a 'communal and inclusive spirit within the [fan] community' (98) and it might be heartening for classical music organisations to consider this model also, recognising that informal communication between audience members is a potentially valuable and under-utilised practice in concert hall settings. Where this comes about accidentally, as between regular concert attenders who sit in the same booked seats for years (O'Sullivan 2009), there is pleasure to be gained in talking about the listening experience with others who are known to share a loyalty to the performers or repertoire under discussion. Arranging this more formally—and potentially digitally—is a greater challenge but could help to form a bridge between the 'official' communications of an orchestra or other arts organisation and the otherwise unrecorded audience responses to concerts.

An example of this developing practice can be seen through a return visit to the City of Birmingham Symphony Orchestra website (cbso.co.uk), where the

@TheCBSO Twitter feed interleaves largely factual tweets from the orchestra (reminders of concert times, possible travel disruptions and remaining ticket availability) with more emotional responses to concerts from audience members: 'I love this venue Part of the CBSO visited my school in the 50s Fantastic!' There is an immediacy (albeit one with an attendant risk) in these unmediated audience responses that gives them an authenticity sometimes lacking in the carefully chosen quotes that are often included in the marketing and programming materials of arts organisations. Without much prompting from the CBSO, audience members share memories and reactions in ways that broaden access to the value of 'being there' (Radbourne, Johanson and Glow 2014) even for those who were not, with benefits for both the audience community and the arts organisation alike. Links are made to recorded music listening, too, both in the CBSO's promotion of radio broadcasts of concerts and by audience members making connections with their own recent listening. In this informal context, audience responses to concerts tend to describe the personal experience of listening ('spine-tingling,' 'incredibly moving') or otherwise affirm the 'brilliant' or 'fabulous' quality of the performance they have heard. There is little display of technical language or musical knowledge beyond some naming of instruments or performers, so the brevity of a tweet circumvents some of the challenges of talking about music that are sometimes an obstacle to new concertgoers (Dobson and Pitts 2011). These voices might not be representative of the whole audience since the confidence to tweet a response to a concert is likely to imply a level of comfort and familiarity with the event (Brown 2004), though conversely, new audience members might feel able to join discussions more readily than they would at the interval bar, since they are able to see how their own experiences of the concert fits with those around them. Online interactions therefore bring the private experience of listening into a more public forum, providing fresh insight into what it means to be an audience member.

The interesting point of discussion here is not so much how digital communication is changing the relationship between audiences and arts organisations—since any such observations will quickly become obsolete as attitudes and practices move on—but rather the ways in which new modes of interaction are exposing the challenges and pleasures of live classical music listening. Firstly, the situating of discourse around classical music in an online context more used to selling and sensationalising appears to increase the emotional intensity with which the concert experience is described by both arts marketers and arts consumers. This fits well with audiences' stated desires for high quality and emotional engagement in their listening (Radbourne, Johanson and Glow 2014) and so places this important aspect of concert attendance more firmly at the heart of communications between promoters and their publics. A move away from more knowledge-rich writing about music, at least in initial contact with audiences, might also circumvent some of the terminological barriers that can leave new audience members worried that they have the 'right' language to talk about their listening experiences (Dobson 2010; Dobson and Pitts 2011).

68 *Stephanie E. Pitts*

Secondly, the opportunity for more open discussion about concert experiences, unmediated by the organisation itself, could enhance the social enjoyment of 'like-minded listening' that is also a recurring finding in studies of audience satisfaction (Pitts et al. 2013). As might be expected, pop music has already established practices of online fandom that are still new territory for classical music audiences (Baym 2007), but the opportunity to see how other audience members experience a concert brings exciting possibilities for understanding and participating in live classical music.

Finally, this informal, public discourse around classical music could help to address one of the most persistent barriers to arts attendance, namely the need for a 'guaranteed good night out' that can be an inhibiting factor in trying a new cultural experience (Martin, Bunting and Oskala 2010). Audiences unfamiliar with classical music consistently report finding it hard to make selections from season programmes, and published reviews of concerts often do little to help with this since their language and level of assumed knowledge is aimed at established concertgoers. Risk aversion in ticket booking is heightened in times of financial constraints, exacerbating arts organisations' concerns about falling ticket sales: 'the new calculus of risk and reward goes something like this: as the price of admission goes up, the willingness to risk an unsatisfactory experience goes down.' (Brown 2004, 2). One route to minimising this risk is to share ticket booking decisions with a trusted friend, and online discussions of arts events and organisations can help to broaden that circle of virtual friends and increase booking confidence. Just as online hotel reviews have been shown to build consumer trust and influence booking intentions (Sparks and Browning 2011), so audience tweets and forums could help to create brand loyalty around arts events for new attenders as well as those already committed to the organisation. How long, I wonder, before TripAdvisor spawns ArtsAdvisor, with the same risks and benefits to consumers and providers?

Conclusion

So does, or should, classical music 'have people worried'? (Kramer 2007, 1). The evidence suggests that it does but that this worry in itself might be the source of renewed advocacy for classical music, as those currently emotionally (and financially) invested in live music promotion seek to broaden its appeal to potential future audiences. Classical music organisations face a constant challenge in balancing the desires of their loyal audience members with the need to attract new ticket sales in order to survive (Rizkallah 2009), and there are clear dangers in changing concert formats and publicity materials in ways that will be resisted by established listeners (Brown 2004). What this chapter's brief review of current research and practice suggests, however, is that there are mutually beneficial ways for new and established listeners to co-exist, both in the concert hall and online.

Even if established listeners are more likely to have the confidence to share their responses to concerts on Twitter, the informality of online communication makes that audience community visible to new listeners in ways that might

then make first time attendance at a concert seem less daunting. As a result of this, online discussions between audience members can provide new insight for arts organisations and marketing teams about how concert attendance is experienced in terms of emotion and quality, so supporting an apparent trend to emphasise these aspects of live listening in promotional materials. Almost as importantly, all this online communication is eminently ignorable by those established concertgoers who are already confident in making booking decisions and seeking out information about the repertoire they are choosing to hear. The concert format is left largely untouched by these changes, but the supporting materials surrounding it are in transition from the dense analytical descriptions of programme notes (Margulis 2010), towards the emotional and social sharing of experiences amongst like-minded listeners.

This is an idealistic view, admittedly, which deliberately resists the sense of 'worry' around classical music with which this chapter began, but there are grounds to remain optimistic that classical concerts and their audiences can adapt to digital consumerism and online communication in ways that could be enriching rather than undermining. Surveys of audience demographics (e.g., Martin, Bunting and Oskala 2010) and research into audience satisfaction (e.g., Radbourne, Johanson and Glow 2014) have tended to place the responsibility for managing these transitions in communication and engagement firmly with the arts organisations themselves, but the suggestion here is that audience members—both established and new listeners—are increasingly assuming the curator's role for classical music by making their responses visible to one another and to the wider world. Knowing how fellow audience members are experiencing live performance has traditionally been largely inaccessible to other listeners, especially limiting newcomers' access to the talk about music that can help to build community and understanding. Researchers have a role to play in interpreting and contextualising these newly visible perspectives, contributing to an 'evaluative triangle [of] artist-audience-researcher' (Dobson and Sloboda 2014, 173) that highlights the changing relationship between classical music and its listening publics but does not irresponsibly exaggerate its decline. Advocacy for classical music—by its audiences, performers and promoters—needs to be watchful rather than worried, keeping the stories of committed, enthusiastic listeners at the heart of any account of live classical music listening, while ensuring that the many other potential concert-goers are welcome and not forgotten.

Acknowledgements

The research referred to in this chapter has been funded by two small grants from the British Academy, and a Cultural Value research grant from the Arts and Humanities Research Project. I am grateful to all the participants and organisations involved in the research and to past and present members of the Sheffield Performer and Audience Research Centre (SPARC) for our many stimulating conversations, particularly Sarah Price, Lucy Dearn and Jonathan Gross, who offered helpful feedback on this chapter.

70 *Stephanie E. Pitts*

References

Associated Board of the Royal Schools of Music (ABRSM). 2014. *Making Music: Teaching, Learning and Playing in the UK*. London: ABRSM. Accessed 8 January 2015 at http://gb.abrsm.org/pt/making-music/

Baym, Nancy K. 2007. 'The New Shape of Online Community: The Example of Swedish Independent Music Fandom.' *First Monday* 12 (8). Accessed 15 January 2015 http://journals.uic.edu/ojs/index.php/fm/article/view/1978

Bennett, Lucy. 2014. 'Texting and Tweeting at Live Music Concerts: Flow, Fandom and Connecting With Other Audiences Through Mobile Phone Technology.' In *Coughing and Clapping: Investigating Audience Experience*, edited by Karen Burland and Stephanie Pitts, 89–100. Farnham: Ashgate.

Benzecry, Claudio E. 2009 'Becoming a Fan: On the Seductions of Opera.' *Qualitative Sociology* 32: 131–51.

Brown, Alan. 2004. *Smart Concerts: Orchestras in the Age of Entertainment*. Knight Foundation Issues Brief Series No. 5. Miami, FL: The Knight Foundation. Accessed 14 January 2015 at http://www.polyphonic.org/wpcontent/uploads/2012/04/2004_Magic_of_Music_Issues_Brief_5.pdf

Bull, Michael. 2005. 'No Dead Air! The iPod and the Culture of Mobile Listening.' *Leisure Studies* 24 (4): 343–355.

Burland, Karen & Stephanie E. Pitts, eds. 2014. *Coughing and Clapping: Investigating Audience Experience*. Farnham: Ashgate.

Crawford, Garry, Victoria Gosling, Gaynor Bagnall & Ben Light. 2014. 'Is There an App for That? A Case Study of the Potentials and Limitations of the Participatory Turn and Networked Publics for Classical Music Audience Engagement.' *Information, Communication & Society* 17 (9): 1072–1085.

DeNora, Tia. 2000. *Music in Everyday Life*. Cambridge: Cambridge University Press.

Dobson, Melissa C. 2010. 'New Audiences for Classical Music: The Experience of Non-attenders at Live Orchestral Concerts.' *Journal of New Music Research* 39 (2): 111–124.

Dobson, Melissa C. & John A. Sloboda. 2014. 'Staying Behind: Explorations in Post-performance Music-audience Dialogue.' In *Coughing and Clapping: Investigating Audience Experience*, edited by Karen Burland and Stephanie E. Pitts, 159–173. Farnham: Ashgate.

Dobson, Melissa C. & Stephanie E. Pitts. 2011. 'Classical Cult or Learning Community? Exploring New Audience Members' Social and Musical Responses to First-time Concert Attendance.' *Ethnomusicology Forum* 20 (3): 353–383.

Gracia, Pablo. 2015. 'Parent-Child Leisure Activities and Cultural Capital in the United Kingdom: The Gendered Effects of Education and Social Class.' *Social Science Research* 52: 290–302.

Hesmondhalgh, David. 2013. *Why Music Matters*. Chichester: Wiley-Blackwell.

Hodgkins, Chris. 2009. *Problems Arising from Changing Demographics*. London: Jazz Services Ltd. Accessed 10 January 2012 at www.jazzservices.org.uk

Johnson, Julian. 2002. *Who Needs Classical Music? Cultural Choice and Musical Value*. New York: Oxford University Press.

Kolb, Bonita M. 2000. 'You Call This Fun? Reactions of Young First-time Attendees to a Classical Concert.' *Journal of the Music and Entertainment Industry Educators Association* 1 (1): 13–28.

Kolb, Bonita M. 2001. 'The Effect of Generational Change on Classical Music Concert Attendance and Orchestras' Responses in the UK and US.' *Cultural Trends* 11 (41): 1–35.

Kramer, Lawrence. 2007. *Why Classical Music Still Matters*. Berkeley: University of California Press.

Lamont, Alexandra, David J. Hargreaves, Nigel A. Marshall & Mark Tarrant. 2003. 'Young People's Music in and Out of School.' *British Journal of Music Education* 20 (3): 229–241.

League of American Orchestras. 2009. *Audience Demographic Research Review*. Accessed 9 January 2013 at www.americanorchestras.org

Margulis, Elizabeth Hellmuth. 2010. 'When Program Notes Don't Help: Music Descriptions and Enjoyment.' *Psychology of Music* 38 (3): 285–302.

Martin, Vanessa, Catherine Bunting & Anni Oskala. 2010. *Arts Engagement in England 2008/09: Findings from the Taking Part Survey*. London: Department of Culture, Media and Sport. Accessed 9 January 2013 at http://artscouncil.org.uk

North, Adrian C., David J. Hargreaves & Jonathan J. Hargreaves. 2004. 'Uses of Music in Everyday Life.' *Music Perception* 22 (1): 41–77.

North, Adrian C., David J. Hargreaves & Susan A. O'Neill. 2000. 'The Importance of Music to Adolescents.' *British Journal of Educational Psychology* 70 (2): 255–272.

O'Sullivan, Terry J. 2009. 'All Together Now: A Classical Music Audience as a Consuming Community.' *Consumption, Markets and Culture* 12 (3): 209–223.

Pitts, Stephanie E. 2005. 'What makes an Audience? Investigating the Roles and Experiences of Listeners at a Chamber Music Festival.' *Music and Letters* 86 (2): 257–269.

Pitts, Stephanie E. 2012. *Chances and Choices: Exploring the Impact of Music Education*. New York: Oxford University Press.

Pitts, Stephanie E. 2014a 'Musical, Social and Moral Dilemmas: Investigating Audience Motivations to Attend Concerts.' In *Coughing and Clapping: Investigating Audience Experience*, edited by Karen Burland and Stephanie E. Pitts, 21–34. Farnham: Ashgate.

Pitts, Stephanie E. 2014b. *Dropping in and Dropping Out: Understanding Cultural Value from the Perspectives of Lapsed or Partial Arts Participants* [Report on an AHRC Cultural Value project]. Accessed 5 October 2015 at http://www.sparc.dept.shef.ac.uk/research/

Pitts, Stephanie E. & Christopher P. Spencer. 2008. 'Loyalty and Longevity in Audience Listening: Investigating Experiences of Attendance at a Chamber Music Festival.' *Music and Letters* 89 (2): 227–238.

Pitts, Stephanie E. & Karen Burland. 2013. 'Listening to Live Jazz: An Individual or Social Act?' *Arts Marketing* 3 (1): 7–20.

Pitts, Stephanie E., Melissa C. Dobson, Kate Gee & Christopher P. Spencer. 2013. 'Views of an Audience: Understanding the Orchestral Concert Experience from Player and Listener Perspectives.' *Participations* 10 (2): 65–95.

Radbourne, Jennifer, Hilary Glow & Katya Johanson, eds. 2013. *The Audience Experience: A Critical Analysis of Audiences in the Performing Arts*. Chicago: Intellect.

Radbourne, Jennifer, Katya Johanson & Hilary Glow. 2014. 'The Value of "Being There": How the Live Experience Measures Quality for the Audience.' In *Coughing and Clapping: Investigating Audience Experience*, edited by Karen Burland and Stephanie E. Pitts, 55–67. Farnham: Ashgate.

Radio Joint Audience Research Limited (RAJAR). 2014. *Quarterly Summary of Radio Listening: Survey Period Ending 14th September 2014*. London: RAJAR. Accessed 8 January 2015 at http://www.rajar.co.uk/docs/2014_09/2014_Q3_Quarterly_Summary_Figures.pdf

Rainbow, Bernarr and Gordon Cox. 2006. *Music in Educational Thought and Practice*. Woodbridge: Boydell.

Rizkallah, Elias G. 2009. 'A Non-Classical Marketing Approach for Classical Music Performing Organizations: An Empirical Perspective.' *Journal of Business & Economics Research* 7 (4): 111–124.

Sloboda, John A., Susan O'Neill & Antonia Ivaldi. 2001. 'Functions of Music in Everyday Life: An Exploratory Study Using the Experience Sampling Method.' *Musicae Scientiae* 5 (1): 9–32.

72 *Stephanie E. Pitts*

Sparks, Beverley A. & Victoria Browning. 2011. 'The Impact of Online Reviews on Hotel Booking Intentions and Perception of Trust.' *Tourism Management* 32 (6): 1310–1323.

Tomes, Susan. 2012. 'To talk or not to talk?' Accessed 14 January 2015 at http://www.susantomes.com/talk-talk/

Upright, Craig B. 2004 'Social Capital and Cultural Participation: Spousal Influences on Attendance at Arts Events.' *Poetics* 32 (2): 129–143.

Vaux Halliday, Sue & Alexandra Astafyeva. 2014. 'Millennial Cultural Consumers: Co-creating Value through Brand Communities.' *Arts Marketing* 4 (1/2): 119–135.

Walmsley, Ben. 2015. 'Respond: A critical analysis of an online platform designed to deepen and broaden audience engagement with contemporary dance.' Paper presented at Sheffield Performer and Audience Research Centre one day symposium, *Understanding audiences for the contemporary arts*, University of Sheffield, April. Abstract Accessed 3 May 2015 at http://www.sparc.dept.shef.ac.uk/

5 The Meaning of Lived Experience

Paddy Scannell

I. The Two Kinds of Lived Experience

Experience comes to us in two ways. There is firstly the slow incremental process of *becoming* experienced. An experienced parent or teacher gets to be so in the course of time, through the day to day business of coping, managing and dealing with their own children or a classroom of them—and children, of course, reciprocally, become experienced in dealing with their parents and teachers. *An* experience however stands out from the unremarkable, unnoticed, incremental accumulation of life experience. It is by definition an occasional, now-and-then occurrence—a singularity, a one-of-a-kind sort of thing. This distinction has something in common with that, in German, between *erlebnis* and *erfahrung*, the former referring to special or meaningful life-experiences, and the latter to the weight of incremental life experience. The former is immediate and unreflective; the latter accumulates in time and is reflective.[1]

In either case experience, whether in general or particular, is always reflexive: it gives rise to reflection, it looks back on itself. Experience is thought-*ful*. It demands that we think about it if, as I will argue, we are to own our experience and experiences. Our lived experience is a life-long *learning process*. Through trial and error, we (hopefully) learn from our mistakes in the incremental, continuing process of becoming experienced. Aristotle called this *phronesis* or practical wisdom. Our experiences, on the other hand, are a *storage process*. They accumulate in a memory bank in which we hoard those experiences in our lives that stand out against so much else that vanishes into the unremembered past.

In this short essay I will focus on experiences as distinct moments that stand out against the background of ordinary lived experience as it goes on from day to day. More exactly, I will be concerned with the things we do *in order* to experience them, for the sake of the experience itself. In other words I will be concerned with *events*.[2] I have argued elsewhere for a taxonomy of events based on a distinction between the things that happen to us (events as happenings) and the things we make to happen (events as occasions) (Scannell 2014: 217). Their crucial difference is that happenings are not meant to happen,[3] while occasions always are. Here I set aside the large and important class of unexpected events[4]

74　*Paddy Scannell*

in order to focus on events as occasions and the hopes and expectations with which they are invested.

In either case, events stand out against the backdrop of uneventful day to day life in which nothing ever happens. Harvey Sacks, in his brilliant discussion of how to perform 'being ordinary', has pointed to the 'awesome, overwhelming fact' that ordinary life has no *storyable* features (Sacks 1992 vol. 2, 218). 'What did you do at work (home; school; the office) today?' In each case the right and proper answer is—'nothing'. It is not that, in some cosmic, existential sense *nothing* happened—as if your day had been an experiential black hole—but just that what happened was in every way routine, usual and ordinary just like every other day. And if you tried to make more of the question then you might, as Sacks points out, end up in difficulties:

> If you come home and report what the grass looked like along the freeway; that there were four noticeable shades of green, some of which had just appeared because of the rain [and so on and so forth], then there may well be some tightening up on the part of your recipient. And if you were to do it routinely, then people might figure that there is something odd about you . . . You might lose friends.
>
> (Sacks 1992, vol 2, 219)

It is not a trivial fact that events are good conversational objects. That is, perhaps, their point. They are solutions to the demonic problem of finding things to talk about in our ordinary conversations with one another.

In what follows I move promiscuously between the kinds of event that all of us now and then create and partake in (think of them as *amateur* productions) and public *professional productions* performed in theatres, concert halls and other dedicated public venues. In a famous essay on the fate of music as it succumbed to mass production and distribution Theodor Adorno, borrowing a phrase from his piano teacher, Eduard Steuermann, wrote of 'the barbarism of perfection' (Adorno 1978: 284). The professionalization of music was a marked feature of the rapid rise of the music industry in the 1930s and went hand in hand with the fetishization of authenticity (the great voice, the definitive performance, the lionized conductor or solo instrumentalist):

> The new fetish is the flawlessly functioning, metallically brilliant apparatus as such, in which all the cogwheels mesh so perfectly that not the slightest hole remains open for the meaning of the whole. Perfect, immaculate performance in the latest style preserves the work at the price of its definitive reification. It presents itself as complete from the very first note. The performance sounds like its own phonograph record.
>
> (Adorno 1978, 284)

The reification of performance in an ideology of professionalism relegates non-professional musical life to the inferior status of 'amateur' performances.

The Meaning of Lived Experience 75

To assert for instance that 'it is just as possible to make beautiful music with a moderately good voice on a moderately good piano', is to encounter 'a situation of hostility and aversion whose emotional roots go far deeper than the occasion' (ibid., 277). There is a special charm, for instance, in a child's stumbling performance in a school play or concert (with my inner ear I hear my young daughter many years ago playing a simple piano piece on just such an occasion).

I make this point not simply to avoid privileging public, professional events over private and amateur occasions. The more fundamental point is that both are driven by a deliberate, intentional commitment to making something happen for the sake of the experience to which it will give rise. The difference is perhaps more in the strength of expectations invested in the occasion by those for whom it is meant and intended. We are more inclined to make allowances for the cooking of friends who have invited us for dinner than that of the expensive restaurant where we were lucky to be able to book a table. We do not judge amateur performances by the high standards we reserve for public, professional efforts. They are, however, different in degree not in kind, and their *care structure* is similar in all essential respects.

The care structure is the central concept in my recent study of live broadcasting (Scannell 2014). It is a re-interpretation of Heidegger's analysis of care as a (perhaps *the*) defining characteristic of our common humanity. By the care-structures of events I mean all the hidden, invisible work that goes into the making of any event, no matter how great or small—from a family wedding or a small-town amateur production of a play, to the marriage of a prince or a national theatre production. Events don't just happen. They must be made to happen. They must be produced as that which they are meant and intended to be. The care-structure is everything that contributes to the realization of the event: it is the sum of all the advance work of preparation *and* its enactment, live and in real time on the day. But it is not just a question of the invisible labour of its producers and actors (care as toil); it is also the care and concern for the event *as such*. Any event aspires to be a meaningful, significant experience for all concerned. Most fundamentally the care structure of an event is its *meaning*-structure—its realization, live and in real time, as that which it was meant and intended to be for producers, performers, guests or audiences. What comes together, as the care-structure of an event, is on the one side the care and commitments of its producers and actors and, on the other, the expectations of all those for whom it is produced and enacted. For all parties, in any event, it matters that it works, that it triumphs over the ever-present threat of failure and disappointment. Success is never something that can be guaranteed in advance.

The terror that haunts live events lies in the fact that when things go wrong, it can't be hidden. It is not like film making or writing where you can endlessly re-take the same shot or revise the manuscript. In all the live performing arts technical failure and human error are the nightmarish possibilities of any performance, amateur or professional. If someone fluffs their lines, if a voice goes off-key, if part of the scenery wobbles alarmingly or the lights fail, the spell

has been momentarily broken and it is hard to recapture the sought for mood, the aura of the occasion. Hence, the necessity of all the rehearsals, technical run-throughs and frantic preparation in the run-up to the opening night. The production care-structures of live performances (and this includes television coverage of news, sport and ceremonial events) are meant to anticipate and forestall, as far as possible, anything that might disturb the effortless unfolding of the live performance for a live and present audience (and absent viewers, in the case of television).

But it is not just a matter of damage limitation. It is more crucially a matter of bringing the event to life, and this means, essentially, creating the mood that is appropriate to the nature of the occasion. A wedding should be joyful, a funeral solemn. A tragedy should be tragic, a comedy comic. Mood is not some value added to events. It is that for the sake of which they were made and meant to happen. If the occasion is to be festive, its sought for mood is fun and enjoyment and there are specific ways of securing such effects. Parties require mood enhancing devices which their organizers take care to lay on in advance: jellies, ice-cream and cake for children; wine, beer and finger food for grown-ups. If the occasion is to be solemn, there are prescribed ways of securing that effect, too. As it is in private events so it is with their public equivalents. In either case they are meant to be memorable. The hope is that, on the day, all the advance preparations for it will happen as they were meant to happen so that the occasion turns out to be that which it was meant to be, whether festive or solemn, a *great* occasion, a cherishable moment in time; something worth remembering, something to look back on with pleasure. Yes, it *was* a good wedding. The bride was radiant. Her wedding dress was beautiful. The church service went off without a hitch. The wedding feast was appreciated by all the guests. The speeches were not disasters. All the anxious care that preceded it and all the expense were worth it if, in the end, all can say, looking back, yes, it *was* a great day. The *care structure* of the occasion has worked to produce it really and truly as that which it was meant and intended and so found, in the end, to be.

This is the gift of events. We arrange occasional events for the sake of the experience—the sought-for mood that defines the kind of event that it is. In doing so we get to *own* the experience. For this to happen we must be open to the possibility of the experience that the event may promise but not necessarily deliver. Those who dismiss events have closed themselves off from this potential. To be open to the event means to allow oneself to be possessed by it: not simply 'to enter into the spirit of the occasion' as they say, but also the reverse—to let the spirit of the occasion (which we can and do sometimes resist) enter into our ownmost self so that we own it. To own an experience (to possess it) is to have been possessed by it. These are uncomfortable notions for those who prefer to think of possession as a feature of ritual cults in pre-modern societies. But experience, in its absolute purity, is momentary ecstasy—an even more uncomfortable thought.

II. Experience as an Existential Phenomenon

The cultural 'turn' of the 1950s re-specified the meaning of culture as 'a way of life', the ordinary day-to-day life of ordinary people. It was their 'lived experience' that became the object of inquiry. A later generation, influenced by the theoretical 'turn' of the 1970s and 1980s, found this concern with lived experience to be profoundly problematic. The new critical paradigm, with Ideology as its master concept, dismissed the earlier faith in the authenticity of the lived experience of individuals or groups as naïve humanism (Hall 1980). Ordinary experience explained nothing. It was, in fact, the home and heartland of ideology wherein and whereby individuals and groups lived in an imaginary relation to the real conditions of their existence. Experience became a contested, divisive term (Scannell 2015). For me it has always been a quite indispensable starting point for thinking and this essay is yet another attempt to clarify its meaning, to get at what it *is*.

Experience is not an analytical concept, a theoretical abstraction. Nor is it a sociological, psychological or cultural phenomenon—not in the *first* place. To be sure, experience has sociological, psychological and cultural dimensions, which show up in any actual human situation. But in the first place it is an existential phenomenon, and must be understood as such. But what are existential phenomena? They belong to existence understood in a certain way: existence as *life*. Not everything that is (that exists) has life. We talk of the *lifeless* universe—a universe made up of lifeless (mostly dark) matter which we are anxiously scanning for signs of life. Life, to the best of our knowledge at this moment in time, is unique to our own small planet earth. Experience is *the* word for the immediate encounter with existence (with being alive and living in the world) that is common to every individual human being—it is the term that captures *how* we (human beings) encounter life, our own life and the life of the world (the *living* world) as a whole. This encounter, for every individual and every generation of the living, is always fresh and as if for the first (and last) time. The question of the meaning of experience is an entry point to the meaning of 'life'. Our problems with the meaning of the latter compound our difficulties in getting some purchase on the former.

For the meaning of life has long been abandoned in theology and philosophy and is simply outwith the concerns of the natural sciences, for which it is a meaningless question. In the long European metaphysical tradition, ontological inquiry into the meaning of being came to focus more or less exclusively on Being (the existence of God). It was Martin Heidegger's quite extraordinary achievement to resurrect ontology, more or less single-handed, and breathe new life into the moribund question of being by re-specifying it as being-in-the-world. In *Being and Time* the ultimate question of traditional metaphysics has been stripped of all its onto-theological trappings. The meaning of being becomes mundane, resolutely situated in the *umwelt*, the immediate roundabout-me-world of ordinary life and experience in which I (or anyone) live with others.

78 *Paddy Scannell*

In posing the ontological question in a radically down-to-earth way *Being and Time* was well in advance of its time. The post-war discovery of everyday life as a new topic of academic inquiry in the 1950s was quite untouched by Heidegger's immense contribution to its renewal and clarification. It is only in the late twentieth century, in the decades following his death in 1976, that there has been an explosion of interest in Heidegger's thinking as part of a renewed interest in phenomenology whose core concern was always with the immediacy of human experience (Keller 1999). The postmodern turn against grand narrative and grand theory (the metaphysics of today) fitted well with phenomenology's commitment to 'the things themselves' purged of preconceptions and theoretical abstractions.

The easiest way to dismiss experience is to tag it as 'subjective'. Indeed it is, but that is not *all* it is. If experience were *merely* subjective (i.e., uniquely, in each case, mine and no one else's), then there would be nothing to be said (more exactly, nothing sayable) about it. It would be a private and incommunicable matter that had no language to give expression to it. But evidently this is not the case. Experience *is* shared and shareable. That is the whole point of public events and occasions. Of course, we do not all have the *same* experience. One half of the crowd at the football game has a good experience, while the other half (whose side has lost) has a bad experience. The gift of public occasions is that they are shared and sharable, meant and intended as such. They compel us to talk about them, to compare our responses, as an affirmation that they were as we felt them to be, really and truly, in our own experience.

I did not choose my life. I did not choose to be born, nor the being that I get to find as mine: being male, white and British in my case. All of us must come to terms with the fore-given conditions of our existence in the specific situation in which we find ourselves. These two things—the conditions of existence, the nature of situation we are in—constitute the common ground of the experience of being alive and living in the world in every particular instance. *The* condition that all of us share is death—not someone else's, but *our own*. Death is the ownmost condition of existence, the one sure and certain gift of a given life, the life that I own as mine. And following directly from this, the experiential structure of an unfolding life is what each and all of us live through (work through) as we move from infancy through childhood, youth and adulthood towards old age and death. In life we must come to terms with the existential givens that come at birth: our given sexuality perhaps above all. As we go through life we must come to terms with the life-choices we confront along the way: making a living, a life-partner, to have children—or not. This is the meaning of *lived* experience—always subjectively mine and, at the same time, the universal fate and destiny of that common humanity of which one of us is a uniquely particular and perishable instance.

In *Television and the Meaning of 'Live'* I started with an anecdote about Heidegger and television. He was deeply suspicious of modern technologies

(Heidegger 1954/1978) and publicly he deplored television. There wasn't a TV set in the Heidegger household. And yet, as his biographer tells us, in his later life he would sneak round to a friend's house, now and then, to watch soccer (of which he was a great fan) on television. During one memorable European Cup match he got so carried away that, in his excitement, he knocked over his cup of tea (Safranski 1998, 428). Which is more interesting: what Heidegger (the great thinker) thought about television? Or what happened to him as he watched it? The answer is, surely, the latter.

Heidegger, who dismissed television on the one hand and was carried away by it on the other, thinks of the authentic 'now' as *die Augenblick*, the ecstatic moment of vision, the twinkling of an eye in which everything is transformed:

> That *Present* which is held in authentic temporality and which thus is *authentic* itself, we call the '*moment of vision*'. This term must be understood in the active sense as an ecstasis.[5] It means the resolute rapture with which Dasein is carried away to whatever possibilities and circumstances are encountered in the Situation as possible objects of concern . . .
> (Heidegger 1962, 387)

Heidegger will later insist that 'Ecstases are not simply raptures in which one gets carried away' (416), but even so that is one of the things they are. What then is the ecstatic now? I take it to be what Heidegger experienced when he knocked over his teacup watching the soccer match at his friend's house. It was an experience embedded in everyday life and ordinary, routine, humdrum existence. Heidegger is watching television *and* having his cup of tea. The game goes on in ordinary time, marked by the presence of the clock and the minutes ticking away on screen in present day soccer coverage. It can be tedious, the play may be dull but at any moment it may be ecstatically transformed by the scoring of a goal—the most fleeting and transient of things which comes and goes in the twinkling of an eye.

The meaning of 'the moment' is a recurring motif in the arts and literature of the modern era. Vermeer's paintings of a maidservant in the scullery pouring milk into a bowl, of a young woman absorbed in making lace or reading a letter transform insignificant moments of everyday life into surpassing works of art. Wordsworth's *Prelude*, an autobiographical meditation on the formation of the artist, contains several beautiful accounts of what he calls 'spots in time'—moments of unsolicited and unexpected pure experience ('surprised by joy') that provide the essential impulse to poetic expression. Proust thought of 'the moment' as time regained. It is 'brief as a flash of lightning', 'a fragment of time in its pure state'. It is a moment 'freed from the order of time' in which we ourselves are free from time and necessity. Such a moment is 'deathless'. 'Situated outside time, why should [we] fear the future?' (Proust 1996, 224–5). Heidegger redeemed the living moment for philosophy. The *Augenblick*—the authentic moment of vision that comes and goes in the twinkling of an eye—is

80 Paddy Scannell

central to his notoriously difficult meditations on time in Division Two of *Being and Time*.

Time, for Heidegger, is the horizon of our being, disclosed as such by death. It is not just that death is, in each case, the termination of the life that is mine. It is rather disclosive of life as such, for it is that which gives life the very condition of its possibility. Death is not life's end but the precondition of its everlasting renewal. It is that wherein and whereby *being* and *time* appear. It is that which yields the existential temporal structure of birth > life > death as the everlasting cycle of regeneration which constitutes the one-and-only life sustaining world of all living things as utterly distinct from the boundless, lifeless, timeless eternity of the universe. The temporality of *the* moment is existence bounded in a nutshell, contracted to an ecstatic *now!* in which we encounter the aliveness of being (our being alive) as pure unalloyed experience. That is why, as they say, the moment is 'to die for'. It is a little death, *une petite mort* as the French put it. In its utter transience and perishability it is nevertheless a moment out of time, never to be forgotten by those who experienced it.

'Being' and 'time'—the two great themes of Heidegger's fundamental existential inquiry—are unobtrusively grounded in the existential temporalities of lived experience. We live in many different orders of experiential time, which come together, for each one of us, as the time-that-is-mine: my time, the time of *my* being in the world. Life time is a one-way street: forward moving, linear, irreversible and unstoppable. There is no time out from life and the time of lived experience. The given conditions of life time are the unavoidable, implacable and necessary terms upon which we encounter our being in the world. If freedom is, in the first place, freedom from necessity it means to be liberated from the unavoidable and inescapable constraints, which are the given conditions of existence. Freedom is escapist in this existential sense.

Events are not necessary things. From any utilitarian perspective they are useless: a waste of time and money. At best they are a bit of 'added value': an unnecessary something stuck onto the real and serious business of life, making a living, doing what has to be done in order to exist. They are occasional escapes from ordinary everyday life and its inescapable realties. But escapism is not only an escape *from* something. It is an escape *into* something. Events are devices whereby we escape necessity and enter the realm of freedom. This perhaps is the greatest gift of the occasions that we make to happen for the sake of the experience they promise. From the moment they start events are in being towards their end. As such they replicate the inescapable existential structure of life itself. And yet, for the moment—for the sake of the experience of *being in the moment*—the inevitable end is deferred. In our ordinary understanding an event 'goes on' from moment to moment. An event is made up of moments. But this is to think of moments as the fractional components of ordinary time, like the tick and tock of the movement of a clock. What then is the moment of pure experience if not a moment out of ordinary time, the moment of Heidegger's spilt teacup? Something of this is the wager and reward of every

The *Meaning of Lived Experience* 81

performed and enacted event that we commit to making happen for the sake of their experiential promise.

Notes

1 For a discussion of these terms (especially in the writings of Walter Benjamin and Theodor Adorno) in the context of a sweeping historical survey of the category of experience as discussed in philosophy, theology, aesthetics, politics and history in Europe and North America from the eighteenth century to the present, see Jay (2006).

2 This essay is, in part, a contribution to a phenomenology of events. It is, in many ways, indebted to Dayan and Katz's grounding breaking sociological study of *media* events (Dayan and Katz 1992).

3 'Happening' and 'happen' come from the Old English noun, 'hap' and the Middle English verb 'to hap'. Both have the same root meaning, in which the element of chance is key. Good or bad fortune, a fortuitous occurrence, a chance event—these are the core original meanings of the word. 'Haply' and 'happily' both mean 'by chance'.

4 Again we may distinguish two major sub-divisions of unexpected events: blessings and disasters. In his study of happiness based on a popular radio show of the 1930s, in which listeners were asked to write and describe their happiest moment in the course of a whole month, Elihu Katz found that the largest category in the sample of 250 letters was of an unanticipated happiness—a letter, a phone-call, a visit out of the blue from a friend or family member (Katz 1950/2012). I have discussed unexpected disasters in an analysis of television news coverage of the terrorist attack on the World Trade Center on the day, September 11, 2001 (Scannell 2014, 191–224).

5 '*Temporality is the primordial 'outside-of-itself' in and for itself.* We therefore call the phenomena of the future, the character of having been, and the Present, the "*ecstasies*" of temporality' (Heidegger 1962: 329. Italics as in the orginal). This conceptualization of Temporality is one of the less perspicuous aspects of Heidegger's struggles with time in Division Two of *BT.* For further explication see Inwood (1999: 220–222).

References

Adorno, Theodor. [1937] 1978. 'On the Fetish Character in Music and the Regression of Listening.' In *The Essential Frankfurt School Reader*, edited by Andrew Arato and Eike Gebhardt, 270–99. Oxford: Blackwell.

Dayan, Daniel & Elihu Katz. 1992. *Media Events*. Cambridge, MA: Harvard University Press.

Hall, Stuart. 1980. 'Cultural Studies: Two Paradigms.' *Media, Culture & Society* 2 (1): 57–72.

Heidegger, Martin. 1927/1962. *Being and Time*. Oxford: Blackwell.

Heidegger, M (1954/1978) 'The Question Concerning Technology.' In *Heidegger: Basic Writings*, edited by D. F. Krell, 311–341. London: Routledge.

Inwood, Christopher. 1999. *A Heidegger Dictionary*. Oxford: Blackwell.

Jay, Martin. 2006. *Songs of Experience: Modern American and European Variations on a Universal Theme*. Berkeley: University of California Press.

Katz, Elihu. [1950] 2012. 'The Happiness Game. A Content Analysis of Radio Fan Mail.' *International Journal of Communication* 6: 1297–1445.

Keller, Pierre. 1999. *Husserl and Heidegger on Human Experience*. Cambridge: Cambridge University Press.

Proust, Marcel. 1996. *Time Regained*. London: Vintage (Random House).

Sacks, Harvey. 1992. *Lectures in Conversation* (2 volumes). Oxford: Blackwell.

Safranski, Rüdiger. 1998. *Martin Heidegger: Between Good and Evil*. Cambridge, MA: Harvard University Press.

Scannell, Paddy. 2014. *Television and the Meaning of 'Live'*. Cambridge: Polity.

Scannell, Paddy. 2015. 'Cultural Studies: Which Paradigm?' *Media Culture & Society* 37 (4): 645–54.

6 Affect and Experience

Matthew Reason

When I watch dance there is often a moment when I find my attention becoming detached from the performance and I wonder to myself what I am thinking. I become aware of my own act of watching and also conscious that I am surrounded by other people, also watching. I wonder for a moment what they are thinking and then—if the performance is any good—I lose myself once more in the dance.

All of which perhaps explains why I conduct audience research, pursuing that question of what other people think of the dance and theatre performances that they see. It is an enquiry, I find, particularly resonate with contemporary dance, watching performances of people moving in space and wondering what do I *think* of this?

Yet 'think' is an inadequate word. If I could record and replay what I was thinking during a performance then no doubt it would include and even be dominated by a ticker tape of the inconsequential and quotidian. I would be thinking about how I was going to get home; about the clothes people around me are wearing; about whatever is currently bugging me at work; about summer holidays; about our new cat; about sex; about why all men have beards these days; about what I think about this dance performance I'm watching. And I write as somebody who enjoys going to dance, who actively seeks out dance to see, but who can only conclude that my thinking is inadequate to the nature of my experience.

Consequently, when I conduct audience research, I am aware that when I ask a spectator-become-research-participant what they thought of a particular performance, I need to be careful about the nature of this question and the kind of answers it might elicit. Often spectators find it very difficult to say what they thought, such as in this example from an individual who when asked what she thought of Needcompany's *Porcelain Project* answered:

> I don't know, because it is quite difficult to put into words I think [. . .] I don't know what to think, I don't know if I was trying to think, well, what are they doing, I just liked watching the movement I think. I don't know... I just enjoyed watching the people dance, really.

The scrambling for articulacy in this quotation reminds us that some things seem to resist being put into words, indeed Maxine Sheets-Johnstone declares that 'the lived experience of dance is ineffable' (1979, 65). To acknowledge the ineffable is to acknowledge not only that some things escape language, but also that some things are outside of language. These are not so much experiences that we have, but experiences that have us.

Such experiences are evocative of audience encounters with dance that are affective, rather than interpretative. As Dee Reynolds writes, 'affect in terms of dance might be considered the expressive content, the energies, of the medium itself for its own sake, rather than its representational content' (2012, 123). If we know dance then it is often an expressive and tacit kind of knowing, rather than something propositional that we can pin down and put into words. As Nigel Thrift writes in his book on non-representational theory, dance invites us to 'understand the body as being expressive without a signifier' and the challenges the 'privileging of meaning' (2008, 24) that asking us to think presupposes. The fourfold repetition of 'I don't know' in the quotation above is resonant of this, pointing towards an internal struggle. This spectator did know (perhaps sensually, kinaesthetically, emotionally), just not in a way that she was able to articulate or could hold and communicate outside the moment of knowing. This demonstration of inarticulacy above does not mean the performance had no impact on or meaning for this spectator, but rather that there was something in the live encounter ('I just enjoy watching people dance, really') that has significance in and of itself. Something that we might term affect.

The value of notions of affect in enabling us to engage with the lived experience of dance is, therefore, one focus of my discussion. At the same time, this chapter is also in part an argument for the need for a more holistic (or perhaps humanistic) understanding of affect. In doing so I explore the arguments of scholars such as Ruth Leys and Margaret Wetherell who want to reintegrate affect, emotion and meaning making as part of a broad-based understanding of the experiencing self. For I *can* think of dance and these thoughts are both the product of and impact upon my unthinking affective experiences. And it is in pursuit of this kind of understanding of the experience of watching dance that my audience research has also often involved asking spectators to draw, or paint, or move or make poems. Ways of responding that involve thought, but invite a different kind of thinking. Here, as I shall elaborate upon in this chapter, affect becomes part of a more holistic concept of experience.

In exploring this topic, this chapter draws together various strands of my own research that has sought to engage with audiences' embodied, kinesthetic, affective experiences of dance, projects in which I have had to consider not only what I mean by such experiences but also how it might be possible to research such experiences through qualitative empirical research. They are projects that have used visual arts and creative writing workshops with audience members and in doing so represent an intersection between the philosophical and the empirical (Reason 2010a, 2010b, 2012).

Affect and Experience 85

According to Deleuze and Guattari, 'philosophy is the art of forming, inventing, and fabricating concepts' (1994, 2); meanwhile, the definition of empirical rests on building conjecture through observation and verifiability. The approach presented here is a pragmatic hybrid between the two, an exploratory philosophy that seeks to get its hands dirty with the objective of fabricating new concepts that both arise from and construct the phenomena in question.

The Autonomy of Affect

At this point in time, the field of affect feels at once both familiar and also unstable (for Thrift [2008,175] 'there is no stable definition of affect'). Familiar in the manner in which it has entered into discourses across disciplines, becoming a shared concept through which we can point towards the existence of felt, bodily, sensorial intensities. In *The Affective Turn* for example, Patricia Clough describes affect as emerging from the 'lines of thought' of writers such as Deleuze and Guattari, Spinoza and Bergson to describe 'affectivity as a substrate of potential bodily responses, often automatic responses, in excess of consciousness' (2007, 2).

At the same time there are key areas of contestation within affect theory, with Rhonda Blair noting that there is much disagreement about things such as 'the differences between affect and emotions, what affects and emotions precisely are, and how they should be understood, particularly in terms of whether they are primarily bodily or consciously registered' (2013, 141). For the purposes of this chapter, it is precisely these points of contestation that are of interest, particularly in terms of the relationship between perceptions of affect as purely non-conscious and the possible relationships between this and conscious experience and meaning making.

For Brian Massumi, affect is 'a prepersonal intensity' (2013, xvi) and 'irreducibly bodily and automatic' (2002, 28). The ideas here are worth dwelling upon. 'Prepersonal' is differentiated from the personal, and therefore also from the biographical and from feelings and emotions. An emotion, for Massumi, 'is a subjective content, the socio-linguistic fixing of the quality of an experience which is from that point onwards defined as personal' (2002, 28). Emotions are therefore conscious, personal, subjective; affect in contrast not only precedes both emotions and language (although it might be what gives emotion its intensity) but is also non-conscious. That is, like the notion of the ineffable, it escapes our ability to hold it within our conscious knowing. Tellingly, Rhonda Blair describes 'ineffability' (along with 'contingency' and 'futurity') as a key term within the field of affect (2013, 143).

In a summation of Massumi's position, 'affect is a non-conscious experience of intensity; it is a moment of unformed and unstructured potential [that] cannot be realised in language [and] is always prior to and/or outside of consciousness' (Shouse 2005). As a prepersonal intensity, affect is not under an individual's conscious control. We cannot consciously opt to be or not to be affected.

86 *Matthew Reason*

It is valuable to return this formulation of affect to the experience of watching dance, with which I opened this chapter. Here there is an immediate challenge, for in attempting to do so I am turning to conscious reflection, to language, and therefore operating in a manner precisely counter to the nature of affect. 'To be "affected"' by dance, writes Reynolds, 'is to be moved in an embodied sense, rather than in the more cognitive sense' (2012, 126); to render this in language would be to exit from that moment and construct a new story or explanation about the experience. Language, writes Massumi, 'is not simply in opposition to intensity. It would seem to function differentially in relation to it' (2002, 25). Perhaps, instead, I would be better off saying:

> I don't know, because it is quite difficult to put into words I think [. . .] I don't know what to think, I don't know if I was trying to think, well, what are they doing, I just liked watching the movement I think. I don't know... I just enjoyed watching the people dance, really.

For this spectator—and equally for this researcher—the live experience is something that had impact upon her yet simultaneously escaped her. The value of affect theories to contemporary performance is exactly its ability to acknowledge that which we cannot put our finger on but is utterly essential nonetheless. As Claire Colebrook writes, 'art may well have meanings or messages but what makes it *art* is not its content but its *affect*, the sensible force or style through which it produces content' (2002, 24–5). The corresponding limitation is expressed by the pioneering affect theorist, Lawrence Grossberg, who states that 'affect' can become a too simple label, suggesting that 'if something has effects that are, let's say, non-representational then we can just describe it as "affect"' (2010, 315). It avoids, he suggests, the harder work of 'specifying modalities and apparatuses of effects.'

An Integrated Understanding of Affect

For the field of performance studies, therefore, the affective turn has a seductive quality. It affirms a long-standing focus on the performative encounter between body-and-body, providing a theoretical language of intensity and excess that might be transposed to the problem of our inability to adequately *think* or *speak* about experiencing liveness. Perhaps the live encounter can be considered in terms of its *intensity*, or described as an *excess* that overwhelms our ability to hold it in conscious knowing.

Massumi's elaboration of the nature of 'intensity' (always a close correlate of affect) could almost read as a description for the positive valuation of the intensity of liveness as a non-repeatable, never-to-be-regained experience:

> [Intensity] is a nonconscious, never-to-be-conscious autonomic remainder. It is outside expectation and adaptation, as disconnected from meaningful sequencing, from narrative, as it is from vital function. It is narratively

delocalized, spreading over the generalized body surface like a lateral back-wash from the function-meaning interloops that travel the vertical path between head and heart.

(2002, 25)

From within the prism of performance studies the parallel is obvious: intensity circumvents the head (thought) and even heart (emotion) and hits the spectator instead in the gut (affect). Indeed, when spectators want to assert the particularly visceral or physical experience of a piece of dance, they often turn to language of the gut, such as responses to Rosie Kay's contemporary dance *5 Soldiers*, who described it in terms of 'I felt sick with the feeling,' 'it grabs you in the gut,' 'gut wrenching' or 'we felt our [stomach] churn.' With such language spectators are describing an embodied, physical attitude and feeling, one that is non-representative, non-interpretative, that speaks of an embodied encounter and which we might therefore describe as affective. And yet it is also, of course, a language. And it is therefore not only affective but also metaphorical, personal, emotional, contemplative; and all of these things seem important, as well as that knotted, churning, unspeakable tension of the gut.

While a forceful articulation of the power and nature of affect, there is a danger that the framing of affect as autonomy results in a narrowing of our conceptual attention with regards to other elements of experience. For this reason two critiques of Massumi's conceptualisation of affect are worth considering here.

In the first, Ruth Leys examines the Deluzian model of affect, particularly as presented by Massumi, in order to expose what she sees as its re-establishment of a straightforward dualism between mind and body, now simply reversed to privilege the body as the site of knowledge (2011, 468). In particular Leys points out how affect theory presumes a separation 'between the affect system on the one hand and intention or meaning or cognition on the other' (443):

What the new affect theorists and the neuroscientists share is a commitment to the idea that there is a gap between the subject's affects and its cognition or appraisal of the affective situation or object, such that cognition or thinking comes 'too late' for reasons, beliefs, intentions, and meaning to play the role in action and behavior accorded to them

(443)

It is this re-establishment of a neo-Cartesian split between mind and body that Leys seeks to challenge, asking what alternative accounts of affect are possible that 'do not make the mistake of separating the affects from cognition and meaning' (469). In terms of the audience encounter with performance this seems vital, for the moment of *excess*, that hit of *intensity*, is accompanied by other elements of a wider experience that includes the social, the emotional and the interpretative. Rather, therefore, than dismiss the spectators' conscious

responses to a performance as inadequate to the task of articulating the 'true' nature of the experience, or otherwise simply 'too late' (Thrift [2008,58], for example, asserts that 'much cognitive thought and knowledge may, indeed, only be a kind of post-hoc rumination,') it is more valuable to consider how affect might be integrated with other cognitive processes.

This is what is argued by Margaret Wetherell, in *Affect and Emotion*, which provides a constructive engagement with ideas of affect while echoing Leys' critique of the division between affect and processes of meaning making. Wetherell observes that for some the attraction of affect theory is precisely that it is not about discourse: 'affect seems to index a realm beyond talk, words and texts, beyond epistemic regimes, and beyond conscious representation and cognition' (2012, 19). In this manner the affective turn can be considered as a corrective (or even over-corrective) response to the focus on talk and meaning making that accompanied the discursive turn.

Here the seemingly more commonplace term 'experience' is worth considering. Experience is clearly connected to affect, but the precise nature of this connection is under-articulated and perhaps points to the fault lines between an autonomous and an integrated understanding of affect.

Massumi, for example, at times seems to align experience with the 'higher functions' of cognition: for, he writes, 'something happening out of mind in a body directly absorbing its outside cannot exactly be said to be experienced' (2002, 29). 'Experienced' here is related to will, consciousness and language and is therefore 'subtractive,' 'limitative,' 'derived' (ibid). It is this positioning of experience that leads Wetherell to write that for Massumi 'affect actually happens "out of mind," beyond the phenomenological, and what is normally understood by experience. It is in this sense, then, that affect is excessive, exceeding what people can know explicitly' (2012, 57).

Experience therefore would seem to entail conscious knowing, an idea which might be traced back to John Dewey's description in *Art as Experience* where he distinguishes between the 'inchoate' flow of experiences and the composed, reflective and complete nature of 'an experience' (1934, 35). Psychologists Sheila Greene and Diane Hall, for example, adopt Dewey's understanding of experience when they write that 'experience is interpretative and the medium by which humans interpret their encounters with the world is linguistic or at least symbolic' (2005, 5). Thinking back to those articulations of the experience of dance as felt in the gut: these were assertions of affect (as automatic, felt, bodily responses) but also assertions of experience (as composed, symbolic, human responses).

The difficulty here is the sharply distinctive relationship being constructed between affect and lived experience, between interpretative meaning-making and non-representational knowing. Massumi, however, does point towards a relationship, writing that:

> Although the realm of intensity that Deleuze's philosophy strives to conceptualize is transcendental in the sense that it is not directly accessible to

experience, it is not transcendent and it is not exactly outside experience either. It is immanent to it—always in it but not of it.

(33)

As 'immanent,' affect is not accessible to experience, but equally not outside of it. Perhaps affect is the material of experience, in the manner of remaining within it as an indwelling. There is useful conceptual fissure here, which can be linked to Wetherell's ambition to find ways to connect affective and cognitive processes, arguing that 'any strongly polarized distinction between controlled versus automatic processes, or conscious verses non-conscious, is probably too simplistic' (65). Instead, Wetherell argues that affect is 'highly dynamic,' integrating 'automatic bodily responses (e.g., sweating, trembling, blushing)' along with subjective feelings, cognitive processing, verbal reports and other communicative signals (62). 'An emotional episode,' writes Wetherell, 'integrates and brings together all these things in the same general moment' (62).

Spectators' use of a vocabulary of the gut could be seen as illustrative of this, combining bodily responses (knotting, tension, churning) with a cognitive processing that recognises and gives metaphorical and emotional value to that impact as an integrated experience.

Assemblage

The notion of an assemblage of affect and experience provides the potential for understandings in a ladder of complexity. At one level, assemblage points towards an integrated or holistic perspective, such as in choreographer Martha Graham's description of dance as 'the nervous system and the body as well as the mind are always involved in experience and art cannot be experienced except by one's entire being' (1980, 46). A more theoretical framing of this perception is provided in Vivien Sobchack's engagement with the phenomenology of perception, where she describes embodiment as the:

> radically material condition of human being that necessarily entails both the body and consciousness, objectivity and subjectivity, in an *irreducible ensemble*. Thus we matter and we mean through processes and logics of sense-making that owe as much to our carnal existence as they do to our conscious thought.
>
> (2004, 4)

Furthermore, the irreducibility of body *and* consciousness does not mean an always equal or always synchronic relationship—which would entail a static perception, a 'fixed identity'—but rather might variously, differently and dialectically preoccupy us at different moments where 'one may hold sway over the other' (ibid). Within this dialectical relationship, Sobchack envisions perception as 'embodied and conscious subjects who both "have" and "make sense"'— both 'having sense of the world' and 'making sense of the world' (75).

90 *Matthew Reason*

By returning to the philosophy of Deleuze, a further understanding of the nature of this assemblage can be developed, one that recognises that an assemblage is defined not by homogeneity (that is, a sameness in which all components offer the same, the result a kind of structured stasis) but instead 'an assemblage is first and foremost what keeps very heterogeneous elements together,' where any coherence or unity is of 'intensive continuity' (2007, 179). Rather than easy or linear, the relationship between affect and experience—between having sense and making sense—occurs within an assemblage of disparate natures that is dynamic and always becoming.

If held within the assemblage, process of sense-making and meaning-making are integrative looping, shimmering, infecting. The result is something akin to what Wetherell describes as 'affective meaning making,' which recognises both how affect is dynamic across the assemblage of human psychology and how processes of meaning-making are relational, dialogic and distributed, rather than fully conscious, planned and linear (53).

Moreover, I would argue that to deny the integrative nature of this assemblage is to deny the full nature of existence. Affect as autonomous intensity becomes purposeless, automative and without effect—transcendent in the manner by which it is apart, beyond, unholdable. Equally, discourse as all powerful meaning-making is deadening, subtractive and without force. To this end I would like to propose the concept of 'affective experience making' to describe the manner in which spectators *both have* and *make* sensual, sensate and sentient experiences from the performances they witness.

Experience, Ceaselessly Woven

Affective experience making describes the ways inchoate sensation becomes immanent with experience. This is not fully planned, conscious, linear or intentional:

> I don't know, because it is quite difficult to put into words I think [. . .] I don't know what to think, I don't know if I was trying to think, well, what are they doing, I just liked watching the movement I think. I don't know... I just enjoyed watching the people dance, really.

Here meaning (or perhaps better, *knowing*) exists within the utterance, always becoming. For Deleuze and Guattari 'the plane of immanence is ceaselessly being woven' (1994, 38) and in a similar way affective meaning-making isn't a terminal or linear process in which having sense becomes making sense.

What, however, would the integrative moment between having sense and making sense look like and feel like? Or rather, how might we hold, examine and interrogate this process of having sense and making sense? How can we slow it down, make it concrete, make it knowable to ourselves conceptually? To illustrate this further, to help construct the concept I seek to create, I am going to present two examples of what I mean by affective experience making

Affect and Experience 91

in relation to audience responses to dance performance: the first operating through art making, the second through writing.

Paying Attention to Affect

The first example is selected from one of a number of workshops where I invited audience members to explore their experience of dance through a combination of art making and reflective conversation. For the purposes of this chapter I will present just one example, in which the spectator is responding to *Ride the Beast*, choreographed by Stephen Petronio and performed by Scottish Ballet. The purpose here, however, is not to explore the response to the performance itself, but rather to further this reflection on the dynamic relationship between having sense and making sense within the affective experience (for an extensive discussion of this methodology, with a focus on the concept of visual knowledge, see Reason 2010b).

In this example one participant elected to laboriously cut and paste long, taut strips of vibrant red card onto a black background. In doing so it was particularly striking how her form of expression resonated with the nature of the response when asked to talk about it:

> I mostly got a feeling from it, I got a kind of sense of it being very very angular and full of energy. But with a real kind of tension there that I thought really invigorated me and it was. . . . And it wasn't completely staccato but that was the feeling that I got. I found it quite mesmerising and I was quite happy just to sit and . . . Sometimes I can be quite mesmerised by dance but I'm not really taking it in but whereas this I was really quite leaning forward sort of erm, it just felt very very sort of long and taut. I think taut was a word that sort of summed it up for me.

In both the visual artefact and the description there is a clear sense of an embodied response to the movement. This is dance as felt, as affect, with the spectator 'moved in an embodied sense, rather than in the more cognitive sense' (Reynolds). This was not an interpretative strategy that extracted meaning from the dance, but instead points only back to the dance itself. Here there is clear resonance with the notion of 'having sense,' but one that is not divorced from an idea of 'making sense.'

More than this, however, there is an intensive continuity between the language, visual artefact and the affective experience making that is being performed: each is different (an assemblage of heterogeneity) but each adheres to the other. This can be seen in how words such as 'angular,' 'tension,' 'staccato,' 'mesmerising,' 'long' and 'taut' all register between the artefact and the experience. Or it can be seen in the way in which the process of making impacted upon the response articulated; the specific manifestation of both her words and the affective meanings evoked are the product not *only* of the dance itself *but*

also of the artistic labour. This is something that the spectator was able to reflect upon, when asked during the workshop:

> [laughs] ermm . . . I'm kind of enjoying the repetition . . . it's pretty kind of repetitious. I think because I felt . . . I didn't realise it was going to take me so long, because when I was watching the piece I felt there was so . . . I wanted to have more movement in here, more kind of sense of . . . up and down and . . . its taking me much longer than I realised. Lots of it was sort of, I suppose a lot of it was juddery and lot of it, I suppose I thought that lot of it was in many ways it was quite ugly. And that was what I quite like about it.

Again, language, visual artefact and performance align, whether in the words (repetitious, juddery, ugly), in the non-representation qualities of the image, or in the echo of the affective intensity of the performance that emerges through and between both of these.

In part the point here is about the impact of asking spectators to filter their responses through not just language but also visual representation. Certainly, one of the reflections on the workshops was that for many of the participants the act of visual representation became a form of thinking. They did not simply decide what to depict, but rather discovered both the what and how of the art-making in the act of doing. This is central to much artistic research and can be seen in terms of what art theorist Henk Borgdorff describes as 'the pre-reflective, non-conceptual content of art' that 'creates room for what is unthought, that which is unexpected' (2010, 61). In other words, it is a process that sits between the non-conscious and the intentionally, not linear or fully planned but equally not fully unintentionally. More than this, however, this was a process that exposed the unthought and the unexpected to the spectators themselves, with one participant describing the process as opening up 'a conversation with myself about my memory of what I'd seen.'

The assemblage of language, visual artefact, memory and affect allows us to witness the process of affective experience making. In making this visible, I would argue, it also provides illustration of practices and processes that operate within the perceptual assemblage much more generally. Within the spectatorial response described above, the dance experience is manifested through the 'entire being,' (Graham) within an 'irreducible ensemble' that both has sense and makes sense (Sobchack) and at a plane of immanence (Deleuze). Through these processes affect shimmers into (and out of) consciousness and, as a result, has consequence.

At the same time, perhaps even typically, our aesthetic encounters with theatre, dance and performance rarely enter this state of holistic enquiry. Rather than being ceaselessly woven, the experience quickly becomes dead: fixed, stratified, subtracted. The moment of experiencing live is brief and then descends out of knowing:

> I don't know [. . .] I don't know [. . .] I don't know [. . .] I don't know...
> I just enjoyed watching the people dance, really.

Wetherell similarly describes how although most brain activity is likely non-conscious, when the situation demands it is possible to 'pay sustained attention' in a manner that is transformative:

> paying attention strongly amplifies the patterns of activation, and is correlated with the experience of consciousness. It is likely then that much of what goes on non-consciously [...] can be made conscious given enough time, information and context.
>
> (2012, 65)

In the context the process of asking spectators to engage in visual and verbal reflection on their experience of watching dance provided a structured—and concrete—process of paying attention that allows us to witness an act of affective experience-making. It is, in fact, something like the experience of the emancipated spectator who, as described by Jacques Rancière, 'participates in the performance by refashioning it in her own way' (2011, 13).

For this discussion the crucial observation is that the processes involved in rendering the experience as experience—processes that include memory, interpretation, narrativisation, metaphor, symbolism, representation—are themselves affective. To articulate (in words or visually) a memory of judderiness, of tautness, of angularity is not only to evoke but also momentarily to adopt—synaesthetically, within the body, as affect—a sense of judderiness, tautness, angularity. In bringing the concept *to mind*, the concept is also brought *to body*. In recalling the memory of this particular experience—of a certain juddery, taut, angularity—it is joined, modified and re-enforced by memories of other aligned-and-different experiences of juddery, taut, angularity. The act of paying attention, therefore, produces not just conscious reflection and interpretation, but also produces a return to affect. The point, therefore, is that there is a potential for a kind of integrated engagement than unifies responses across the whole ensemble of perception and thereby continues the intensity and excess of the live experience into our living assemblage of being. To pay attention, therefore, is to experience live, something that resides in the affective power of the spectators' experiential attention.

Dialectic Affect/Experience

Holding these ideas in mind (and in body), it is worth continuing to build the concept through another example of affective meaning-making in relation to the experience of watching dance. This time rather than constructing a visual artefact, spectators were invited to take part in creative writing workshops during which they produced various forms of written, reflective, poetic accounts of their experience (for fuller discussion of this project and approach, see Reason 2012). In a moment of unintentional serendipity these explicitly perform Rancière's description of how the emancipated spectator 'composes her own poem with elements of the poem before her' (2011, 13). On this occasion the

94 *Matthew Reason*

spectators were responding to *Awakenings*, choreographed by Aletta Collins and performed by Rambert Dance Company:

> Pre-planned symmetry
> Couples move in synchronicity
> Performing in their disparate parts
> Love as a performing art
> A strange crash of themes
> Alienated all of what we dreamed
> And brought us back into the physical
> And my own inner spaciousness alone

Such pieces of writing could be considered within the literary tradition of ekphrasis, that is, the attempt to represent the experience of visual art (or less commonly music) in language. For W.J.T. Mitchell the problem of ekphrasis— how to represent one form in the medium of another—produces a particular fascination that shifts through three stages of realisation. Firstly, indifference (for it is surely attempting the impossible); secondly, hope (the belief in the possibility that language might be able to 'make us see'); finally, fear (arising from the realisation that if successful our perception of a fundamental differ- ence between the visual and the verbal would be destroyed) (1994, 151–6). For Mitchell, ekphrasis is the genre in which we construct and conceive the distinction between the verbal and the visual, a place in which each medium encounters the paradigmatic other.

As such, ekphrasis can also usefully serve as a metaphorical parallel for the relationship between affect and experience, which has been continually nego- tiated in a dialectic of becoming. That if there must always be awareness of the impossibility of explicitly knowing affect in our conscious live experience (indifference), a sense that we are always on the edge of knowing (hope), and a trepidation as to what a collapsing would entail (fear).

(In parenthesis it is also worth noting how Mitchell's triumvirate of fascina- tion usefully describes attitudes to the relationship between live performance and documentation. *Indifference* marking a sense that performance is inviolate to secondary representations; *hope* accompanying the possibility that something might be saved of the original event; and *fear* describing the realisation that as a result of ephemerality documentation might come to be valued above the thing itself.)

We can therefore consider spectatorial poems, art works, utterances as shim- mering moments within this negotiation where the focus of attention (and care and art and craft) hold the potential to collapse indifference, hope and fear. In these moments the affect is held close to consciousness, it is there in phrases created by spectators that describe a dance as: 'boneless clowns and elastic men turning into animals, both reptile and mammal' or another of 'tormented by the body, frozen in stilted motion, a world in which normal movement has

become an unfamiliar thing.' As with the simultaneous bringing to consciousness and returning to the experience present in the word/image dialectic of juddery, taut, angularity, these ekphrastic responses reconstitute affect within the conscious experience. Reconstitute, crucially, being distinct from recreate or replicate or return; they do not return to an original affective encounter, but rather constitute a new one in a new language.

The proposal, therefore, is that these moments in which spectators construct poems with elements of the poem before them are moments of affective meaning-making. They are moments when spectators actively construct experience from the affective memory of the dance performance. Moments of making sense that also demonstrate having sense. Moments of dialectic between affect and experience.

Conclusion

One of the central scepticisms of Massumi's philosophy is his critique of intentionalism, such as when he writes that experience 'is never fully intentional' (2002, 191 and 287 n 4). The observation is fine, correct even, but also not fully correct. For clearly experience is not fully intentional, but equally never fully unintentional. Instead, it is co-constructive of itself, coming into knowledge and realisation of itself in the moment of coming into knowledge and realization of itself. This can be seen in the examples explored above, where the responses are not fully intentional; they are not fully planned, consciously, from the outset, but rather their form and nature are produced through the doing. Yet at the same time they are not without intention in the manner of the pre-personal or non-conscious that Massumi describes.

The articulation of the autonomy affect at times feels like an overcorrective response to previous discursive and cultural turns. In the context of the experience of performance, for this chapter in the context of dance, a single performance engages the spectator along the full extent of this continuum. The affective and meaning-making processes that are provoked by the performance are not isolated from each other, but intervene and intersect in moments of instability and uncertainty. Within these co-constructive processes we experience with both prepersonal intensity and affective meaning-making, lending each other, respectively, force and subjective instrumentality.

Without affect, the meanings that we posit, the stories we tell ourselves, the emotions that we experience, the ideologies and political positions that we adopt are inconsequential. Forceless echoes. But equally, without engaging in the process of re-experiencing affect to ourselves, without bringing affect to the very edge of consciousness, it is destined to be without effect. To experience live is to do so with the full assemblage of our being and to allow affect to infect our ongoing lived experience of the world. It is the gift of the spectator to pay attention in an active manner that combines, but never collapses, affect into experience.

References

Blair, Rhonda. 2013. 'Introduction: The Multimodal Practitioner.' In *Affective Performance and Cognitive Science: Body, Brian and Being*, edited by Shaughnessy, 135–46. London: Bloomsbury.

Borgdorf, Henk. 2010. 'The Production of Knowledge in Artistic Research.' In *The Routledge Companion to Research in the Arts*, edited by Biggs and Karlsson, 44–63. London: Routledge.

Clough, Patricia, T., ed. 2007. *The Affective Turn: Theorizing the Social*. Durham and London: Duke University Press.

Colebrook, Claire. 2002. *Gilles Deleuze*. London: Routledge.

Deleuze, Gilles & Félix Guattari. 1994. *What is Philosophy?* Translated by Burchell and Tomlinson. London: Verso.

Deleuze, Gilles. 2007. *Two Regimes of Madness*. New York: Semiotext(e).

Dewey, John. 1934. *Art as Experience*. New York: Minton, Blach and Co.

Graham, Martha. 1980. 'A Modern Dancer's Primer for Action.' In *The Dance Anthology*, edited by E. C. Steinberg. New York: The New American Library.

Greene, Sheila & Malcolm Hill. 2005. 'Researching Children's Experiences: Methods and Methodological Issues.' In *Researching Children's Experiences*, edited by Greene and Hogan, 1–21. London: Sage.

Grossberg, Lawrence. 2010. 'Affect's Future: Rediscovering the Virtual in the Actual'. In Gregg, Melissa and Seigworth, Gregory J (Eds) *The Affect Theory Reader.* edited by Melissa Gregg and Gregory J. Seigworth, 309–338. Durham, NC: Duke University Press.

Leys, Ruth. 2011. 'The Turn to Affect: A Critique.' *Critical Inquiry* 37: 434–72.

Massumi, Brian. 2002. *Parables for the Virtual: Movement, Affect, Sensation*. Durham and London: Duke University Press.

Massumi, Brian. 2013. 'Notes on the Translation.' In *A Thousand Plateaus*, edited by Deleuze and Guattari, London: Bloomsbury.

Mitchell, W.J.T. 1994. *Picture Theory*. Chicago: University of Chicago Press.

Rancière, Jacques (2011). *The Emancipated Spectator*. London: Verso.

Reason, Matthew. 2010a. 'Asking the Audience: Audience Research and the Experience of Theatre.' *About Performance* 10: 15–34.

Reason, Matthew. 2010b. 'Watching Dance, Drawing the Experience and Visual Knowledge.' *Forum for Modern Language Studies* 46 (4): 391–414.

Reason, Matthew. 2012. 'Writing the Embodied Experience: Ekphrastic and Creative Writing as Audience Research.' *Critical Stages* 7: n.p.

Reynolds, Dee. 2012. 'Kinesthetic Empathy and the Dance's Body: From Emotion to Affect.' In *Kinesthetic Empathy in Creative and Cultural Contexts*, edited by Reynolds and Reason, 123–36. Bristol: Intellect.

Sheets-Johnstone, Maxine. 1979. *The Phenomenology of Dance*. London: Dance Books.

Shouse, Eric. 2005. 'Feeling, Emotion, Affect.' *M/C Journal* 8: 6. Accessed at http://journal.media-culture.org.au/0512/03-shouse.php

Sobchack, Vivian. 2004. *Carnal Thoughts: Embodiment and Moving Image Culture*. Berkeley: University of California Press.

Thrift, Nigel. 2008. *Non-Representational Theory: Space, Politics, Affect*. London: Routledge.

Wetherell, Margaret. 2012. *Affect and Emotion: A New Social Science Understanding*. London: Sage.

Shorts

1 Live Art, Death Threats

The Theatrical Antagonism of *First Night*

Alexis Soloski

'Fall in the shower,' said the fortuneteller. 'Heart attack. Car crash.' Then she fixed her eyes on mine. 'Brain hemorrhage,' she said.

(Forced Entertainment, *First Night*, 2011)

As a theatre critic in New York, I'm sunk into a red plush seat four or five nights each week. But often I'm somewhere else entirely. What made me love theatre? Its close-enough-to-touch immediacy, its blink-and-you've-missed-it evanescence, its imperative that all of us—actors, spectators, ushers, spotlight ops—breathe together in tall, windowless rooms. Yet during most plays my interest flags and suddenly I'm wondering which subway to take home or worrying that my husband never soothed the baby to sleep or (shamefully) working out the opening paragraph of the review so that I can get to sleep a little earlier myself. At these shows, I'm a sad example of Bertolt Brecht's derided audience: 'true, their eyes are open, but they stare rather than see, just as they listen rather than hear' (Brecht [1949] 1992, 187).

As much as I want to believe that theatre demands the real-time interaction of actor and audience, it isn't always true. There are plenty of shows where the flow of energy and empathy—from the actors, from the audience—slams into that imagined fourth wall like a bird arcing into a shut window. There's a sameness to these shows, a slickness, a complacency; they might be pre-recorded for all the notice they take of us watching. And with our whispered conversations and glowing phone screens and crinkling water bottles, do we deserve their notice? Sometimes the curtain call is the only time at which an event seems truly live. Sometimes not even the curtain call. There are nights I've craved a fire alarm, a wobbling flat, an out-of-control snow cradle—anything to wake us up and force us together.

Maybe I feel this theatrical deadness even more acutely because I'm at the theatre so often. Theatre critics are a paradoxical bunch. On the one hand, most of us eventually develop a been-there, seen-that hauteur, because after thousands of shows we really have been there and seen that. Also, we must detach ourselves from the work of art far enough that we can consider it analytically (empathy doesn't assign star ratings). But on the other hand, we have an explicit

professional responsibility to pay attention to the work, to engage with it fully, to see and hear and feel and report back. Our salaries depend on it. And personally, part of me is still the theatre-mad schoolgirl eager for any ticket she could get. I'm always a little hopeful that this will be the show that surprises me, the show that shakes me, the show that makes me feel alive, the show that seems actually, unpredictably, impulsively live. There are a handful of these shows every year; they are thrilling.

What creates liveness? There are certain artists who have a gift for immediacy: actors so engaging, playwrights so surprising, directors and designers so attuned to the possibilities of performance that hours go by before I'm trying to sneak a glimpse of someone's watch. And then there are immersive or participatory works that force audiences to contribute corporeally as well as sympathetically. It's that much harder to disengage when you're on stage, too, no matter the quality of the show. I've mixed drinks for John Fleck, stood at the table in Gob Squad's 'Andy Warhol's Kitchen,' and eaten the chocolate truffles and hard-boiled eggs that Wallace Shawn and his collaborators set out for me. I've had a Punchdrunk performer tuck me into a hospital bed and had a Praxis duo gently shut me up in a coffin. (Burying a critic: every artist's dream?) I've been groped by several members of the Living Theatre, and once had axes hurled at me during a magic show. These pieces operate via a sense of invitation—even the one with the axes—recasting audience members as fellow theatre-makers, as co-conspirators. They aren't always successful: that Living Theatre show was a particularly maddening example of the form. But participating bodily, with all the excitement and apprehension and wariness that it entails, makes one a lot more engaged, a lot less distractable. At their best, these shows craft a sense of mutual endeavour and support, of performers and spectators co-operating to create and enhance the theatrical event.

But when I think of the piece out of the thousands that made me feel the most present and absorbed and alive, I think of a piece that wasn't like that at all. Well, maybe it was like the one with the axes.

<p style="text-align:center">★ ★ ★</p>

I saw Forced Entertainment's *First Night* on a theatrical fact-finding trip to London in 2009. Several artists and curators I admired had cited Forced Entertainment's work as influential, but the only thing its artistic director Tim Etchells had brought to New York was a solipsistic solo. So I wandered into Toynbee Studios fairly ignorant, mostly unprepared.

First Night is structured as a sort of seaside variety show from a seedier, crueler universe, performed by a cast of seven dressed in sequined tops and shiny suits. At the top, the compere doesn't stride confidently on stage. Instead, another performer hustles him on with prods and pinches, compelling him into a sadistic sort of ventriloquist act. Haltingly, nervously, increasingly desperately, he previews the evening's enticements. 'Um, we've got a lovely show lined up for you tonight, ladies and gentlemen. Yes, a lovely show with songs and dances and jokes and er . . . you know . . . people. There's people in it doing . . . doing stuff,'

Live Art, Death Threats 101

(Forced Entertainment 2001, 7) he says. Then his minder downs a glass of water—a riff on the trick where the ventriloquist's dummy continues to chat while his partner sips—and the compere helplessly wets himself.

A fortune-telling act begins. The performers stagger on stage blindfolded and announce that they're receiving vibrations and messages from the audience. 'I'm getting a photograph,' one says. 'I'm getting arthritis,' says another. The predictions grow increasingly dire: a dead daughter, a wicked babysitter, identity theft. 'I'm getting something now. A strong visual image of a fire. A terrible fire in a place of public entertainment. Hundreds killed,' says one, a line to make you laugh and squirm and search out the exit signs.

And if that weren't sufficiently ominous, one of the women then removes her blindfold, steps to the forefront of the stage and calmly and methodically begins to foretell the deaths of audience members. Pneumonia, breast cancer, kidney failure, etc. Toynbee Studios seats about 280 people and I'd swear she divined the deaths of most of us. I can't say how long this particular segment went on; it felt endless. Sitting in my chair, I knew this was only a play. I also knew that I don't believe in psychic emanations or precognition. But that didn't ease my growing dread as she worked her way down my row and then to me and then said, 'brain hemorrhage.'

For just a moment, I couldn't breathe, let alone check my watch or worry over the tube home. There was no sense of support or consolation from those around me. This routine had fractured the unity of an audience—the concord that laughter and applause and darkness encourage. It left each of us alone in his or her seat, thinking of his or her own death, discomfited and even a little angry at the performers who had brought on this unease. I felt I had to somehow arm myself against what was still to come. And that's the brilliance of the piece. To know how much one's spectatorial presence is disrespected and disregarded, unwanted and unwelcomed, is to make one incontrovertibly aware of that presence. To be on one's guard is to be alert, attentive. Through antagonism, Forced Entertainment compelled me to be absolutely present, in that moment, in that room, excited about and frightened of what might happen next.

★ ★ ★

First Night is shocking because it takes as its subject the largely unspoken and unacknowledged contract between performer and spectator. Magnifying the small print, the show reveals the hostility and bad faith on both sides of the footlights: the actors who resent the ignorant, entitled, impertinent audience; the spectators who believe those same actors are mocking them, spurning them, failing them in some way.

In another introductory sequence, a performer steps forward and lays out what he calls 'a few simple rules':

> Basically, um, we're going to be up here . . . and you're going to be down there . . . and we're going to be in the light and you're going to be in the, the shadows . . . er we're going to talk and er you're going to try and be as

102 *Alexis Soloski*

> quiet as mice ... um ... er ... we're going to be standing up, uh most of the time and ... you're going to be sitting down. Er ... you're going to do what you do and we're going to do what we do.
>
> (2001, 13)

While *First Night* abides by these basic strictures, it bares the antipathy that underlies them. Subsequent skits deliberately miscarry, intentionally frustrating audience expectations. Witness the exceptionally unsexy striptease or the comedian who can't arrive at a punchline. Eventually he dries up, saying, 'I'm frightened, I'm shitting myself. I, I don't know where to go next. Can one of you bastards help me?' (2001, 14) Because we're good, respectable audience members ('you're going to be down there ... and er you're going to try and be as quiet as mice') we stay in our seats. As he lays writhing on the stage, we each must confront our own fear and failure until he gets up and walks back into the wings.

Even seemingly friendly speeches have a way of turning rotten. A benign request that we forget about the world outside morphs into an invitation to effect our own effacement. A performer begins, 'Try not to think of anything outside of this room' (2001, 16). By the end of his monologue he's asked us to erase 'everything that makes you who you are. Your passports, your identity cards, your date of birth, your face, your experiences, everything you did today and everything you said' (2001, 17). Anodyne flattery complimenting what a lovely audience we've been mutates into vitriol. 'You make us feel like splitting open your stomachs and pulling out all your intestines and smearing them over the walls' (2001, 25) a performer says. In fact he pronounces himself so disgusted by us that he insists on ending the show. 'We're not doing anymore,' he says. 'You make us feel like doing something, saying something that we're really going to regret. There's nothing else here for you tonight' (2001, 25).

★ ★ ★

In the *First Night* programme, Etchells uses a quotation from the film *Performance* (1970) as epigraph: 'I know a thing or two about the clientele. They're a bunch of liars and wrigglers. Put the frighteners on them ... give 'em a bit of stick. That's the way to make them jump. They love it' (2001, 3). He could just as well have cited Alfred Jarry, writing in 1897: 'it is because the public ... are an inert and obtuse and passive mass that they need to be shaken up from time to time so that we can tell from their bear-like grunts where they are—and where they stand' (Blackadder 2003, 66). As a professional audience member, I suppose I ought to be insulted. But the thing is, I don't disagree. I do need shaking. (Of course, I'd like to see most actors shake themselves, too.) *First Night* demanded that I re-evaluate what I expect from live art. It made me ask how I can best uphold my end of the troubled actor-audience bargain. For a start, it's time I let go of those mental grocery lists.

I'm not claiming that this Forced Entertainment's fashioning of a deliberately hostile and assaultive relationship with the audience is a new or unique concept. Just look back to F.T. Marinetti's *The Pleasure of Being Booed* (1911), Peter Handke's insult-jammed *Offending the Audience* (1966) or further back than that to the kind of Menippean satire Aristophanes produced, which spotlights the audience's prejudices and practices. There are very recent examples, too, like Blast Theory's *Kidnap* (1998), which imprisoned two (more or less willing) civilians for 48 hours, or Ontroerend Goed's *Audience* (2011), which needled the whole of the audience before turning, venomously and sexually, against one particular woman who was possibly a plant informed of the bullying in advance, although many audience members did not know this (Ontroerend Goed 2014, 420; Wilson 2015). Nor do I think that *First Night* actually meant to do me any harm. I didn't feel injured or indignant as I left the theatre, instead I felt alive, excited. Six years after I saw the performance, I still feel some of that excitement—and some unease too, a prickling along my spine—as I remember the closing lines: 'Ladies and gentlemen, don't drive home safely. Drive as fast as you can' (2001, 26).

References

Blackadder, Neil. 2003. *Performing Opposition: Modern Theater and the Scandalized Audience*. Westport, CT: Praeger.

Brecht, Bertolt. [1949] 1992. *Brecht on Theatre: The Development of an Aesthetic*. Edited and Translated by John Willett. New York: Hill and Wang.

Forced Entertainment. 2001. *First Night: Performance Text*. Sheffield: Forced Entertainment.

Ontroerend Goed. 2014. All *Work and No Plays: Blueprints for Nine Theater Performances*. London: Oberon Books.

Wilson, Anna. 2015. '"Playing the Game": Authenticity and Invitation in Ontroerend Goed's *Audience*.' *Participations* 12 (1): 333–348.

2 Attention as a Tension

Affective Experience between Performer and Audience in the Live Encounter

Victoria Gray

To be had is to be had in a flash.

(Manning and Massumi 2014, 29)

To my right side, kneeling on the ground beside my bare feet, is a young man. The man holds a large camera with an intimidating lens to his left eye. He pauses, re-positions his crouched body, and reframes a potential shot. Standing monumentally still, I stare down into the lens until the tension of our mutual stillness is almost painful. Through the silence of my gaze, I defy him to take the shot.

Though the camera has me in its sight and the lens registers a body within its frame, it seems he, on the other hand, does not see me at all. I exist by proxy in the room of the lens and only in the room of the lens; not, as I had wished, in the room of the performance. Any direct encounter with my eyes is fettered by the mediation of the camera. The immediacy with which we are present to each other, more or less, depends on his courage, or lack of, to experience the mutuality of our presence without this shield. Our encounter has become tethered within the limitations of lens and shutter: a fixed object for re-experiencing later, rather than a temporal process to be lived through in the now. Presence, albeit, at a safe distance.

The incipience of the moment, just before the moment that the camera captures 'the' moment, causes a hiatus. As he presses the shutter, the moment is already gone; it has already been and been had in a flash. Slowly, apologetically, he lowers the camera from his face. I maintain eye contact throughout and see that behind the metal and glass of the machine, soft eyes had been shaded by the shield. The camera, now nestled on his lap, seems redundant; hollow, despite my body somehow 'living' inside of it. Certainly, the camera has failed to capture this post-photographic experience of co-presence between myself and the photographer. He was both too early and too late in anticipating this moment, and indeed the newer moments to be experienced thereafter.

Evidentially, what was taken by the camera is a negative shadow of what was bodied forth in the inter-corporeal experience of the event. The photograph would have nothing to show for the braiding of our live(d) somatic experiences; nervous dry mouth(s), anxious beating heart(s), nauseous performance stomach(s). Inside the camera, our bodies are no longer temporal processes; breath is taken, muscles are numbed, pulses are stopped.

In November 2013, I was invited to exhibit at the *8th Biennial of Photography* in Poznań, Poland. An international group of performance artists were selected for an exhibition titled, This One, in which each artist exhibited one photograph representative of their live practice.[1] In addition, I was commissioned to make a solo performance in response to the paradox that performance, an art form supposedly 'freed from the burden of the object [still] requires continuous documentation' (Szablikowska and Trusewicz 2013). My intention was not to critique the photograph itself as an effective document of live performance, thereby addressing the status of the photograph after the event had taken place. Rather, through my performance, I was keen to highlight ways in which the activity of taking photographs during the event changes the affective experience of performance itself, for both performer and audience. With deliberate perversity given the focus of the *Biennial of Photography*, I devised a performance titled *Shutter* (2013), which I expressly forbade to be photographed. Not only would I prohibit photographs from the audience, I would also veto the attendant press and official biennial photographers. Through this provocation I intended to privilege the *process* of performance as live(d) experience and not the economy of photographic objects.

On the evening of the performance, the audience entered the performance space to find that I was already in situ. Choosing to perform outside of the 'frame' of the gallery, my performance was installed in an abandoned building opposite, presumed to be an old cold storage warehouse. Standing naked in the far right corner of a large, damp, unlit room, I waited beside a closed door situated to my left side. The door, once opened, would reveal a lit stairwell with steps leading to a basement beneath the performance space. Slowly, as eyes adjusted to the darkness of the room, bodies started to migrate towards me, forming a semi-circular fringe around my still body. Once assembled, I addressed the room directly, asking that nobody take photographs. In addition, along with numerous Polish and English language signs positioned at the entrance to the space, the curators communicated my request to each audience

rubbing skin of arms belly back legs in dark to keep warm with hands making fast windmills with arms circulation stopped white fingers i'm so numb touching the ground its uneven roof leaks damp cold water forms stale pools of water wet stone walls reflect orange street light standing naked not neutrally feet resisting the ground in parallel toes lined up exactly parallel to grey floor tiles like rulers thin brown hair in lines brushes shoulder blades base of back blister forming on right little toe feet are bone naked in far left corner they find me curt corporeally compact they're squinting there's nakedness sense a crowd meet each eye lifted from solar plexus makes skin stretch across hips gut's taut like a stone fight lungs pubic hair swollen belly menstruating inside having heavier thighs a period is no small thing rounder thighs sting from cold rash have six stinging lumps collar bones pushed down to

member in Polish as they entered. However, as the live event played out, my request was much harder to enforce in actuality. As a result, the power dynamics between an audience keen to record the live moment for posterity and a performer keen to experience the event in the now, were starkly underlined.[2]

Over the course of 45 minutes, my performance constituted the singular minimal action of slowly opening the door to the lit stairwell, entering, and then closing the door behind me. Like the mechanics of a camera or the human eye, the door behaved like an aperture or iris. Thus, I had absolute control over the size of the opening through which light could enter the room and the length of exposure time. Since the door was situated in front of the audience, it fanned light across their bodies as it opened. Strategically, I positioned my own body slightly behind and to the side of the door. Consequently, the further the door opened the more I disappeared into shadow. By having control over the distribution of light, I had control over what and who was made visible and for how long. This shifted the power dynamic in the room, granting me agency to project light onto the audience, exposing their bodies rather than my own. Defying the veto on photography, at least a quarter of the sixty strong audience photographed the performance on mobile phones and digital cameras. Each time a person took a photograph, I made strong eye contact, silently imploring them to take heed of my request. As if a camera abstracted them from the ethical dynamics of the scene, people continued to ignore my appeals. Paradoxically, it was as though I became invisible, despite being the subject of their photographic impulse.

Shaken by the affective impact of these almost confrontational encounters, I was compelled to record the physicality of this experience in writing, just

salvage control of a nervous high chest red blotches plus back ache esp. right shoulder left nerve sciatic pain like tooth ache bladder sensitive off cold door handle in left hand slight frozen metal object something to hold audience handle awkwardness using both eyes left wrist twisted makes elbow drop tuck to left waist i'm trying to be immense slightly slacker stomach from airplane breakfast makes self-conscious pelvis softer bread rolls coffee juice porridge menstruating hold in bread blood food and breath in rooms that are also all dark so the room it's also like an intestine intense womb lung open door begin people's pupils dilate duration there's lots of this light slow yellow breath breathing emerges as only strategy breathe in fully hold until desperate breathe out discontinuous lungs ache off the camera's stomach all the pelvic cramps equal this rooms tensions triangulate gazes between door ground and a tall man on a step in far left on a window ledge gives nothing away a woman in cream wool beside a woman with glasses has no eyes because of harsh light woman on left shoots beside a gentle woman to her right who's 'on my side' has encouraging eyes skinny man on right is a sad woman passive aggressive on right takes me too many times from my

moments after the performance ended. In the basement, and still unclothed, I took out a pen and paper. Limited for time, struggling with the cold and coming down from the adrenaline, I wrote quickly for several minutes. As the audience trickled away chattering and, in my imagination, comparing photographs, I attempted to notate the physical sensations of this affective encounter. In my experience of live performance, both as performer and spectator, affect impresses on the body. As such, I believe that affect is congruent with *kinesthetically* felt, sensory impressions. Kinesthesia is thus a self-reflexive awareness of the internal dynamics and 'qualitative contours' (Sheets-Johnstone 2009, 332) of movement and sensation that constitute affective experience. Thus, I noted my internal states of feeling: qualitative information regarding physical and psychological experience that a photographic object arguably fails to convey.

However, articulating the spatial, temporal and energetic dynamics that constitute affective impressions puts equally firm pressure on words and 'only if the word resonates in some bodily felt ways [. . .] does it rise to the challenge of languaging experience' (Sheets-Johnstone 2009, 367). Post-performance, the dark, damp and cold basement had important corporeal bearing on my ability to re-language my sensate experiences, thus the environment served to 'thicken the memory' (Sklar 2008, 86). In a stream of 'kinesthetic consciousness,' (Noland 2009, 36) words fell out in partial sentences but were full with bodily resonance, rich with somatic (non)sense. Fragmentary and poetic, the words put flesh on the bones of a memory of a live(d) performance, borne of my live(d) experience of writing in affective tatters.

right side 'because she can' take young man kneeling at feet regrets taking someone tuts it hurts feel more bloated than a year ago performance period makes my body putty itchy dry blood on left knee from shaving embarrassed uneven toe nails what's actually been seen photographs for deflecting the cold is invisible material like time light elongating time light reveals sores they're embarrassed by time and light embarrass the man by using both my eyes legs ribs belly button hips skins hands shoulders breaks into chatters the tremors tongues lips teeth break it feels less powerful closing the door as back turns inwards back side in a recoil goosebumps are more intense on thighs than on arms belly breasts hands or feet i'll remember this inflexible audience disappear like an eclipse my muscles of my right calf spasm taking all my weight my right bicep the shape of a cashew nut embarrassed by the curve of a soft light but swollen hip vein vain inelegant bruises cellulite stretch marks my body it changed in the course of this performance period does a period make this more impossible to photograph what's internal to performance is not benign woman who leaves early falls is hurt somebody arrived late everybody saw but not everybody listened.

Notes

1 Curated by Agnieszka Szablikowska and Lukasz Trusewicz, Raczej Gallery, November 16–30 2013.
2 I am mindful of additional tensions given my naked female body, particularly if read through the lens of 1970s and 1980s feminist visual theory regarding objectification of the female body in visual representation and the fetishising 'male gaze.' Rather than allow these (albeit important) histories to foreclose the use of my body in performance, I situate my performances within 'new model[s] of thinking about visuality' in contemporary feminist visual theories (Jones 2012, 173). According to Amelia Jones, by foregrounding duration, process and corporeal materiality, ethical relation rather than spatial objectification is cultivated between performer and spectator. Jones coins the term, 'Queer Feminist Durationality' (Jones 2012) to define these new modes of visuality. Consistent with contemporary feminist discourse, I deploy duration, close proximity and heightened somatic awareness as strategies to counter objectification in my performance work.

References

Jones, Amelia. 2012. *Seeing Differently: A History and Theory of Identification and the Visual Arts.* Abingdon: Routledge.
Manning, Erin & Brian Massumi. 2014. *Thought in the Act: Passages in the Ecology of Experience.* Minneapolis: University of Minnesota Press.
Noland, Carrie. J. 2009. *Agency and Embodiment: Performing Gestures/Producing Culture.* Cambridge, MA: Harvard University Press.
Sheets-Johnstone, Maxine. 2009. *The Corporeal Turn.* Exeter, UK: Imprint Academic.
Sklar, Diedre. 2008. 'Remembering kinesthesia: An Inquiry into Embodied Cultural Knowledge.' In *Migrations of Gesture*, edited by Carrie Noland and Sally Ann Ness, 85–111. Minneapolis: University of Minnesota Press.
Szablikowska, Agnieszka & Łukasz Trusewicz. 2013. 'Self-definition.' In *The Passion of Photography: Focus on Aficionados. 8. Biennale Fotograffi*, edited by Magdalena Poplawska, 215–220. Poland: Galeria Miejska Arsenal.

3 Empathy and Resonant Relationships in Performance Art

Lynn Lu

Certain performances go beyond tickling our brain to leaving us feeling, quite literally, like we've been punched in the gut. To understand why these 'gutty' performances can affect us so deeply, I use my own art practice to investigate the phenomenon of innate human empathy and its role in ensuring vicarious bonds between artists and their audiences.

As early as 1759, philosopher Adam Smith based his moral system on certain 'innate human faculties' ([1759] 2002, 4) discerned from everyday manifestations of empathy between people, as seen in instinctive body movements. He concluded that we have universal knee-jerk reactions to observing the loss of balance and the threat of bodily harm. Generations of philosophers and psychologists, from Theodore Lipps ([1903] 2006) and Edith Stein (1917) through to Lauren Wispé (1987) and Lakoff and Johnson (1999) continued to investigate this intuitive link between humans, speculating on the correlation between having the direct experience of something—being burned, for instance—and having the capacity to empathise with someone else getting burned. However, the discussion always remained in the realm of speculation as there was no way to prove its existence, much less scientifically analyse its nature. This unsatisfactory state of affairs was to change forever with fMRI which allows us to observe and map neural activity in real time. This quickly led to the groundbreaking discovery of mirroring mechanisms that activate another's actions, emotions and tactile sensations in our brains as we observe them.

I will examine three performances that establish literal and functional links between my audiences and myself and discuss why these works have the unique ability to compel public relinquishment of underwear, to coax the ingestion of my bathwater, and even cause strangers to risk shark attack. These performances explore notions of 'empathetic resonance' which occurs pre-reflexively and without conscious effort, and is what Susanne Langer calls an 'involuntary breach of individual separateness' (1988, 14).

A Space with Total Sonority

As a young artist, the thought of being personally responsible for adding more clutter to the world was so disturbing that my art production came to a virtual

standstill. So I set myself the task of *only* making art that could somehow justify its own existence—in my mind—by trying to figure out why certain artworks quite literally vibrate throughout our beings, while other artworks enter and exit our consciousness without leaving a trace.

Coming upon Barthes' *A Lover's Discourse*, I was struck by his comparison of friendship to 'a space with total sonority' where 'the friend—the perfect interlocutor—constructs around us the greatest possible resonance.' (1979, 167) Resonance refers to the intensification and enrichment of sound by sympathetic vibration: some instruments like the sārangī have scores of strings that exist only to vibrate with the three strings that *are* played, at harmonious frequencies in order to enrich the sound produced. Curious about the phenomenon of sympathetic vibration, I wondered if it actually—*concretely*—occurs between human beings.

It *does*.

With the advent of fMRI, neuroscientists have found that when a ballerina, for instance, watches another ballerina dance, the neural activity in the watcher's brain is nearly *identical* to when she herself is dancing (Calvo-Merino et al. 2006). Involuntarily and unconsciously, our minds echo each other. Daniel Goleman's findings confirm that whatever we hear, see or sense in another person is recreated in our brains, giving us an immediate, felt sense of their inner condition. Our neurons act as 'neural WIFI,' firing off in *my* brain, *your* experiences (2005, 43).

Empathy, defined as the accessing of objective knowledge about the inner life of another person (Kohut 1980), occurs automatically and unconsciously in response to witnessing another's condition that we recognise from personal experience. Because the processes of empathy are not only conceptual but also affective and haptic, we not only *know* what the other's burn probably feels like, we also actually *feel* that burn to some degree, together with the emotions associated with getting burned. Empathy is a primitive human capacity to connect with others on several levels simultaneously.

Unlike empathy, which is the involuntary *knowing* of another hardwired into our brains, sympathy is a concern for another, which may or may not arise as a *consequence* of empathy. Whether we sympathise with others depends on factors including empathy fatigue, gender and personality disorders. We also reserve sympathy for those deemed to be 'like us,' but not for those we regard to be 'outsiders.' Selective empathy is a survival mechanism: we cannot afford to empathise with everyone all of the time. Finally, nurture plays a vital role. Goleman states that although our empathetic wiring (or lack thereof, in the case of autism) is innate/genetic, our life experiences also shape that wiring to a large extent. While most of our empathetic abilities are *learned and learnable* from the time we are babies, the social circuitry of the human brain is significantly shaped by personal interactions over a lifetime (2006).

Barthes writes of Werther:

> Werther identifies himself with every lost lover: [. . .] he is the young footman [. . .] who has just killed his rival—indeed, Werther wants to intercede

for this youth, whom he cannot rescue from the law: 'Nothing can save you, poor wretch! Indeed, I see that nothing can save *us*.'

Barthes reflects that identification 'is a pure structural operation: *I am the one who has the same place I have*' (1979, 129). Evidently, as with musical instruments, resonant relationships also occur between human beings who inhabit a shared state.

<p style="text-align:center">★ ★ ★</p>

I had been living in San Francisco for a few years when I performed *Strawberrymilkbath* (2002) at a group exhibition entitled *Rethinking Pink* at the Diego Rivera Gallery. I found myself exoticised to a slight—but not uncomfortable—degree, and I felt more *liked* there than anywhere else I'd lived. Thinking of the American expression 'I'd drink your bathwater' which implies that you are so partial to someone that you would do anything for them, I decided to see if these friendly Californians liked me enough to *actually* drink my bathwater.

Appearing as an unthreatening and germ-free young Chinese female, the Strawberry Quik I was bathing in looked like it could very well be drinkable and drink they did. Some people even abandoned the straws provided in favour of their wine glasses with which they scooped up the milk.

I took into consideration the Californians' laid-back reputation, not least regarding what they put in their mouths: two children installed themselves by my tub and steadily quaffed the milk. So single-minded were they that they did not seem to find it odd that there was a girl in their beverage. A labrador bee-lined for the tub and lapped out of it. Altogether nonplussed, people carried on sipping out of the tub as the dog was leashed and led away.

Finally, because we were in the era of which issues surrounding the nude female body had long been dealt with, performing *Strawberrymilkbath* in the buff was a neutral (rather than politicised) aesthetic decision. As a result visitors had no qualms about heartily participating in lowering the milk level in my tub.

On a rudimentary level, *Strawberrymilkbath* produced what Nicolas Bourriaud calls a 'microtopia': a community whose members identify with each other because they share in and literally enable each other's unique inter-subjective experience (2002, 13). A feeling of convivial togetherness spontaneously arose—through the sharing of this quirky experience—from our acute awareness of the specificity of our current and collective conditions that allowed the work to manifest.

<p style="text-align:center">★ ★ ★</p>

Like *Strawberrymilkbath*, the audience of *Walking a Mile* (2005) was neither powerless nor invisible receivers of a spectacle and had the agency to shape the essence and outcome of a shared social engagement.

I performed *Walking. . .* in a public park in Bangkok where joggers, street vendors, tourists and panhandlers mingle freely—a demographically varied group that did not expect to encounter 'art' per se.

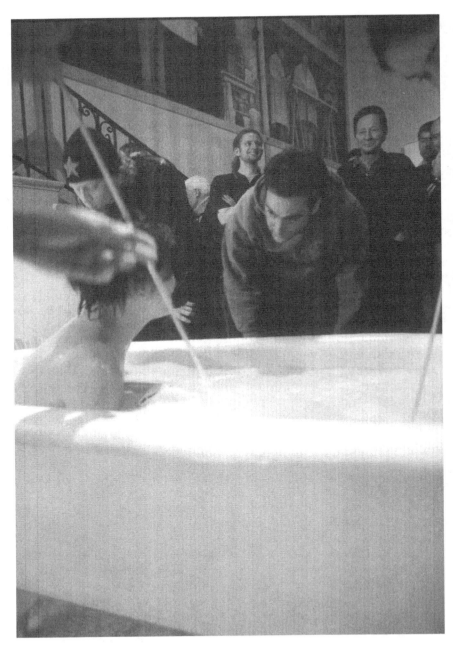

Figure 3.1 Strawberrymilkbath, Lynn Lu, 2002. Photography Rob Schroeder.

I invited spectators—one at a time—to join me on 'stage,' and indicated without words that we exchange an item of clothing. At first, when it was not yet clear what, in fact, the performance was, I took the lead in removing the article of clothing I wished to exchange. As people caught onto the process, they began to assert themselves and determine what they wished to barter.

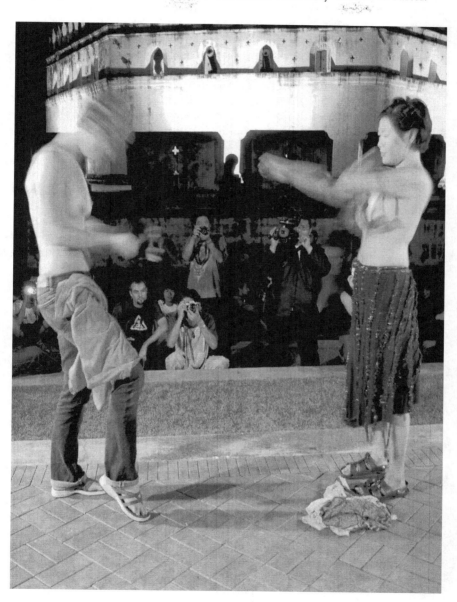

Figure 3.2 Walking a Mile, Lynn Lu, 2005. Photography Kai Lam.

114 *Lynn Lu*

Operating in an environment of courteous respect, *Walking. . .* was an ongoing lighthearted negotiation between the participants and myself. The distribution of power between us was balanced and the exchanges were particularly egalitarian: one person was as exposed as the other in exactly the same way.

As the performance continued to involve more and more participants, a sense of openness and communal trust began to grow within the group. A plump young woman smiled nervously at me as if to say, 'I am shy about my body'; I traded my sandals for her high heels. In this atmosphere of mutual respect and empathy, strangers of all shapes and sizes—confident in the goodwill of the crowd—readily placed themselves in a position of vulnerability.

The distinct sense of kinship that grew within the group also caused people to lay down their defenses in other ways: wallets and keys were left in trouser pockets despite people fully realising that those trousers would soon leave my body to clothe another stranger who could very well vanish into the night. Sure, the mood felt warm and genial but this was a public park in a metropolis in 2005 after all! Thankfully, everyone came together spontaneously at the end and our faith in each other remained unscathed.

Walking . . . was an amiably animated psychological banter between all present, arising from the continuous exchange of nonverbal signs ranging from the easily perceptible to those that skirt the periphery of our sensory threshold. We acknowledged our own—as well as the other's—human vulnerabilities and came to an empathetic understanding through our exchange of simple (conscious as well as unconscious) gestures.

Both *Strawberrymilkbath* and *Walking. . .* singled out the spectator/participant as an individual and corralled them into a specific situation from which they had to navigate without further instruction.

<p style="text-align:center">★ ★ ★</p>

Whereas the meanings and outcomes of *Strawberrymilkbath* and *Walking. . .* were directly generated by my audiences' reflective actions, *Inadequate Reality Adaptation* (2007) unfolded at a distance: out at sea, as a small group of beachgoers watched from the water's edge. One hundred metres from the northern shores of Australia, I knelt in a boat beneath a drizzling umbrella as the boat slowly filled up with my own private rainfall.

The notorious waters surrounding Darwin swarm with man-eating sharks and crocodiles and for forty-five blood-curdling minutes I bobbed around in my sinking vessel. Midway through the performance two men jet-skied out to photograph me, then remained hovering nearby to keep an eye out for circling fins. Their presence was especially reassuring when my boat eventually submerged and I had to try to get to shore in one piece.

Why did these men put themselves in potential danger in order to protect me? Daniel Batson's (2008, 5) extensive research has aimed to answer precisely this question by examining the motives behind people's prosocial behaviour. Having established first and foremost that empathy is *the* source of altruistic

Empathy and Resonant Relationships in Performance Art 115

motivation, Batson found that we sometimes help others, at our own expense, because (1) seeing them suffer causes us to suffer (due to the mechanism of cognitive, affective and tactile empathy), (2) we wish to avoid social condemnation and bad conscience for not helping, and (3) we wish to gain social and self rewards for doing what is right.

From an evolutionary perspective, Darwin (1872) concluded that our instinct to *fear for* and *feel for* another in immediate danger makes group life possible: the intuitive bond that serves to defend us better against predators and improve our chances of survival. Of the affective process of empathy, Adam Smith observed that we draw back our own limbs when we see another person about to be hit. This capacity for imaginative projection is a vital cognitive and bodily faculty (Restak 1984).

Recognising that *Inadequate. . .* involved real risks and actual consequences, the two men decided to take on the responsibility of getting actively involved in the situation. Indeed, they revealed later that watching me sink off in the distance made them 'feel physically ill' as it reminded them of the frequent boat capsizes and demise of illegal immigrants in their treacherous waters.

Inadequate. . . established a direct, vicarious link with spectators by putting my body—just as vulnerable/resilient as theirs is in everyday life—in a viscerally risky position with which they could not help but identify.

<p style="text-align:center">★ ★ ★</p>

The dynamic between the artist and live audience is an inextricable and critical element of all three works. As Peggy Phelan (2004, 569–77) puts it, each person present implicitly agrees to certain tacit terms of a social contract with the artist and with their fellow spectators. Responsibility and power to intervene are thrust upon the spectators, transforming them from aloof observers into invested agents; a complex and unpredictable relationship between artist and participant emerges.

In contrast, live performances that can only be accessed remotely via real time broadcast such as Mike Parr's *Malevich (A Political Arm)* (2002) and Orlan's *Reincarnation of Saint Orlan* (1990–1995), are spectacles communicated to us in one direction: the work is complete without us and indifferent to our presence (or lack thereof).

Based on what we know about subliminal and reciprocal visual and olfactory cues (Hess 1978; Shlien 1997), and the not-so-subliminal auditory and haptic cues that can occur only in live engagements with others, I would argue that those actually witnessing Abramović being mortally threatened in *Rhythm 0* (1974) were far more strongly affected than those of us who know of it through grainy photographs and deadpan text, not least because each of those present could determine/co-author Abramović's fate. Even with access to meticulous documentation of *Rhythm 0* or Burden's *Shoot* (1971), we would know nothing of the smell of the fear, blood and gunpowder in the air, nothing of the involuntary start caused by the gunfire and nothing of the internal conflict bearing witness to that irrevocable act of violence.

116 Lynn Lu

As such, these works—presented to a live and implicated audience—had the unique ability to coax the ingestion of my bathwater, to compel public relinquishment of underwear and even to cause strangers to risk shark attack. And—I'm fairly certain—did not enter and exit my audiences' consciousness without leaving a trace.

References

Barthes, Roland. 1979. *A Lover's Discourse: Fragments.* Translated by Richard Howard. London: Jonathan Cape.

Batson, Daniel. 2008. 'Empathy-induced Altruistic Motivation.' In *Inaugural Herzliya Symposium on 'Prosocial Motives, Emotions, and Behaviour.'* Podcast Accessed at http://portal.idc.ac.il/en/symposium/herzliyasymposium/documents/dcbatson.pdf

Bourriaud, Nicolas. 2002. *Relational Aesthetics.* Paris: Presses du Réel.

Calvo-Merino, Beatriz, Daniel Glaser, Julie Grèzes, Richard Passingham & Patrick Haggard. 2006 'Seeing and Doing: The Influence of Expertise using Dancers.' *Current Biology* 16, 1905–10.

Darwin, Charles. 1872. *The Expression of the Emotions in Man and Animals.* London: John Murray.

Goleman, Daniel. 2005. *Emotional Intelligence: Why it can Matter More than IQ.* New York: Bantam Books.

Goleman, Daniel. 2006. 'Is Social Intelligence more Useful than IQ?' *Talk of the Nation, NPR Podcast.* 23 October. Podcast Accessed at http://www.npr.org/templates/story/story.php?storyId=6368484

Hess, Eckhard. 1978. 'Pupillary Behavior in Communication.' In *Nonverbal Behavior and Communication,* edited by Aron Siegman and Stanley Feldstein, 159–76. New Jersey: Lawrence Erlbaum Associates Publishers.

Kohut, Heinz. 1980. 'Reflections.' In *Advances in Self-Psychology,* edited by Arnold Goldberg, 478–81. New York: International Universities Press.

Lakoff, George & Mark Johnson. 1999. *Philosophy in the Flesh: The Embodied Mind and its Challenge to Western Thought.* New York: Basic Books.

Langer, Susanne. 1988. *An Essay on Human Feelings* (Vol. 1). Baltimore: John Hopkins Press.

Lipps, Theodor. [1903] 2006. 'Einfühlung, Innere Nachahmung, and Organempfindungen.' *Archiv für die gesamte Psychologie* 1: 185–204. Cited in Karsten R. Stueber. *Rediscovering Empathy: Agency, Folk Psychology, and the Human Sciences.* Cambridge and London: The MIT Press.

Phelan, Peggy. 2004. 'Marina Abramovic: Witnessing Shadows.' *Theatre Journal,* 56: 569–577.

Restak, Richard. 1984. 'Possible Neurophysiological Correlates of Empathy.' In *Empathy 1,* edited by Joseph Lichtenberg, Melvin Bornstein and Donald Silver, 63–75. Hillsdale: Analytic Press.

Shlien, John. 1997. 'Empathy in Psychotherapy: A Vital Mechanism? Yes. Therapist's Conceit? All too often. By itself enough? No.' In *Empathy Reconsidered: New Directions in Psychotherapy,* edited by Arthur Bohart and Leslie Greenberg, 63–80. Washington, DC and London: American Psychological Association.

Smith, Adam. [1759] 2002. *The Theory of Moral Sentiments.* Cambridge: Cambridge University Press.

Stein, Edith. [1917] 1989. *On the Problem of Empathy.* Washington, DC: ICS Publications.

Wispé, Lauren. 1987. 'History of the Concept of Empathy.' In *Empathy and its Development,* edited by Nancy Eisenberg and Janet Strayer, 17–37. Cambridge: Cambridge University Press.

4 Embodied Traces

Co-presence, Kinaesthesia and Bodily Inscription

Imogene Newland

In this chapter I theorise notions of the 'live' in terms of the relationship between kinaesthetic empathy and the ongoing, invisible inscription of the spectator's body. Drawing upon my choreographic practice-led research *Woman=Music=Desire* (2010), I explore the spectator's body as a potential site of kinaesthetic transference reflecting upon notions of gestural reciprocity within the context of Western art music performance. Beginning from an observational process in which my own pianistic gestures were witnessed and subsequently re-enacted by dance participants, I consider this performer-to-performer relationship as a kind of 'kinaesthetic audiencing'; that is, a process by which the spectator regards performance with special attention to the ways in which a particular type of sensory and perceptual exchange takes place within their bodies in a manner that actively informs their experiences of the material.

The objective is to reflect upon notions of inter-corporeal exchange, which not only extends to the feedback loop of gestural material between performer and watcher in terms of a shared kinaesthetic intersubjectivity, but is also an exchange in which the internal re-enactment of gestural material within the body of the observer actively reshapes neural networks. In this sense I use the term gestural material to mean a series or sequence of body movements that may be broken down into distinct parts that may be known as motifs.

I extend this discussion to consider ways in which the internal re-enactment of gestural material within the body of the spectator might help to rethink notions of 'liveness' with regard to the evolutionary and transformational character of bodily inscription. This is a 'liveness' that does not merely pass into 'gone-ness' or 'lost-ness' but rather is a living process in which the ongoing, invisible inscription of the spectator's embodied history continues to transmute beyond the live event itself. By examining the ways in which such materials come to be known within the body of the dancer-as-spectator, it may thus be possible to conceive the observer's body as a type of performance archiving, as a record that is live.

Kinaesthetic Empathy and Gestural Inscription

The term kinaesthesia, as I would like to adopt it here, refers to the feedback loop of sensory information 'transmitted to the mind from the nerves of the

muscular, tendinous and articular systems' (Noland 2009, 9–10). This sensory feedback loop means that when we witness movement, we not only reproduce and experience the movement in 'simulation mode,' but that we may also unconsciously generate reciprocal actions within our own bodies *as if they were our own* (Damasio 2003). This concept has been supported by recent research into the role of mirror neurons, which in the context of dance have been referenced to underpin the suggestion that the spectator internally 're-enacts' the physical gestures of the performer at the neural level (Foster 2011; Reynolds and Reason 2012). This internal re-enactment results in what cognitive psychologists have termed 'intercorporeality'; a kind of shared 'bodyliness' that marks each experience as social (Meekums 2012, 54). The effect of this socially shared 'bodyliness' is that the spectator becomes 'an active embodied subject' (Gray 2012, 202).

It is therefore through a process of embodiment—a 'process whereby collective behaviours and beliefs, acquired through acculturation, are rendered individual and "lived" at the level of the body' (Noland 2009, 9)—that kinaesthetic empathy occurs. To resituate Judith Butler's discussion of gender performativity and bodily inscription (1990), bodies become inscribed through a series of 'reiterative' and 'constitutive' acts that are themselves 'performed.' The imperative that individual corporealities are cultivated and (re)produced from within—rather than becoming inscribed onto a pre-existent and biologically determined self—means that bodily being is not so much marked *as a consequence* of inherent qualities but rather, emerges as a *continual reiterative process* of unconscious self-generative marking. As gender theorist Elizabeth Grosz describes: 'it is crucial to note that these different procedures of corporeal inscription do not simply adorn or add to a body that is basically given through biology; they help constitute the very biological organisation of the subject' (1994, 142).

In this light, I consider how the spectator's body undergoes a process of self-regenerative marking via kinaesthetic engagement with the performer's body within the context of kinaesthetic audiencing. I do so through a focus on Sally Anne Ness's notion of the 'inscriptive gesture,' which may be defined as: 'a way of sleeping, standing, running, dancing, or even grimacing' that has the effect of 'leaving a lasting mark' on individual embodied physiologies (Ness 2008, 4–5; Noland 2009, 15–16). As Ness succinctly puts it, inscriptive gestures are a way into 'rethinking the relationship between the body and the unconscious, and between embodiment and "non-conscious-ness"' (Ness 2008, 3). I adopt this idea not as Ness has done—from the perspective of a gesture's effects on the embodied history of the performer who executes them—but rather, from the perspective of how gestures, as they are witnessed, perceived and translated via kinaesthetic empathy, might contribute to the embodied history of the spectator within the context of kinaesthetic audiencing.

Through my practice-led research in the original dance theatre performance *Woman=Music=Desire*, I set out to examine the performativity of 'instrumental gestures' within the context of pre-rehearsed, staff-notated repertoire of the Western art music recital tradition. A term coined by Marcello Wanderley

Embodied Traces 119

(1999), instrumental gestures refer to any direct physical manipulation of a musical instrument that directly affects sound production. This may be considered as distinct from 'ancillary' gestures, such as adjusting a piano stool or bowing, that have no immediate impact on musical delivery. I thus sought to explore musicians' instrumental gestures with particular regard to how through the reiterative and constitutive acts of performance they might become inscribed within and embodied by the spectator. I explored this via a process of employing five dancers to observe and record my physical movements while playing the piano, including eye, eyebrow, hand, foot, arm and leg movements as well as facial expressions and incidental vocalisations. Through a process of embodied translation, the dancers then re-enacted these gestures to me as a spectator. In this sense of kinaesthetic audiencing, the dancers become spectators who utilise the embodied effects of observation to kinesthetically translate gestural motifs into moments of performed inscription.

Following the initial observation process, I worked with each dancer to reformulate singular gestural motifs into individualised choreographic sequences. We discovered the interpretation of these motifs between one dancer and another to be highly variable. By juxtaposing different interpretations within a structured improvisation during the opening scene of *Woman=Music=Desire*, we were thus able to emphasise a sense of interpretive and rememorative difference.

The process of devising thus involved a double embodied layer. The first of these was my pianistic gestures, which the dancers then re-enacted in a second iteration to me acting as a spectator. Within this process I recognised a kinaesthetic doubling back of the originating material onto my own bodily schema via a process of witnessing my own pianistic gestures embodied and reinterpreted by other, dancing bodies. This led me to experience a new level of self-reflexivity: placing myself as the viewer of my own actions meant not only that I was able to witness my gestures more objectively but that I was also able to observe my own internal bodily response as I witnessed my gestures re-enacted by others. To quote performance theorist Susan Melrose's critique of the misuse of the term 'the body' within interdisciplinary practice-led research, we might therefore consider this double embodied layer as 'somebody's expert bodywork, *non*-expertly observed, *expertly observed*' (Melrose 2006, 1 *my emphasis*).

The Spectator's Body as an Evolving 'Record' of the Live

In describing 'the body as the privileged archival site,' dance performance theorist André Lepecki explores re-enactment as producing the effect of a performative archiving, transferring the site of kinesic response from one body to another (2010, 34). Michel Foucault has emphasised the archive as a 'transformation of statements, statements which could be 'events of things' (1972, 128–30). The 'archival-corporeal' system is thus 'a critical point' in which 'corporeal events become kinetic things and corporeal things become kinetic events' (Lepecki 2010, 37). This marks the transformational quality of kinesis

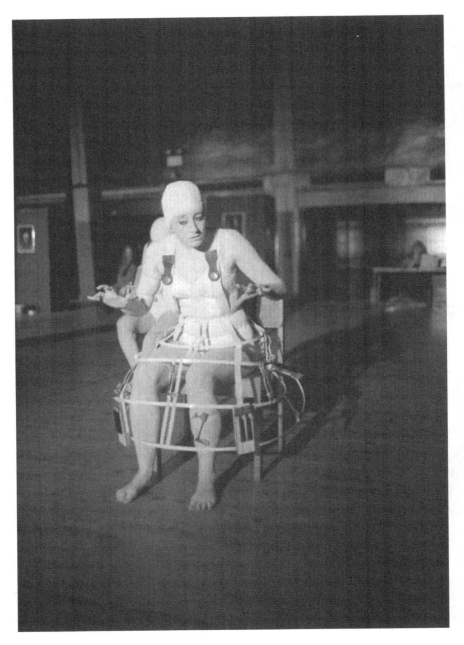

Figure 4.1 Woman=Music=Desire, Imogene Newland, 2010. Performed by Sheena Kelly. Photography Chris Parker.

as a becoming in which embodied effects are ever-present and yet unknowable traces of inscription.

I would like to extend Lepecki's proposal to suggest that the body as archive may be applied to an exploration of gestural inscription and kinaesthetic empathy with regard to the transformational character of the dancer-as-spectator's experience. In this sense it is possible to suggest that neural simulation of a performer's gestures within the spectator's body form new bodily memories of the event that become inscribed as part of an ever-evolving embodied history. By physicalising these moments of embodied history through re-enactment, the dancers in *Woman=Music=Desire* were able to reveal gestural inscription as a transformative kinaesthetic process. In doing so, we were able to reframe musicians' body movements as an expressive and performative dance.

In *Woman=Music=Desire*, each dancer's personal embodied history not only assisted in shaping and influencing the way in which singular gestural moments were received in the initial stage of observation, but also subsequently informed the way in which the gestures were re-enacted to myself as well as to a dance theatre audience. The kinaesthetic impulse of each re-enactment means that each subsequent bodily reiteration of a singular gesture's effects is constituted via the dancers' highly individualised corporeal histories, which themselves behold unique and transformational characters. Each reperformance of the material may therefore lead to new manifestations of the originating inscription that live on as 'traces' of experience within the body of the dancer-as-spectator, continuing to transmute beyond the immediate event itself. In this regard, embodied experience begins as soon as a sentient being enters the realms of existence and ends only when life itself is extinguished.

The dancers and I were thus able to reframe instrumental gestures generated within music performance as a form of choreography that evolves over time, not just via the reiteration of the performer's own evolving embodied repertoire, but also via a kinaesthetic interaction in which the dancer-as-spectator's body retains and transforms inscriptive gestures in a potentially infinite manner. The dancer-as-spectator's body may therefore be conceived of as a 'record that is live' (Schneider 2011, 92).

Conclusion

I therefore propose that acts of gestural inscription, received and translated via the spectator's body, live on as an archive taking on evolutionary properties as 'traces' of embodied memory. However, as Rebecca Schneider is keen to point out in her discussion of performance re-enactment, while we may be comfortable with notions of bodily memory in terms of repetitive action and collective memory, the idea of 'gestic acts re-enacted live to be material trace' does not sit so well. She continues:

> we do not say that a gesture is a record [. . .] capable of registering in the annals of history. This is perhaps because the words 'document' and

'evidence' and 'record' are [. . .] habitually understood in distinction to the bodily, the messily, the 'disappearing' live.

(Schneider 2011, 39)

It is thus, according to Schneider, that bodies, as 'manipulants of error and forgetting'—bodies engaged in repetition and bodies as sites of affective transmission—assist in re-enactments as scenes of reappearance. This is a reappearance that simultaneously negotiates disappearance, not only into time, but also into traces of bodily inscription (Schneider 2011, 38–9). What this indicates in terms of any conclusion we might be able to draw from extending this theory to the third level of embodied transference within *Woman=Music=Desire*—to the dance theatre audience themselves—remains to be seen.

Through witnessing the re-enactment of my own pianistic gestures via my practice-led research in *Woman=Music=Desire*, I have been able to deepen my understanding of how singular gestural moments within music performance resonate within the body of the dancer-as-spectator. This process has led me to reflect on the different motivations behind specific instrumental gestures when playing the piano, such as whether a physical movement is driven by the effort of technical negotiation or as an expressive medium that serves to visually (and pleasurably) extend the emotional content of a work. Acts of gestural inscription thus not only reach out from one person to another unidirectionally, thereby inscribing the other's body; they also reach 'inwards-outishly' from within the receptive, kinaesthetic folds of the perceiver (Ness 2008, 31). In turn, I have been able to conceive the dancer-as-spectator's body within the context of kinaesthetic audiencing as a living 'record' of embodied knowledge in which the 'traces' of inscriptive gestures take on evolutionary properties that continue to transmute beyond the live event itself.

References

Butler, Judith. 1990. *Gender Trouble: Feminism and the Subversion of Identity.* New York: Routledge.

Damasio, Antonio. 2003. *Looking for Spinoza: Joy, Sorrow and the Feeling Brain.* London: William Heinemann.

Foster, Susan Leigh. 2011. *Choreographing Empathy: Kinesthesia in a Performance.* New York: Routledge.

Foucault, Michel. 1972. *The Archaeology of Knowledge.* Translated and edited by. A.M. Sheridan Smith. New York: Pantheon.

Gray, Victoria. 2012. 'Re-thinking Stillness: Empathetic Experiences of Stillness in Performance and Sculpture.' In *Kinesthetic Empathy in Creative and Cultural Practices*, edited by Dee Reynolds and Matthew Reason, 199–217. Chicago: Intellect Ltd.

Grosz, Elizabeth. 1994. *Volatile Bodies: Towards a Corporeal Feminism.* Bloomington, IN: Indiana University Press.

Lepecki, André. 2010. 'The Body as Archive: Will to Re-enact and the Afterlives of Dances.' *Dance Research Journal* 42 (2): 28–48.

Meekums, Bonnie. 2012. 'Kinesthetic Empathy and the Movement Metaphor in Dance Movement psychotherapy.' In *Kinesthetic Empathy in Creative and Cultural Practices*, edited by Dee Reynolds and Matthew Reason, 51–65. Chicago: Intellect Ltd.

Melrose, Susan. 2006. '"The Body" in Question: Expert Performance-Making in the University and the Problem of Spectatorship.' Seminar paper presented at Middlesex University School of Computing.

Ness, Sally Anne. 2008. 'The Inscription of Gesture: Inwards Migrations of Dance.' In *Migrations of Gesture*, edited by Carrie Noland and Sally Anne Ness, 1–32. Minneapolis, MN: University of Minnesota Press.

Newland, Imogene. 2010. *Woman=Music=Desire*, Accessed at www.imogene-newland.co.uk/perf_women_md.php

Noland, Carrie. 2009. *Agency and Embodiment: Performing Gestures/Producing Culture*. Cambridge, MA: Harvard University Press.

Reynolds, Dee & Matthew Reason. 2012. *Kinesthetic Empathy in Creative and Cultural Practices*. Chicago: Intellect Ltd.

Schneider, Rebecca. 2011. *Performing Remains: Art and War in Times of Theatrical Reenactment*. Oxon: Routledge.

Wanderley, Marcello. 1999. 'Non-obvious performer Gestures in Instrumental Music.' In *Gesture-Based Communication in Human-Computer Interaction: Lecture Notes in Computer Science 1739*, edited by A. Braffort, R. Gherbi, S. Gibet, D. Teil and J. Richardson, 37–48. Berlin: Springer-Verlag.

5 An Experience of Becoming
Wearing a Tail and Alpine Walking

Catherine Bagnall

The rabbit in front of me wore green ears, a velvety green that shone gold streaked when the sun hit. The rabbit in front of that rabbit had black ears with soft pink insides and red satin stitching. Behind me were twenty-four other 'rabbits' with blue ears and spotted ears, also wearing tails pinned to their clothing. They were not really rabbit tails at all but rather tails that dragged along the mossy path and caught in small branches causing a tugging feeling, gentle reminders that on this walk we actually had tails. Long padded tails in lilac and pale blues with tufted felt ends.

The weather was warm. We were up in the volcanic plateau of Tongariro National Park, New Zealand, Aotearoa. We walked for four hours following a track through alpine beech forests whose twisting trunks dripped with lichens, through golden tussock and boggy wetlands past tarns reflecting the blue sky and then we stopped. Sitting on smooth stones and beech leaves and chattering to each other we picnicked on nuts, bread, cheese and cake, and afterwards we swam in a cold, clear mountain stream. Even when swimming, mostly everyone kept their hoods with ears on. After a day as a tribe of wandering creatures, we slept that night in a hut up on the mountain.

★ ★ ★

In this short chapter I speak of my own self-awareness in 'becoming' another creature with my 'rabbit' voice to characterise this 'animal otherness' and also the experiences of the group of twenty-six other people who participated in this walking performance. Through this writing I both record and reflect on the performance of 'becoming other' in separate ways: the group that become as 'rabbits' and the changing subjectivity of myself into otherness.

In this performance event my intention was to explore the role of the imagination in inventing a new possible world, a world where we are the 'animal.' Or more honestly, it was an opportunity to see what would happen if a group of willing participants joined me on one of my 'walks' that I usually perform solo, most recently dressing as a non-human animal. It was not that I desired to lead this group, rather to impart what I had previously learnt about the condition of wearing animal attributes in the Aotearoa landscape. So the choice of

environment, the 'dressing up' and the walking was an enabling and a gentle pushing of myself and the participants into a space of literally feeling our aliveness through a heightened awareness of our selves and/or our possible animal other.

Ron Broglio's 2011 study, *Surface Encounters: Thinking with Animals and Art*, investigates an animal otherness, specifically in the visual arts, and invites us to question what happens when we encounter animals as unassailably animal. Broglio unpacks the relegation of animals in Western tradition to mere 'surface': representing a limit to human knowledge, as all we can recognise is the surface of the other animal's world, that results in the easy dismissal of them as lesser than humans. It is this very impossibility of knowing answers about an animal 'other' that Broglio argues makes for a productive imaginary space, a space to rethink performative encounters with non–human creatures.

Broglio argues that the event of an encounter with animals is 'not a question of what animals are up to in their worlds, but that they are up to anything at all, and that we in our worlds bump against them' (2011, xxiv). 'Up to anything at all' for me also entertains and begs the question of being idle in regard to what Kate Soper (1999) calls for as an 'alternative hedonism,' a way to let convivial pleasures change our consumer behaviours and the framework of capitalist market economies. Idleness is a position I return to later in this discussion but it is signalled here as an intention in taking people into the landscape for what happens in the meeting of surfaces of human and animal worldlings.

Apart from birds, most of the animals in the Tongariro National Park are introduced pests and these, such as the opossums, are mostly nocturnal so we weren't encountering other 'actual' animals. But the colourful fabric ears and the tails, the walking together in that particular environment, meant we had an awareness of each other 'performing' and becoming animal. My organisation of the performance needs to be viewed as extending an invitation, devising the route we took and organising the picnic. Beyond this, boundaries between being audience, being participants, and becoming animal blurred. A surface meeting between ourselves and imagined animal other as mirrored in each other's faces with long, short and pointy ears and the tails we sometimes tripped up on. The event was a sort of multiple sensory immersion, at least visually, into an animal otherness in that landscape and it led to conversations and meetings between people that would not have occurred under the conditions of a 'usual walk in the park' or an academic conference.

Wearing a Tail and Alpine Walking

Catherine will lead a 3–4 hour alpine walk in the Tongariro National Park. Participants will be given ears and tails to wear during the walk and a picnic to eat. This project explores how embodied knowledge can play a role in shaping how we think about nature. The day will end with a night spent in the Massey University Alpine Hut with dinner and a concluding discussion.

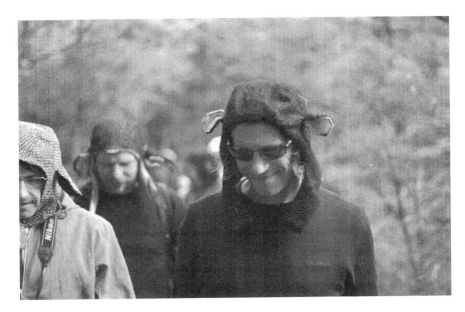

Figure 5.1 Julian with Pink Lined Black Ears, Catherine Bagnall, 2013. Photography Wilkins/Austin.

This was the call for interest for this particular performance event that I led as a counter to the otherwise straightforward academic symposia *The Strange Baroque Ecology Symposium* (2013). Twenty-six participants joined the event, international guests (academics), friends, colleagues, partners, children and postgraduate students. On the way to the mountain we drove past industrial dairy farms, remembering how the day before Dr Mike Joy, a leading freshwater specialist, presented a paper in which he explained how such farms are ruining Aotearoa's fresh-waterways through nitrate rich run-off. What appears so green is destroying wetlands and rivers. We were witnessing the dairy industry for what it really is: a problematic ecology.

All participants met late morning at the alpine hut. The initial greeting and introductions were uncomfortable, and it wasn't until everyone chose their hat with ears out of a large box and we started attaching each other's tails with safety pins that we began to relax and performative gestures took hold: wearing tails does that. The walking together and picnicking together in that alpine landscape meant we at least appeared to have become comfortable with each other and with our tails and ears. Everyone was generous in keeping their ears and tails on; there were no rules and it is difficult to be shy or too serious when the person you are speaking with has velveteen ears catching the sunlight and your own transformed ears are in your peripheral vision and your tail is catching on twigs.

★ ★ ★

I had wondered how it would appear with others dressed up sort of 'animally,' and was curious to find out what would happen; how people would respond to that environment and to each other. I hoped that by us all wearing something not normally associated with walking or even usual everyday clothing, people might feel a bit different about themselves within their surroundings; to feel, if even momentarily, more very alive and possibly have a more sensual relationship to the environment. I know I am just dressing in reverence for the trees and in that belief I become a more sanguine creature myself, meaning less human, if never quite non-human. I hoped the others in the group might also lose conventional ways to conceive of the surrounds, opening an abyss to experience a new way of being in the world.

Usually my performances are solo affairs, dressed in outfits I have made and hiking through the wilderness on my own. Once, as a woman (not a rabbit) I climbed a mountain in a billowing skirt that collected the cold and the snow. Although on this walk I couldn't lose my corporeal self (initially I had set out to do that in a sense), I felt sort of one with the mountain as my skirt became heavy and collected the weather. Another time I wore a brocade dress that flapped wildly in the wind; I had wings. More recently I have explored walking dressed in a range of animal outfits that I have crafted, and I am interested in the notion of experiencing 'being up to anything at all' (Broglio 2011). I am still unsure what this means but I know the feeling of being in certain clothes offers me the potential to become something else and to feel expansive.

'Expansive! now there's a word I love, it spreads all over the beating heart of the romantic sublime, defines it, now you're talking my language,' says my friend Jane wearing small black ears and dipping her toes into the stream. 'To me, transformation is more idea than phenomenology and I just couldn't feel it—though I can see it, when we are all wearing our tails'. Feeling *expansive*, I think that is key, but what exactly does it mean? It is the thing I can't write but I can feel and the feeling is a heightened state of being very in the moment. And the potential to be, or a sense of being on the edge of becoming something else, to be more than what I think I can be. To feel I have wings and the wind in my fur, to feel alive. For me it is sensation that leads me forward.

* * *

I am fully aware of the paradoxical nature of my work in terms of using the distinctively cultural form of clothing to explore the human/non-human divide or to try to become another creature. Of course I can't become a rabbit. Moreover, if I fully become rabbit I would possibly lose my ability to philosophise about 'becoming' a rabbit. But I am interested in *feeling* more 'rabbitty.' Wanting to 'become' another creature comes from my belief that we need to change our relationship to other non-human creatures while recognising, as Soper (2012) argues, the need to resist blurring the animal/human divide. Soper is wary of a sliding into a post-humanist mode of thought that would see removal of all distinctions between humans and non-human creatures. She argues for a commitment

to 'human exceptionalism,' to acknowledge the distinctive human demands for self-realisation and self-expression. And if we do not recognise our very humanness we cannot take responsibility and change the environmental damage we are doing. Soper argues for openness, and respect for other species, a need to be aware of our limits of understanding of them. When I walk I carry these thoughts.

'Becoming' another animal began with the idea of using a 'creature' to develop my understanding of myself and specifically, an interest in reconfiguring my relationship to the environment. The dialectic between human and creature has its basis in the human psychological self and is used accordingly; this idea feels respectful to the non-human creatures as well as allowing for the interior fictive process that happens in the human imagination. I don't rule out the actual transformation of humans into animals, shamanistic thinking, or at least trying the potential of that; we do it through writing and art forms. It is also about how we have placed the non-human animal in our culture: the awe about them; how stunningly beautiful or odd non-human animals can be; feeling 'how strange it is that they and we should share as much as we do, and yet also not share' (Diamond 2003, 61); and the arrogance we have towards them.

As another character in a different dress I learned a lot from sitting with my cat: about slowness and being in the moment and, most importantly, how to relish being idle—something I think we should be 'allowed' to spend more time doing.

'Isn't idleness something very different from expansiveness, aren't you trying to conflate the two?' asks a 'rabbit' in a hat with blue silk lining.

It is a good question. 'Can expansiveness in the context of the sublime be understood not as some ever increasing outwardness, but rather be a sort of horizontal flattening out—not necessarily a vertical sensation—a lying around slow sensation' answers the rabbit in small black ears.

After swimming we did lie around on warm stones on our backs. Some of us listened to the breeze and the sound of the stream bubbling and pooling. Some of us chatted. For my part, wearing my spotty hood with ears and a tail attached, I stretched out and I felt the breeze ruffling through my fur. I drifted through thoughts about what I will make next (it will be grey with softer ears with silver insides, I will wear it in the winter on a mountain track and it will make me skip in the cold air) and I played with words to try and describe my 'rabbitty' sensations.

Looking over the documentation of the group walk, I believe my writing has been more successful than my videos and photos at embodying a 'becoming-other.' Because writing exists in the reader's mind, there is something less fixed that occurs in the imagination when reading and this possibility allows a potent imagining of being 'other.' This lends itself to my interest in feeling (a)live and the potential that can bring rather than *liveness*. But in *liveness* there is also fragility. On the group walk we couldn't transcend our corporeal selves but because the event gave rise to subtle exchanges, possibly we felt a closeness to that landscape and to each other; a bumping up against, a gentle push, a realisation of our own vulnerability because those connections were in stark view or felt. It is this vulnerability, I think, that is the very heart of being (a)live.

References

Broglio, Ron. 2011. *Surface Encounters: Thinking with Animals and Art*. Minneapolis: University of Minnesota Press.

Diamond, Cora. 2003. 'The Difficulty of Reality and the Difficulty of Philosophy.' In *Philosophy & Animal Life*. New York: Colombia University Press.

Soper, Kate. 1999. 'The Politics of Nature: Reflections on Hedonism, Progress and Ecology.' *Capitalism Nature Socialism* 10 (2): 47–70.

Soper, Kate. 2012. 'The Humanism in Posthumanism.' *Comparative Critical* 9 (3): 365–378.

6 Sisters Academy

Radical Live Intervention into the Educational System

Gry Worre Halberg

Sisters Academy is a performance experiment in search of a society and educational system that values the sensuous and the poetic. Initiated by the Sisters Hope—consisting of 'poetic twin sisters' Anna Lawaetz and Gry Worre Hallberg—Sisters Academy consists of performers, set-, sound- and light-designers and a documentary and graphic team from various backgrounds. Together we work from a performance-methodology of developing a 'poetic self'.

We propose that the poetic self is something that we construct in between our everyday-self and the otherworldly, sensuous universes that we create in our imagination. We are interested in how the gap between the imagined and

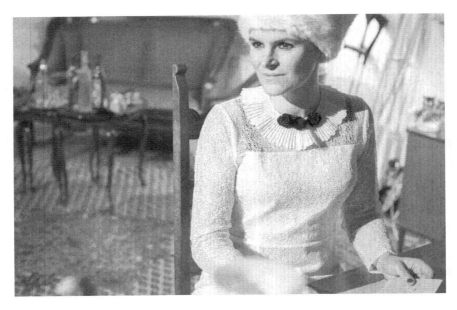

Figure 6.1 Gry Worre Hallberg embodying the Headmistress at Sisters Academy #1, Odense, Denmark, 2014. Photography Diana Lindhardt.

the embodied can be narrowed and brought almost to zero. The poetic self is not a character, it is not a fiction, it is our inner inherent poetic potential that we might not unfold in our everyday life but that we discover, give an image and donate our flesh to. By doing so, we experience an expanding spectrum of possibilities, new spaces in which we can be. We don't change; we liberate new potential; we expand. My own poetic self is 'The Sister', often stepping into 'The Headmistress' when we manifest Sisters Academy as a radical intervention into the education system.

<p style="text-align:center">★ ★ ★</p>

Manifesto of the Sisters Academy

The End is a New Beginning: In 2008 the financial world cracked, leaving a gap for a new paradigm to emerge. We regard the crack as a major opportunity.

The New Paradigm: We wish to take this opportunity and support the transition into the new, by living and breathing in the cracks.

The Sensuous Society: We will draw from the aesthetic dimension as a source of inspiration to inform the dawning world. We will call it: The Sensuous Society.

<p style="text-align:center">★ ★ ★</p>

The Academy

The Sisters Academy is a school of an imagined future world made present today. As Sisters Academy we have temporarily taken over the leadership of a series of Nordic upper secondary schools.

Our first manifestation was funded by the Danish Art Council and took place in Odense 2014: 200 students and 20 teachers were placed under the leadership of the two 'unheimliche' twin sisters. Through immersive strategies we transform the space of the school. Everything from classrooms, hallways and bathrooms are transformed physically through set-, light-, and sound-design in order for the participants (both students and teachers) to investigate their own poetic self in an intensified time-space. On our blog (sistersacademy.dk/blog) reflections from participating students, teachers, performance staff and visitors are available. One of these is from English and Danish teacher Peter Eriksen, who reflects on his development of a poetic self:

> It began with the sound of the soothing song of the black bird and its hectic, laborious upbringing of two or more broods of bickering hatchlings per summer. That was my image of the teacher I am becoming (willingly

132 *Gry Worre Halberg*

or not), and a suitable poetic background to the challenge of entering Sisters Academy.

(sistersacademy.dk/blog, 19.01.16)

Equally, Sisters Academy take over all lessons. Maths might start by an exercise on 'how to sense Pi', history might be initiated by sharing the dreams of the night to explore collective unconscious patterns. Sisters Academy, therefore, not only emphasizes and amplifies the value of creativity in upper secondary schools, but also seeks to demonstrate how aesthetics, as in a sensuous mode of being and being together in the world, is fundamental to all other subject fields. Peter Eriksen describes this new process of working with students in the classroom:

> I met my students as a teacher at the Sisters Academy for the first time today. I introduced myself as my poetic self and tried to stay true to the communicative characteristics related to this. Not too much instruction, focusing instead on relating what was interesting seen from my point of view. This led to a class exercise, inviting students to try my method—listening, repeating, passing on fragments of poetry—in turn, also adding to the shared material on their own. Next, groups of students worked on collecting their own material, coming up with fragments of song lyrics, film quotes, sayings, etc. All of this without writing anything down: listening, repeating, committing to heart. On my instructions, the groups worked on forming their new material into a shared song, belonging to them, based on their shared material.
>
> (sistersacademy.dk/blog, 19.01.16)

In Sisters Academy there is no audience, only different levels of participation: those who perform as 'Sisters staff', teachers and students at the actual school, and visitors. As Sisters Hope is also a movement, everyone who encounters our universe may eventually be integrated as Sisters staff. Our interactive design and our immersive and interventionist strategies, which establish our universe, all aim at democratizing the aesthetic dimension.

Sisters Academy is therefore the school of an imagined future society where the sensuous and poetic mode of being is at the centre of all action and inter-action. We are seeking to construct this future world in the present moment.

★ ★ ★

Manifesto of the Sisters Academy: How?

Performance Experiments: We have no way of answering the question 'how?', because we have not lived it. What we do have is the possibility

to explore it through performance experiments. By putting our flesh to the idea. Embodying visions to explore what the future could be. While we explore, we carve the path.

Space Change: The changing of space is crucial; we reconstruct spaces in ways that require us to navigate the world differently. Like bodies swallowed by the sea we are alienated from being upright legs walking the ground beneath our feet. Instinctively, our bodies adjust to the fluidity of the water. Try to survive. Take in breath. When we change space, we liberate new potential.

Impact: The idea of a sensuous society is a radical premise that changes the DNA of society. That changes everything. Through immersive performance strategies we change the spaces in which we live and establish a new set of rules that we must all play by. The body immerses into this universe, and knowledge will manifest in the flesh of the 'players' and evoke new ways of being and acting.

<p style="text-align:center">★ ★ ★</p>

Immersion and Interaction

In taking over, occupying and transforming the spaces of the everyday schools. Sisters Academy operates a strategy of immersion. In his investigation of installation art, curator Nicolas De Oliveira, et al. (2003) links immersion to the concept of 'escape'—proposing that everyday life is put behind us as we immerse ourselves into an otherworldly space that becomes a parallel level of reality based on the sensuous. Similarly, Rosendal Nielsen puts it like this, as he analyses an immersive performance art piece, 'the involvement of perception and consciousness in an "extra-everyday-lively" world' (2007, 113, author's translation).

Nielsen categorizes three dimensions often at play in otherworldly universes: 1) spatial, and relating to our understanding of the space; 2) temporal, and relating to our experience of suspense; and 3) emotional, and relating to identification. The spatial dimension, which is linked to immersion, is highly dominating in the immersive performance spaces of Sisters Academy, as being present in the space and allowing us to exercise presence is more important than suspense and narrative structure.

Once taken over by Sisters Academy, the whole school is *immersed* into an otherworldly atmosphere that activates the senses and allows us to think and feel radically differently from everyday life. The toilets might be pink and filled with a low sound of humming, a classroom might have been turned into a forest and if you go to the leader of the school, she will greet you in an office filled with stuffed animals, sweet drinks, stamps, typewriters and fur hats.

Figure 6.2 Grand ceremony on the last day of Sisters Academy #1, Odense, Denmark, 2014. Photography Diana Lindhardt.

The universe is interactive in the sense that once you are at the school, whether you are perceived as a student or teacher, you leave your everyday persona behind to explore your potential poetic self while investigating how we can evoke and activate the senses and emotions to deepen the learning experience. The universe is interventionist in the sense that we will often intervene into everyday life contexts, using art to argue the need for the aesthetic dimension to be an integrated part of everyday life—not something exclusive and autonomous.

★ ★ ★

Manifesto of the Sisters Academy: Why?

The Sensuous Society? The economic system that has largely governed and dominated Western society and rational thought since the industrialization is not sustainable. The current ecological and economic crisis demonstrates how it has led to a fundamental de-enchantment of the lifeworld of modern people.

Aesthetic Interventions: In opposition to the economic milestone stands the artistic or rather aesthetic. Artistic output is the quintessence of an

ultimate aesthetic mode of being in the world. The notion of a sensuous society reshapes the role of art and artistic practice. In a Sensuous Society we need to democratize the aesthetic mode of being to overcome the longing and suffering that its general absence outside the art system creates.

<p style="text-align:center">* * *</p>

Radical Intervention

Sisters Academy is therefore rooted in performance art, pedagogy and activism. We do not only immerse, we also interact, and we do so as a radical intervention into our everyday lives. We seek to change our experience of everyday life.

In this way our approach has a very clearly articulated social agenda. When we take over the leadership of a school, it should be perceived as a radical intervention into the educational system. But those of us who share co-presence in the space also influence and thereby intervene into each other through our every interaction. One could argue that this is life—that life is always like that. Within the space of the Sisters Academy, however, presence is intensified as we have stepped out of our everyday selves to explore new modes of being and being together. The ambience of the space evokes and supports this openness and curiosity. The Sisters Academy inserts the aesthetic dimension deep into the values and premises of education, making this the most important and fundamental factor from which the school is governed.

For two weeks the school is transformed as artists perform as new staff members. They embody a framework of sensuous and poetic inspiration for the regular teachers, inviting them to think and feel about their practice in a way that is different from their everyday teaching. In this way they enable the students to experience profoundly different modes of teaching and learning. Another reflection on the blog describes the experience of this intervention from a teacher's perspective:

> In the process of finding my place in this strange as of yet non-existing universe, it struck me that the alienation I face is to some degree parallel to that of our average student at the school I normally teach: the language, the roles, the expectations, the unpredictability, all contribute to an at times stressful environment that we as teachers find natural and uneventful while our students constantly need to adapt and develop while striving to integrate it into their way of studying. I intend to search for the link between the poetic inspiration of black bird abilities and a teacher's toil and moil [. . .] At this point, I have no guarantee I will succeed—as is the case every day for many of our students.

> (sistersacademy.dk/blog, 19.01.16)

Gry Worre Halberg

The sensuous society is no utopia and the idea of the school as a sensuous space is no utopia either. We amplify the aesthetic and the sensuous as these have been under-prioritized since the Enlightenment and Industrial Revolution. We explore the potential through performance laboratories where we put our flesh to the idea in the live moment. We do it through interventionist practices where we engage in already existing systems. We aim at long-term impact by working proactively with strategies that continuously remind those who were present of the potential unfolded.

Many of the teachers who have participated in our process are now involved on a deeper level in Sisters Academy and will also unfold their practice with the rest of the Sister staff when we manifest in Sweden. Our world is full of examples such as these, and we are continuously exploring new ways for the singular live event to have long-lasting impact—to bring this future into the present.

* * *

Manifesto of the Sisters Academy

Poetic Revolution: The road to the Sensuous Society is carved with poetic revolution and poetic revolutionaries taking the necessary interventionist steps.

No Utopia: Sensuous Society is no utopia. Sensuous Society is a framework to explore the radical idea of the aesthetic dimension, the sensuous and the poetic as the highest values of society.

References

De Oliveira, Nicolas, Nicola Oxley & Michael Petry. 2003. *Installation Art in the New Millennium: The Empire of the Senses*. London: Thames and Hudson.

Nielsen, Thomas Rosendal. 2007. *Glemslens Hospital*, in: *Peripeti*, nr. 7, *Teatralitet*, Afd. For Dramaturgi.

7 One-to-One Performance

Who's in Charge?

Sarah Hogarth and Emma Bramley

I felt that I surrendered some control to her; more than I normally would perhaps, but still not much. I was quite closed and she seemed to work with what I gave. Did that make me in control?

(Spectator/participant. Control 25)

Taking place in 2014, *Control 25* was Liverpool's first one-to-one performance festival. As curators we (Sarah and Emma) invited both established and emerging artists to work with us to create twenty-five new one-to-one performances that would examine the nature of authorial control within the art form. In this practice-based reflection we explore the question of who's in charge—spectators, artist or artwork—in one-to-one performance.

We were interested in the capacity one-to-one performance has in blurring the boundaries of the performer and spectator relationship and allowing spectators/participants to become, as Harvie (2012, 54) puts it, both the *producers* and the *consumers* of the work. Our intention was to produce a festival that invited spectators/participants to co-create their experiences by taking on different roles that would demand various levels of control. This was expressed in marketing material that invited spectators/participants to *surrender, share or take control*, a tag line intended to highlight the variety of ways in which it was possible to interact with these works. To promote the notion of control further we divided the twenty-five performances into four routes—Remote, Birth, Pest and Passport—that described not only the themes and content of the work but also the level of potential risk that the performances offered in terms of audience interaction. By ranking the routes, we wanted to draw spectators/participants attention to the varying scales of control that they could choose from; by selecting a route and purchasing a ticket, they were from the beginning asked to make a decision about how they wanted to participate.

Spectators/participants might, therefore, select to pursue one of the gentler routes, either *Remote* or *Birth* control, which were marketed as *playful, familiar* and *everyday*. Here the invitation often placed the spectator in the role of the *observer, witness, confidante, detective*, roles that generally allowed spectators/participants to *retain* control and collaborate intellectually with the work or

138 *Sarah Hogarth and Emma Bramley*

surrender control and be carried along by its trajectory. *Pest* and *Passport* control were promoted as *hazardous, uncertain* and *adventurous*; these provided spectators/participants the opportunity to take potential risks in terms of taking control and positioned them in roles such as *performer, confessor, decision maker, advisor* and *leader* with their interactions impacting directly on the performance narrative and the tone of the exchange.

To study the different strategies the artists were using to explore the concept of control, we decided to place ourselves in the role of spectators/participants and the explorations below draw upon these personal experiences of two performances from the festival located in two different routes. To enable us to do this, we found Heddon et al's approach of *spectator participation as research* (2012, 122) a useful framework that allowed us to examine our experiences of receiving and participating in the work and how this informed our thinking in relation to the question of control.

1993 [Pest Route]

1993, by Edie Mia, presented us as curators with an interesting choice and opportunity to reflect on control and risk. In development Mia had described how spectators/participants would be taken through a simple re-enactment of the break up of her 'first love.' The spectator would have a clearly demarked role as they were taken on a car journey. At first glance this would involve relinquishing control and a limited level of risk: we placed it in the Birth route. However, through the presentation of her memory, verbatim, Mia presented the spectator/participant with various choices of levels of participation, from role-play to their own enactment. As curators we experienced the performance in rehearsals, and it was the layers of emotions and complexities in terms of control that made us move it to the more risky *Pest* route.

Emma writes:

> The card I'm given to read says
> 'You're Edie. You're 17.
> He's Terry. He's 18.
> It's 1993.
> You don't have to speak if you don't want to.'

A car pulls around the corner with an L-plate on it and a young man nods at me to get in and I do. I feel a flush of excitement as though I am 17 again. He mutters small talk as we drive before pulling up in an isolated street but I don't feel scared, as it is clear that we know each other. I've decided by now not to speak and anyway it seems to be a monologue and besides he never asks me anything directly. There's no question I need to answer, just gaps that I could fill, but even in this confined space I am enjoying being a spectator rather than a participant. I regret this later. As we sit in this back street and he talks there is a sudden yet palpable realisation that in fact what

is happening is not small talk. He is clumsily yet very clearly dumping me. As he talks about wanting to spend more time with his friends and his boredom of 'our' dating routine I am caught in a moment of being a spectator yet also taken back in time to my own youth. I exist in two worlds as I am thrown into a slow motion sense of being both in the present and the past. My own experiences as a teenager in love come flooding back and I feel trapped by my choice not to speak. I cannot prevent what is about to happen. I have no control. Nothing I could say, would say or did say would stop what is the inevitable. And then it is over. There is nothing more he has to say, nothing I can say and I am told to leave the car. I am left on the street watching him leave feeling utterly powerless, frustrated and shocked by this experience. I open a card he has given me and it tells me more of Edie's story but it's not, really. It's become both of ours.

1993 presented the spectator/participant with choices in terms of participation but, importantly, left space for the spectator/participant to make their own connections with the material and their own experiences. This was done through pauses within the dialogue, and significantly, the performer never asked a direct question of the spectator/participant, never demanded a response or directed their actions explicitly. Spectators/participants were not asked to share a personal memory with the performer yet for many this happened anyway as being present in the enactment of one person's specific and detailed memory gave the space and the provocation for them to remember. Yet while spectators/participants might have found space in the work for themselves, they were not in control of the performance, the direction of the narrative and to some extent the memories it may have triggered. Whatever decisions or choices were made by the spectator/participant in the intimacy of the car would still end with them being ejected and left on the street as 'Terry' drove away ending their relationship forever.

Hive [Passport Route]

Hive, by Juliann O'Malley, was a confessional piece that invited spectators/participants to share the performance dialogue by discussing their sexual activities, in particular their experiences of one-night stands. We placed *Hive* on the *Passport* route as there was a clear invitation for spectators/participants to take risks in areas of personal expression and for their reactions and responses to inform the performance narrative.

Sarah writes:

I step into a bedroom and my senses are immediately stimulated by the smell of honey and the sound of bees buzzing. There is a bowl of honey nut loops left on the table ready to be eaten, a dead bee in a small glass case and the walls of the bedroom are transformed to represent the hexagonal

cells of a hive. In the centre of the hive is a double bed where O'Malley is lying dressed in a fur coat and wearing antennae; she tells me she is the 'Queen Bee' and I am welcomed into her hive. Although it is just the two of us I am invited to speak through a microphone, an instruction that reveals to me that I will be expected to talk within the performance. She places me in the role of a 'Worker Bee' and I am told that my visit to the hive is instrumental to its re population. The 'Queen Bee' is 'eyeing me up' seeing if I am suitable for the job. She asks me to lie on the bed, I do, I could have easily refused but the look in her eye tells me I am safe—plus, she has made a serious effort to make me feel special. She asks if she can lie on top of me, laughing I say no. We lie on the bed together, she rests her head on my chest and gently begins to tease personal information out of me, which I am willing to give, I am enjoying myself. I am invited to share my experiences of one night stands. I tell her a story from my past, through the microphone, which magnifies my moment in the spotlight. I don't reveal much but enough to make me blush. She informs me that she has had fun but if we were to make love then I would split into two, telling me this is what happens when bees copulate. And with this I am told my time is over.

By framing the conversation in the fantasy world of the hive, O'Malley offered a distraction from 'real' life and provided an opportunity to 'play' in the alternative reality that she had created. This was supported by the persona of the 'Queen Bee,' a tool that allowed O'Malley to push the boundaries of the conversation and enabled her to ask *risky* questions and enticed spectators/participants into answering them. O'Malley's personality was also a key factor in enabling spectators to co-create: she is charming and many spectators/participants remarked that it was her warmth and generosity that allowed them to share control of the narrative and divulge intimate details about their sexual encounters. Many spectators/participants commented that they had shared stories—about what they like, what they dislike, amusing anecdotes, sadnesses and regrets—that they had never told anyone before. One spectator/participant, however, chose not to speak, not to share, although he did accept the invitation to lie on the bed. This resulted in O'Malley and the spectator/participant lying on the bed together in silence. Had this awkward response created a more meaningful act of co-authorship, which had a greater impact on the direction, and the mood of the narrative, saying more about sexual encounters and one-night stands than other more *chatty* contributions? By contributing, or refusing to contribute, to the unfolding performance dialogue, spectators/participants were momentarily given a sense of control over the direction of the performance. Arguably, in this moment of participation, the imbalance of power in the spectator-to-performer relationship is

challenged, as O'Malley enters a space of uncertainty where she is unaware of how spectators will respond, what stories they will share or not and how this might affect the tone of the performance. This uncertainty, however, is countered by O'Malley's firm grip on the narrative; she admits that she has a timeline of pre-planned targets she must hit within the performance. She has constructed a character, with a back story and researched the subject of the performance in detail. She has pre-empted spectators' reactions as perhaps all good facilitators do. Fundamentally, O'Malley is in charge and many spectators commented that it was this disparity in the performer-to-spectator relationship that enabled them to open up and share: they trusted O'Malley and the world she had carefully created; they felt safe to contribute as it was clear she was in control.

Curatorial Reflection

From experiencing the work ourselves and listening to the feedback of others, we observed a frequently occurring craving for a set of codes in the performances that we as spectators/participants could understand. When the performances were prescriptive regarding instructions, rules of behaviour or creating a clear atmosphere, then spectators/participants were more willing to participate. Spectators commented that these considerations from the artists allowed them to confidently handle the constant renegotiating of power that was expected from them whilst they continuously discovered and rediscovered the contract of spectatorship and participation that worked *for them*. We discovered that it was not always the physical acts of participation, such as sharing with words and actions, that had the greatest impact on the performance narrative; instead, it was often when the spectator/participant had decided to intellectually and emotionally engage in a less visible way with the work that a more meaningful act of co-creation occurred. For instance, the decision shared by both Emma in *1993* and the spectator/participant in *Hive* not to speak.

On reflection, by grading the routes according to levels of risk and control, we set into motion an overly dualistic viewpoint of these concepts. The groupings of the performances were based on the notions that *retaining* and *surrendering* control were safer than *taking* control. However, what we discovered in practice was that there is vulnerability and power in both *taking* and *surrendering* control that can offer either comfort or risk with the nuances between these being both subtle and highly personal. How spectators managed the invitation to *surrender, share* and *take control* depended on them as individuals, bringing with them to any performance their personal histories (Heddon, Iball and Zerihan 2012, 130) which fundamentally affect how spectators will receive and respond to the invitations that the various performances provided.

References

Harvie, Jen. 2012. *Fair Play: Art, Performance and Neoliberalism*. Basingstoke: Palgrave Macmillian

Heddon, Deidre, Helen Iball & Rachel Zerihan. 2012. 'Come Closer: Confessions of Intimate Spectators in One to One Performance.' *Contemporary Theatre Review* 22 (1): 120–133.

8 A Performatic Archive

Kerrie Reading

This short chapter addresses a practice-as-research experiment that was generated by undertaking research in the archive of Chapter Arts Centre, Cardiff, UK. Based in a former school, Chapter was founded in 1971 by artists Christine Kinsey and Brian Jones and journalist Mik Flood, to provide ample space to host artists and present an array of work, from film, visual art to theatre. During the 1970s it both produced and presented performance work, which was a model adapted by Flood after visiting the Mickery Theatre in Amsterdam and seeing the relationship that the venue built with its visiting companies. Flood was particularly interested in how the theatre groups and the venue worked in collaboration, and he was keen to establish the same methods at Chapter. It was his objective to ensure venues were active partners in the process of making the work, not merely ticket sellers. He stated at the time that the 'commitment must be made beyond the show' and that he wanted to 'see a move away from product towards an emphasis on process' (Flood 1977) The residency scheme model that Flood adopted was to bring companies in for a 2–4 week process where they made the work *within* the building and then presented it. This not only gave a base for the company to present but allowed Chapter to become involved as producers. My research focus has been on the first decade of the venue's operation, as this period was crucial in establishing its reputation as a leading arts venue in Europe.

Within my experiment I set out to approach the archival documents as 'detritus,' a term used by Reason (2003) to reconfigure the archive. The leading question in much of the recent debate on documentation and archiving has been, as Reason frames it, '[h]ow can we know live performance through its representational traces?' (2006, 4). Here, I am reformulating and extending this question to include the venue in which the performance takes place, with the overriding question for my research becoming: how can we understand the place in which live performance happened, and its impact on the performances it hosted, through its representational traces? This foregrounds the relationship between the venue, performance and the archive, and this initial investigation allowed me to begin understanding how Chapter made work in the 1970s. The experiment sought to use performance-related material from

the archive (especially performance photographs and scripts) as stimuli to create what I term a 'performatic' archive.

In *The Archive and the Repertoire*, Diana Taylor introduces 'performatic' as an alternative term to 'performative' 'to denote the adjectival form of the non-discursive realm of performance' (2003, 6). She argues that through 'shifting the focus from written to embodied culture, from the discursive to the performatic, we need to shift our methodologies' (16). While performance documents might usually be counted among the realm of the discursive, I use the term 'performatic' to argue that the archival document can be approached in an embodied way that is able to make it (a)live and be open to interpretation, rather than viewing them as fixed and authoritative documents.

With these thoughts in mind, my practice seeks to develop an embodied and performatic archive of Chapter Arts Centre through engagement with its saved documents. Consequently, the archive becomes a performed object, and its meanings can be shared collectively and publicly. This chapter is a reflection on my first piece of practice that arose from this research.

Figure 8.1 Chapter Arts Centre, Cardiff, Archives. Photography Kerrie Reading.

Creating a Performatic Archive

In September 2012, I began my explorations into Chapter Arts Centre's past. At this point I knew I wanted to engage with the project through the mode of performance, but I was unsure what the impetus to begin this would be. The Art Centre's archive is stored away in a room with no public access; this would later become an important consideration of the work since making something performatic opens it to the public. I was intrigued about what I might find in this room as I was told that the material on Chapter's early years in the 1970s was sparse. This was the era that I was most keen to explore (as I wanted to engage in how it became a leading arts centre), and I would seek to discover this through looking at a range of archival material including, for the first investigation, its performance history.

The first archive folder that caught my eye was of a production of *Woyzeck* in 1977 by The Pip Simmons Theatre Group, the first company to partake in the Arts Centre's residency scheme. *Woyzeck* was performed using almost the entirety of the building—an early example of what would now be called immersive or site-specific theatre.

The documents were sparse, consisting of: reviews from local and national papers; photographs of the performance taken from reviews; a programme of the production; a reordered script of Georg Büchner's play of *Woyzeck*; a rewritten scene one (The Barber Shop scene) stapled to the front of the script; handwritten notes about props, reviewers, audience capacity. I was, therefore, not in a position to be selective, but rather simply create a new piece of performance with what remained of this production. I spent my time examining and (re)ordering the materials, creating a performance score to work from where I attempted to piece *Woyzeck* together via fragments of information. I experimented with ways in which I might present these reimagined documents to an audience. My relationship to the archival material became integral to this process, which became about how I would give these past documents (which were effectively 'dead' and locked away in boxes) a new sense of life, liveness and relevance. I did not want to merely attempt to re-enact the performance, but rather mix the materials all together and see what would come out of them in the live moment.

I ordered the documents, I disordered them, I rearranged them, I took from them and I gave to them. I displayed them and stared at them. I recorded my thinking, I erased and I re-recorded. I began layering the materials, I learned the words of the materials and I added my own music. Through this process the documents were beginning to become (a)live, they no longer belonged on the page but, through a performatic approach, they were becoming something new, something corporeal.

In November 2013, I presented what I had formulated from these remains. *Playing (at) Woyzeck* was a ten-minute devised work-in-progress, presented at the Chapter-based *Experimentica* festival. The piece aimed to reconstitute bits of Pip Simmons' performance from the materials that have survived in the archive. It was a solo work that used disembodied voices, instructions, physical performance and present-day music in an attempt to give the documents a contemporary presence.

Figure 8.2 Playing (at) Woyzeck, Kerrie Reading, Chapter Arts Centre, Cardiff, 2013. Photography Warren Orchard.

This was not a re-enactment of the original, but rather it functioned as a methodological enquiry that arguably produced a performatic archive through approaching the remains as 'detritus,' described by Reason in relation to the archive:

> The idea of detritus as archive is also not so far from the state of archives: but the archive as detritus turns around the presumptions of neutral detachment, objectivity, fidelity, consistency, and authenticity—instead claiming partiality, fluidity, randomness, and memory. And having abandoned claims to accuracy and completeness, such an archive is able to present archival interpretations, proclamations, and demonstrations, consciously and overtly performing what all archives are already enacting: dumb objects not allowed to speak for themselves, but spoken for.
>
> (2003, 89)

If we consider the archive as detritus, two things happen: firstly, one must accept that the pieces that make up the detritus are scattered and can no longer be put back together to form an original, coherent whole; and secondly, the documents now exist both on their own and in relationship to others, including additional accumulations that have nothing to do with the original at all. I would like to suggest that this is where the archive becomes performatic: not through

A *Performatic Archive* 147

remaking an original to which the documents once belonged, but by generating something new, something that can be viewed as contextually relevant for today, yet still speak about the past from the place of the scattered archive. The scattered archive of detritus becomes the primary impetus for generating the performatic work. The detritus of an archive is less authoritative and therefore lends itself to becoming performatic through its openness.

Pip Simmons' *Woyzeck* was a turning point in how Chapter operated as a venue and was therefore a significant moment in its history, yet the documents from this work had hitherto been locked away in a room or remained only in people's memories. This experiment brought the work back to life for past audiences, with some of Chapter's audience from its early days present, due to the performance being part of a larger event called *Marking Time: A Coach Trip into Cardiff's Performance Past*, by Mike Pearson and Heike Roms. Through activating the documents, history was activated.

Playing (at) Woyzeck as an enquiry became about making the archive *live*, giving documents a life outside of the box in a way that not only assessed their potentiality in the immediate but also looked at the wider implications. In response to Phelan's famous proposition that 'performance's being becomes itself through disappearance,' (1993, 146) Reason argues that 'performance also endures' (2006, 1) and posits how, when performance is represented in its various forms, something of that performance remains. He suggests that discussion should also focus on 'what exists outside or beyond or after live performance [. . .] things that are not performance, but which allow us to see and say something about performance' (2006, 3). Responding to this perception, the next stage of my performatic archival experiment was therefore to investigate documents that do not have an immediate relationship to a performance event but can potentially reveal something of what happened within a venue, e.g., administrative documents, finance records, correspondence and venue plans.

Using the term reconstitution, rather than re-enactment (or related terms such as restaging or reconstruction), signalled that this was not an attempt to replicate what was presented in 1977. *Playing (at) Woyzeck* was an experiment in ascertaining what historical and artistic significance the traces of materials from past performances have for today, through examining them, interpreting them and making them (a)live. The re-constitution was very much about me trying to understand a performance history with which I was not familiar, and trying to make meaning from the documents for myself as a practice-based researcher.

The performatic archive gave the research an immediate impact as it reached a wider (and non-academic) audience, for which it potentially awoke an interest in the venue's history. It has the capacity to not only give life and liveness to documents, but also to create shared moments—the audience becomes new witnesses to an event and new memories are generated. A performatic archive privileges the transformative quality of the document and archive, rather than viewing it as something authoritative and unchanging. It thus contributes to the continual cycle of the making of an art that is supposedly always at the 'vanishing point' (Blau 1982).

148 *Kerrie Reading*

References

Blau, Herbert. 1982. *Take up the Bodies, Theatre at a Vanishing Point*. Champaign, IL: University of Illinois Press.

Flood, Mik. 1977. 'Chapter Theatre—Plans for 1977/78.' *National Library Wales*, CCC D/C/20/70, WAC.

Phelan, Peggy. 1993. *Unmarked, The Politics of Performance*. London and New York: Routledge.

Reason, Matthew. 2003. 'Archive or Memory: The Detritus of Live Performance.' *New Theatre Quarterly* 19 (1): 82–89.

Reason, Matthew. 2006. *Documentation, Disappearance and the Representation of Live Performance*. Basingstoke: Palgrave Macmillan.

Taylor, Diana. 2003. *The Archive and the Repertoire, Performing Cultural Memory in the Americas*. Durham, NC: Duke University Press.

9 Theatre of Bone

Rebecca Schneider

Brilliantly resplendent on the face of the small bone disk is the unmistakable visage of a person—an actor—wearing a theatrical mask. Turned in profile, the mask and the masked actor we partially see behind it, looks off to the side. Through the classical downturn of the mask's large and open mouth, a small boney tongue still flickers. In fact, this little masked bone-face, relic of the Roman Empire, has ridden Western history all the way through its Dark Ages, its Renaissance, its Enlightenment and industrialisations, across the sprawling anthropocene to our mutual 'now.' The circle of bone gazes out at us even as the little masked face looks off to our left, calling or responding to some tragedy just out of view. What does it see? The vast and violent obscene of Empire.

I am in the basement of the RISD Museum of Art in Providence, Rhode Island. It is fourteen years into the second millennium since the birth of Christ, as these things continue to be counted. The bit of bone was carved in the first century B.C.E and Rome, on the cusp of its Christianity, had not yet scorned the theatre. Curator Gina Borromeo hands this object to me in a small box, together with the plastic gloves I can use to 'touch' it. I extend a hand. I'm initially sad that I can't meet the bone precisely pore to pore. But as I reach out and pick it up, I almost feel in advance its certain smoothness. In the hollow of my hand, I feel its minor weight. It strikes me that one historical thing we can know about this object is clearly still true: the token would have sat perfectly in the palm of an 'ancient' hand, if such a hand can be called to the scene, just as it does so today, 2,200 years later. Then, as now, it can easily pass, hand to hand, like a coin. Even through the thin layer of plastic, I feel this aspect of its currency. It is made to pass.

With the disk in my hand, it seems a strange question to ask whether I am experiencing the object live. Of course I am, in that I am living, and experiencing an encounter with the disk in a cellar in an archive in the twenty-first century. But the question is complex. If the coin (let's call it that for now) is part of an ongoing scene—say, the long Roman Empire—then the bone face and I are both playing parts in an ongoing *live* scene. The degree to which we live in the twenty-first century, late capitalist 'developed' world, is the degree to which we are solidly what philosopher Jacques Derrida called 'globalatinized' (see

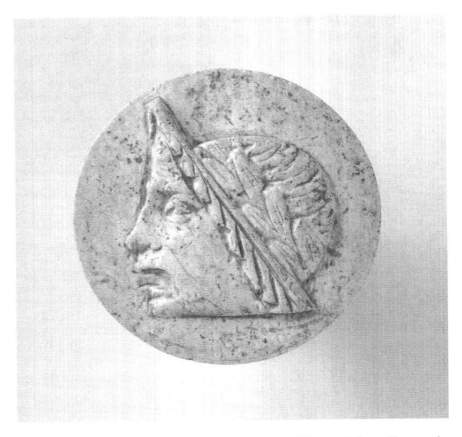

Figure 9.1 Roman Gaming piece, 1st century CE. Bone. Diameter 3.2 cm. Photography Erik Gould. Courtesy of the Museum of Art, Rhode Island School of Design, Providence.

Derrida 1998:11, Mignolo 2005:92, Agamben 2011). This is to say that detritus of the Roman Empire includes the living—many empiric habits, many settler-colonial assumptions, circulate within that ongoing empire much as this bit of bone has been doing. This is one way of suggesting that we still live within the empiric purview of this small masked player. If we live in that empire, not only among its ruins but *as* its ruins, then who is to parse one liveness from another (see Johnson 2009)? We cannot completely separate, in this sense, the being 'live' in time of the bone from the being alive of Gina and myself here in the small room with it. I, Gina, the bone, the plastic gloves, the light, the table, the room itself are all a part of this liveness or livingness, in a basement scene, off stage from the museum proper (descendant, as obscene, of the Latin *obscaena* (offstage)). And as momentary as it was (our meeting with the bone lasted an

Theatre of Bone 151

hour) and banal as it was (as an archivist, Gina does this kind of work every day), it was also a scene of significant duration, spanning, if you will, millennia, in which this bit of bone has been passed hand-to-hand-to-hand and in which hands have reached out to receive it.

Yet clearly, we can't stop there and just say that being in an archive with an object is experiencing it live. For, if our meeting with the bone was live, as I have just suggested, it was not *only* live. Surely the bone is also evidence of another sense of passing—not only the passing hand-to-hand-to-hand, but the passing of year upon year, eon upon eon, of *discrete* scenes and contingent historical encounters, most of which are, if not completely lost to us, then certainly no longer live. Or no longer *entirely* live. They have passed on.

Think of the appearance of this bone *in utero*, nested within an animal foetus within an animal mother, following a scripted molecular drama of other bones in other animal bodies in other times. This bone, then, as part of a bigger bone being of animal species, repeating itself across generations. Think, too, of the bones of the human hand encountering the animal bone. Imagine the first hands to carve this little bone, to feel its little tongue and enable its possible words. Bone separated from bone by the flesh of fingers. The bones of those particular human hands have likely long turned to dust and circulate on air, like pixels, or have otherwise petrified or become sedimented, no longer discernible as discrete objects. But even if the particular animal body and human hands have passed away, the work of those hands, that is, the handicraft of carving, may have been passed on as technique, and thus may be more easily found. *Those* hands, hands that carve, may yet remain.

But what of the first uses of this little bone disk? What was it used for before it became a 'relic'? The uses to which we put the bone now—as relic—are different than the uses when it was *in play* in the first century Rome. Now the disc is both art and evidence of a time supposedly past. Scholars have variously called similar bone disks coins, game tokens, or theatre tickets. Today, the disk has value as a museum artefact, but is not passed hand-to-hand anymore as a token or a coin or a ticket exchanged for goods or services or as a surrogate for the player of a board game. And so the prior uses are no longer live even as the bone is clearly a player in our live scene in the RISD basement. In this scene, the bone stands as evidence of other scenes nested in sets of historical contingencies that are long past. As such, is it fair to say that I am experiencing the coin/ticket/token *only* live? If it had been a coin, the exchange rate has certainly changed. If a theatre ticket, the show has long closed. If a game token, then the players have long dispersed. So, while there is a live encounter between us, the other scenes this disk would have witnessed or enabled are somewhere off screen, out of the present picture, *ob scene*—if not entirely lost.

Gina and I pass the small disc back and forth between us as we discuss it together. Was it a ticket? A coin? We don't really know what it actually was, says my host, but it was not a coin. She is adamant about this, though I beg to differ. It may have been a 'theatre ticket,' as theatre historian and classical scholar Margarete Bieber would name such objects (1961, 247). Others, like Elizabeth

152 *Rebecca Schneider*

Alfoldi-Rosenbaum, would see such 'tesserae' as 'game counters' used either on mobile game boards or on mosaic games sedimented in place (1971, 1–9). But it being a game counter does not necessarily cancel its use as coinage for, as Archer St Clair argues, gaming pieces were 'undoubtedly used in commerce and as gambling tokens as well' (2003, 111). And theatre? Alfoldi-Rosenbaum, adamant that the tokens are not coins, also argues with Bieber, claiming the tokens have 'no relationship to the theatre' (Spielman 2012, 21).

No relationship to theatre? The tiny actor's masked face suggests otherwise. Something of ancient theatre persists in the object even if the object was not used in the theatres themselves, or exchanged exactly like tickets or coins. For, of course, something of gaming, and of circulation and exchange, belongs as much to theatre as it does to coinage. As Jennifer Wise argues in *Dionysus Writes:* 'The rise in the use of coinage just prior to the appearance of drama helped determine that the theatrical stage was, and remains, a mercantile space' (2000,181). In fact, upstairs in the RISD collection, a coin from Naxos winks at me from behind a glass case. Dionysus, the god of theatre, is on one side; Silenus, his chief satyr, on the other. In this case, coinage and theatre are (literally) flipsides of the same coin.

At the very least, the small bone token invites us to recalibrate our contemporary understanding of theatre and art to a more ancient worldview, when theatre and game were not as distinct as we sometimes imagine high art and popular sport to be today. The great theatre festivals in Greece were, after all, competitions. In the vibrant world of variety entertainment in Rome, competition for favour from audiences could reach fevered peaks. And as Renaissance historian Stephen Greenblatt has claimed, wherever live theatre flourishes one can find the 'circulation of social energy' that also motivates economic exchange—the passing of coins from hand to hand (1989, 1–20).

But Gina and I were not at the City Dionysia, nor the sixteenth-century Globe. We were in the basement, in an archive, backstage of the twenty-first century Museum. And the player we were considering was not exactly 'live' in the conventional sense. For example, we couldn't quite see what the bone face sees and couldn't quite hear what the bone face hears. (The back of the coin is empty of carving—smooth and white like a faceless moon.) What the wee actor might be saying, or the mask might be seeing, is anyone's guess. Held in the palm of a hand, the little masked face might 'see' a wide arc of fingers or, turned toward the palm, the little mask might 'see' the rutted crease of a fleshy lifeline. If, that is, bone can 'see' or 'sense' the flesh that holds it. If, that is, objects participate as sensate subjects in events. And why not? As Slavoj Zizek recites, wearing a mask of Jacques Lacan (or his famous sardine can): 'I can never see the [object] at the point from which *it is gazing at me*' (1992, 125).

Generally, we parse the animate from the inanimate along anthropomorphic lines of bias. We don't often ask about the sensations of objects themselves—art or otherwise—or openly acknowledge the 'feelings' objects might experience in relation to us. Instead, we consider subjects to sense and objects to be insensate. Feelings are for people to have, not animals or objects, or so we are

Theatre of Bone 153

generally taught. It is people who are conventionally at the top of an 'animacy hierarchy' (Chen 2012, 23–30; Schneider 2015), and liveness, lived experience, and all the things that go with living—feelings, thoughts, sensation—are commonly considered to belong most properly, if not entirely, to humans. Conventions of humanism, anthropomorphism and the long arm of the Western Enlightenment, have allowed that subjects have feelings but objects are only felt. Objects, like puppets or actors who are objectified by viewers, are conduits to feelings, but the feelings such objects may appear to have are not considered *their own*. Conventionally, to ascribe feelings to objects is to anthropomorphise them or overestimate their agency in relationship to the feelings they provoke. For objects can provoke feelings, surely, and in that we grant them a *kind of* agency. But for objects to have their own agency as well as their own feelings, the idea of sentience would have to jump the bounds of bios that customarily limit it and take up residency in *inanimate* life. Conventionally, sentient beings are *living* beings, at the very least. And though since the 1960s some scientists have conceded that plants think and feel (Pollan 2013), for the *in*animate to think and feel requires a bolder leap across the habit of the animacy hierarchy.

While many in the academy have granted credence to the idea that objects carry affect (thus the noted 'affective turn' in the humanities), that affect is usually considered to be on loan, or on hold, laminated onto objects by *human* use, growing like a patina over time. Affect (understood as the residue of human use or the result of manipulation, such as carving, effected by human agents) may be sheltered by preservation, protected in museums, archives, or the private collections of the wealthy. But assumptions about affect as only human, or the trace of humans, are being questioned today by a variety of scholars in several academic 'movements' including, most productively, the 'non-human turn' and the new materialism (Coole and Frost 2010; Grusin 2015). W. J. T. Mitchell's *What Do Pictures Want* (2006), for example, usefully explores the agency of objects and, in the process, redeploys outmoded words from the bowels of modernist primitivism. Words like 'fetish,' 'totem' and 'animism' are brought out of boxes, dusted off and put to work again (though, in Mitchell's work, carefully, with attention to the legacies of colonialism just *ob scene*). Think also of Jane Bennett (2010) for whom matter is not only animate but 'vibrant'; Bruno Latour (2005) for whom objects become 'actants'; Karen Barad (2007) for whom matter is agential and intra-active; Graham Harvey for whom affect is the result of many forms of animate beings only some of whom are human (2005, xi). Each of these writers might invite us to think about the ways in which 'experiencing live' is not limited to a human capacity, nor necessarily only to the so-called living, but a matter of what I have elsewhere termed 'inter(in)animation' (Schneider 2011, 7).

Gina puts the little face back in its box. It's hard to see the cover go back on top, although I wonder if the bit of bone isn't somewhat relieved—I've been staring rather rudely. As I get ready to leave, Gina hands me a photograph, and there is the bone in replica on a glossy 8x10. 'I can send you a digital image as well if you'd like,' she says. I'd already snapped a few on my phone when she had

stepped out of the room but I assumed her's would be better quality. 'Yes,' I say, 'please do.' I hold the glossy photo in my hands for a moment before sliding it inside the pages of a book for safekeeping in my backpack.

Walking back to my car I think it all over. The travels of this little object have lifted off, from its manifestation in a mode made for passing hand-to-hand, and catapulted the face into the realm of pixels and light. The game token, two millennia later, continues to circulate, but do we still experience it live? Are circulation and exchange still effected hand-to-hand if the touch of our hands is now through keyboards (another kind of plastic), the exchange of gaze between the disk's 'eyes' and ours is one mediated by a photographic image? Does it matter that the bit of bone is now masked by the virtual image that surrogates it? The weight of the little disk, like its smoothness, is lost to the screen, that's true. But when Gina sends the email attachment and I open it with a touch of my finger, the image that opens onto the screen hails me, without question (see Bernstein 2009, 73). Like a gesture, it inaugurates relation. And the flicker of the little tongue reminds me that the mask *is a mask* after all. As a mask, it has, like a mask, always dissimulated, always been an image of surrogation, even on bone. This is to say that its agency has been the theatrical real as well as the material real (a problem that will require further thought, I tell myself, downloading and saving the disk to a file).

That evening, remembering the bone tucked away in a Providence basement, the scene of the photograph of the bone disk as a digital image on my screen passed across my mind. I had to admit to myself a certain uncertainty or, better, a sense of unease about the *ob scene, unheimlich*, off stage right of the mask. On the screen, like on the bone, the little face still seems to see what it sees off screen (even if we cannot). Be quiet, the tragedian sharply intones and a hush falls across the crowd over the threshold of the bone's own future. I can almost hear it, flickering a line not yet written in its own time: 'Oh, woe is me, I have seen what I have seen, see what I see!' Children of Rome, playing a game with tokens, laugh and extend their hands. It is their turn next.

References

Agamben, Giorgio. 2011. *The Kingdom and the Glory: For a Theological Genealogy of Economy and Government*. Palo Alto: Stanford University Press.

Alföldi-Rosenbaum, Elizabeth. 1971. 'The Finger Calculus in Antiquity and the Middle Ages: Studies in Roman Game Counters.' *Frühmittelalterliche Studien* 5: 1–9.

Barad, Karen. 2007. *Meeting the Universe Halfway: Quantum Physics and the Entanglement of Matter and Meaning*. Durham, NC: Duke University Press.

Bennett, Jane. 2010. *Vibrant Matter: A Political Ecology of Things*. Baltimore: Johns Hopkins University Press.

Bernstein, Robin. 2009. 'Dances with Things.' *Social Text* 27 (4): 67–94.

Bieber, Margarete. 1961. *The History of the Greek and Roman Theater*. Princeton, NJ: Princeton University Press.

Chen, Mel. 2012. *Animacies: Biopolitics, Racial Mattering, and Queer Affect*. Durham, NC: Duke University Press.

Coole, Diana & Samantha Frost. 2010. *New Materialism: Ontology, Agency, and Politics.* Durham, NC: Duke University Press.

Derrida, Jacques & Gianni Vattimo. 1998. *Religion.* Palo Alto: Stanford University Press.

Greenblatt, Stephen. 1989. *The Circulation of Social Energy in Renaissance England.* Berkeley, CA: University of California Press.

Grusin, Richard, ed. 2015. *The Nonhuman Turn.* Minneapolis: University of Minnesota Press.

Harvey, Graham. 2005. *Animism: Respecting the Living World.* New York: Columbia University Press.

Johnson, Odai. 2009. 'Unspeakable Histories: Terror, Spectacle, and Genocidal Memory.' *Modern Language Quarterly* 70 (1): 97–116.

Latour, Bruno. 2007. Reassembling the Social: An Introduction to Actor-Network Theory. Oxford University Press.

Mignolo, Walter. 2005. *The Idea of Latin America.* London: Blackwell Publishing.

Mitchell, W.J.T. 2006. *What Do Pictures Want: The Lives and Loves of Images.* Chicago: University of Chicago Press.

Pollan, Michal. 2013. 'The Intelligent Plant: Scientists Debate a New Way of Understanding Flora.' *The New Yorker.* 23 December. Accessed at http://www.newyorker.com/magazine/2013/12/23/the-intelligent-plant.

Schneider, Rebecca. 2011. *Performing Remains: Art and War in Times of Theatrical Reenactment.* London: Routledge.

Schneider, Rebecca. 2015. 'New Materialisms and Performance Studies.' *TDR: The Drama Review* 59 (4): 7–17.

Spielman, Loren R. 2012. 'Playing Roman in Jerusalem: Jewish attitudes toward sport and spectacle during the second temple period.' In *Jews in the Gym: Judaism, Sports, and Athletics,* edited by Leonard Greenspoon, 1–24. Purdue, IL: Purdue University Press.

St. Clair, Archer. 2003. *Carving as Craft: Paletine East and the Greco-Roman Bone and Ivory Carving Tradition.* Baltimore: Johns Hopkins University Press.

Wise, Jennifer. 2000. *Dionysus Writes: The Invention of Theatre in Ancient Greece.* Ithaca, NY: Cornell University Press.

Zizek, Slavoj. 1992. *Looking Awry: An Introduction to Jacques Lacan Through Popular Culture.* Cambridge, MA: MIT Press.

Part 2

Materialising

Introduction

Matthew Reason and Anja Mølle Lindelof

Consisting of six full-length chapters and nine shorts, this section brings together different perspectives on the qualities or properties of the *live* work of art. Here we are influenced by Tim Ingold's (2013) articulation of creative processes as occurring between sentient practitioners and active materials. What happens we when relate this concept of 'active materials' to the context of live performance?

There is a deliberate and not unproblematic tension here, between the notion of materiality and the concept of liveness. One seems redolent of matter, stuff, things; if we think of materials we might think of stone, canvas, paint, clay, all of which we can hold in our hands and work. The other has, at least partially, been defined by its ephemerality, by its disappearance, almost by its lack of materiality. Of course, within performance—within dance, music, theatre, live art—there are plenty of *things*, plenty of materials: from puppets to costumes, props to instruments, bodies to loudspeakers, digital toolboxes to wind and weed, and the various contributions in this section often engage with the properties and utilisation of these kinds of materials. However, we are also tickled by the possibility of thinking of the material of liveness itself: particularly those more intangible aspects of live performance, including time, presence, resonance, memory, community and witnessing.

Ingold describes how 'the experienced practitioner's knowledge of the properties of materials [. . .] grows out of a lifetime of intimate gestural and sensory engagement in a particular craft or trade' (2013, 29). The experienced practitioner develops a knowledge of their materials—again we might list them, from puppets to loudspeakers—but also, we would propose, develops a knowledge of liveness as a kind of material—as something that has properties and qualities that can be worked, crafted and handled. That can be used to generate particular kinds of relationships and particular kinds of affects. In this collection we are interested in the material of liveness, in the act of making something live, in the properties of liveness and in the manner in which these qualities are structured and composed in acts of performance. The contributions to this section explore questions of temporality, archive, improvisation, scenography, composition and technology, as they examine the processes and implications of the materiality of live performance.

158 *Matthew Reason and Anja Mølle Lindelof*

The section opens with a fundamental question: 'What is a live event?' In addressing this, and with reference to musical improvisation, **Gary Peters** explores how thinkers such as Derrida, Deleuze and Badiou have in different ways sought to question the notion of being 'in the moment'. Suggesting that the live has more to do with the event-ness of the live than the liveness of the event, Peters turns away from the interest in presence and ephemerality and towards practice and rehearsal—investigating processes that lie outside the 'now' of the live event but are nonetheless necessary to it. In what reads like a deliberate improvisation, the chapter rehearses the answer, suggesting that the live event is materialised—is brought into liveness—through all the spontaneous choices made possible by habits of practice, through sensation and surprise, because of the enjoyment of enjoyment that 'intensifies and thus enlivens the event as a unique moment of lived time.'

Musical improvisation is also the point of reference for **Steve Tromans'** investigation of the temporal nature of improvisational music making. His chapter, 'Improvising Music Experience: The Eternal Ex-Temporisation of Music Made Live', explains time as a mode of practice rather than a medium of presentation. Fostered by a distinction between duration and eternity—a conceptual tool borrowed from Deleuze and Guattari—and by reference to other musicians' practice, the chapter explores intensity, flow and interruption as it has been discussed by Csíkszentmihályii, Massumi and Spinoza. Tromans argues that improvised music-making's failure to endure beyond its time of performance enables another kind of survival, which he describes in terms of sensations of intimately-felt intensities.

Both these chapters embrace the ephemerality of live performance as a kind of material substance, and thereby deliberately challenge the dictum that Tromans (with reference to Carolina Abbate) formulates as a main rule in the research into performance: 'document or die'. In contrast, the next two chapters engage explicitly and critically with such object-focused criteria of performance studies. Through a discussion of key texts by Auslander, Phelan and Amelia Jones, **Jonah Westerman** examines historical and theoretical propositions of liveness in the discourse of performance art in his chapter: 'The Place of Performance: A Critical Historiography on the Topos of Time'. Through a historical account of how the non-reproducible character of performance art has been validated because of its ephemeral, transitory and unique qualities, Westerman highlights the way in which the binary of absence and presence haunts performance studies with its temporal bias through which time becomes ahistorical. Illustrated by an analysis of Marina Abramović's 2010 installations at MoMA, and its lack of historical contextualisation, the chapter argues for a need to pay closer attention to the specific temporal and spatial circumstances in which we encounter performance art.

Lisa Newman also engages critically with a key discourse of performance art as she discusses the use of bodies as artistic material. Her chapter, 'Objectifying Liveness: Labour, Agency and the Body in the *11 Rooms* Exhibition', examines the curatorial and institutional strategies in exhibiting live art, specifically

in relation to bodies as a form of labour. The process of casting bodies that represent certain qualities needed for a specific exhibition—whether disabled, beautiful or supposed to look like the artist in an original performance event they re-enact—raises ethical and political dilemmas, as it turns interactive art practices into repeatable and commodifiable products. Newman shows how the social and economic value of such objectified live is negotiated within the context of a commodity-based art market.

While these two chapters take on the debate within the body-cantered discourse on performance art, the next two contributions engage with the concept of liveness in non-human performance. In 'Reconsidering Liveness in the Age of Digital Implication', **Eirini Nedelkopoulou** reflects on Mark Hansen's notion of 'phenomenology of implication'. Through analysis of United Visual Artist's work *Rien à Cacher, Rien à Craindre* and its use of ubiquitous technology in the hi-tech, panoptic environment of the re-launched La Gaîté Lyrique, Paris, Nedelkopoulou shows how human and non-human participants become part of a larger operation. Liveness, in networked performances, she argues, is anchored in different modes of interactivity, which are not always bound to conscious decision-making. Technology becomes diffused in the physical space while the participants become implicated in the project's networked processes. While Nedelkopoulou discusses the role of digital interactive technology in the performance ecology, the next chapter, 'Environmental Performance: Framing Time' has nature as its non-human agent. Co-authored by **Anja Mølle Lindelof, Ulrik Schmidt and Connie Svabo**, the chapter examines how environmental performances frame the temporality of the natural world. The non-deterministic nature of these performances—from the slow rotting of a compost heap to the changing of a skyscape—has an irreducible duration. Through framing this duration—quasi-theatrically—spectators enter into a relationship of liveness in which their attention, their presence, at once alters nothing but yet is experientially vital.

<p style="text-align:center">★ ★ ★</p>

Paul Carter writes of how 'material thinking occurs in the making of a work of art. It happens when the artist dares to ask the simple but far-reaching question: What matters? What is the material of thought?' (2004, xi). From sometimes very different contexts the nine 'shorts' in this section are all written by practitioners (often consciously researcher-practitioners) which we have grouped together for the manner in which they engage with the material of liveness.

The first three shorts could each be considered as dealing with the materiality of time, a feature already discussed in several of the chapters in this section. Time isn't an object, but as these shorts demonstrate it is something with affective and relational properties that can be worked, framed and contextualised. **Mathias Maschat and Christopher Williams** present an experiment in musical improvisation, producing scores that both question and construct the time of their 'live' performance—at once something past, recorded by its

documentation, and something present and actively performed in the reading of the scores. The time of the performance becomes an ever allusive 'now'—which is always also a then, a past, a gone. A now that is simultaneously present *and* past is also a feature of **Craig Dworkin**'s textual experimentation in what we might describe as a hyper-self-conscious act of live writing—which becomes a hyper-self-conscious act of live reading. Attempting to continually comment on time in time ('It has been one second since I began typing this text') Dworkin's text extends the notion of ephemerality (lasting but one day) to that of utter simultaneity—the live must continually begin again and again. **Paul Forte**, meanwhile, takes the materiality of time to the extreme of commodification, presenting a 1977 performance project *Time Table* for which he sold a minute of his time for one dollar to anybody who requested it. Now re-presented as documentation and reflection, it is interesting to consider whether these minutes have a re-sale value, whether such documented moments of time have the same materiality as any other moments of time. Certainly, the act casts time in a particular manner, materialising time as something that, as Forte comments, is 'suspended in time.'

In their shorts **Dugal McKinnon** and **Martin Blain** engage with the processes and practices of technology in musical performance, a context in which the basic binary opposition between the live and the mediatised is redundant. Instead, for both writers there is concern for the exact experiential and material properties of technologically produced sound in performance: how is it heard, how does it occupy space, how does it relate to an audience? For Blain the consideration is how acoustic transparency might be established during 'laptop performances', in which there is no recognisable connection between the gestural features of the performers controlling the laptops and the performance's audio-visual expressions. For McKinnon it is the search for perceptual transparency that fuels his investigation of the arbitrary relationship between the enthralling and somatically powerful auditory objects and the mere physicality of the immersive loudspeaker systems. Liveness in 'loudspeaker music', he argues, happens precisely due to absence of performer and performance, and in the presence of the loudspeaker.

The final three shorts resist grouping thematically, but share a kind of attitude or nature of engagement—that is, of reflective and experimental live practice. Each presents a process of thinking, of decision-making, of working with the material of performance—which might variously include animatronic puppets, film, text, but which also includes the material of liveness. **Allen S. Weiss** discusses the *Theater of the Ears* and he observes how in a performance of 'pure orality' the 'problem became how to induce people to come to a theatre to listen to a CD!' This is also, of course, a question of 'why?' which we might relate to all live performance: why should people attend in person? For Weiss, the partly pragmatic solution was a kind of marionette theatre, but the vital question is really: what were the consequences of this solution—what are the differences of attention or relationship that resulted? **Mike Pearson**'s account of the National Theatre Wales's production *Coriolan/us* similarly traces a set of

decisions made, the product of a collaborative process and of a material process. The result was something Pearson terms a 'live film enacted on the equivalent of a sound stage'. As this description might suggest, much of what the audience experienced was mediated—specifically via screens and headsets—and yet this mediatisation was utilised in order to manage, focus and stage a distinctly live experience. In the final short in this section **Judd Morrissey and Mark Jeffery**, of performance collective ATOM-r, draw upon computing to describe liveness in terms of the concurrent execution of multiple processes or flows of information. Considering that a work might have a two- to three-year process of generation, an asynchronous sense of liveness might entail various kinds of 'live' encounters and relationships—such as research visits to Bletchley Park, Buckinghamshire, and Derek Jarman's cottage at Dungeness, Kent. For Morrissey and Jeffery such experiences have presence within the work, underlining how their 'experience of the live could be described in terms of a ritual of double or divided presence'.

In our discussion on audiencing we proposed that experience (at least when meaningful, when felt, when remembered) is an active relationship, rather than a passive or neutral state. We can have plenty of experiences, but it is our active participation with and in them that transforms them into *experiences*. What these shorts reveal are the complex and diverse manner of the active relationships that practitioners have with the material of liveness. These are not passive relationships—the qualities and properties of liveness are never unconsidered or taken for granted—but instead represent active and conscious working with the material of the live.

References

Carter, Paul. 2004. *Material Thinking: The Theory and Culture of Creative Research*. Melbourne: Melbourne University Press.

Ingold, Tim. 2013. *Making: Anthropology, Archaeology, Art and Architecture*. Abingdon: Routledge.

7 What is a Live Event?

Gary Peters

The Absence of the Event

This chapter will start by assuming that there is something particular, often special, about a live event, something that most people would acknowledge without necessarily knowing or understanding exactly what the essence of this particularity is. As such, the primary concern here will not be the nowness of the 'now' so frequently conceived as the central pillar of the live event but rather, the pre-history and post-history of the event as embodied in the regimes of practise and rehearsal necessary to preserve (re-originate) the live event.

And in advance, the discussion of improvisation here functions only as one possible means of highlighting certain overlooked particularities (or peculiarities) of the event rather than offering any particular insights into improvisation itself. It is the oft-assumed tension or even contradiction between practising, rehearsing and improvisation that will be considered, as a means of shifting the emphasis away from the performative/existential nowness of the live experience (or the experience of liveness) towards what might be called the ontological absence/presence of the evental, understood and considered in the self-emergent terms of *autopoiesis*. It is this displacement that will suggest a reconceptualisation of the live event as a *rehearsing* rather than a *happening* space. Or, put another away, what makes what happens live a 'happening' is the preservation of the event—that has always already happened—as an essential moment of the 'now.' Thus, it is the implications of the Heideggerian term *preservation* of the event that will be one, if not the most important focus of the following reflections.

Much of what follows draws upon the work of Martin Heidegger, Gilles Deleuze and Alain Badiou; for all three the event is never present but has always already happened. If, to use Badiou's language, the 'site' of the event is never within the present 'situation,' then the sense of authenticity that is often sought in the perceived purity of the improvised live event—its 'truth'—can itself only attain authenticity if it is recognised that what is live is not the event itself but the repetition of the event as an act of being-true-to its legacy, an act of 'fidelity' (Badiou 2001, 67ff). This affirmation not only keeps alive a memory of a

164 *Gary Peters*

past occurrence, but through this affirmation ensures a future for the event that, nonetheless, remains absent from the liveness of the moment. Putting aside on this occasion the fundamental disagreements between Badiou and Deleuze, the latter nonetheless captures this same thought:

> The event [. . .] in its impassibility and its impenetrability has no present. It rather retreats and advances in two directions at once, being the perpetual object of a double question: What is going to happen? What has just happened? The agonizing aspect of the pure event is that it is always and at the same time something which has just happened and something about to happen; never something which is happening.
>
> (2004, 73)

Does this mean that there *is* no live event? If the event has always *already happened* or is *about to happen* then what exactly *do* we experience at a live event? Obviously, we are aware, thanks in part to Philip Auslander, that the experience of liveness can, contra Peggy Phelan, be just as intense when witnessing a performance that has already happened and is endlessly reproducible. But do these different (and now somewhat entrenched) positions really grasp the essential issue, which has more to do with the event-ness of the live than the liveness of the event? What both of the above perspectives on liveness share is what Derrida described long ago as a 'metaphysics of *presence*.' While this is obvious in the case of Phelan, it is just as true of Auslander, given that whether what is experienced in the live moment is produced or re-produced, embodied or disembodied it is nevertheless valorised as a presence, 'now.' For both Auslander and Phelan, liveness *is* presence, regardless of its immediacy or mediacy: but is it? If that were the case what role could, do or should *practise* and *rehearsal* play in the construction of the live event, given both their necessity and the fact that they are situated *outside* of the 'now' of live experience?

Practise/Rehearsal

It is possible to distinguish practise and rehearsal: practising is essentially linear, progressive and teleological, whereas rehearsing is circular, regressive and without an ultimate goal. Practising is inherently futural; rehearsal is inherently historical (and thus also responsible for the continued, albeit discontinuous, 'happening' of the past in the present and the future). Practising is a form of work, but it is one in service to either the mastery of a 'work' or the mastery of a practice, understood as a body of work, where the verb becomes a noun, and acts become things or skills. Practising is intentional, the intention being to progress within the parameters of given performative benchmarks; rehearsing is retentional and protentional. Rehearsal is not concerned with self-improvement but with the retention, preservation and the continued 'happening' in the future (protention) of what is already given as a *working* rather than a work; that

is to say, as ontologically eventual rather than existentially eventful. The intentionality of practising is focused primarily on the solidification of chance idiosyncrasies and tics. Technical facility, prowess and virtuosity become, through practise, defining *properties* of the self that can and often do take on moral, spiritual and even mystical (certainly *mystifying*) qualities for audiences hungry for 'special moments' and 'special ones.' But where practise serves the development of technical facility, rehearsal preserves what might be described here as a performative knowingness that, while essential to technique, is either obscured or, indeed, obliterated by mere technicality. It is precisely this ontological distinction between technicality and τεχνή (*techne*) that Heidegger works so hard to readdress in his, so often misunderstood, 'critique' of technology. Here is his description in 'The Question Concerning Technology':

> *techne* is linked with the word *episteme*. Both words are names for knowing in the widest sense. They mean to be entirely at home in something, to understand and be expert in it. Such knowing provides an opening up. As an opening up it is a revealing. Aristotle [. . .] distinguishes between *episteme* and *techne* [. . .] with respect to how and what they reveal. *Techne* [. . .] reveals whatever does *not* bring itself forth and does *not* yet lie before us.
>
> (1977, 13)

We might say, then, that practise relies upon a body of existing knowledge (*episteme*) that can be *put into* practice, the transference of what lies before us, and is already known, from one domain to another. Rehearsing, on the other hand, can be understood as an enactment of *techne* to the extent that it is a form of *knowing* rather than a knowledge of the already given. Such knowing, while 'entirely at home' and thus profoundly habitual (*habere*), is a form of dwelling (*habitus*) that is at home in the very *unhomeliness* of the homely (1971a, 161). *Techne*, unlike *episteme*, brings forth what does *not* lie before us; the unfamiliar and the extra-ordinary: what Badiou would call the 'naming' of the eventual 'void' (2001, 69). Practise *prepares* the improviser for a negotiation with the unknown, rehearsal does not. Rehearsal has nothing whatever to do with the *love* or *fear* of the unknown, any more than it does with the dramatic uncertainties of the live event. Interestingly, it is precisely this fact—this dwelling *within* the unhomely—that makes rehearsal so vital for the event-ness of the event. Practise ensures that something *will* happen, in spite of all the (sometimes stage-managed) uncertainty, a live event *will* take place no matter what. But ultimately, this is all quite trivial: it is not that *things* happen which is significant but rather, *that* things happen—the *happening* of what happens—that is what enlivens the live and 'brings forth' the event-ness of the event.

Machination, Lived Experience and the Live Event

While it might be true that the improviser has no (or limited) knowledge (*episteme*) of what will happen in an improvisation, the improvisatory act—as

techne—is, as Heidegger insists, *already* a form of knowing or knowingness that is ontologically prior to and essentially other than the technicalities and 'machinations' (Heidegger 2012, 99ff) of the knowledge economy. But, to reiterate, Heidegger is not merely reviving the ancient concept of *techne* in order to 'critique' the technical and machinic; on the contrary, his aim is precisely to reillumine or *rehearse* the essence of machination, which (and this is the point) he sees as ontologically obscured by its apparent opposition to what he sees as the promotion and valorisation of 'lived experience' in modernity. For our purposes this interrogation of the hidden relation between machination and lived experience will be extended into the discussion of the creative act experienced as a live event.

To clarify, for Heidegger machination (*Machenshaft*) is essential to what he understands as the event of 'beying' (Heidegger utilises an antique form, *das Seyn* rather than the modern *das Sein*, which in some translations is rendered as 'Being' or 'be-ing:' the being-ness of being/beings). In essence, such makeability originates not exclusively in the technical productivity/creativity of 'man' but in what the ancient Greeks called φύση meaning the self-emergence of nature or beying. The importance of *techne* (similarly obscured by its modern reduction to mere technicality and technique) is the manner in which it mediates between nature and 'man' (or beying and beings) through its inherent duality, one that might be conceived as the co-existence of knowingness and know-how. For Heidegger, knowingness is rooted in wonder, wonder at the self-emergence of nature, or to use his language, the 'making itself by itself' (2012, 100) of beying. Know-how by comparison is rooted in the creative productivity of 'man' understood as the translation and actualisation of wonder in the act of fabricating a world. It is the extent to which this world comes, historically, to be understood almost exclusively as the arena for the lived experiences of 'man' as maker that compels Heidegger not (as is often claimed) to 'critique' modern machination, whereby experience replaces wonder, but, on the contrary, to reveal their belongingness. Here is an extended, but still radically abbreviated passage from *Contributions to Philosophy: Of the Event* which hopefully captures some of what Heidegger sees as the transition from this the *event* of machination to the *experience* of machination and the concealed belongingness within the perceived opposition.

> The name machination should immediately refer to *making*, which we assuredly know as human activity. This latter, however, is possible precisely only on the grounds of an interpretation of beings in which their makeability comes to the fore [. . .] The *making itself by itself* is the interpretation of φύση [self-emergent nature] carried out by τεχνή [techne] and its outlook on things [. . .] Since φύση is starting to lose its power at the time of the first beginning, *machination* does not yet step into the light of day in its full essence [. . .] the machinational now thrusts itself forward more clearly [. . .] through the Judeo-Christian thought of creation. [. . .Thus] the

What is a Live Event? 167

cause-effect connection comes to dominate everything. That is an essential deviation from φύση and is at the same time the transition to the emergence of *machination* as the essence of beingness in modern thought. [. . .] the more decisively machination conceals itself in this way, all the more does it press toward the predominance of that which seems completely opposed to its essence and yet is of its essence, i.e., toward *lived experience*. [. . .] If machination and lived experience are named together, that indicates an essential belonging of the two to each other but at the same moment conceals an equally essential *non-simultaneity* within the 'time' of the history of beying [. . .] Yet even when machination takes definite form, as in modernity, and shows itself in popular interpretations of beings, it is not recognised as such and certainly is not grasped. (2012, 100–101)

Heidegger, in this text, goes on to conclude that it is specifically 'mechanistic and biologistic modes of thinking' (100) that obscure the originary *event* of machination through a humanisation, individualisation and subjectivisation of the machinic in modern technocratic/bureaucratic *life*. Here, one might say, the 'self-made man' replaces self-emergent beying and individual productive output replaces the *autopoiesis* of what might be called (following Bergson) 'creative evolution.' Thus, as is well known, Heidegger 'turns' towards art (and particularly poetry) in his later philosophy in an effort to disclose and preserve the event of machination concealed by the machinic experiences of a manufactured world: formalised, commodified and indeed *grasped*. But before falling into the trap of thinking that Heidegger simply turns to art in order to 'critique' modern technology and the domination of science (including the 'lifeworld' and 'lived experiences' of the human sciences), we should be mindful of the fact that, for him, the concept of 'creation' and the subsequent lionisation of the cause-effect model of individual creativity is also *itself* a primary 'deviation' from the event of self-emergence that he is intent on preserving. So, thought in these terms, the creativity of the 'creative arts,' so often celebrated as an antidote to the mechanisation of modern culture is, sorry to say, every bit as machinic as the machinations of mechanistic and biologistic thought. Taking our cue from Heidegger then, we might consider the extent to which 'lived experience' as he understands it and the live experience, or the experience of liveness being considered here, are *all* in equal measure deviations from and thus concealments of the originary event of the live.

To be clear though, the real crux of the problem here is neither life, the lived nor the live but rather, *experience*—very much a modern, post-Kantian *concept*. The moment life is reduced to the singular experience of the 'transcendental ego'—the imagination/understanding of the self-reflective subject—is the moment the self-emergence of beying is 'forgotten' or 'abandoned': that is the issue for Heidegger. Similarly, the celebration and promotion of liveness or 'the live' as a claimed, intended or assumed intensification of experience in general—'*An Experience*' of the 'real,' the 'authentic' and unmediated

168 *Gary Peters*

(or mediated) 'presence'—is only conceivable existentially as a series of happenings, occurrences and episodes *within* the lived space-time of the subject's lifeworld. For Heidegger it is precisely this that conceals the 'worlding of the world' *itself*, outside of the human: something that points forward to the contemporary 'object-orientated philosophy' of Graham Harman and others. The interruption of the dead weight of everyday experientiality by the sudden immediacy of the 'live' assumes a concept of creativity that *makes* things happen in the 'now' and the experience of the 'moment.' But it is precisely this existential creative act of making, one that *grasps* the moment and *makes* something happen that, Heidegger would say, reveals the secret belongingness of the machination of beings (performers, artists let us say) and the concealed machination of beying. Looking ahead to the discussion of Deleuze below, we might say that it is not the concept of creativity that should be paramount in the account of liveness but rather, the 'creation of concepts,' the creation of space-times *within which* concepts operate; a creativity that, being prior to concepts, is not subject to the subjective machinations that concepts allow: hence Deleuze's notion of 'passive creativity,' a close relation to Heidegger's the self-making of beying.

Returning now to *techne* and Heidegger's use of this mode of knowing as a way of remembering the ontological essence (or 'origin') of makeability and technology, it is clear that his primary concern is not with the production of artworks, crafts or performances—'*techne* never signifies the act of making' (1971b, 59)—and yet it is, as suggested above, a creative act. As mentioned, Deleuze argues in 'What is a Creative Act?' (2006) that what all disciplines or domains have in common (philosophy, science, painting, film making, music, performance . . . and so on) is the 'formation of space-times.' (315) In other words, it is not what happens and is experienced within the space-time of, let us say, a live improvised performance that is the essential creative act but, to repeat, the creation *of* the space-time within which the performance happens—the happening that allow things to happen—that is the event. And, once again, the evental is here understood, with Heidegger, as a form of 'self making,' or 'self-positing' as Deleuze and Guattari describe it.

> Creation and self-positing mutually imply each other because what is truly created, from the living being to the work of art, thereby enjoys a self-positing of itself, or an *autopoetic* characteristic by which it is recognized [. . .] What depends on a free creative activity is also that which [. . .] posits itself in itself: the most subjective will be the most objective. (1994, 11)

Difference, Diversity and Habit

Let us stay with Deleuze. In *Difference and Repetition* he differentiates difference and diversity, (1994, 222) which he thinks in relation to the repetition of difference and the repetition of the same (and remember that rehearsal is *repeater* in French). Glossing this, we might speak of the *same difference* (diversity) and

What is a Live Event? 169

a *different sameness* (difference). This in turn suggests the following: that in preparation for an improvised live event, *practise* enables the improviser to manufacture in advance a *diverse* repertoire of 'solutions' to imagined 'problems' that might occur in the performative confrontation and negotiation with the unknown. But it is not just a question of know-how; the 'in the moment' moment leaves no time for the careful consideration of the epistemological structure and available resources that allow a performer to perform, it is not what you know but what you *do* that counts. The ability to translate knowledge into action, in the blink of an eye, is something that needs practise. This should remind us that practising is not primarily about mastering what you know or what is available to be known but rather, of transforming such knowingness into habit. It is only by doing this that a performer could ever be prepared for an improvised performance, and it is the endless repetition of what we know that allows us to forget it—as habit—when we are required to act *now*. Obviously, the best habits are those that have built (or ground) into them the greatest degree of flexibility and diversity when faced with the unknown, and it is this skill set that promises the most when it comes to audience expectations of surprise and wonder and the subsequent valorisation of liveness.

Conversely, rehearsing creates a *different sameness*. Practise operates at the level of choice, in that endless repetition and the conscious formation of 'good' habits, it allows the performer to *choose* different improvised strategies within the performative moment. Rehearsal operates at the level of *decision*, where the decisive moment is, while enacted in the now, the *a priori* 'canonization of being's improvisations' (Malabou 2005, 74) to use Catherine Malabou's striking phrase, where chance is transformed into habit. Not just the habit of doing but, more essentially, the habit of *being*—'Plato's commitment to philosophy, Pericles' to politics, Phidias to sculpture'—to use Malabou's examples (74). Here commitment is not being used as an existential category, where the subject commits to his or her art practice and the self-identity that this brings with it (the artwork and the artist), but ontologically as that which one is committed-to (as one is committed-to the asylum), there is no voluntarism intended here. Just as Heidegger sees the *working* of Art (rather than the work of art or the artist at work) as *decisive*, so beneath or behind the necessary 'dissemblance' of practise lies another form of repetition that, to repeat, creates a different sameness rather than the same difference produced by such practise. In a sense then, practising and rehearsing take place simultaneously, one creating performative habits, the other repeating (or re-enacting) the decisive *transition* of chance into habit and the origination of one's singular habitual fate.

Practise allows the practitioner to develop a practice that is stable enough and recognisable enough (habitual enough) to allow a live performance to take place; practise is, thus, a form of preparation. As such, the *practice* is a given at the moment of any live event, but the *practise* necessary to produce and maintain this practice must cease before the commencement of the live event itself.

This is not at all the case with rehearsal, understood in the ontological sense. Indeed, it is as a work of *re-hear-sing* (to indulge in some long-resisted Heideggerian wordplay) that the live event attains to the very liveness and event-ness that is so cherished by performers and audiences alike. In other words, rehearsing is not the preparation for, but the *preservation of* an event: the (forgotten, Heidegger would say) transition from beying to beings, or (with Deleuze) from the virtual to the actual, or (with Malabou) from being's improvisations to singular habitual acts.

All of those days, months and years of practising are fixated on the fixing of the unfixed in order for a performance to take place; but the liveness and the event-ness of a performance are directly related to the sense in which (and the sensation of) the fixity of creative practise and practice is *unfixed* as a moment of repetition. Not the repetition of technical skills (*episteme*) as a performative spectacle—'public and accessible to everyone'—but the repetition of an act of knowing (*techne*) that clears a space-time within which truth (Heidegger/ Badiou) or the sensible (Deleuze) are dis-closed.

Perhaps the live event can be best understood as the *re-enactment* of the decisive moment when Art becomes artist and artwork, or Performance becomes performer and performed work. Understood in this way, and recalling Heidegger, the liveness of the event is not primarily about the live experience of the performer and/or the audience as living embodied creatures existing together in a unique *now*. No, the liveness of the event relates to two times: an originary moment that is, over time and habitually, fixed in the creative act; and the performative time of preservation where this act is re-enacted, unfixed, and thus *re-enlivened* and revivified. The rehearsal of this does not cease prior to the commencement of the live event but is, rather, the defining characteristic *of* the event: all events are rehearsals. When they are not, they are neither events in the evental sense, nor are they properly 'live': lived perhaps in the most banal way, but that's not the focus here.

Of course, liveness means that something must be happening *now*, but it is not the nowness that is essential or, we would say, eventual, but *that* it is happening now that needs to be sensed. Of course, liveness bespeaks a unique moment that is unreproducible, but this is trivial if we fail to acknowledge the fact that each of these pristine unreproducible moments are themselves the actualisation (or preservation) of a decisive moment-movement-transition that can only be re-called, re-heard and re-lived to the extent that it can be reproduced. True, the liveness of live events cannot be reproduced, but that does not change the fact that, ontologically, they are already and inescapably reproductive in nature, what Deleuze would describe as an order of simulacra, and Heidegger as 'dissembling' (1971b, 54). As such, live events are a mixed economy, containing both a productive and a reproductive moment, a creative and preservative dimension or, as I shall suggest in the conclusion, activity and passivity. Needless to say, it is the productive/creative aspect that receives most attention in our celebration of liveness, something further exaggerated when

an event is improvised and thus promoted as an encounter with the surprising and the unexpected.

Happening and Surprise

But alongside this, something different happens, or *can* happen, or *must* happen if we are to speak of an event in the strict sense, rather than merely acknowledging the fact that something happens. Such happening is not in itself surprising in the usual sense, in fact it is always the same and to that extent, and in the ontological sense discussed famously by Heidegger, profoundly *boring* (1995, 74–180). So why then is it such common practice to mobilise the language of surprise when trying to grasp the event-ness of the event? Jean Luc Nancy here offers a typical example:

> The 'surprise' is not only an attribute, quality, or property of the event, but the event itself, its being or its essence. What eventuates in the event is not only that which happens, but that which surprises—perhaps even that which surprises itself (turning it, in short, away from its own 'happening', not allowing itself *to be* event).
>
> (1998, 91)

Derrida, too, sometimes falls back on a conceptualisation of the event as that which attends the surprisingness of the unscripted, the impromptu and the unpredictability of an improvised situation, as he does here:

> I must say, ultimately, what is happening here, to the extent that it was unforeseeable, that it was unanticipated for me—since we improvised to a large extent—is that an event will have taken place.
>
> (2007, 239)

Here, as elsewhere, Derrida shows himself to have a peculiarly pure and undeconstructed notion of improvisation, one that, in demanding absolute unpredictability, is bound to fall short and expose its own impossibility—hence, the wariness Derrida often admits when finding himself (as he often did) in the midst of an improvised situation. As he states in *Derrida*, the feature film directed by Kirby Dick and Amy Ziering Kofman (2002):

> I believe in improvisation, and I fight for improvisation, but with the belief that it is impossible.

As with the 'impossible possibility of saying the event,' Derrida here plays a double game with improvisation, both fighting for its possibility while, at the same time, denying its possibility. The result is that improvisations are always seen as ultimately doomed to failure and the surprise of the event is always compromised by the possibility of its inevitable impossibility.

172 *Gary Peters*

But, perhaps Derrida is here becoming unnecessarily entangled in the aporia of possibility-impossibility and the investment of the subject (whether performer or audience) in the *live experience* of the event and its possibilities, rather than recognising, with Nancy, that the surprise of the event 'is not a surprise for the subject. No one is surprised.' (1998, 101) In fact, whether improvising is possible or not, just as whether speaking the event is possible or impossible, quickly becomes a matter of indifference the moment we recognise that the peculiar alterity of the event is one that is exterior to what is considered *humanly* possible or impossible: '*it* is boring,' (Heidegger 1995, 135) '*it* happens.'

What Deleuze describes as the 'defect of the possible' (1994, 212) is that, contrary to the view that the realisation of possibilities epitomises the improvisatory production of endless difference, such realisation is 'produced after the fact, as retroactively fabricated in the image of what resembles it' (212). It is not so much, then, that practise makes perfect but rather, that practise makes possible, and the more we practise the more we make possible—which in Derrida's eyes results in a saturation of the improvisatory field to the point where improvisation itself becomes impossible.

Virtuality, Actuality and Sensation

Something else is happening, something to do with liveness, with the physicality of the performance, the proximity of bodies, the fallibility of the human, the phenomenological intensity of the 'flesh' and the nowness of the *now*. This is what lovers of live performance love above all else: the unmediated, unreproducible and unwonted happening of improvisers improvising. Yes, but something else is happening. For Deleuze the relation between possibility and reality, through the becoming of realisation, locks us into a regime of resemblance—of 'like to like'—that produces only 'pseudo-movement' (212). Instead, he proposes the non-dialectical, disjunctive binary of virtuality and actuality mediated by the becoming of actualisations that *do not* resemble that which we actualise. It is this non-resemblance that, for him, makes possible both creativity and performance.

> Actual terms never resemble the singularities they incarnate. In this sense, actualisation [. . .] is always a genuine creation [. . .] For a potential or virtual object, to be actualised is to create divergent lines which correspond to—without resembling—a virtual multiplicity. The virtual possesses the reality of a task to be performed.
>
> (212)

The key term for Deleuze is *sensation*, and it is the degree to which we can *sense* the actualisation of the virtual alongside or in addition to the experience of surprise and the proximity of the human body that we bear witness to the event-ness of the event. While implicitly acknowledging that phenomenology's

valorisation of art as the locus of affect appears to bring us close to the sensation of the event, it is precisely this proximity that most effectively *obscures* the event-ness of this very event:

> the being of sensation is not the flesh but the compound of nonhuman forces of the cosmos, of man's nonhuman becomings, and of the ambiguous house that exchanges and adjusts them [...] Flesh is only the developer which disappears in what it develops: the compound of sensation.
>
> (Deleuze and Guattari 1994, 183)

As the reference to the 'ambiguous house' testifies, prior to the affectivity of the human body is a compound space or territory within which, and from out of which the human becomes what it is. As with Heidegger (1971a), Deleuze and Guattari give priority to dwelling above the dweller, a perspective that again brings us back to habit as an essential component of the live event. Here we should note the importance of *habitus* not only as the originary dwelling place of the live performer/improviser, but as the preterritorial and nonhuman swarming of habitual forms and functions that crystallise into the 'expressive features' of the virtual: 'the canonization of being's improvisations.'

So, to our live improvised event: the habits of practice, and all of the spontaneous choices they allow, are in full flow which, in turn, excite a phenomenological experience of the other as human body and flesh that intensifies and thus enlivens the event as a unique moment of lived time. To be sure, all of this helps us to understand the celebrated liveness of the live event, but the event-ness of the event remains obscure and will continue to do so unless we can find a way of further sensitising ourselves to the sense that 'something else' is happening. The difficulty is that, to follow Deleuze and Guattari's lead, we are required to hone human sensitivity to enable ourselves to sense the nonhuman, 'a world before man yet produced by man' (1994, 187). The difficulty is that what is 'produced by man' obscures the 'world before man,' and thus desensitises us to the pure force of sensibilia that courses through us all at the level of the habitual.

Here we see the advantage of Deleuze over Heidegger: where for the latter the 'singing' of beying can be 'hearkened-to,' but only in the obscure melody of the poet's dissembling intoning, Deleuze and Guattari obsessively catalogue the infinite components of the 'great Refrain,' (189) tracing the 'song's' territorialising-deterritorialising flight through the vertical multiplicity of the virtual 'total work of art' that both precedes and succeeds the actualisations of 'man.' But, and this is the essential problem, the vertical difference of the virtual, understood as multiplicitous blocs of sensation, is profoundly resistant to a sensibility habituated to the aesthetic pleasures of surprising diversity played out across the horizontal plane of live human improvisation, interaction and dialogue: performers and audiences and their mutual pleasures. For all of the dynamism of Deleuze's writing, the constant flight, becoming,

174 *Gary Peters*

nomadism, transformation, he is in fact attempting to describe something that, *within human lived-experience*, is always the same—the eternal return of the same—albeit a sameness that both produces and is the product of infinite transformation.

What we are trying to sense is a different sameness where transformation is not measured from lived moment to lived moment in terms of *what* is happening, but rather outside of the 'in the moment' moment where *that* it happened and *that* it will happen is the issue. As seen, for Deleuze the event has either already happened or is yet to happen; just as the event of song, while actualised (for us) through the human voice, is outside of the finite duration of the individual song: 'the song of the universe, the world before or after man' (189).

If liveness is all about what happens in the moment of performance—in the now—then this, to say it again, would seem to contradict the very concept of a live *event*. And yet perhaps the eventness of the live event is not the momentary occurrence of an habitual practice, but rather the keeping alive—the preservation through rehearsal—of a *sensibility* capable of registering (re-hearing) the event of habituation outside of the public display and spectacle of human foibles and manners, and not just keeping alive the sensibility but, through sensation, the event *itself* in all of its infinite multiplicity.

Passive Creativity

Keeping alive this infinite multiplicity seems like a lot to ask of those attending or experiencing a live event. It sounds like a demand that we try a bit harder to sense the eventality of the event or the liveness of the live rather than just getting on with enjoying the performance. It sounds like a lot of unnecessary work dreamt up by philosophers who have forgotten what it means to have fun. But that's not it at all: the truth is there is no work involved in this; to sense is not to labour. Sensation, unlike perception or conceptualisation is not an act: sensation is the epitome of *passivity*. It is the event that works on *us*, we are *created by* the event to the extent that we are 'true' (show fidelity) to it. Bringing Heidegger and Deleuze back together, it is the machination of beying or the 'self-making' of the event that, in 'making' us as creative/making beings—subjects are subject-to the event—challenges our assumptions about agency and the so-called creative *act*, the challenge being to consider and confront the passive dimension of creativity.

As Ronald Bogue explains (ending with a passage from Deleuze and Guattari's *What is Philosophy?*):

> Sensation is fundamentally a conservation or retention of vibrations, a contraction of vibrations that takes place in a contemplative soul, *not through an action*, but a 'pure passion, a contemplation that conserves the preceding in the following [. . .] Sensation is pure contemplation, for it is through

What is a Live Event? 175

contemplating that one contracts, contemplating oneself to the extent that one contemplates the elements from which one arises.'

(2003, 181)

The challenge then, particularly in the hyper-active lifeworld of live performance, is to sense that which 'precedes' and 'follows' rather than the 'now' of the live act. This would require a certain disengagement from the action in order to contemplate a different order of passion, one quite distinct from the expressivity or intensity that has attained near regal status within the world of live performance. Does this mean then that the sensation of the event-ness of the event is only possible for those outside of the action, for the (contemplative) audience? Is sensation merely the passive reception, conservation and preservation of a creative act, rather than the act itself? Is it possible for the performer, as creator, to sense the event-ness of the event in the live moment of performance; or, following Badiou, is the event only recognised and acknowledged *after* its occurrence, when all, including the creator, have become an audience of preservers? In other words, does the absence of the event from the *lived experience* of the 'in the moment' moment, necessarily preclude us (either creator or audience) from sensing the eventual as a dimension of, indeed the essential dimension of, the liveness of the live?

One response to these questions would be to consider making a distinction between active and passive forms of creativity, with the former mapping onto the familiar process of practise and the conscious formation of performative habits discussed above, and the latter returning us to the decisive contraction-contemplation of habit at the level of Heideggerian beying, and as a condition of the very formation of a creative identity: the subject of rehearsal; the rehearsal of the event. It is the fact that Deleuze always thinks of the contraction and the contemplation of habits together that opens up the possibility of sensation/contemplation, having a 'mysterious' passive creative dimension:

Contemplating is creating, the mystery of passive creation, sensation. Sensation fills out the plane of composition and is filled with itself by filling itself with what it contemplates: it is 'enjoyment' and 'self-enjoyment.'

(1994, 212)

The question though, as regards the liveness and event-ness of the live event, is: can such active and passive enjoyment, as the contemplation of active and passive creativity, be sensed together, simultaneously, in the moment? Deleuze believes they can:

The contraction that preserves is always *in a state of detachment in relation to action or even to movement* and appears as a pure contemplation without knowledge. This can be seen even in the cerebral domain par excellence

of apprenticeship or the formation of habits: although everything seems to take place by active connections and progressive integrations . . . the occurrences, must [. . .] be contracted in a contemplating 'imagination' while remaining distinct in relation to actions and knowledge. Even when one is a rat, it is through contemplation that one 'contracts' a habit. It is still necessary to discover, *beneath the noise of actions*, those internal creative sensations or those *silent* contemplations

(213)

The discovery of this passive creativity beneath or within the active creativity of a performance is to introduce into the enjoyment of the moment another form of enjoyment that, while sensed in the 'now' is necessarily detached from the present as are the primary habits-contemplations that, as posture, lines of colour, sonorous blocs, enjoy themselves as a condition of their own nonhuman becoming or machinic self-emergence. To bring these 'silent contemplations' into the 'noise of actions,' to imagine/retain/preserve them as that which resonates with self-enjoyment is not only to experience the enjoyment of a performance but also to sense an enjoyment of enjoyment that *can*, to the extent that we can distinguish between the practising of a practice and the re-hear-sing of rehearsal, inhabit the live event.

References

Badiou, Alain. 2001. *Ethics: An Essay on the Understanding of Evil*. Translated by Peter Hallward. London. Verso.

Bogue, Ronald. 2003. *Deleuze on Music, Painting and the Arts*. New York: Routledge.

Deleuze, Gilles. 1994. *Difference and Repetition*. Translated by Paul Patton. London: Continuum.

Deleuze, Gilles. 2004. *The Logic of Sense*. Translated by Mark Lester. London: Continuum.

Deleuze, Gilles. 2006. 'What is a Creative Act?' Translated by Ames Hodges and David Lapoujade. In *Two Regimes of Madness*. 317–29. New York: Semiotext(E).

Deleuze, Gilles & Félix Guattari. 1994. *What is Philosophy?* Translated by Graham Burchell and Hugh Tomlinson. London: Verso.

Derrida, Jacques. 2002. *Derrida*. Feature film directed by Kirby Dick and Amy Ziering Kofman. Jane Doe Films.

Derrida, Jacques. 2007. 'A Certain Impossible Possibility of Saying the Event.' Translated by Gila Walker. In *The Late Derrida*, edited by W.J.T. Mitchell and Arnold I. Davidson, 312–24. Chicago: The University of Chicago Press.

Dick, Kirby and Kofman, Amy Ziering. 2002. *Derrida*. Jane Doe Films.

Heidegger, Martin. 1971a. 'Building Dwelling Thinking.' Translated by Alfred Hofstadter. In *Poetry, Language, Thought*, 141–60. New York: Harper and Row.

Heidegger, Martin. 1971b. 'The Origin of the Work of Art.' Translated by Alfred Hofstadter. In *Poetry, Language, Thought*, 15–86. New York: Harper and Row.

Heidegger, Martin. 1977. 'The Question Concerning Technology.' Translated by William Lovitt. In *The Question Concerning Technology and Other Essays*, 3–35. New York: Harper and Row.

What is a Live Event? 177

Heidegger, Martin. 1995. *The Fundamental Concepts of Metaphysics*. Translated by William McNeill and Nicholas Walker. Bloomington: Indiana University Press.

Heidegger, Martin. 2012. *Contributions to Philosophy (of the Event)*. Translated by Richard Rojcewicz and Daniella Vallega-Neu. Bloomington: Indiana University Press.

Malabou, Catherine. 2005. *The Future of Hegel: Plasticity, Temporality and Dialectic*. Translated by Lisabeth During. London: Routledge.

Nancy, Jean-Luc. 1998. 'The Surprise of the Event.' Translated by Lynn Festa and Stuart Barnett. In *Hegel After Derrida*, edited by Stuart Barnett, 91–104. London: Routledge.

8 Improvising Music Experience
The Eternal Ex-temporisation of Music Made Live

Steve Tromans

Artists live and die, artistic movements rise and fade, yet the artistry of prior generations continues to engage our sensibilities in ever new and interesting ways. In considering this longevity, one could easily be forgiven for assuming that an artist's enduring capacity to affect our senses is closely related to the medium of presentation of her/his artworks. The painter's canvas, the sculptor's monument, the composer's score, the author's publication: these are media that stand the test of time.

However, in concentrating our attentions on the role of an artist's media of presentation in these matters, we are at risk of undermining our understandings of the *experience* of his/her practice. To do so is to side-line—even to eliminate from consideration altogether—artists who operate in media of a far more fleeting nature than canvas, stone or print on paper. Think of the dancer, the actor, the performance artist or (in the case of the focus of this chapter) the improvising musician. How are we to understand the experiential impact, in and through time, of those who practice their art-making in performance, in and through time? Does the end of a performance mark the end of the art that was made during its event? These are the questions that drive this writing, with recourse to certain philosophical concepts drawn, principally, from the works of Gilles Deleuze (alone and with Félix Guattari), Brian Massumi and Benedict de Spinoza.

In what follows, I rethink our understandings of our experiences of artistry in terms of modes of practice rather than media of presentation. I argue that an artist's chosen medium or media is of less relevance to such understandings than perhaps we have tended to assume—an assumption that has side-lined performance as an art form demonstrating little potential for endurance or research worthiness, even, in terms of substance for enquiry. In so doing, I voice a critique of the recorded document and its prevalence in our theoretical enquiries into the practice of improvising music. My use of the term 'improvis*ing* music,' here (rather than the more commonplace 'improvis*ed* music') is in recognition of the dynamic nature of the music-making activities relevant to this writing. This distinction was brought to the author's attention in the work of the ethnomusicologist and improvising musician David Borgo (2005, 9 and 191–2).

As the musicologist and dramaturge Carolyn Abbate cautioned over a decade ago: 'actual live, unrecorded performances are [. . .] almost universally excluded from performance studies' (2004, 508). In the years since the publication of Abbate's attack on the object-focused criteria of performance studies, however, little has changed with regard to the place afforded 'live, unrecorded performances' in academic research. Document or die would appear to remain the primary rule of research in or into performance. Without a knowledge-object to analyse and present (and re-present) in one or another media, the performer-researcher's epistemological credentials evaporate as rapidly as their performances, at least where the latter are considered solely in 'ephemeral' terms (cf. Phelan 1993).

Given that I am an improvising musician, the grounding for my research explorations is plainly from the experience of improvising music in performance. However, it is my belief that many of the issues raised and discussed will find resonance with artists operating in other areas of the performing arts and the arena of performance more generally. I am a performer; I perform, therefore I am. I am, in the words of the anthropologist Victor Turner, '*Homo performans*' (1987, 81). Of course, as members of a society of sentient beings interconnected through all manner of complex socio-cultural practices, we each perform various roles in the course of our lives. However, performing artists are those for whom the act of performance is a disciplinary practice—a mode of existence, in fact, as a majority of those engaged in that existence will testify.

As the phenomenologist Thomas Clifton stressed, on the question of experiencing music: 'in the presence of music, I qualify my own ontology' (1983, 282). Through my own experience, my nature of being, in the act of improvising, is complexly related to that of the unfolding music as it emerges in the event of performance. In my capacity as an improviser, I am familiar with the experience of making new art in and through time, where such temporal grounding is not so much the *medium of presentation* of the art form in question as it is part and parcel of its *mode of practice*. In other words, given an event in which music is made in the course of its own performance (such as a concert of free improvising), I would suggest that our understandings of that music-making would be best served by attending to the various temporalities in (its) play. To adopt such an approach is to build on the philosopher Lydia Goehr's (1992) well-known critique of the concept of the musical work, and to propose a model of improvising music in which a number of experiential-temporal factors are brought into relation in the event of performance itself. These different aspects of temporality are essential to our experiences of performance and, in what follows, I explore our understandings of these temporal aspects from a number of philosophical perspectives, beginning with that of the *sensational*.

Sensation and Eternity

Writing in the early 1990s, the philosophers Gilles Deleuze and Félix Guattari theorised the role of sensation in the process of artistic creativity thus: 'We

paint, sculpt, compose, and write with sensations. We paint, sculpt, compose, and write sensations' (1994, 166). That great art is sensational and that all art engages our senses and our sensibilities is uncontested. But what do Deleuze and Guattari mean, specifically, in their use of the term 'sensation'? In their understanding, sensations are not 'perceptions referring to an object' but instead sensations refer 'only to its material' (166). To focus exclusively on the *object* of art is to fall into the trap of presuming the enduring temporal impact of an artist's practice to be a product of its media of emergence or capture (e.g., the score or transcription as representing 'the knowledge' proper to a musical act). I would argue that it is this devotion to the ideal of the object of knowledge that has hampered our previous understandings of the experiences of art made in performance. If, in Deleuze and Guattari's terms, sensations are not produced in reference to a given object but, rather, are part and parcel of how we experience the material of artistic creativity, we are offered a way of thinking beyond the object-centred. And, in addition, we are able to move our understandings of improvising music beyond a fixation with the media of its presentation to the (temporal) modes of its practice.

The material of the improvising musician who creates in the act of performance is decidedly short-lived in comparison to those of the painter, the sculptor, the composer, or the writer. After all, a note played must inevitably end, its eventual sonic decay an inherent property of its very nature. The specifics of that decay are many and varied, in accordance with complex factors such as the particularities of the instrument in question and the acoustics and set-up of the venue of performance. There are, of course, techniques of prolongation: strings can be bowed; notes played on percussion can be reiterated, rapidly, to give at least the illusion of a sustained sound; and wind players can circular-breathe. However, in spite of these strategies the cessation of sound is held off only temporarily. Sounds and performances alike are fragile states of affairs. With regard to this fragility, the sound artist Christian Marclay has argued that 'the true nature of music' is its 'impermanence' (2008, 140). For Marclay, improvisation is 'all about the present, you do it and then it's gone' (ibid). In resonance with Marclay's line of thinking, the improvising musician Eddie Prevost has argued that 'nothing is more dead than yesterday's improvisation,' adding how 'at least one feature of an improvisation is absent in a recording: that is, its *transience*' (1995, 60).

As much as I also find delight in that aspect of live music-making that infuses performers and audience members alike in a shared experience of the here-and-now, I would argue that when improvising music is reconceived in terms of the temporal we are provided with a link to the possibility of a survival beyond the momentary, or the present-oriented. In these terms, the failure of a performance to endure or to be documented (or, indeed, documentable), is less an indicator of its 'impermanence' (Marclay), or its 'transience' (Prevost), and more a reflection of its sensational and temporal character. But which aspect, or aspects, of the temporal?

Duration and Eternity

In further elaborating their theorisation of sensation, Deleuze and Guattari employed a curious distinction between two aspects of the temporal: *duration* and *eternity*. As they wrote: 'even if the material lasts for only a few seconds it will give sensation the power to exist and be preserved in itself *in the eternity that coexists with this short duration*' (1994, 166, emphasis in original). This distinction can be put to use in modelling the experience of performance before, during *and* beyond the event of its happening—including that elusive 'magic' quality of the truly affective performance, attested to and experienced by all at one time or another. This is the 'magic' one feels 'in the air' in relation to certain performances: that otherworldly, untimely quality which would be (and is often) easy to attribute to the working of powers beyond the human ken. The saxophonist Evan Parker has, for instance, been quoted as believing 'the best parts of his playing to be beyond his conscious control and his rational ability to understand' (Borgo 2007, 52). Although Parker is reflecting specifically from the perspective of the performer in action, I see no need to draw too heavy a distinction between the experiences of the performer and those of the audience in respect to the more mysterious qualities of performance. We are all 'in it' together, after all, in the event of its emergence—none stand outside the process, nor remain unaffected by its movements. However, I would argue that by making use of the kinds of conceptual tools proffered by Deleuze and Guattari we are able to move a little further in our understandings of the experience of performance, while yet not reducing all to a matter of mere rationality.

The intriguing distinction that Deleuze and Guattari make between duration and eternity has its origins in Deleuze's work on the philosophy of Benedict de Spinoza. First published in 1970, Deleuze's *Spinoza: Practical Philosophy* contains, for the most part, a reference guide, in dictionary form, to the main conceptual ideas found in Spinoza's seventeenth-century *Ethics* (1996). In the entry under 'Duration,' one reads the following: 'eternity is neither an indefinite duration nor something that begins after duration, but it *coexists* with duration' (Deleuze 1988, 63, emphasis added). The similarity to the wording in Deleuze and Guattari's (1994) theorisation of sensation (quoted above) is plain, regarding the coexistence of eternal and durational temporality. Further, duration is contrasted with the eternal in terms of its having a beginning; eternity, on the other hand, has none. Neither have an ending (62–63). The sensations inherent in the material of music made live in performance, therefore, are *not* a property of the durational time of that performance—as we would be led to assume from both the music-as-object model and the notion that the essential nature of any music performance can be captured by various media of documentation (audio, video, transcription, etc.). These sensations of experience are instead related to the eternal aspect of the temporality of performance: an eternity that, as Deleuze (with and without Guattari) made clear, is coexistent yet differentiated from the durational time of the event of performance. This eternal aspect

of performance temporality and its relation to sensation in our experiences of music made live are discussed further below. First, however, I examine the idea that durational time, in Deleuze's (1988) view, can have a beginning yet no end, and how this relates to our temporal experiences of performance.

In his *Ethics* (published posthumously in 1677), Spinoza used the term 'duration' to signify 'existence insofar as it is conceived abstractly, and as a certain species of quantity' (IIP45S).[1] This relates well to our rational/linear understanding of performance with regard to, for instance: the time measured out by the set or sets of an event of performance; the track lengths on an album recording; or the timeline on an audio or video player. These are examples of durational time, in Spinoza's terms (and note how he considered such temporal properties to exist in *abstraction*, rather than concretely, as our rational faculties would tend to prefer to model them). However, the force that drives a thing's abstract, quantitative existence, Spinoza proposed, 'involves no definite time [. . .] it will always continue to exist by the same power by which it now exists, unless it is destroyed by an external cause' (IIIP8). In this conception, I would argue, Spinoza brings us close to our experiences of performance, as it is ongoing, when considered from the perspective of its sensational temporal aspect. In the words of the violinist and composer Tony Conrad, on his creative practice in the 1960s with the viola player and composer John Cale: 'we hungered for music almost seething beyond control—or even something just beyond music, a violent feeling of soaring unstoppably' (Conrad 2000). Powerful, though not necessarily violent (at least not in the destructive sense), seething, unstoppable: these are the qualifiers that indeed signal 'something just beyond music' or, at least, beyond music as it is more traditionally conceived in terms of notes on a score or transcription, or data in an audio or video file. And also beyond time, considered in its commonsensical, everyday aspect in definite, linear terms. I am referring to that sensation of endlessness one is absorbed in as one experiences artistic creation in performance: an indefinite temporality, or rather a temporality wherein our more commonplace, rational definitions are irrelevant to the virtues of our lived experiences.

There are, of course, similarities here to Mihály Csíkszentmihályi's notion of *flow*: 'the state in which people are so involved in an activity that nothing else seems to matter' (2008, 4). Indeed, Csíkszentmihályi has defined one of the key characteristics of 'flow experience' as a sense of 'timelessness,' wherein one is 'thoroughly focused on the present' (2014, 237). However, reflecting on my experiences as an improvising musician, I would place less emphasis on the feeling of being focused in the present moment, or of being utterly immersed in a particular activity (at the exclusion of all else). Rather, I am more concerned with exploring the feeling that one is experiencing a temporality that is beyond the bounds of the rational/commonplace, and that brings into play a sense of endless movement—of performance without end.

Of course, even powerful, creative events of performance do indeed, and regrettably, conclude. Such conclusions are, however, experienced more along the lines of *interruption* and come about through the intervention of external

Improvising Music Experience 183

causes, rather than through any diminishing of the sensational aspect of those performances. Such conclusion/interruption is plain, when we consider the failure to endure of the sonic event: it is always the external that impinges on the singular thing that is a note played, or a performance given, bringing a cessation—of sorts. The inability of music made in the moment to maintain its audible existence is not a consequence of the driving force that brought it into existence in the first place (measured by its duration, with a beginning, but not an ending), but rather on account of the multiple causes of its destruction: instrumental sonic decay, the limits imposed by even the most enduring of reverberations and, ultimately, the definite point in time at which a given performance must finish. However, all is not lost in these conclusions: following Deleuze and Guattari, the sensational experience of performance lives in mutual coexistence with the eternal. And it is to this question of the eternal that I return in the sections that follow.

Intensity/Affect and Eternity

What, then, can we point to as indicative of the eternal in our experience of performance considered through its sensational (and beyond its media-bound) aspect? That which we cannot—should not—reduce to the rationality of the linear-temporal, or capture in one or more media of documentation, we are able, instead, to conceive in terms of *intensity*. In the words of the percussionist Gerry Hemmingway, on his experiences in the Anthony Braxton Quartet in the 1980s: 'there's a feeling of intense power [. . .] a feeling of suspension—and once you're inside it there's nothing that can describe it, an amazing feeling. It has to do with connection, where all four of you are really unified' (Lock 1988, 253). Intensity, suspension, connection: in spite of his professed inability to describe the experience of making music with Braxton's ensemble, Hemmingway in fact hits the nail on the head in terms of indicating the kinds of processes in action in sensational performance experience.

The philosopher Brian Massumi has developed this connection between intensity and temporal suspension further, writing: 'intensity would seem to be associated with non-linear processes: resonation and feedback that momentarily suspend the linear progress of the narrative present from past to future' (2002, 26). Performance has the power to ignite a complex process of resonance and feedback between the various, interconnected (human and non-human) 'entities' present—e.g., performers, audience members, instruments, various performance practices and aspects of a venue's set-up.[2] Either as performers or audience members, we become intimately involved in these intensive processes and the peculiar type of temporality we associate with them, in experiencing the creative acts of music made live in performance.

Drawing on my work in improvising music, I would add that despite the time-suspension that Massumi signals, during the intensity of music-making there is less a feeling of moving away from the temporal conditions of a given performance, than there is a sense of connecting up with 'non-linear' temporal aspects

of *other* performance experiences. In other words, I have found that the temporal experience is intensified, rather than negated. In resonance with Massumi, that intensity, and the processes we associate with it express a form of the temporal that is at odds with the narrative timelines more commonly imposed on our experiences in the world. The temporality of this other form is *ex*-temporal in nature, where intensity is 'like a temporal sink, a hole in time.' (ibid) I would speculate, from this perspective, that a lack of performer-engagement with the ex-temporal 'otherness' of the wider temporality of performance may contribute to that curious sense of 'non-event' one experiences in less intense instances of performance. The strange, otherworldly state of being we associate with high intensity in more 'eventful' performances is an eternal (ex-temporal) temporality that ever escapes the quantifications of linear representation. It remains, however, coexistent with the commonsensical temporality of past-present-future and is vital to our understandings of the potential longevity of sensational performance, but it is not reducible to the recorded document.

As the composer (and one-time improviser with AMM) Cornelius Cardew pointed out in his essay 'Towards an ethic of improvisation': 'documents such as tape recordings of improvisation are essentially empty [. . .] and give at best an indistinct hint as to the *feeling*' (1971, xvii, emphasis added). Following Cardew, it seems clear to me that rather than the 'empty,' impersonal analytic of the linear-temporal document (in any of its media-bound forms), it is our own felt experiences, in their living, multifarious intensity, that provide the most direct access to the eternal in the sensational. Through Massumi, our conception of intensity can be developed in terms of feelings and, more specifically, with regard to emotion and *affect*. For Massumi, intensity is 'qualifiable as an emotional state [. . .] a state of suspense' (2002, 26). The temporality of the suspended is that of the eternal. It is a suspension from everyday happenstance; a suspension, even, of the processes in which our emotional responses are clarified, which brings in the notion of affect. Equating affect with intensity (27), Massumi has posited a difference between emotion and affect in terms of their being 'ownable or recognisable': emotion is, while affect is not (28). If the affective remains forever irreducible to the codifications of emotion, then (maintaining the equation of intensity-affect) the temporal intensity of improvising music in performance is likewise resistant to representation in the dimensions of the document. However, it is not inconceivable that a *sense* of the eternal/ex-temporal can be evoked, given an appropriate philosophical modelling. And if the intensity-affect of the eternal/ex-temporal can be evoked through the senses, it will be felt, inwardly, and on a personalised level. It is to the matter of inwardly-felt intensity that I now turn, via Deleuze.

Fall and Eternity

For Deleuze, 'whatever the sensation may be, its intensive reality is a descent in depth that has a greater or lesser magnitude' (2005, 58). Through his philosophical encounter with the art-making processes of the painter Francis Bacon,

Deleuze developed a new series of critical and conceptual tools, including this curious conception of intensity and sensation in terms of descent—or that of the *fall*: 'all tension is experienced in a fall' (ibid). This conception may at first seem counterintuitive, given that we tend to think of tension/intensity in terms of *rising*: a rising up (though to where?) rather than a falling of any description. However, the 'depth' of Deleuze's falling intensity-sensation is not to be thought in everyday terms (i.e., as one thinks of a fall in the coordinates of space). Rather, the intensity of the sensational has a *non*-spatial nature; it is a 'most inward movement' (ibid). We feel that movement as we experience (though in internally-differentiated fashion) the sensorial intensity of performance (i.e., it moves us and we move with it). 'I was moved by the performance,' we say; not moved anywhere in terms of distance, but moved inwardly, on an affective level and, I would add, with regard to a certain species of temporality.

Resonating with Massumi on intensity as a 'temporal sink,' Deleuze's non-spatial conception of the fall moves us beyond the spatialising-temporal confines of media and quantification/linearity into the temporality of the ex-temporal/ the eternal and into the experience of performance in its enduring, sensational intensity. For Deleuze, the fall 'is what is most alive in the sensation, that through which the sensation is experienced as living' (2005, 58). It is, therefore, in internal/eternal not external/durational terms that our experiences of sensational performance can best be theorised in their intense, eternal nature, since these are the dimensions in which they themselves inhere—dimensions in which they live, and live on, beyond the event of performance itself. Although, the suggestion of living on (i.e., onward) beyond an event is, of course, a spatial/ linear metaphor and, therefore, relevant only to the durational aspect of performance, not to the concerns of its sensational-experiential dimension, which is characterised by an eternal temporality. At this point I return our attentions to Spinoza on eternity.

Performance and Eternity

'By eternity,' wrote Spinoza, 'I understand existence itself, insofar as it is conceived to follow necessarily from the definition alone of the eternal thing' (ID8). There is in these words the intimation of an experience of performance beyond the context of its event of emergence. I am referring to that aspect of performance that can be conceived in eternal, not durational terms. In the context of this chapter, it is the ex-temporal form of the temporally-grounded practice of improvising music in performance. This is what one *feels*—inwardly, intensively—when one is engaged in the process of improvising live. Of these matters of sensation and affect, I am able to speak from repeated experience in the event of performance. Through my work as a performer, I *know* of the intimate involvement of the ex-temporal in the making of music; there is more going on than can be rationalised in accordance with the durational aspects of time, but it need not remain unknown to our understandings of performance experience.

The eternal, as theorised in this writing, is an active component in the mode of existence that I am signalling (via Turner) as that of the *Homo performans*. Such a mode of existence does not survive translation into the media of documentation without losing that which gives it its essential quality in the first instance: what Spinoza called the 'essence under a species of eternity' (VP29). Following Spinoza, the essential qualities of the eternal cannot be conceived in terms of 'actual existence' (ibid), i.e., those things we enumerate according to the criteria of durational time, such as are betrayed in the acts of documentation and analysis. The 'essence' of the eternal has, instead, to be experienced live and, in being experienced, enters into relations with the ex-temporal dimension of our own modes of existence as performers and/or members of an audience. As with live performances, so with lives lived in and through performance: it is the *experience* that prevails, in excess of the more tangible elements in play.

We qualify our own ontology (via Clifton) in events of performance—these are acts of transformational experience, in and through time. As a performer, my experience of improvising music balances a co-existence (via Deleuze and Guattari) between the durational and the eternal. The durational, we know very well, in our studies of the documented (and documentable). However, as we move beyond the dominant notion that the media of documentation are adequate to the task of capturing and re-presenting a given performance (on the level of the sensational and the intensive-affective), I would argue that we are in a position to open a fresh epistemological perspective on that other aspect of improvising music experience: that which I have articulated in this chapter as the eternal ex-temporisation of music made live.

Understanding the 'essence' of performance beyond its durational-temporal aspects requires a kind of epistemological shift. Unless we are willing, in our enquiries, to consider—and to explicitly reference—the eternal, ex-temporal mode of performance (via Spinoza, Deleuze, Guattari, Massumi and others), we remain always within the limits of the object-oriented, spatialised temporality of more traditionally-minded performance research. The eternal finds no explanation as a function of the durational and the same is true of our experiences of the eternal aspects of performance in its sensational, ex-temporal intensity. Our experiences are testament to the vitality of these aspects. It is therefore high 'time' for our performance research enquiries to take note and adapt in accordance, lest we continue to remain epistemologically ignorant of that which strikes us directly, internally/eternally, in our lives' experiences in, and of, live performance.

Notes

1 Following academic convention in citation of Spinoza's *Ethics*, the numerals given here refer, respectively, to the part number, proposition, and scholium entry. This convention is maintained for other citations of Spinoza in the main body of the text. The 1996 English-language edition for Penguin Books is indicated in 'References' as a useful source material, and is similarly coded in terms of part number, proposition, etc.

2 See Tromans (2013) for an exploration of the inseparability of the various human and non-human elements of performance in terms of Deleuze and Guattari's notion of the *haecceity*.

References

Abbate, Carolyn. 2004. 'Music—Drastic or Gnostic?' *Critical Inquiry* 30 (3): 505–536.

Borgo, David. 2007. *Sync or Swarm: Improvising Music in a Complex Age*. London: Continuum.

Cardew, Cornelius. 1971. *Treatise Handbook*. London: Edition Peters.

Clifton, Thomas. 1983. *Music as Heard: A Study in Applied Phenomenology*. New Haven: Yale University Press.

Conrad, Tony. 2000. *Inside the Dream Syndicate, Volume I: Day of Niagara*. Table of the Elements TOE-CD-74.

Csíkszentmihályi, Mihály. 2008. *Flow: The Psychology of Optimal Experience*. New York: Harper Perennial Modern Classics.

Csíkszentmihályi, Mihály. 2014. *Applications of Flow in Human Development and Education: The Collected Works of Mihály Csíkszentmihályi*. Dordrecht, Netherlands: Springer.

Deleuze, Gilles. 1988. *Spinoza: Practical Philosophy*. Translated by Robert Hurley. San Francisco: City Lights.

Deleuze, Gilles. 2005. *Francis Bacon: The Logic of Sensation*. Translated by Daniel W. Smith. London: Continuum.

Deleuze, Gilles & Félix Guattari. 1994. *What is Philosophy?* Translated by Graham Burchell and Hugh Tomlinson. London: Verso.

Goehr, Lydia. 1992. *The Imaginary Museum of Musical Works*. Oxford: Clarendon Press.

Lock, Graham. 1988. *Forces in Motion: Anthony Braxton and the Meta-reality of Creative Music*. London: Quartet Books.

Marclay, Christian. 2008. 'Conversation between Christian Marclay and David Toop.' In *Arcana III: Musicians on Music*, edited by John Zorn, 138–152. New York: Hips Road.

Massumi, Brian. 2002. *Parables for the Virtual: Movement, Affect, Sensation*. Durham: Duke University Press.

Phelan, Peggy. 1993. *Unmarked: The Politics of Performance*. London: Routledge.

Prevost, Eddie. 1995. *No Sound is Innocent*. Harlow: Copula.

Spinoza, Benedict de. 1996. *Ethics*. Translated by Edwin Curley. London: Penguin Books.

Tromans, Steve. 2013. 'Scenography: Separating the Inseparable?' *Performance Research* 18 (3): 195–196.

Turner, Victor. 1987. *The Anthropology of Performance*. New York: PAJ Publications.

9 The Place of Performance
A Critical Historiography on the Topos of Time

Jonah Westerman

> Even the most perfect reproduction of a work of art is lacking in one element: its presence in time and space, its unique existence at the place where it happens to be.
> (Benjamin 1936, 220)

Since the 1960s, the ephemerality of performance art has been its most characteristic, potent and difficult attribute; prized for its ability to confound viewers' aesthetic expectations, frustrate habits of vision and spectatorship and, consequently, derange our ideas about reality and the social world. This ephemerality was first characterized through the 1960s as creating a unique kind of presence, that an action taking place in the space of art thrusts viewers into an overwhelming superflux of experience: something is happening right *now*. Focusing more closely on an action's relation to its mediated registration in photography, film or video, however, a later moment of performance practice and discourse (beginning in the mid-1970s), insisted that such presence is impossible; performance creates an insuperable absence; something happened just *then* but we will never again know what it was. This focus on ephemerality, whether rendered in the language of presence or absence has constricted the ways we evaluate performance-based work, generating a conceptual stagnation. The historiography that follows will detail just how mired we (and our interpretive and critical lexicon) are in this problematic of performance's (temporary) temporality.

Performance art multiplied across the globe's visual art scenes from the moment of its inception, from Happenings to Vienna Actionism to the New Art Practice to Gutai. The critical discourses that followed, however, failed to proliferate at an equal rate and instead generated a critical language that has made 'performance' a unified, sovereign category based on a unique set of 'time-based' attributes. This emphasis engendered a temporal bias that has been universalised, leading to an ironic and unfortunate scholarly situation in which disparate intermedial artistic practices—all of which developed as challenges to local, historical conventions of representation—are understood according to a doctrinal, medium-specific rubric. I am not suggesting that duration, liveness, embodiment, repetition and so on (all as experiences of time) are unimportant or irrelevant concepts for tackling what it is that performances do. Rather,

I wish to call attention to how each of these complex temporal-spatial operations has, over the years, been reduced in theory and criticism to a tactic for approaching a kind of uninflected, ahistorical, universalised time—a time of absolute *now*, a special time outside of quotidian sequence and protected from its ordinariness.

This chapter reviews signal developments in the history of performance theory that centre on the question of presence and draws from these writings a portrait of this drive for a notional 'now.' I will demonstrate how this focus on universalised time has organised discourse around the question of performance's ontology, obscuring questions about history—both performance's own and the role it plays in reception in any given 'present.' I will argue that by placing performance works in both space and time as an interaction between a work and its audience that occurs on a contextually specific stage—'at the place where it happens to be'—a new mode of spatialised analysis becomes possible. This approach understands performance not as a guarantee of revelatory transformation that leaves the past behind but as a bounded situation in which history's persistence in the present becomes visible.

Presence, or How to Produce a Rupture in Time (Part 1)

That performance from the 1960s onward gets so entwined with its theorisations owes not least of all to its emerging directly from the crucible of the post-medium condition—the early 1960s saw a break with traditional approaches to art's evaluation and comprehension at the same time that its production came to include expanded environments, greater roles for audience participation and physical gestures performed by the artists themselves—whether outlandish and virtuosic, like those of Joseph Beuys, or simple and understated, like some by Judson Dance Theater. The work of art came increasingly to rely on the viewer's physical and/or interpretive involvement for an event, action, object or person to become meaningful. And what people have said about all these performance-based practices has tended to variously plot the same story that begins with presence and ends with the revelation of truth.

Allan Kaprow, for example, insisting that 'Happenings are events that, put simply, happen' describes the point of these activities as an attempt to expand painting beyond the bounds of mediation (1961, 16). He writes, 'Pollock [. . .] left us at the point where we must become preoccupied with and even dazzled by the space and objects of our everyday life, either our bodies, clothes, rooms, or [. . .] the vastness of 42nd Street. Not satisfied with the suggestion through paint of our other senses we shall utilise the specific substances of light, sounds, movements, people, odors, touch' (1958, 7). The apogee of modernist painting in its Greenbergian teleology of ever-refined medium specificity pointed beyond the frame, eventually toward art as immediacy. This has become a familiar story (e.g., Foster 1996). What is important for my purposes here is the extent to which this immediacy was achieved through disorienting experience and what it was meant to do to viewers. Happenings were confusing, even, according

190 *Jonah Westerman*

to Susan Sontag, violent, using people as 'material objects.' One example is her account of *A Spring Happening* (1961), in which visitors were assembled in a crate with a low ceiling and horizontal slits at eye level that allowed them barely to follow surrounding actions—such as a naked woman being chased by a spotlight—even as heavy objects were dropped on the crate's roof. At the finale, menaced by an advancing lawnmower, the audience was finally allowed to escape when the crate's walls suddenly fell apart (Sontag 1962). The relentlessly alogical and unpredictable nature of a Happening, for Kaprow, 'invite[s] us to cast aside for a moment [. . .] proper manners and partake wholly in the real nature of the art and (one hopes) life' (1961, 18).

Michael Kirby, writing in *The Tulane Drama Review* in 1965, develops in a more scholarly idiom what it might mean to 'partake wholly in the real.' He writes, 'all Environments have made use of light, sound, and movement [. . .] Kaprow went one step further by employing human beings as the "mechanized" elements' (1965, 24). They are mechanised elements because actions carried out by people, either scored (for performers) or unscored (for the audience), are structurally constitutive of the work but in and of themselves have no meaning, no literary or dramatic motivation. They simply happen; in Kirby's words, they are 'non-matrixed' (1965, 25). People whose performance is nonmatrixed—not part of an overarching story illusionistically produced through conventions of character and narrative—are simply being themselves, even if they're doing something they would not normally do, like charging others with a lawnmower. That they are not playing a role means observers more easily confront their emotions, anxieties, confusions and so on, and in reacting, contribute their own unalloyed persons as material for the performance. They are also stuff that happens. He writes, 'in this theatre, "suspension of disbelief" is not operative and the absence of character and situation precludes identification' (Kirby 1965, 43). On Kirby's reading, inability to suspend disbelief produces immediately experienced reality—everyone is just being who they really are, even more so since everything around them is so strange and alienating. The reality made available through this alienation is a glimpse of what is most essential and intimate to one's own personality, a peak behind the veil of our normal well-behaved and socialised selves. Initially, Happenings depend on groups to produce this hyper-self-aware atomisation effect, but Kaprow moved on to imagine less collective modes of achieving the same effect—for example, dipping one's hands in hot and cold water, and reflecting aloud, as in *Affect* (1974).

By the time Kaprow produced *Affect*, which scored and illustrated a series of such phenomenological experiments, performance practices that explored the capacities of the physical body could be found everywhere. Vito Acconci was trying to catch balls thrown at him while blindfolded (*Blindfold Catching*, 1970), Chris Burden had himself shot in the arm (*Shoot*, 1971), Gina Pane climbed a ladder studded with sharp metal barbs (*Unanaesthetized Climb*, 1971), and Marina Abramović took drugs for catatonia to see what would happen (*Rhythm 2*, 1974), just to name a few examples. The differences that separate these projects from Kaprow's go well beyond any obvious taboo-busting one-upmanship.

The Place of Performance 191

This generation of post–1968 body artists directly thematised and called into question any notion of gaining access to a root reality or basic nature. Where an early moment of performance had imagined it could secure presence, the next generation focused on its impossibility. Fleeting actions, fraught encounters and futile auto-manipulations worked to uncover the fact that the body held no special knowledge; rather, it became the vehicle through which one demonstrated the existential relation between meaning and action.

Absence, or How to Produce a Rupture in Time (Part 2)

Reflecting this practical shift in focus, Lea Vergine's psychoanalytically inflected *Il Corpo Come Linguaggio* [*The Body as Language*], published in 1974, set the tone for much scholarship to come by focusing on how performer and viewer meet in the space of art to confront and satisfy their inherent emptiness: each needs the other to become significant. As a result, what we find in performance is not a heightened moment of reality that reveals our basic nature but instead we discover through the power of this encounter that we have no essential nature. Or rather, that our nature consists in our dependence on others to make us who we are. Acconci needs the gallery-goer to whom he can whisper not-so-sweet nothings and Abramović needs her audience to use her as they will. Absence replaces presence as the central analytic trope for dealing with performance art as early as 1974. Yet while essence may have absented itself, this newly available truth still resides in interpersonal encounter in the temporal present—being-with the Other right *now*. Therefore, it may be more appropriate to say that absence becomes the mode of articulating presence at this moment, for one must be co-present with the artist to experience this particular intersubjective absence. In the end, because the time of performance is eruptive, its lesson is universal, and *vice versa*.

In a groundbreaking essay of 1981, 'Re-Viewing Modernist Criticism,' artist Mary Kelly seized on performance art's newly visible negative core and took it in a different direction. Describing the same developments in painting that moved Kaprow beyond the frame, Kelly writes, 'the painterly signifier is manipulated precisely to trace a passage, to give evidence of an essentially human action, to mark the subjectivity of the artist in the image itself' (1981, 83). For her, as for Kaprow, the notion that the painting had become 'an arena in which to act' served as catalyst and precursor for performance. She states, 'in performance work it is no longer a question of investing the object with an artistic presence: the artist *is* present and creative subjectivity is given as the effect of an essential self-possession [. . .] the actual experience of the body fulfills the prophecy of the painted mark' (1981, 91–93). According to Kelly, however, this effect is more reactionary than revelatory. Bringing into view 'the peculiar paradox of photography for [these] precarious art practices,' she asserts, 'Benjamin's "aura" may wither away in the age of mechanical reproduction but authenticity remains. What is made more explicit, more transparent, by the so-called dematerialization of the object, is that *the production of authenticity*

requires more than an author for the object; it exacts the 'truth' of the authorial discourse' (1981, 92–3). For Kelly, the trace of an action—whether in paint, photography or film—pries open a space between an original moment and the significance with which it becomes invested. In performance, she maintains, this space is all too easily co-opted, as the presumed replacement of artistic presence in the object (something like aura) with the actual presence of the artist (authenticity) reduces the role of art to the ratification of reality. The reality to which this authenticity is made to attest—for which it is taken in a conflating misprision—is that heroic self-possession of the masterful artist.

Kelly's diagnosis renders performance—as spoken by theorists and critics—pathological. For her, it necessarily falls prey to patriarchy insofar as it (1) responds to the demands of high modernism's investment in authorial presence and (2) brings human bodies into ideological capture the moment their live processes revert to static images (e.g., as photographs). Kelly points away from the value of presence, suggesting such an achievement in artwork is not only impossible but undesirable in the first place, as it bolsters two intertwined discourses of mythical self-sufficiency: that of the artwork and that of the artist.

For the next generation of performance's interlocutors—Peggy Phelan and Amelia Jones—the fact that performance cannot be wholly captured by documents, that it flashes into existence only to fade away, makes it the perfect conveyance toward postmodern liberation (rather than the prolongation of moribund modernism). For them, presence becoming absence—as the moment of activity passes from momentary existence into mediated forms—only redoubles the ability of performance to shock and realign perception. In *Unmarked: The Politics of Performance* (1993) Phelan defines the ontology of performance as a live encounter that always already recedes into the past, and hence, 'performance is the art form which most fully understands the generative possibilities of disappearance. Poised forever at the threshold of the present, performance enacts the productive appeal of the non-reproductive' (1993, 27). This productive appeal is the way in which artist and viewer can reveal each other's continual becoming through a unique, ephemeral encounter. Even the static images Kelly worries about can only serve as always inadequate aides-mémoires. Phelan lauds this inadequacy as it announces the absence that deflates the myth of presence; it is the guardian of the contingency of meaning. Further, for her, performance is metonymic for the very nature of life: 'the after-effect of disappearance is the experience of subjectivity itself' (Phelan 1993, 148). The result is that the viewer again gets to peek behind the veil that shrouds reality—this time to see that reality itself has no essential nature. Any conventional notions we have about the world and ourselves are exactly that: provisional half-truths arrived at for convenience or through the machinations of discourses invested with coercive power.

Jones's *Body Art: Performing the Subject* (1998) harnesses Phelan's negative ontology, bringing it to bear on the analysis of performance documentation and into art history's battlefields of 1990s identity politics. Replacing Phelan's 'unmarked' with a structurally similar 'radical narcissism,' Jones argues that

The Place of Performance 193

performance art is the postmodern art *par excellence* in its ability to debunk modernist myths about the self-contained insularity of masterful genius artists. For Jones, works by body artists like Carolee Schneemann, Hannah Wilke, Yayoi Kusama and Vito Acconci possess radical political potential in their burlesquing of dominant codes of identity, which point to their mere historicity, their inessential contingency. Jones writes, 'by exaggeratedly performing the sexual, gender, ethnic, or other particularities of this body/self, the feminist or otherwise non-normative body artist even more aggressively explodes the myths of disinterestedness and universality that authorize these conventional modes of evaluation' (Jones 1998, 5). She thus brings us full circle to Kelly's criticism, except that for Jones any ascription of self-sufficient presence to the artistic subject (whose activity produces traces we call performance art, or in Pollock's case, 'action' painting) can now be unveiled as the universal truth of subjective absence, the non-being that exceeds ideological inscription.

For Jones, protecting this absence is not only the correct theoretical and political move but an honest response to a methodological problem. She is constantly reminded of her own partial apprehension of the works about which she writes by dint of their simple historicity, their pastness: she was not *there* for the moment of performance and comes to know historical works through photographs and other documents; hence, there exists an insuperable temporal barrier to accurate knowledge. Even more significantly, however, this holds true for Jones even when one *is* there. Confronted with the twenty-first century wave of re-enactments in the museum context of historical performance art works, Jones redoubles her commitment to performance's infinite regress. She writes:

> Looking at Abramović's re-enactments in *Seven Easy Pieces* [2005] and her self-presentation in *The Artist is Present* [2010], I find that what her recent projects expose, in spite of claims [. . .] to the contrary, is that there cannot be a definitively 'truthful' or 'authentic' form of the live event even at the moment of its enactment [. . .] it becomes painfully clear that there is no original event—or that there was, but it was never 'present.'
>
> (Jones 2011, 19)

Capable of being there to witness a performance results, for Jones, in a full reinstatement of Phelan's conclusions. Jones continues, 'the live act itself both claims and destroys presence; the live act is always already passing' (2011, 26). Ephemerality reigns and in direct proportion to the insistence on presence as the most salient avenue of inquiry. This is not surprising, given all we've already seen of Jones's understanding of what performance is and does.

What is surprising, however, is the tone of the passage. Why should performance's irremediable disappearance seem to Jones a 'painful' truth? She writes, 'All "events"—those we participated in as well as those that occurred before we were born—can only be subjectively enacted (in the first place) and subjectively retrieved later [. . .] We are always already in the "now," which can

194 *Jonah Westerman*

never be grasped, and yet all experience is mediated, representational' (Jones 2011, 42). History (and not just art history), on this reading, is foreclosed. Each of us is marooned on the island of our own partial experience, doomed forever to repeat that all we know is that we don't know. In the end, the meaning of every performance is that we cannot know its meaning—or rather, that is has no single meaning, but only many subjective meanings—and this solipsistic trap (dressed up as philosophical circumspection) gets writ large across the expanse of interpretive endeavour, as well as human agency. This focus on performance's temporality gives birth to a profound anxiety concerning our ability to engage with the world, to know anything about it, or to influence it in any way.

In this abstracted 'now' of performance, time becomes ahistorical. For Jones, this 'now' is itself transcendental—it would be equally true for a performance in the 1970s as it would for the work's restaging in 2010—with no consideration as to how art, its institutions or audiences may have changed in the interim, how temporal-spatial place might determine, channel or provoke particular concerns. The key point is that the assertion of performance's irremediable 'pastness' unintentionally propagates the modernist notion that meaning is something contained in the work itself—this time, however, in the form of that proposition's negation. That is, if one contends that a work is never present, that it is always already inaccessible, the supposed singularity of 'the work itself' explodes into an infinity of pure subjectivism (itself unified as the necessary outcome of meta-discursive reflection), i.e., *the* meaning of any performance is that performance never has one meaning.

Philip Auslander's diametrically opposed approach attempts to stem this hermeneutic eschatology. The analytical frame of the historiography offered here makes clear that, while usually understood as solving the problem of performance's pastness, his emphasis on 'the performativity of performance documentation' (2006, 1) affords only one further turn of temporality's screw and, therefore, equally falls prey to ahistorical thinking. For him, rather than ephemeral, performance is eternal. He writes, 'documentation does not simply generate image/statements that describe an autonomous performance and state that it occurred: it produces an event as a performance' (Auslander 2006, 5). That is, a photograph, film or video of a performance should be understood not as a partial attempt to capture something of its ungraspable truth, nor merely to prove and attest that there was a performance that happened at some past moment in time, but as something that draws our attention to the event as something significant, something worthy of our attention because it has left its mark on the world and our experience of it.

Polemically, Auslander compares Yves Klein's confabulated photograph *Leap into the Void* (1960) to Chris Burden's more forensically conceived *Shoot* (1971):

> What difference does the fact that the image of Chris Burden documents something that really happened and the image of Yves Klein does not make to our understanding of these images in relation to the concept of

performance documentation? My answer: If we are concerned with the historical constitution of these events as performances, it makes no difference at all.

(2006, 5)

Auslander divorces the facticity of depicted events from the reality effect produced by their ultimate forms. He concludes, 'it may well be that our sense of the presence, power, and authenticity of these pieces derives not from treating the document as an indexical access point to a past event but from perceiving the document itself *as a performance* that directly reflects an artist's aesthetic project or sensibility and for which we are now the present audience' (Auslander 2006, 9). Such a thought experiment washes away layers of accrued anxiety over coming to performance(s) too late. 'Presence, power, and authenticity' are all guaranteed in perpetuity.

Auslander simply negates Jones's negation. For him, even if a performance's live action is absent (because we missed it), its documents are present and, therefore, act as the wellspring of the work's true meaning. Performance has a meaning after all and it coincides with what he calls 'the artist's aesthetic project,' suggesting that the work's essence is inherent in its form, deposited somewhere within by the hand of the artist, whether intentionally or not. In reasserting the self-sufficiency of the artist and the artwork, Auslander's seemingly ameliorative intervention appears as a nightmare vision of everything against which Kelly, Phelan and Jones have written. Moreover, in staying narrowly within the confines of the presence/absence problematic and its temporal bias, time again becomes ahistorical. The focus on presence—here, of the work's essence through its documents—exempts performance from historical time, projecting it, yet again, into a perpetual 'now.'

Placing Performance or, Seeing Historical Time

So how do we move past the presence/absence problem to reclaim history? First, we have to finally jettison the paradoxically policed notion that a given work of performance art's nature, meaning or essence resides in the initial moment of its enactment, that there is an *original* performance, whether that is conceived as residing in ephemeral action or in self-sufficient mediation that guarantees essence in perpetuity. Rather, we have to rediscover performance's intermediality. This expanded field of production has always constituted aesthetic choices designed to participate in or disrupt distinct artistic and media ecologies; in short, attempts to use new means (the artist's body, other people's bodies, everyday objects, durational experience and so on) to accomplish some end. These choices have to be seen in relation to those fields of possibilities and expectations, those cultural horizons. Second, we have to see each encounter with a work (in live presentations, displays of 'documents' and so on) as an iteration, a spatialised articulation, a version related to previous versions, but never as an attempt to reclaim an original condition. Such a focus would only turn

196 *Jonah Westerman*

that same old screw and miss what a performance can tell us about history, both its own and our vantage onto it. We have to think geographically, institutionally and materially: where is the work being shown, in what configuration and for what audience? Finding the place of performance as the coincidence of its spatial forms and a particular moment in time can reanimate history.

Let us return to Jones's favoured case study, Marina Abramović and the question of her works' so-called 're-performance' in New York in 2010 for *The Artist is Present*. Abramović provides an excellent example for demonstrating what a placed reading can bring into focus, as we can discern a clear mismatch between how her works of the 1970s were received by Yugoslavian audiences and how critics explained that same local reception using the rhetoric of universalised, abstracted time imported from the West. As a result of that imported discourse, the spatial aspects of her work have been subordinated to temporal ones from the outset; *The Artist is Present* bears the marks of this intertwined discursive and practical history.

Abramović made her first body-based performance work, *Rhythm* 10, in 1973 at the Edinburgh International Arts Festival. The fact that she was permitted to present work on an international stage should already suggest something of the unusual political-aesthetic environment that obtained in Yugoslavia, which held a unique position in the Cold War. As art historian Bojana Pejić puts it, 'due to the break between communist Yugoslavia and the Soviet Union in 1948, the "official" art in Yugoslavia was not socialist realism, but Modernism' (1999, 72). The particular brand of modernism that flourished in postwar Yugoslavia was always promoted as an enlightened riposte to centrally planned Soviet culture. That is, the promotion of modernism valorised 'aestheticized, nondogmatic, ideologically neutral, and artistically independent expression and presentation' (Šuvaković 2006, 10) in direct opposition to the dictates governing Soviet socialist realism. Art historian Miško Šuvaković terms this aesthetic imperative 'moderate modernism' and argues, 'on the one hand this allowed artists to approach the mainstream of international Western modernism, while on the other it was a voice of resistance to the more radical versions [. . . It] focused on the laws of form and pictorial problems' (2006, 11). Pejić avers, 'despite a one-party system and a state-run economy, Titoist Yugoslavia was a country which intended to prove its internationalism and cultural openness' (1999, 72).

Whereas the 1970s saw repression of underground art exhibitions enforced by bulldozer in Russia (Hoptman and Pospiszyl 2002, 65–77), in Yugoslavia the decade witnessed a rapid expansion in state-funded 'unofficial' activities. Particularly in the capital city, Belgrade, the government financed experimental productions and hosted international festivals. The Belgrade International Theatre Festival (established in 1967), for example, convened foreign practitioners of various stripes of conceptual and performance art (including Michelangelo Pistoletto and his Lo Zoo troupe, Jannis Kounnelis, and Daniel Buren) along with Yugoslavian artists like Slovenia's OHO (Pejić 1999, 72). Similarly, in nearby Novi Sad, public galleries like Tribina Mladih not only showed such works, but published reviews and reports on international goings on—this

gallery published the first Yugoslavian-printed, Western analyses of body art in 1972. Pejić underscores the importance of this publication, *The Artist's Body as Subject and Object of Art* (edited by Vlado Kopicl) hazarding, 'if I am to mark the very *beginning* of body art in Serbia, I can say that, although some works are of earlier date, the *body boom* occurred in 1973' (1999, 73): the year Abramović presented *Rhythm 10*.

The mismatch between American theory and Yugoslavian practice surfaces when we consider how curator and historian Zdenka Badovinac invokes Phelan's language to describe how Abramović's 'ritual body [. . .] featured in performative practices primarily as a bearer of freedom and individuality' (1999, 16). She writes, 'the pain in body art is irreproducible, and precisely this quality makes it [a] significant "means of expression"' (1999, 11). This focus on the 'irreproducible' moment of performance, the experience in time that disappears instantly, undergirds the assertion that Abramović's practice could signify as eluding ideological capture; the part of performance that cannot be reproduced is the part that could stand aloof from official discourse. At the same time, however, Badovinac relates that Abramović's body possessed a subversive element for artists and audiences attuned to the way it differed in relief against the 'asexual, androgyne' body of socialist realism and the body's absence from state-sanctioned modernism (1999, 16). What actually made Abramović available to social-critical discourse then, was precisely the ways it did signify, what it did represent; a counter-discourse of sexual embodiment only visible through comparison. *Pace* (Phelan and Badovinac), the legibility, the representational capacity, of performance is what provided any political thrust. The ability to speak to an audience rooted in a particular place and its ideological horizon drew on a collective condition of subjection to authority and, hence, acted as subversion. The focus on 'irreproducible' time, again, universalises performance, denaturing its site-specificity, and, crucially, cannot account for the facts of reception as Badovinac relates them. In the United States of the 1960s and 1970s, the discourse of ephemerality functioned, among other things, as an assault on the work of art's commercial value; in Yugoslavia such an intervention was not only unnecessary, but incapable of comprehending the facts on the ground. To account for the legibility of Abramović's body in durational performance works, we have to locate that practice in space, within a specific political-aesthetic economy. When we do, we can see how time itself is relative; while ephemerality might have been the most important facet of the work in the American field of reception, it was less so in the Yugoslavian context. This difference is enough to demonstrate the fallacy of considering ephemerality (as presence or absence) as performance's essence.

What we must consider, then, in examining the staging of such works in 2010 in *The Artist is Present* is not to what extent re-enactment can faithfully recapitulate the original works. That question, the one that obsesses Jones and haunts Auslander, is beside the point. Conceding that no audience is ever homogeneous, the visitors to MoMA in 2010 differ substantially from the Yugoslavian audience of the 1970s; the works invariably function differently

198 *Jonah Westerman*

in this other time and place. Rather, I am interested in how the staging of the exhibition handled this temporal-spatial relocation of the works on view. That is, given that the works could never be the same, what came to the fore as the most important elements to be reiterated? Its principal focuses were, clearly, 'the artist' and 'the present'—that is, the originary body and ephemerality. Such emphases amount to little more than a vindication of Abramović herself as a modern day Mesmer and, as a result, the suggestion that perhaps Kelly was right all along: that maybe performance puts on view, above all, the 'truth of the authorial discourse.' And in this connection, it becomes obvious that Kelly's concern about individual authorship's regressive character cannot be universalised itself; Abramović's individuality worked against official aesthetic discourse in Yugoslavia, while that of American artists of the same generation conformed to local ideological demands. The MoMA retrospective, therefore, converted whatever was critical in Abramović's initial stagings into complicity by repositioning her author-function without remark.

I would like, however, to ask a second question. Or rather, turn the arrow of that first question round in the opposite direction: what can we learn about our current situation, about where we are now, in terms of our relation to art and history from the fact that *The Artist is Present* set out to offer audiences an experience of an authentic and transcendental 'now' by presenting performance as something that exists outside of time? At the very least, it should be clear that approximately fifty years of ephemerality-based performance discourse plays a significant role in the exhibition's form. It is the entrenched, disciplinary, temporal bias that underwrites such an ahistorical approach by projecting performance relentlessly into the 'now.' While Jones bridles at the show's attempts at securing presence, she is also one among many to claim this quixotic endeavour as the stock-in-trade of performance's medium identity. In this way, the retrospective is an effect and symptom of the homogeneity I have tried to outline here. The word 're-performance' is another.

In the same way that the discursive focus on ephemerality was at one time and place transgressive, but has now become *de rigueur* and lost its political thrust in universalising itself, the movement of that 'now' time into the space of the museum demonstrates just how important is the place of performance. That is, for *The Artist is Present*, MoMA colluded to the utmost in producing a (willful, mythical) historical vacuum. Take, for example, how the geometric and disciplinary order imposed on the eponymous centrepiece created that awareness of right *now*. Abramović sat at a table in the middle of the central atrium inside a large rectangular border; museum-goers arrayed around the room, either just watching, or waiting for hours or days to join her. Kelly tells us that when the artist is present aura may fade, but authenticity remains, insofar as what we get is the authenticity produced by the authorial discourse. That discourse was everywhere in evidence, exerting its considerable infrastructural force. Absent such critical distance (or suspicion), however, one wonders whether the effect of this concerted staging was not, for most people, the production of aura itself.

The Place of Performance 199

For his part, Benjamin says that, robbed of aura by mechanical reproducibility, the basis of art ceases to be ritual and becomes politics. *The Artist is Present*, however, sought to overcome its own investment in reproduction, and to restage performances as originals. Even though we know such a goal to be impossible, we also know that the exhibition occluded history in the process: it used the space of the museum to create a ritual. By obscuring history and politics, the space of the museum became a vortex of centripetal force, all roads leading to Abramović at its centre. Meaning could only be secured by acknowledging, through enactment with one's own body, the organising presence of the artist. The authority of that presence, then, had as much to do with the repetitive offerings made by participants, who received an experience of an 'authentic' moment in return.

I am not suggesting that people innately seek this kind of ritual affirmation; neither do I contend that MoMA (or any museum) is inherently ahistorical. Rather, the particular strategies and emphases enacted by *The Artist is Present* evacuated MoMA of history and it became a space outside of time, a collection of moments with no sense of place. The only location in which one was afforded that sense of belonging—that is, a context—was right in front of the artist. The show conspired to strip people of their connection to the world, only to have the artist offer it back. I do not dispute that people who felt themselves moved truly were, but offer a way to understand these effects through analysing the materials marshalled by the artist and how these functioned in a particular space and time to produce a specific experience of (dislocated, disconnected) selfhood. Viewed through a 'placed' lens, *The Artist is Present* offers us a warning. Only by seeking the place of performance can we understand its position in history, and without history we can only repeat the same moment over and over, as if for the first time.

References

Auslander, Philip. 2006. 'The Performativity of Performance Documentation.' *PAJ: A Journal of Performance and Art* 28 (3): 1–10.

Badovinac, Zdenka. 1999. 'Body and the East.' In *Body and The East, from the 1960s to the Present*, edited by Zdenka Badovinac, 9–18 Ljubljana: Moderna Galerija Ljubljana.

Benjamin, Walter. [1936] 1969. 'The Work of Art in the Age of Mechanical Reproduction.' In *Illuminations*. Translated by Harry Zohn, 217–51. New York: Schocken.

Hoptman, Laura & Tomáš Pospiszyl, eds. 2002. *Primary Documents: A Sourcebook for Eastern and Central European Art since the 1950s.* New York: Museum of Modern Art.

Jones, Amelia. 1998. *Body Art: Performing the Subject.* Minneapolis: University of Minnesota Press.

Jones, Amelia. 2011. '"The Artist is Present": Artistic Re-enactments and the Impossibility of Presence.' *TDR: The Drama Review* 55 (1): 16–45.

Kaprow, Allan. [1958] 2003. 'The Legacy of Jackson Pollock.' In *Essays on the Blurring of Art and Life*, edited by Jeff Kelley, 1–9. Berkeley: University of California Press.

Kaprow, Allan. [1961] 2003. 'Happenings in the New York scene.' In *Essays on the Blurring of Art and Life*, edited by Jeff Kelley, 1–9. Berkeley: University of California Press.

200 *Jonah Westerman*

Kelly, Mary. [1981] 1996. 'Re-viewing Modernist Criticism.' In *Imaging Desire*, Cambridge: MIT Press.

Kirby, Michael. 1965. 'The New Theatre.' *The Tulane Drama Review* 10 (2): 23–43.

Pejić, Bojana. 1999. 'Body-based Art: Serbia and Montenegro.' In *Body and The East, from the 1960s to the Present*, edited by Zdenka Badovinac, 72–78. Ljubljana: Moderna Galerija Ljubljana.

Phelan, Peggy. 1993. *Unmarked: The Politics of Performance*. New York: Routledge.

Sontag, Susan. 1962. 'Happenings: An Art of Radical Juxtaposition.' In *Against Interpretation and Other Essays*, 263–74. 2001. New York: Picador.

Šuvaković, Miško. 2006. 'Impossible Histories.' In *Impossible Histories: Historic Avant-Gardes, Neo-Avant-Gardes, and Post-Avant-Gardes in Yugoslavia, 1918–1991*, edited by Dubravka Djurić and Miško Šuvaković, 2–35. Cambridge: MIT Press.

Vergine, Lea. 1974. *Il Corpo come linguaggio: La 'Body-art' e storie simili*. Milan: Giampaolo Prearo.

10 Objectifying Liveness

Labour, Agency and the Body in the *11 Rooms* Exhibition

Lisa Newman

> Traditionally, the human body, our body, not the stage, is our true site for creation and materia prima. It's our empty canvas, musical instrument, and open book; our navigation chart and biographical map; the vessel for our ever-changing identities; the centerpiece of the altar, so to speak. Our body is also the very centre of our symbolic universe—a tiny model for humankind and at the same time, a metaphor for the larger socio-political body. If we're capable of establishing all these connections in front of an audience, hopefully others will recognise them in their own bodies.
>
> (Gómez-Peña 2004, 78)

In his 2004 manifesto, 'In Defense of Performance Art,' Guillermo Gómez-Peña outlines the tenets of performance art and, in particular, its historical usage by artists to better respond to socio-political injustices and oppression in the specific time, place and context in which they live. He also asserts that despite the variety of methods and approaches used by artists, a constant element of performance art is the use of the body as 'materia prima,' or the irreducible flesh and blood vehicle of the artist. 'Whatever the reasons,' he writes, 'the fact is that no actor, robot, or virtual avatar can replace the singular spectacle of the performance artist's body in action' (Gómez-Peña 2004, 79). Additionally, he proposes that because the performance artist is also a citizen, and therefore both part and product of a larger culture, their work is informed by their position within a social network. By presenting their own body in performance, as a microcosm of the 'larger socio-political body,' they offer a catalyst for exploring and challenging social and economic valuations of the body through intersubjective exchanges with audiences.

The body in performance art since the 1960s has been both implicitly and explicitly reflective of social and economic concerns. As part of the conceptual art movement, or what Lucy Lippard has referred to as a period of 'dematerialization,' or de-objectification, of art, many artists turned to the use of their bodies as vehicles of expression in order to develop work which 'focused on the de-mythologization and de-commodification of art, on the need for an independent (or "alternative") art that could not be bought and sold by the greedy sector that owned everything that was exploiting the world and promoting

202 *Lisa Newman*

the Vietnam war' (Lippard 1973 and 1997, xiv). Conceptual approaches to art-making included 'self-imaging' or performances made for the camera or video, as in the work of Vito Acconci, Skip Arnold, Ana Mendieta and Lucas Samaras. Similarly, performance and body artists such as Carolee Schneemann, Chris Burden, the Vienna Aktionists, Gina Pane and others turned to the use of the body as the primary material and site of the work, thereby problematising the institutionalisation of the body-in-action as a collectible and commodifiable art object. Despite the diversity of these works, a unifying tenet was the identification of the body as singular and the narrative of the performance intertwined with the irreducible life of the artist.

In this chapter, I examine performance art in relation to the contemporary visual art market: specifically, the promotion of liveness as a facet of performance art as a repeatable, marketable experience. One particular element of this being how, in the twenty-first century, the body in performance art is being reconsidered through new curatorial strategies which replace the singular artist body with employed surrogates, enabling a work to be repeated for any duration and in any location.

Surrogate Bodies

The employment of anonymous performers to enact works has become more prevalent over the last decade. Vanessa Beecroft, for example, employs identical rows of hired models, soldiers, or immigrants to be displayed in her museum installations as living sculptures, instructed to remain still until they can no longer physically stand (*VB performance series* 1997–present*)*. Marina Abramović as an iconic performance artist who began making both solo and collaborative works with her (then) partner, Ulay, in the 1970s, has put forth the concept that the only way to properly historicise performance is through live re-enactments of the original performances, regardless of the separation of the action from the original body and social context. For the duration of her retrospective exhibition at MoMA in New York in 2011, *The Artist is Present*, a series of performers were employed to recreate several of her earlier works simultaneously during opening hours of the museum.

By replacing the singular body of the artist in performance with a potentially infinite number of surrogates, the live action of the performance can be continued and repeated for any duration for any number of audience members. By translating the performance to a set of instructions and visual elements, rather than specific to the body and social context of the artist, the live performance can be exhibited, and even collected, like a sculpture or painting. As MoMA curator, Klaus Biesenbach suggests: 'experience becomes just another object' (cited in Scott 2010).

Indeed, my own initial response to these works is a deep concern that these methods for marketing performance art using traditional tropes of curating visual art objects threaten to compromise its relevance as a powerful mode of creative agency with economic efficiency. On further investigation, I have found

Objectifying Liveness 203

several complexities relating to the social and economic value of the live body in art institutions—including works that reflexively use their institutionalisation to emphasise larger social injustices and the marginalisation of certain bodies.

Rebecca Schneider examines this recent approach to the commodification of liveness through the Marxist concepts of 'living' and 'dead' labour. In her 2012 essay, 'It Seems As If . . . I Am Dead' Schneider addresses what she terms 'zombie capitalism,' or the distinction in the economic value of the body during 'live' or active labour, and the lack of capital generated in the absence of the body—or 'dead' labour. In order to maximise profit, the amount of live labour should meet the needs of the consumer by being available on demand (during exhibition hours, for example). As Schneider explains: 'the time lag, or interval, inherent in the production of a commodity (whether object or affect) is at once necessary to capitalism and is also its potential downfall in the form of a small crisis of pause that over time can accumulate to disaster' (2012, 159). By minimising or eliminating these intervals, by increasing the amount of 'live labour' through the employment of more bodies to revivify a performance work for any duration, more of the experience of liveness-as-product can be marketed to more consumers.

By employing bodies to enact performances as labourers, rather than as creators or artists of the works, there is a risk of what Marx identifies as 'alienation,' or the separation from the labourer from the product they create ([1859] 2008, 51–60). Given the historical relevance of performance art as a vehicle of socio-cultural activism, this separation has profound implications in regards to what is being communicated to audiences in these works.

In his study, *The Body in Culture, Technology & Society*, Chris Schilling emphasises the ramifications of the alienation of the body from the results of labour:

> The general meaning of alienation refers to an environment in which individuals forfeit control of their physical activity, and become estranged from their essential humanity. [. . .] By separating the products of labour from their producers, capitalist labour alienates individuals by removing them from an essential part of their species life and also from their relationship with the natural world.
>
> (2005, 32)

Therefore, by employing performers to enact works which are not of their design, nor are dependent on their identities or social relevance to be effective, the performer as hired labourer rather than as artist would appear to be reduced to their essential 'liveness' as art commodity, rather than a medium for social expression. By this I am referring to what philosopher Nick Crossley translates as 'agency' via Michel Foucault as the 'ability for the body to be both active and acted upon,' and what allows for intersubjective or empathic exchanges with audience members (Crossley 1996, 104). In other words, the embedded economic and social value of an individual, as Schilling suggests, must have the ability to communicate or translate this inscription through actions of their

204 *Lisa Newman*

own making in order to avoid alienation and remain connected to their social sphere.

To further explore the issues of labour and agency and the commodification of the live body in performance art, I use as a case study the *11 Rooms* exhibition, curated by Biesenbach and Hans Ulrich Obrist (Serpentine Gallery) as a commissioned piece for the 2011 Manchester International Festival, UK. In this exhibition, the curators invited eleven artists to create performance installations, all of which involved employing a variety of participants to enact artworks as 'living sculptures.' In this commission the variances in agency allowed to the performers in their interactions with audiences, their levels of training and remuneration, and diverse socio-political backgrounds were significant across the exhibits. Yet at the same time, the institutional framework containing the exhibition, and the spatial/security parameters of the museum, created a flattening effect which homogenised the social relevance of the exchanges between performers and audience members.

In this chapter I will consider how intersubjective exchanges between performers and audience members, socio-political provocations, or the agency of the performers were not always pre-empted or excluded. Whether these variances signify genuine considerations of social and economic validations of the body in performance art on the part of the curators of these exhibitions, or demonstrate a form of institutional commodification of performance art, is an issue that is an important locus in my exploration of this exhibition.

11 Rooms

The *11 Rooms* exhibition was held in the Manchester Art Gallery in July 2011 as part of the Manchester International Festival and featured a group showing of eleven performance artworks authored by leading contemporary artists. The artists were invited to make work where 'the human body, or several human bodies were on display' in an attempt to rethink what the curators considered to be a traditional reductive 'human-to-object-relationship' between viewers and collections within a museum (Biesenbach in TateShots; *11 Rooms* 2011, unpaginated). The artists did not perform themselves in these works, but instead instructed 59 employed participants, who were assigned to perform these works in shifts ranging from 10 minutes to 1 ½ hours during the opening hours of the gallery.

The novelty of the experience of engaging with a body as museum piece, and the thrill of the unexpected that comes with liveness, is at the core of the curatorial vision for the exhibition, rather than the socio-political content of the work. The recurring framework of *11 Rooms*, and in successive exhibitions (*12 Rooms* [2012]; *14 Rooms* [2014]) as put forth by Biesenbach and Obrist emphasises that none of the artists perform their own work, that each work was clearly instructed or scripted and that 'all the sculptures go home at 6 pm' (Dorment 2011; Tate Shots 2011; Stefan 2014).

The Manchester Art Gallery, built in 1823, is temple-like in its architecture with a Greek façade at the entrance. The interior is postmodern, however, with

a mixture of nineteenth century *en filade* spaces that direct the visitor through the collections on display chronologically, and contemporary white cube spaces designed to be modified to accommodate changing exhibitions. The *11 Rooms* exhibition took place in one of these mutable spaces, with eleven separate white-walled spaces constructed to the specific needs of each work. Although audience members were given a map to direct them to each of the installations, descriptive information about the works in each exhibit was only available through the purchase of an exhibition pamphlet.

Outside of the artist's statements found in the pamphlet, the signage for each work was limited to the artist's name and the title of the work. The names of the performers were listed alphabetically in the exhibition programme but were not identified in relation to the specific work(s) they performed in. By contrast, biographical information about the artists and curators was listed in numerous publications and media associated with the event. This distinction emphasised the authorship of the work and the exhibition as that of the artists and the curators, whereas the performers who executed the pieces received no direct validation of their contribution to the work. Though the curatorial intention of the exhibition was stated in the pamphlet and in media surrounding the exhibition, the underlying issues of employing bodies as art material were not directly communicated to audiences.

Their anonymity did not necessarily occlude the ability of the performers to have meaningful, and personal, live exchanges with audience members, although the parameters and types of interactions were determined by the artists. The performers, therefore, had some level of agency and influence within their roles, though with various limitations.

A number of the installations incorporated bodies in what might be considered a more traditional theatrical manner, in that they required performers with certain skills sets to be able to fulfil the particular requirements of the work. Examples include Simon Fujiwara's *Playing the Martyr*, where performers had to have previous acting experience, or Jennifer Allora and Guillermo Calzadilla's *Revolving Door*, which required dancers to execute choreographed actions. In both these instances performers were recruited through agencies or professional websites and reimbursed at industry standard rates. Tino Sehgal's *Ann Lee* also required performers with the ability to enact choreographed movements and recite scripted text. In each of these relatively unproblematic instances the status of the body within the work was that of performer. In contrast, the following discussion focuses on six examples from *11 Rooms* where the status of the body within the work, and its relationship to themes of agency and objectification, are much more challenging to consider.

Bodies in Place of Other Bodies

Two iconic performance art works were re-enacted in separate rooms of the exhibition. The first, *Mirror Check* (Joan Jonas, original performed in 1970) seeks to disrupt the possessive gaze of the viewer through physical self-exploration

using a hand mirror, thus resulting in a 'fragmentation, reflecting parts of the body but not the whole' (*11 Rooms* 2011). The second, *Luminosity*, (originally performed by Marina Abramović in 1997 and re-enacted as part of *The Artist is Present* MoMA exhibition in 2010) suspends a naked female body within a frame of light. On original performance both works were inherently associated with the singular body of the artist/performer, but during *11 Rooms* were embodied by hired performers.

According to the experience of assistant producer, Edie Culshaw (2011, 14–15), the eight performers recruited for these re-enactments were used in both pieces and rotated between the two works in half-hour shifts. The initial call for participants was sent to acting and modelling agencies, pole-dancing/strip club establishments, as well as broader media avenues such as Facebook and local newspapers. In her reflective analysis of her experience as recruiter, Culshaw reports that with the adult entertainment dancers, the rate of pay offered was below industry standards for public exhibition of their naked bodies and, as a result, became a demographic which did not participate for economic reasons. Similar problems occurred when working with casting and dance agencies, which also required industry standard levels of fee for their clients. This is, therefore, in contrast to the use of agencies and industry standard minimum payment for the skilled performers involved in the works mentioned earlier. The resulting selected participants were predominantly visual artists, though not necessarily with performance art backgrounds. In an email conversation with Culshaw, she said that she did not feel comfortable disclosing the actual amount either offered or paid to performers, though an interview with one of the performers, Julia Griffin, revealed that payment was below industry wage as determined by Equity, the performing arts trade union (Culshaw 2011, 14–15; Griffin 2012).

Criteria in the performer calls included: being female between the ages of 20–30; able to be 'agile' and perform for durations of ½ hour at a time, or 10 minutes for the Joan Jonas work (Culshaw 2011, 14). Proposals for participation included a brief biography and photograph, which were submitted to Abramović (though according to Culshaw's account, were not reviewed by Jonas). The resulting selected bodies were slim, young and shared a similar physical aesthetic. They were instructed to wear body make-up to cover any blemishes, tattoos or scars, smooth their hair back from their faces and there was even reportedly discussion about how pubic hair should look. (Culshaw 2011, 25)

By reducing or eliminating any differentiating physical identifications, as well as culturally non-normative representations of the female body (trans-people were eliminated from the selection process) the visible marks of the individual embodied histories of the performers were subsumed by the desire to create a homogeneous visual aesthetic in the re-enactment. Therefore, it was evident that the primary criteria within the selection of re-enactment performers was a certain physical aesthetic, with a focus on the resuscitation of an *image* of a historical artwork through an interchangeable infusion of similar bodies, rather than a re-presentation of the historical bodies of Abramović and Jonas,

or the social contexts of the original performances. Carolee Schneemann, a contemporary of Jonas, wrote that the turn to the body in art during the mid-twentieth century was a way to challenge the patriarchal perception of women as 'functional commodities or entertainment (to be exchanged as property and value),' and asserted that through performance art it was possible for women to 'remain unpossessable while radicalizing social consciousness' (Schneemann 1983, 2; Stiles and Selz 1996, 683). It is unclear how well the socio-political relevance of feminist performance art of the 1960s and 1970s translated to a context where women were selected based on their aesthetics, within an exhibition of living objects.

Luminosity was originally created two decades after *Mirror Check* and is described by Abramović as exploring issues of 'loneliness, pain, and spiritual elevation' and the 'transcendental quality of the human being in general' rather than an overt feminist agenda. When recounting earlier iterations of the piece in an interview with MoMA, Abramović acknowledges that for both herself and the performers she employs in her stead, the body in *Luminosity* is 'vulnerable,' although she asserts that this vulnerability is secondary to the spiritual quality of the work (MoMA Multimedia 1994). If then it is the *spirit* of the performer that is (literally) highlighted in this piece, why is there a need for a particular *physical* aesthetic and female body, particularly one that emphasises the objectification of the body over agency? Additionally, by applying the same selection criteria for performers in *Luminosity* as those used in a historically feminist work by Jonas, and to rotate them between the two pieces interchangeably, further emphasised the distance between the bodies of the performers as live labour and the social context of the works when they were first performed by the artists. Culshaw voices her own confusion concerning the absence of feminist performance art histories in Abramovic's selection process, though ultimately determines that, indeed, 'aesthetics, rather than politics, was the main concern; I certainly could not argue that Abramović's work lacks political engagement, but in this instance, the "look" of the piece was very heavily emphasised' (Culshaw 2011, 26).

Through the interview with Griffin, however, it is possible to see how from the performers' perspective there was still room for negotiating individual explorations and even moments of empathic exchanges between performers and audiences. Indeed, although she found the selection process, and the homogeneity in the bodies chosen to participate, limiting, Griffin generally emphasised the importance of experiencing the artist's actions through her own body and in this way felt an 'intimate' connection to the work. In her relationship with audiences during her re-enactment of Abramović's *Luminosity* she recounted shifting her gaze inwardly; exploring the physical sensation of the performance and locking eyes with audience members in a reversal of viewership:

> The connections that are created and lost during those moments of intimacy between myself and the individual viewer are very interesting. One

lady stayed for the entire 30 minutes and as I was leaving the space, she came over and whispered 'Thank you'. The narrative that passed between us was very poignant and emotional, it made me realise the power of the body in apparent stillness.

(Griffin 2012)

Perhaps, then, within the structured experience of the exhibition and the physical specificities of the re-enactment, there are interventions and variances which do allow for performer and audience agency, and an alliance with the subjective/objectivity associated with the ethos of performance art. Despite the replication of the performance-as-image in these works, and the public anonymity of the performers, the temporality and liveness of the body-to-body co-presence, along with the variances in these interactions, can allow for a certain amount of intersubjectivity, or empathy, within these exchanges.

Bodies as Samples

In contrast to the historical re-enactments of performances by Abramović and Jonas, contemporary works by Santiago Sierra (Mexico/Spain), Laura Lima (Brazil) and Xu Zhen (China) were designed to include performers selected specifically for their specific socio-cultural histories, their otherness, and these were made explicit in the presentation of their bodies and actions. Sierra's piece was a literal manifestation of its title *Veterans from Wars in Northern Ireland, Afghanistan, and Iraq Facing the Corner;* Lima's *Men=flesh/Women=flesh* included people with visible physical disabilities lying down inside a compressed space; and Zhen's *In the Blink of an Eye,* presented migrant workers in a seemingly impossible suspended animation as a hidden armature froze their falling bodies in the moment before they would otherwise have hit the ground.

Sierra's aim with his piece, as outlined in the call for participating veterans, was to 'reflect the invisibility of former soldiers in society and the difficulties that younger veterans face when leaving the Service' (Sierra 2011). In all of his work, Sierra seeks to expose the hidden and overt economic exploitation of the 'underclass,' and particularly 'the ways in which people exchange their time and energy for money within the capitalist framework' (Spiegler 2003). In early pieces such as *160cm Line Tattooed on 4 People* (2000), which involved four heroin-addicted prostitutes who agreed to have a line permanently etched across their backs in exchange for the price of a shot of the drug (approx. $67); and *100 Hidden Individuals* (2003) wherein unemployed people were concealed for four hours at different points along a street in Spain, Sierra makes evident the extreme disparities of remuneration of labour in relationship to economic and social exchange value (Sierra 2012). By placing these exchanges within the context of gallery and museum exhibitions, the social and economic validation of the bodies involved are further complicated by being presented as Sierra's artistic 'products' within a market economy. Additionally, Sierra's considerably larger financial compensation and celebrity status in comparison to

those enacting his works have generated controversy concerning the ethical treatment of the performers (see Teresa Margolles 2004; Tate Modern website 2008; Amanda Church 2009).

This controversy is, however, Sierra's point. He has no illusions concerning his role within a commodity-driven art world, and even questions the ability of artists to truly engage in radical political activism because of what he views as an inextractable economic structure of cultural production which the artist is a part of. By choosing war veterans as material for his live installation, he further complicates the live/dead labour dichotomy by presenting soldiers who are no longer active as forgotten or hidden members of society, yet also employed performers in an exhibition of 'living sculptures.'

The call for participants for Lima's piece *Man=Flesh/Woman=Flesh* described how in the work the body 'is presented as a sculpture in a counter argument to the art historical perception of beauty and ornament. Lima is not interested in being herself the site of the work, rather, she is looking for possible 'alterities' (embodiments of the Other) by experiencing something through someone else's flesh' (Lima 2011). Participants were required to have a visible physical disability and the ability to lie down in a room with a 50cm high ceiling for, at the most, an hour and 45 minutes per session. In order to view the performer, audience members also needed to be physically willing and able to crouch down or kneel on the floor to look into the low-ceilinged space. Performers were positioned out of physical reach of the viewer, and were lit by a single bare bulb. Eye contact between the performer and the viewer was possible, however, and the shared positioning of the body through the spatial constraints had the potential to create a sense of physical reversal, or empathy, between bodies, something Diprose described as 'a perceived objectification of one's body by another' (2002, 69). This is not to assume that this orchestrated closeness of unknown bodies was without the potential for anxiety. The divided spaces of each exhibition led audiences through closed doors into environments where the roles of interactivity were unknown before entering, lacing the intimacy of the interaction with, as one critic reported, 'more than a whiff of danger,' and the compromising of one's physical and psychic space in order to engage with a living work (Dorment 2011).

The performers employed by Zhen for *In the Blink of an Eye* were described as migrant workers and illegal immigrants, though not in specific reference to the individuals involved. In half-hour rotation, the performer was seemingly suspended in mid-air through a hidden armature which held them at a gravitationally impossible angle just above the ground. The initial presentation of the work in Beijing in 2005 included a Chinese migrant worker, while when staged at the James Cohan Gallery, New York, in 2007 it featured two illegal immigrants Zhen met in Times Square (*11 Rooms* 2011; Pollack 2012). While the social and geographical contexts of these earlier presentations directly informed the performance, in the context of this exhibition in Manchester it was not clear who or where the performers were from, nor their experiences with migration. The alienation associated with cultural migration instead

appeared to be occluded by the alienation of the performers from the labour of the action without any clear correlation between their social identities and relation to Zhen's concept. However, from the perspective of the audience, the symbolic relevance of the migrant body and the social implications of immigration were not dependent on the actual identity of the performer, but rather how the presence of a live performer communicated Zhen's vision.

In these three pieces, the body is representative of social alterity and their duplicity is indicative of a larger social problem concerning issues of invisibility, marginalisation or invalidation. While the individual biographies of these performers were not made available, the subsuming of their marginalisation within the parameters of the exhibition points to a larger exclusion of these bodies in society. Additionally, the shift in valuation from 'living' to 'dead' labour for the performers once the museum closes, emphasises this marginalisation through quantifying the usefulness of their bodies as activated art objects. The intertwining of liveness with objectification in *11 Rooms* would appear to perfectly illustrate Schneider's 'zombification' of live and dead labour through the use of anonymous and interchangeable performers as art objects (Schneider 2012). But what is the value of labour for a performing body that is no longer alive?

Bodies as Presence in Absence

A significant absence of a body in the exhibition was the space which would have displayed a corpse in American artist John Baldessari's, *Unrealised Proposal for Cadavre Piece*. The goal of the installation was to explore the 'representation of death in art,' through the three-dimensional re-enactment of the fifteenth-century painting, *Lamentation of Christ*, by Andres Mantegna (*11 Rooms* 2011). In a statement about the work, Baldessari explained that the 'subject is not the cadaver. The subject is rather the issue of a breaking and mending aesthetic distance' in which the 'shock' of seeing the corpse would be 'cancelled.' (ibid) In lieu of the realisation of this work, the curators opted to follow Baldessari's request to publicly display the paper trail of email correspondence with several agencies in Europe and North America in their attempt, and failure, to purchase a corpse for the piece.

What these emails revealed was both the level of agency of the potential 'performer' as a subject as necessitated by law, as well as the fervent desire by the curators to be the first in the art world to actualise Baldessari's work by actually displaying a dead body as art object by any means (though paradoxically, in a sense, as 'live' labour which performs through its presence in the exhibition). In order to display a corpse, written consent was needed from the deceased (while still alive), stating that they wanted to leave their body for artistic purposes. In pursuing this hypothetical person, various hospice centres and morgues in the United Kingdom and the United States were contacted. There were several close finds, one of which could have been purchased and shipped from the United States for a total of $7500—considerably more than the fee paid to any of the living performers (Lindgren 2012; Fujiwara 2011).

Objectifying Liveness 211

One of the final messages sent throughout the chain of organisers by Biesenbach contained a combination of longing to present the novelty of the piece, paralleled with what the social significance of presenting a corpse in a museum exhibition would be:

> I am seriously worried that the point of John Baldessari's piece is the courageous displacement of something that has no other place in society, neither profane nor art spheres anymore. If there is any way we could still achieve this that would make the exhibition truly unique and groundbreaking [. . .] it will change the way we look at performance and sculpture largely. (email from Biesenbach to Obrist and festival organisers as shown in *11 Rooms* exhibition, author's notes)

For reporter Richard Dorment, these letters, and the absence of the body 'were more resonant than an actual dead body because it raises questions most of us have thankfully never had to consider—like obtaining the artwork-to-be's signature while he can still sign the consent form' (Dorment 2011). I found there to be a paradoxically simultaneous elitism and objectification of the corpses being pursued by the curators. Biesenbach's concern for the failure to actualise the Baldessari piece exemplifies the tension of the curators to present something as spectacular as a corpse in an exhibition, i.e., to make a historical moment within the consecrated art market, though with apparent disregard for the potential of exploiting the body as an ahistorical, apolitical and aestheticised art commodity. The 'courageous displacement' of making death visible in either society or art sphere (as also seen in the 'plastinates' in Gunter von Hagen's 'Bodyworlds' exhibition, or the works of Teresa Margolles, Damien Hirst, Joel Peter Witkin, and other artists who incorporate cadavers, or parts thereof, as art) appears secondary here to the institutional and curatorial drive to achieve what they believe to be novel within the contemporary art market.

Conclusion

Since its inception in 2011, the exhibition has been revisited in subsequent years, with the expansion of an artist/room for each year. In 2014, *14 Rooms* was shown as part of Art Basel, with the additions of live works by Damien Hirst, Ed Atkins, Dominique Gonzalez-Foerster and Yoko Ono (replacing Fujiwara and Baldessari). Biesenbach and Obrist continue to stress the potential for interactivity through intimate engagements with performers in the exhibition, though also express the objectivity of the works and the performers therein as a growing collection of living objects. 'We like the possibility of creating an exhibition that could be restaged later,' Biesenbach explains, 'like music, it could become part of a catalogue of things that can be performed again in different contexts' (Forbes 2014). The diverse uses of the body in these works exhibited the incongruities between agency, intersubjectivity and objectification which were reflective of social inequalities, marginalisation and exploitative

labour practices within the larger social context. That this exhibition took place within the framework of the museum and the tropes of the experience economy as translated to the art world, contrasts these social explorations by positioning both audience and performance bodies within the disciplined space of the institution—first and foremost by promoting live performers as 'living sculptures' within a collection of visual art objects. Additionally, because the works were credited to the curated artists, rather than as collaborations, the anonymous performers were further paralleled with visual art objects as market commodities. The juxtaposition of bodies hired for their skills as performers, alongside bodies employed for their physical aesthetics or as sample of a social group within a visual art exhibition presented a provocative, if blurred, example of the influence of the art world on larger socio-economic considerations of alterity and cultural otherness. Although these works appear to derive from a lineage of ephemerality and activism of historical performance practices and movements, the 'intended commodification of experiences into saleable concepts destined for a museum collection goes against the grain of the founding philosophy of performance art' (Stefan 2014).

However, as briefly touched upon, the *11 Rooms* exhibition shows there also remains a certain room for intervention and intersubjective exchange in the live interactions of bodies in these exhibitions. The body does not necessarily become completely objectified. While the presentation of these works within the institutional structure of the art market and regulations of the museum do create limitations to these exchanges, they also leave room for new tensions and social dynamics to be explored. For Julia Griffin, her experience as both viewer and performer in the re-enactments of Jonas and Abramović resulted in a positive reciprocity of intersubjective exchange throughout the exhibition, though without dismissing the objective qualities of the bodies involved:

> This group exhibition for me as a viewer was about participation, experiencing the act of the revelation of the body in a confined space. For the 'body' to be considered as an object primarily, underplays the powerful dichotomy of its absence and presence. The works generated a kind of energy between the bodies moving from each space, almost as though they were at some extraordinary House of Mirrors, each room revealing and reflecting a different aspect of themselves within the works.
>
> (Griffin 2012)

The placement of mirrors on the external walls of the exhibition rooms implied a doubling of the self and a play on the viewer/object dichotomy through self-reflection. However, within contemporary consuming culture, this doubling also encouraged what *Art in America* critic, Olga Stefan, identified as an 'internet dissemination of selfies, the epitome of corporate-style "guerrilla" marketing' (Stefan 2014). Or, in other words, the push for marking one's own consumption of the experience as singularly one's own, through self-documentation.

Overall, the exhibition demonstrated the tensions related to the commodification of performance art and the employment of bodies in re-enactments and other forms of live artworks. A major unresolved issue for me is whether these works which employ performers can be considered to share the same historical lineage of social challenge and intervention that was so integral to performance art of the mid-twentieth century and subsequent decades, or if this model of curation marks the beginning of a new performance art ethos as it becomes subsumed within art market trends. Is institutionalisation an inevitable result of any art form, no matter how contextually specific the work is? Are these strategies the result of an unavoidable progression as artists and curators respond to shifting socio-economic trends?

Plans for further expansion of the exhibition continue through 2016 and beyond, with the number of artists and rooms increasing with every year indefinitely. There is also a greater emphasis on including robotic and virtual performers, as in the animated self-portraits of Atkins, which explore 'life's mediation through contemporary digital technologies' as engagement through online avatars continues (*14 Rooms* 2014).

Perhaps this is a logical progression as contemporary digital technologies continue to facilitate liveness and interpersonal relationships in more complex ways. As a mode of curating live performance, however, Obrist and Biesenbach's zoo-like approach to performers in visual art contexts runs the risk of replacing any sense of humanity in these works with the aura of artist celebrity and the empty novelty of the live experience becoming 'just another object.'

References

11 Rooms. 2011. Manchester Art Gallery *11 Rooms* exhibition pamphlet.

12 Rooms. 2012. Ruhrtriennale, Germany. http://archiv.ruhrtriennale.de/www.2012.ruhr triennale.de/en/programm1/produktionen/12-rooms/index.html Accessed 15/10/2014

14 Rooms. 2014. 'About the Show.' Accessed 4 February at http://www.14rooms.net/en/About-the-show.

AGR/Anatomy Gifts Registry website. 2012. Accessed 12 July at http://www.anatomicgift.com/index.cfm?page=community§ion=skills_lab

Church, Amanda. 2009. *Art in America.* Accessed 4 May 2009 at http://www.artinamerica magazine.com/reviews/santiago-sierra/

Crossley, Nick. 1996. 'Body-Subject/Body-Power: Agency, Inscription and Control in Foucault and Merleau-Ponty.' *Body & Society* 2 (2): 99–116.

Culshaw, Edie. 2011. '*Luminosity* and *Mirror Check*: Reflections on Reperformance.' MA diss. University of Manchester.

Diprose, Rosalyn. 2002. *Corporeal Generosity: On Giving with Nietzsche, Merleau-Ponty, and Levinas.* New York: State University of New York Press.

Dorment, Richard. 2011. *The Telegraph*, 12 July. Accessed at http://www.telegraph.co.uk/culture/art/art-reviews/8630914/11-Rooms-Manchester-International-Festival-review.html http://confusedguff.blogspot.co.uk/2011/07/11-rooms-part-three.html

Forbes, Alexander. 2014. 'Hans Ulrich Obrist and Klaus Biesenbach Bring *14 Rooms* to Art Basel.' *Artnet*. Accessed on 5 February 2015. Accessed at http://news.artnet.com/art-world/hans-ulrich-obrist-and-klaus-biesenbach-bring-14-rooms-to-art-basel-8564

Fujiwara, Simon. 2011. 'Call for Actors Named Simon.' *Star Now* agency website. Accessed at 10 July. http://www.starnow.com/listings/ListingDetail.aspx?l_id=245067

Gómez-Peña, Guillermo. 2004. 'In Defense of Performance Art.' In *Live Art and Performance*, edited by Heathfield, Adrian, 76–85. London and New York: Routledge.

Griffin, Julia. 2012. Email interview with author. 19 July.

Lima, Laura. 2011. 'Call for Participation in *11 Rooms* Exhibition.' *Disability Arts website*. Accessed 21 April 2012 at www.disabilityarts.org/domains/disabilityarts.org/. . . /laura_lima_advert.doc.

Lindgren, Kevin. 2012. Equity representative. Phone conversation with author on 10/7/2012.

Lippard, Lucy. [1973] 1997. *Six Years: The Dematerialization of the Art Object from 1966 to 1972*. Berkeley and Los Angeles: University of California Press.

Margolles, Teresa. 2004. 'Santiago Sierra by Teresa Margolles.' *Bomb Magazine* 86: Winter. Accessed at http://bobmagazine.org/article/2606/santiago-sierra

Marx, Karl. [1859] 2008 *Capital*. Oxford: Oxford University Press.

MoMA Multimedia. 1994. Audio recording of Marina Abramović discussing *Luminosity*. Accessed 11 July 2012. Accessed at http://www.moma.org/explore/multimedia/audios/190/1994

Pollack, Barbara. 2012. 'Risky Business.' *ARTnews* 2012. Accessed 18 April at http://www.artnews.com/2012/03/29/risky-business/

Schilling, Chris. 2005. *The Body in Culture, Technology & Society*. London, Thousand Oaks, and New Delhi: Sage Publications

Schneemann, Carolee. [1983] 1996. 'Letter to the Editor.' *Artforum* 22 (2): 2. In *Contemporary Art: A Sourcebook of Artist's Writings*, edited by Kristine Stiles and Peter Selz, 683. Berkeley, Los Angeles, and London: University of California Press.

Schneider, Rebecca. 2012. 'It Seems As If . . . I Am Dead: Zombie Capitalism and Theatrical Labor.' *TDR: The Drama Review* 56 (4): 150–162.

Scott, Andrea. 2010. 'High Wire Act.' *New York Times*. 12 February. Accessed 24 March at http://www.nytimes.com/2010/02/28/t-magazine/28well-abramovic.html

The Guardian. 11 July. Accessed 15 July at http://www.guardian.co.uk/artanddesign/2011/jul/11/manchester-international-festival-marina-abramovic.

Sierra, Santiago. 2011. 'Employment—Ex-Soldiers and Young Veterans Wanted.' Call for Performers for *11 Rooms* on *Jobs Oracle* website. Accessed 10 July 2012 at http://www.jobsoracle.com/jobs/security/archive/Ex-Soldiers_And_Young_Veterans_Wanted_8009.htm

Sierra, Santiago. 2012. Artist's website. Accessed 10 July at http://www.santiago-sierra.com

Spiegler, Mark. 2003. 'When Human Beings Are the Canvas.' *ArtNews* 102 (6). Accessed 18 July 2011 at http://www.artnews.com/issues/article.asp?art_id=1335

Stefan, Olga. 2014. *Art in America*. 12 June. Accessed at http://www.artinamericamagazine.com/news-features/news/commodifying-experience-14-rooms-at-art-basel//

Stiles, Kristine & Peter Selz, eds. 1996. *Contemporary Art: A Sourcebook of Artist's Writings*. Berkeley, Los Angeles, London: University of California Press.

Tate Modern website. 2008. 'Performance: Santiago Sierra.' 21 April. Video: Accessed at http://www.tate.org.uk/context-comment/video/performance-santiago-sierra

Tate Shots. 2011. '11 Rooms, Manchester Festival.' 14 July. Accessed 16 July at http://www.youtube.com/watch?v=NLBjw0M1ZvI

11 Reconsidering Liveness in the Age of Digital Implication

Eirini Nedelkopoulou

The increasing use of ubiquitous and network technologies in art and performance entails the renegotiation of liveness on the basis of different inter-agential perspectives. Focusing mainly on United Visual Artist's (UVA) work *Rien à Cacher, Rien à Craindre* (2011), this chapter discusses artists' framing of participatory encounters with technology, which are neither prosthetic, nor representational nor utilitarian. Departing from the oppositional binaries and hierarchical tensions that defined the relationship between the physical and the digital over the past decades, this chapter rethinks liveness in art practices that attempt to displace the centrality of human agency. The chapter diverts from Philip Auslander's view that digital liveness is 'an interaction produced through our engagement with the object and our willingness to accept its claim' (2012, 10) and proposes a shift of perspective that aligns with our emerging new network reality. In this context liveness is regarded as an encounter, a gathering, where human and non-human participants *are implicated* and become part of 'a larger operation' (Hansen 2015a). Reflecting on Mark Hansen's (2015a, 2015b) 'phenomenology of implication,' I ponder on the reconfiguration of embodied performativity in response to ubiquitous and networked environments.

UVA's work experiments with technologies, which are active, responsive and, as Hansen would argue, 'atmospheric' (2013). In this sense, technologies can be active in different ways. If technological interactivity used to be offering to humans the possibilities to do things, *now* interactive networks signify a shift in interactivity by responding to humans in ways that are not always initiated by humans. The physical and the digital in *Rien à Cacher, Rien à Craindre* merge into a number of processes and constitute together the same performance event, which functions beneath participants' imagination and perception. This chapter is particularly concerned with networks that are invisible, lack interface and are self-generating, exploring how the 'implication' of participants within this event is potentially asynchronous. In suggesting that the *nowness* of interaction is not what matters the most, the potentiality of implication comes to the foreground of the performance eventness.

Liveness = Implication?

A network is not a technological ready-to-hand object in the same way a hammer, a telephone or a camera is. Geert Lovink claims in *Networks Without Cause*

that networks have 'a specific ambiguity', as they 'at once talk about the social as well as the machinic. [. . .] Networks integrate sociality with software, interfaces, and routers' (2011, 73). A network system evades human subjectivity as it partly functions as a consequence of data and information provided by participants and users. This system is not non-living, but organic in the sense that it 'acts, senses results, compares to its goal' (Ekeus 2010, 9) and is characterised by continuous and natural development through feedback loops.

For Lovink, a network system's informality, fluidity and invisibility are aspects that can cause 'panic and confusion' to its users (2011, 73). Connected to this, Sherry Turkle (2011) amongst others has discussed the anxiety that the emergence of networks brings to the foreground of our experience and which is often associated with our loneliness, invasion or lack of privacy, and commodification of interactivity. Nevertheless, Lovink underlines that networks are at the infancy of their potential and as 'social-technical formations under construction' (74) override any real/virtual binaries.

In this context of uncertainty and excitement about what networks can do to us and to our environment, especially when the operations expand beyond the user and the device interaction, there is a question about liveness in networked practice. Technological innovations, including RFID (Radio Frequency Identification) databases, the Internet of Things and distributed cognition, have been welcomed by artistic practice. The work of CREW, KMA, Blast Theory, Paul Sermon, The Builders Association, as well as art museums and galleries (The Museum of London, Tate Modern) to name but a few, focus on the relational and ubiquitous aspects of responsive and distributed systems experimenting with new directions in the making and reception of art practices. In his essay 'Digital Liveness: A Historico-Philosophical Perspective' Auslander following Hans-Georg Gadamer's view on art aesthetics argues that:

> some technological artefact—a computer, website, network, or virtual entity—makes a claim on us, its audience, to be considered as live [. . .]. (L)iveness is neither a characteristic of the object nor an effect caused by some aspect of the object such as its medium, ability to respond in real time, or anthropomorphism. Rather, liveness is an interaction produced through our engagement with the object and our willingness to accept its claim.
>
> (2012, 9)

What we consider as live performance changes in the same way that our relationship with our objects, our world and ourselves changes through technology. In the same discussion Auslander proposes that liveness 'derives neither from the intrinsic properties of the virtual entities nor from the audience's perceiving them as live' (2012, 10). Nevertheless, there is an important ontological context to liveness too that needs to be explored in response to the embodied performance of a network system. This is not about the ontology of 'live' or mediated performance (Auslander 1999, Phelan 1993) or the ontological status

of the performer (Auslander 2002) as discussed in the past. Rather, liveness here is closer to what Hansen identifies as 'ontology of potentiality' (2015a, 259), which lies in ways of being and becoming implicated, instigated by the machine instead of the human. Reflecting on the functionality of networks in art practice, I suggest that the performances of living and non-living components, the internal system and responsive processes indicate a type of liveness, which is not always the result of conscious attention and awareness. Yet the network activity is no less live.

In his discussion about interactive technologies and networks, Auslander insists on placing humans in the centre of a liveness locus, which is defined by a clear divide between the status of subject and object during their exchange. Auslander turns to the phenomenological experience of intentionality when he identifies liveness with a 'specific relation between self and other, a particular way of 'being involved with something' (2012, 10). However, networked practices that integrate social media, GPS, RFID and new sensor technologies evidence a shift in the status of objectivity. That means that the function of a network is not based on the differentiation between the participants and the other, the object, the technology.

I propose that Hansen's 'phenomenology of implication' (2015a, 2015b) describes more accurately the 'live' experiential event. That is, participants are involved *in* something, and this is a physical environment made accessible by different technical networks. The following exploration of *Rien à Cacher, Rien à Craindre* discusses the implication of human agency within a technical network that migrates into the physical environment of a gallery space. The discussion of liveness in this artwork departs from Auslander's 'intentional distance,' between self and other, the body and the technology, to identify with Hansen's broader environmental logic of 'collective becoming' (2015a). Hence, liveness identifies with both self's and other's implication within a ubiquitous milieu. Neither the implicated body nor the different technologies are 'the center or agent of sensory processing' (Hansen 2015b, 222) in this scenario of potentiality. Instead, implication appears as a challenge to any 'assumptions concerning the functioning of the phenomenal body and its correlation with the environment/world' (Ibid.). Perhaps then, the discussion of 'the claim' that technology makes on its audiences is not the essence of liveness in the context of technical networks. Not because the technology or the networks cannot make claims on individuals audiences. Rather because of a paradox. That is, an important part of the technology 'works largely outside the realm of perceptual consciousness, yet at the same time inflects their every sensation' (Hansen 2015a).

Rien à Cacher, Rien à Craindre

In March 2011 Théâtre de la Gaîté, Paris, having been closed for almost twenty years, re-opened its doors to the public renamed as La Gaîté Lyrique. With the motto 'A digital revolution in Paris' the president and director Patrick Zelnik and Jérôme Delormas connected the gallery's opening with the emergence of an era where 'our relationship to knowledge, our ways of thinking about the

218 *Eirini Nedelkopoulou*

world, our social relationships' and artistic creation are transformed and challenged (cited in aqnb 2011). They asserted the objective of La Gaîté as being to feed 'the debate about the stakes of the digital revolution in progress and thus to put into perspective some of the most innovative and exciting creative productions of our time' (aqnb 2011).

The London-based UVA were commissioned to create an interactive mega-installation, *Rien à Cacher, Rien à Craindre*, to launch the re-opening of the Parisian landmark. Founded in 2003 by Matthew Clark, Chris Bird and Ash Nehru, UVA is a cross-media company, having at the centre of their practice experimentation with evolving new technologies and materials. UVA's stated aim is to explore 'the tension between real and synthesised experiences, the questioning of our relationship with technology, and the creation of phenomena that transcend the purely physical' (UVA 2015).

The title of the project (*Nothing to Hide, Nothing to Fear*) evokes the Orwellian dystopia of an information society that widely propagandises the need to see, to be seen, cooperate and obey. Based on La Gaîté Lyrique's hi-tech infrastructure, *Rien à Cacher, Rien à Craindre* turns the building into a ubiquitous environment, a circular intelligent system that echoes Jeremy Bentham's 'peripheric building' which is 'divided into cells [. . .] like so many cages, so many small theatres,' according to Michel Foucault's description (1979, 200). However, the panoptic structure proposed by UVA does not intend to demonise the use of network technologies or even present a human versus technology story. Rather *Rien à Cacher, Rien à Craindre* explores the potential of *an all-seeing* network, which lies in human non-human interaction.

La Gaîté is a networked stage divided into different spaces allowing different acts to happen. Over 350 ceiling speakers, a network of architectural lighting, RFID readers embedded at all entry points, in all spaces and the high-speed ubiquitous connection of the building constitute an interactive infrastructure, which offers a technological canvas to the artists in residence. In *Rien à Cacher, Rien à Craindre*, UVA engage the participants as well as its technologies into a system of operations, constructing a panoptic environment where the technology is always on.

Audience's involvement in the interactive milieu of La Gaîté starts before they enter the venue, as participants log on to the gallery's website to book their tickets. A personal fact sheet appears with a list of questions regarding their preferences, their choices, their mood, and so on. What is your favourite colour? Your favourite band? How tired are you? The answers to these and more questions constitute an individual record, which is linked to a RFID tag with a unique ID for each visitor embedded in their passes. A number of antennas placed above most of the doorways inside La Gaîté are connected with RFID readers, which pick up the unique visitor IDs and send the information from the tag and its location through the building's RFID system.

The company orchestrates the sound, audio and RFID capacities of La Gaîté to create, 'Universal Building Gesture'. This is a system, a sound and light-scape which spreads through the large open spaces across each of the floors. 'Universal

Building Gesture' ties the different installations of *Rien à Cacher, Rien à Craindre* together acknowledging the visitors' presence. The production consisted of four installations designed by UVA; here I will focus on the three specifically designed for La Gaîté—'Room 101', 'Assembly' and 'Ensemble'. These, along with the 'Universal Building Gesture', will be the focus of my discussion and in the following paragraphs I will map out participants' experience of the spaces.

Walking Through La Gaîté

Visitors enter La Gaîté and the building instantly wakes up. A wave of different sound effects permeates the space. The visitors listen to voices breathing in and out, often speaking incomprehensible lines. Simultaneously bright, dimmer and dark lights accompany the soundscape and follow or guide the participants' route within the building; it is not clear who leads whom. Alexandros Tsolakis of UVA, in our discussion in January 2013, explained that the 'Universal Building Gesture' functions through 'an operationally cyclical movement of light and sounds, urging visitors from one area to the next' (personal interview).

As audiences move forward and come closer to the individual rooms of the gallery, another part of the 'Universal Building Gesture' is activated through the RFID readers. 'Visitor no # is lonely,' 'Visitor no # wants to get out of here,' 'Visitor no # does not want to use Facebook' are projected on LED screens. Following the free-flowing spatial movement of the 'Universal Building Gesture', the visitors soon enter the individual installations of *Rien à Cacher, Rien à Craindre*. Guided one level up from the main entrance, to the mezzanine area, to encounter an interactive installation, the 'Assembly', the visitors are scanned and categorized (see Figure 11.1). This time, their faces are the primary data input, as the participants stand on a podium and see a multiscreen canvas of

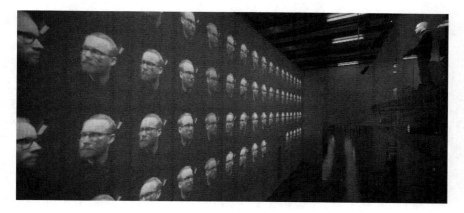

Figure 11.1 Technical Trial of 'Assembly' in *Rien à Cacher, Rien à Craindre*, 2011. Courtesy of Alexandros Tsolakis (UVA).

digital faces projected on a wall across them. Their own faces are captured and projected next to an array of faces of strangers, who do not necessarily cohabit the podium at the same time. Technically, what happens is that 'a facial recognition system isolates their face, tracks their eyes, nose and mouth, and then mixes those features with features taken from other faces to produce a range of composite faces' (UVA 2010, 2). The visitors' data is stored and combined with other participants' data, who partook in the work earlier on that day or the previous days of the exhibition. Present and past visitors contribute to the making of a responsive canvas, which in animated through algorithmic patterns. In effect, the installation software *decides* on the combination and structure of the digital material based on the structure of their faces, the distance between their features and the size of their heads.

The visitors move on to explore the rest of the mezzanine area. And there, under the podium they encounter a field of LED strips forming an immersive installation entitled 'Ensemble'. A ripple of light and sound sets off as soon as individuals enter the field of LED strips, where the visitors' movement affects the pitch, volume and type of sound, modulating the colours and visual patterns of the LEDs. Sensors placed between the vertical LED strips register the presence, absence and mobility of the individuals as they walk through the space. The audiovisual ripple travels across the space, pulsating, evoking a laser effect until it *hits* a static or a slow-paced body. And although the ripple continues its journey, it leaves behind gaps, dark patches in parts of the lightscape where the beam hit and scanned a still body. The more members of the audience group together and stand still the bigger the dark patch they create.

The visitors leave the mezzanine behind to head downstairs, to the petite salle where another installation, 'Room 101', is situated (see Figure 11.2). They enter the installation at a maximum of ten at a time, discovering a dense atmospheric haze of lights and localised sounds. A kinect scanner picks up the participants' presence and single beams of light emerge sweeping across the dark room accompanied by striking sound motifs and target different bodies in the space depending on their activity, mobility and shape. Some participants become immersed into their personal digital maze; the rest can only see an array of beams of light framing their co-participants. In the first case, laser lines turn into a maze-like series of walls and paths, a geometric grid of lights, which spread across the space surrounding each participant. Within the 3D labyrinthine space individual participants come to grips with the potential offered by this generative compositional structure and playfully explore the potential of their physicality within the system while the system reconfigures its behaviour in more/less crowded/louder occasions. Interestingly, the further this virtual maze is explored by the participants, the more its shape and function is reconfigured. Some individuals try to escape the maze by speeding up, others wander around attempting to experience different parts of their individual maze until it dissolves turning back into two-dimensional laser lights.

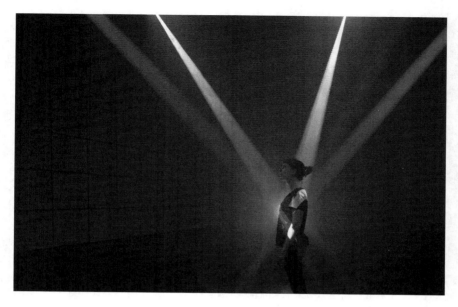

Figure 11.2 'Room 101' in *Rien à Cacher, Rien à Craindre*, 2011. Courtesy of Alexandros Tsolakis (UVA).

With or Without Interfaces: The Role of Technology in *Rien à Cacher, Rien à Craindre*

In recent years a variety of practices in theatre, performance and art have exhibited a fundamental shift towards interactivity and participation, facilitated by the use of network technologies as participatory platforms. Interactive work by Blast Theory, KMA, CREW, The Builders Association, CoLab and Gob Squad, amongst others, re-thinks the social, affective, functional and relational qualities of participants' presence within technological performance spaces. The artistic activity of the above companies demonstrate how digital culture invites audiences to engage with an artwork as collaborators, evidencing that participation and interaction is one of the defining principles of digital culture.

Responding to the postmillennial shift of cultural production towards new forms of communication, materiality and connection, UVA's *Rien à Cacher, Rien à Craindre* admits that interaction has to be conceived differently. UVA stage this moment in time where technology is not contained in discrete apparatic packages; it is not simply in front of us, above us or around us but technology is diffused into our physical environment. This type of technology, which lacks visible interface and evades the physical environment, is identified as 'diffusely atmospheric' by Hansen (2013).

222 *Eirini Nedelkopoulou*

Rien à Cacher, Rien à Craindre's main framework, the 'Universal Building Gesture', along with installations such as 'Room 101' could be considered as an attempt to approach atmospheric technology in art. The 'Universal Building Gesture's' connection with the building and each of the installations is based on a network system. *Rien à Cacher, Rien à Craindre*'s technology is mainly neither instrumental nor anthropomorphic, neither representational nor prosthetic. And although visitors will occasionally encounter individual focal points—for instance, the screens in the 'Assembly' or the LED strips in 'Ensemble'—the artwork overall lacks specific interfaces as well as a centrally controlled hub, contradicting the connotations of its panoptic design. Part of the system, the architectural lighting, the ceiling speakers, the RFID readers are individually responsive. Identifying with Hansen's definition of atmospheric media, I suggest that the networked environment of *Rien à Cacher, Rien à Craindre* is 'no longer object centered, resolutely personal, individually framed' and the technical engagement 'is impersonal, collectively accessible' (2013, 73). The project comprises a network that actually interweaves living and non-living operations into a series of processes of liveness instead.

Audiences stroll around La Gaîté within an interactive environment that is transformed and affected by their presence and vice versa. Sound and light patterns define immaterial routes that participants contribute to, while their data is dispersed, re-assembled or even attached to different parts of the networked architecture. The audiences are not given specific tasks to do, a narrative to complete, something to construct, a puzzle or quiz to solve, a treasure to find. The screens of the 'Assembly', the ambient sound in the open spaces of La Gaîté, the ripple of light in 'Room 101' and the LED strips of the 'Ensemble' and the 'Universal Building Gesture' offer subtle cues to follow. These cues escape some visitors' attention, who instead continue travelling in the space. All visitors are surrounded by a hazy sensation of being part of an audio/light scape, to which they contribute to its making. It is this sensation that implicates the participants into the event of *Rien à Cacher, Rien à Craindre*.

There is an inclination to see technologies as providing instruments to be used for a specific purpose. UVA do not offer to their visitors a ready-to-hand technology for the completion of a purposeful task. The lack of constant interfaces or even ready-to-hand interfaces challenges both the visitors' role in the current environment (What is my role here? What do I do next?) and technology's functionality. If technology is not ready-to-hand then it must be broken, what Martin Heidegger identifies as present-at-hand. For instance, when a hammer breaks, it loses its usefulness and appears as merely there, present-at-hand. When a thing is revealed as present-at-hand, it stands apart from any useful set of equipment but soon loses this mode of being present-at-hand and becomes something else—typically, that which must be repaired or replaced. Yet when the technology is not recognised as fulfilling its familiar uses—as a visible interactive interface or a representational or even an anthropomorphic medium—then audiences' intentionality is challenged as well. Evan Thompson and Dan Zahavi explain that intentionality 'in a narrow sense [...] is defined as

Reconsidering Liveness in the Age of Digital Implication 223

object-directedness'. (2007, 71) Therefore, with ubiquitous and invisible technology audience's intentional states are likely to be questioned or even confused. What is *Rien à Cacher, Rien à Craindre*'s technology about then? What is its *aboutness*?

Rien à Cacher, Rien à Craindre's technologies are neither tools to use, nor simulators of human communication. The networked system of the artwork follows a distributed, impersonal or even beyond perception modes of communication. Liveness in this context diverges from phenomenological intentionality. *Rien à Cacher, Rien à Craindre*'s condition of liveness neither requires the spectators' and actors' co-presence, face-to-face interaction, as Erika Fischer-Lichte would argue (2008, 67), nor is determined by individuals' 'willingness to accept' an object's 'claim' (Auslander 2012, 9). The artwork is defined by both human/technology interactive and system-internal processes, which often escape human consciousness, yet they are still integral to the happening of the work. Regarding the differentiation between intentionality and implication, Hansen claims 'Like intentionality, implication designates a relation between an experiential event and an objectivity informing that event, but it differs fundamentally from intentionality on the question concerning the status of that objectivity' (2015b, 222). In effect, technology is part of an 'autopoietic feedback loop' that depends on participants as well as the technological network.

Feedback Loops in Networked Performance

Visitors enter the dark 'Room 101' and walk in the space to be shortly detected by the kinect scanner followed by a ripple of light. The participants will soon find themselves embedded into individual mazes that are generated by their own movements. Simultaneously, the individuals' movements will be re-informed again by the maze's algorithmic patterns. Both technology and bodies are involved in what Fischer-Lichte describes as an 'autopoietic feedback loop' (2008, 39), which determines the liveness of an event. Although Fischer-Lichte does not touch upon ubiquitous and interactive technologies in performance per se, she strongly argues that 'mediatized performance invalidates the feedback loop' as it severs 'the co-existence of production and reception' (2008, 68). This is not the case for *Rien à Cacher, Rien à Craindre*. Not only because most of the project is not autonomously created, but also because this non-autonomous part of the system does not function according to a logic of technology that identifies with the invitation of explicit modes of interacting. This technology is part of a system that sets a stage or a situation in which visitors find themselves implicated instead. The project is made as it is experienced—or sensed—and it is experienced as it is made. *Rien à Cacher, Rien à Craindre* features an autopoietic feedback loop—that is, a self-generative, a self-organising system.

UVA's artwork is determined by algorithmic variables that respond to the engagement of audience members and vice versa. That is, bodies and technologies are engaged in a process of determining and being determined. Even

in front of a screen-based interface of 'Assembly', the participants soon find out that they are not sole agents, but co-determinants in the making of the artwork. The multiple copies of their faces will be scanned and compared in relation to thousands of other imagery that could be considered compatible according to the algorithmic variables to offer every time a new combination of images. The information is speedily processed and renewed; new canvases with new portraits will replace the older ones. The network-enabled performance relies on a system, which is 'self-generating', 'ever-changing', 'unique' and 'unrepeatable', to use Fischer-Lichte's terminology. Liveness of the event emerges through this loop of combined organic and non-organic variations that produce other variations.

Experiential and technical feedback overlap, defining individual and collective spaces for the participants, who traverse from 'Assembly' to 'Ensemble' and then to 'Room 101' through the 'Universal Building Gesture'. *Rien à Cacher, Rien à Craindre* presents a space-laboratory where technology and participants perform. Their interdependent performances stretch the boundaries of collaboration and interactivity beyond human conscious awareness. Indeed, the autopoietic feedback loop of UVA's network system is 'kept in motion' as Fischer-Lichte would argue and 'not just through visible and audible actions and attitudes of' the individuals 'but also through the energy circulating between them' (2008, 59). Although Fischer-Lichte's sentiment effectively encapsulates the atmosphere of the circular self-generating system of *Rien à Cacher, Rien à Craindre*, I object to her concept of *circulating energy*. Rather, I prefer to describe the inaudible and invisible activity between human and non-human components of the interactive event as 'worldly sensibility' (Hansen 2015a). Namely, 'worldly sensibility' refers to an ontological potentiality and more specifically explicates the role of technology, which can 'enhance human experience' imposing 'a new form of resolutely non-prosthetic technical mediation' (Hansen 2015a, 4).

La Gaîté's aspiration to celebrate the social through the digital and vice versa is put into practice in these moments of the audience's becoming part of an environmental sensibility. What visitors *sense* relies to a big extent on inaccessible operations—a haze of ever expanded spatiality, a social atmosphere of unfamiliar interactions, the unintentional gatherings. Visitors experience the outcomes of their interactions with the network system, yet they hardly grasp the operations behind audio/visual scape they come across. *Rien à Cacher, Rien à Craindre* experiments with new modes of becoming in the sense that it challenges technological instrumentalisation. The project's interactive and ubiquitous practices facilitate the making of a *live* environment. This making effectively departs from ready-to-hand operations and face-to-face communications. Reflecting on Meike Wagner's and Ernst Wolf-Dieter's sentiment that social and technical nature of feedback-loops 'maintain the network in a process of co-evolution' (2010, 175), I propose that liveness aligns with the sense of co-evolution, improvement and potentiality. I refer to potentiality as being-in-the-world-anew beyond human/technology divides.

A Walk in the Woods: When the Human and the Non-Human Become Implicated

Auslander recognises that 'our anthropocentrism is the territory we are not willing to cede to the dominance of the digital' ([2006] 2011, 197) And he is right; we are not ready to cede our anthropocentrism. However, his claim about 'the dominance of the digital' echoes the outmoded mediatised versus 'live' debate. The emergence of ubiquitous networked media in our everyday life has expanded human subjectivity in ways that are nothing like human, yet they impact on human experience.

Rien à Cacher, Rien à Craindre belongs to a context of practice that is networked, and experiments with how technology affects embodied performance relations. According to Turbulence.org and Michelle Riel 'any live event that is network-enabled, including any form of networking in which computational devices speak to each other and create a feedback loop' is identified as a networked performance (cited in Chatzichristodoulou 2014, 22). An emerging generation of artists, such as Blast Theory, Coney, CREW and KMA, have engaged with ubiquitous technologies, locative media and augmented reality to create networked performance spaces. Trying to unpack the notion of 'live' in reference to the networked environment of this interactive work, I suggest that 'live' refers to both the internal system processes (which remain ungraspable, unrevealed and inaccessible to the audience's perception) *and* to the responsive processes between visitors and the network. A network system appears to reorientate participants' experience and that happens by implicating them within the spectrum of non-human and human processes that reconfigure the performance space. Different perspectives, which challenge human subjectivity, are generated and accommodated in a 'live' milieu.

Any attempt to shift the human perspective to a non-human angle still remains far from reality. It is indeed difficult, if not impossible, to think beyond our human capacities. Interestingly, Spike Jonze's sci-fi film *Her* (2013), which is unfolded around the romantic relationship between Theodore (Joaquin Phoenix) and an operating system, Samantha (Scarlett Johansson), demonstrates this impossibility of grasping something that evades the human consciousness. Samantha is very much anthropomorphized until the point that she starts evolving significantly and hectically fast, transcending human consciousness and materiality. And that is the point of separation between the human and his OS lover. Nevertheless, the non-anthropocentric attempts that networked performances, such as *Rien à Cacher, Rien à Craindre* make, do not target the conscious understanding between the human and the non-human. On the contrary, these practices concern new modes of interacting in networks structures, which are generated by algorithmic variations. Often these modes of interactivity overlap with the human experiences that Mark Weiser envisioned about ubiquitous technology almost 25 years ago. Namely, Weiser argued that 'Machines that fit the human environment, instead of forcing humans to enter theirs, will make using a computer as refreshing as taking a walk in the woods'.

226 *Eirini Nedelkopoulou*

(1991) And indeed some of the works by Blast Theory, KMA, Coney and UVA take place within a physical space, which is permeated by different technologies. Weiser and Brown define this type of technology as 'calm' in a sense that it 'informs but doesn't demand our focus or attention' (1995).

Networked performances concern 'real-time [. . .] embodied transmission' (Turbulence.org and Riel cited in Chatzichristodoulou 2014, 22) and when they make use of calm technologies, they could offer a playful ramble into an interactive environment. Similar to a walk in the woods, certain behaviours are expected to happen between the visitors and the environmental surroundings; to observe, stop, and look around the space while being surrounded by nature. In both the forest and the networked performance environment, the landscape sometimes falls into the background of visitors' attention and stays unnoticed. Yet there will be a bird or a tree or the light between leaves that will attract visitors' attention. What people perceive or do not perceive in this context depends on each individual's experience. In both cases people become part of a bigger physical milieu, which happens because of either technical or natural processes that take place without overloading visitors with information. Ubiquitous and network systems as calm technology are run by internal processes for purposes other than storing and manipulating human data. No matter how relaxing a walk in networked performance surroundings could be, audiences always leave behind their traces (such as written or verbal responses, their movement, other data, etc.). The number of processes, human and nonhuman, contribute to the creation of the performance milieu, which is not just a product 'of subjective synthesis' (Hansen 2015a, 257), but an interagential one.

Networked performances invite us to rethink some of our assumptions concerning participants' embodied experiences and their correlation with a techno-environment. In this instance, the eventness of the performance concerns the implication of a body without making it the centre or agent of sensory processing. The idea of new modes of collective becoming is closely linked to the nature of network systems. Commenting on the ubiquity of networks N. Katherine Hayles indicates 'you would never get with a database alone. Now you get that power to really move into the environment, surveil what's happening and also communicate between the devices' (2009, 48). Networked performances attempt to evidence the hidden possibilities of a potential collective becoming, which are related to new ways of experiencing ourselves and the world—and for understanding how we experience the world and ourselves.

There is a (post)phenomenological disposition in the making of networked performances, as the practices invite participants to 'reach for the invisible in order to learn from [their] failure to grasp it' (Bleeker, Sherman and Nedelkopoulou 2015, 16). The networked structure of these artworks is more than simply algorithmic. The structure is equally technical, relational and practical. The locative and mobile media (UVA), sensor technologies (KMA) and augmented reality (Blast Theory) affect, enhance and even demote aspects of the audience's experience, as well as the functionality of the space and how the

space contributes to the making of an organic environment. It turns out that the advent of network and ubiquitous technology prepares for a new era in our engagement with our surroundings. And technology is not the *other* that we have to interact with. Echoing once again Hansen's potentiality of implication in ubiquitous and networked settings, I contend that the temporary or even momentarily loss(es) of cognitive mastery or perceptual access over specific parts of the networked performance experience are very much recompensed by what could be gained in participants' involvement within larger environmental gatherings.

Conclusion

Drawing on Auslander's view that media and our technology in general 'are simultaneously cause and effect of a given historical moment's social formations' (2011, 194), I suggest our specific moment in time asks for new ways on being in performance space. New potential performance ecologies are not (or try not be) exclusively anchored to human agency. Our network culture flirts closely with the potentiality of the Internet of Things and its use in all aspects of human activity when things 'will become agents that [. . .] "speak on" matters from an altogether different point of view, that lend a Thing-ly perspective on micro and macro social, cultural, political and personal matters' (Bleecker 2009, 174). What Bleecker envisages here is not the need to create more refined 'technical frameworks,' but more 'habitable worlds' instead (2009, 174). In this emerging reality, liveness relates to a performance subjectivity that lies in the intertwining between the technical and the experiential, both nested in the same physical surroundings.

References

aqnb. 2011. 'A Digital Revolution in Paris: La Gaîté Lyrique.' March 2015. Accessed at http://www.aqnb.com/2011/03/13/a-digital-revolution-in-paris-la-gaite-lyrique/

Auslander, Philip. 1999. *Liveness: Performance in a Mediatized Culture*. Abingdon: Routledge.

Auslander, Philip. 2002. 'LIVE FROM CYBERSPACE or, I Was Sitting at my Computer this Guy Appeared he Thought I was a Bot.' *PAJ: A Journal of Performance and Art* (PAJ 70): 16–21.

Auslander, Philip. [2006] 2011. 'Afterword: Is there life after Liveness.' In *Performance and Technology: Practices of Virtual Embodiment and Interactivity*, edited by Susan Broadhurst and Josephine Machon, 194–198. Basingstoke and New York: Palgrave Macmillan.

Auslander, Philip. 2012. 'Digital Liveness: A Historico-Philosophical Perspective.' *PAJ: A Journal of Performance and Art* September 34 (3) (PAJ102): 3–11. doi: 0.1162/PAJJ_a_00106.

Bleecker, Julian. 2009. 'Why Things Matter: A Manifesto for Networked Objects—Cohabiting with Pigeons, Arphids, and Aibos in the internet.' In *The Object Reader*, edited by Fiona Candlin and Raiford Guins, 165–174. London and New York: Routledge.

Bleeker, Maaike, Eirini Nedelkopoulou & Jon Foley Sherman. 2015. 'Introduction.' In *Phenomenology and Performance: Traditions and Transformations*, edited by Maaike Bleeker, Eirini Nedelkopoulou and Jon Foley Sherman, 1–19. New York: Routledge.

Chatzichristodoulou, Maria. 2014. 'Cyberformance? Digital or Networked Performance? Cybertheaters? Or Virtual Theatres? . . . Or All of the Above?.' In *CyPosium*, edited by Annie Abrahams and Helen Varley Jamieson, 19–30. Montpellier: Centre de Culture Contemporaine.

Ekéus, Henrik Carl-Olof Julian Oldfeldt. 2010. *Elucidating Novelty and Delight-United Visual Artists and La Gaîté Lyrique*. Media and Arts Technology Programme Project Report, School of Electronic Engineering and Computer Science. Queen Mary University of London.

Fischer-Lichte, Erika. 2008. *The Transformative Power of Performance: A New Aesthetics*. Translated by Saskya Iris Jain. Abington and New York: Routledge.

Foucault, Michel. 1979. *Discipline and Punish: The Birth of the Prison*. Translated by Alan Sheridan. London: Penguin Books.

Hansen, Mark. 2013. 'Ubiquitous Sensation: Towards an Atmospheric, Impersonal and Microtemporal Media.' In *Throughout: Art and Culture Emerging With Ubiquitous Computing*, edited by Ulrik Ekman, 63–86. Cambridge: The MIT Press.

Hansen, Mark. 2015a. *Feed-Forward: On the Future of 21st Century Media*. Chicago and London: The University of Chicago Press.

Hansen, Mark. 2015b. 'Performance as Media Affect: The Phenomenology of Human Implication in Jordan Crandall's *Gatherings*.' In *Performance and Phenomenology: Traditions and Transformations*, edited by Maaike Bleeker, Jon Foley Sherman and Eirini Nedelkopoulou, 222–243. New York: Routledge.

Hayles, N. Katherine. 2009. 'RFID: Human Agency and Meaning in Information-Intensive Environments.' *Theory, Culture & Society* (SAGE, Los Angeles, London, New Delhi, and Singapore) 26 (2–3): 47–72.

Lovink, Geert. 2011. *Networked Without a Cause: A Critique of Social Media*. Cambridge: Polity Press.

Phelan, Peggy. 1993. *Unmarked: The Politics of Performance*. New York: Routledge.

Thompson, Evan & Dan Zahavi. 2007. 'Philosophical Issues: Phenomenology.' In *The Cambridge Handbook of Consciousness*, edited by Philip David Zelazo, Morris Moscovitch and Evan Thompson, 67–87. Cambridge: Cambridge University Press.

Turkle, Sherry. 2011. *Alone/Together: Why We Expect More from Technology and Less from Each Other*. New York: Basic Books.

UVA. 2010. 'La Gaîté Lyrique Artists in Residence- United Visual Artists', Artists Working Notes/Proposal to La Gaîté (unpublished).

UVA. 2015. 'United Visual Artists: About.' September 2015. Accessed at https://uva.co.uk/about

Wagner, Meike & Ernst Wolf-Dieter. 2010. 'Networking.' In *Mapping Intermediality in Performance*, edited by Sarah Bay-Cheng, Chiel Kattenbelt, Andy Lavender and Robin Nelson, 173–183. Amsterdam: Amsterdam University Press.

Weiser, Mark. 1991. 'The Computer for the 21st Century.' *Scientific American* 265 (3). December 2015. Accessed at http://www.ubiq.com/hypertext/weiser/SciAmDraft3.html.

Weiser, Mark & John Seely Brown. 1995. 'Designing Calm Technology.' December 2015. Accessed at http://www.ubiq.com/weiser/calmtech/calmtech.htm .

12 Environmental Performance

Framing Time

Anja Mølle Lindelof, Ulrik Schmidt and Connie Svabo

Do ants and grasshoppers perform? Do clouds, plants and melting ice? Do sky-scrapers, traffic jams and computer vira? And what happens to our understanding of liveness if that is the case?

This chapter takes ongoing theoretical disputes about the nature of live performance in performance studies as its starting point to investigate liveness within a specific kind of contemporary performance: 'environmental performances'. Environmental performances are arts practices that take environmental processes as their focus by framing activities of non-human performers such as clouds, wind and weeds—key examples discussed in this chapter being Francisco López's *La Selva* (1998), James Turrell's *Skyspaces* (1974-), James Benning's *Ten Skies* (2004), Pierre Huyghes' *Untilled* (2012) and Pierre Sauvageots' *Harmonic Fields* (2010). Environmental performances typically persist over several days or weeks, or even indefinitely, thereby transgressing the timespan that audiences and performers alike are capable of giving focused attention. Environmental performances offer experiences of time passing, of temporality. They allow contemplation of the flux and flow, to rhythms of weather and life, to a continuous time-space unfolding in real time. Central are not human characters or theatrical scripts. Rather these works depend on 'natural' forces outside human control. In such situations it is the 'world' that performs, in all its multilayered dynamic complexity.

Environmental performances contribute to an ongoing expansion of 'what performs' in contemporary scholarship on live performance. What happens to our understanding of liveness in performance when it encompasses actions that are not carried out by human bodies with their subjectivity and human intention and identity?

This chapter offers an account of liveness in environmental performance. First, the notion of *live* is expanded to include all sorts of performing entities. As it becomes evident that the quality of *live* may be ascribed to a multitude of performances and entities, liveness is increasingly seen to have to do with *experience*. For this reason the chapter proceeds to a brief look at experience, which in the context of liveness is sketched out as *involvement*: a specific relation between the person and that which is perceived as 'live'. Experiencing liveness is a relationship where involvement and interaction

230 *Anja Mølle Lindelof et al.*

are central. Finally, environmental performance is taken as a fruitful point of departure for exploring how *experiencing liveness* may be unfolded beyond oppositions like live/mediated and human/non-human. Environmental performance helps draw out a notion of experiencing liveness that is characterized by relation and involvement. By presentation of examples, central characteristics of environmental performance are highlighted. Environmental performances are discussed as the framing of living matter, and are characterized as non-representational, unpredictable and durational. We suggest that liveness in environmental performance is first and foremost a question of a certain organization and experience of time. Environmental performances are perceived as live performances, because they frame and give access to a direct sensation of *time*.

Live: People in the Same Place at the Same Time

Within the framework of live performance, liveness has conventionally been closely associated with the human body. This applies in two ways. First, scholars in performance from Richard Schechner (1988) to Peggy Phelan (1993) and Erika Fischer-Lichte (2008) have typically understood performance as an act carried out by people and, for this reason, bodily action has been pivotal. This argument has been supported by a canonical line of examples from pre-modern rituals to modern theatre and performance art in which the body of the performer was at the centre. For example, early pioneers of performance art such as Yoko Ono, Vito Acconci, Bruce Nauman, Marina Abramović and Carolee Schneemann performatively staged, exhibited and exposed their bodies: they painted them, bit and banged them against the wall.

Second, spatial and temporal co-presence of these living human bodies has been at the heart of many notions of performance—emphasizing the ephemerality of performance with regard to sociability as well as the unpredictability and risk of performance and interaction. As an unmediated staging of bodily acts, in which an audience is located in the same physical space as the performer at the same time as the performance is taking place, performance is fixed in the experienced here and now as a communal, unmediated *live* event. Consequently, epitomized by Fischer-Lichte's notion of a 'self-referential and everchanging feed-back loop' (2008, 38) created through the physical co-presence of performers and spectators, embodied (inter)action is articulated as a defining feature of live performance.

However, the enlightening insights from these perspectives into presence and human encounters notwithstanding, the last decades have thoroughly exposed the inaccuracy of a too narrow focus on human bodily action and spatiotemporal co-presence as the pivots of live performance. As argued by theorists such as Philip Auslander (1999), Nick Kaye (2007), Jon McKenzie (2001), Don Ihde (2001) and others, new technologies, new conceptions of the body, new artistic approaches and new ways of consumption have widened our understanding of what live performance is.

Live: Beyond Un-mediated Co-presence

Clearly, then, the notion of liveness is not as straightforward as it maybe once was. Since Auslander's lambasting in 1999, the historical contingency of the term and its constantly changing, reciprocal relation to 'the mediated' has become integral to its meaning when discussing live performance. For example, in his exploration of liveness in modern music, Paul Sanden (2013) identifies seven categories of liveness, all of which outline meaningful understandings of the live in mediatized music. Furthermore, questions of liveness are explored in various intellectual fields outside performance studies, resulting in a broad and inconsistent use of the term. In an overview, Martin Barker maps out what he labels 'the many meanings of liveness' across performance studies, film and television studies, virtual studies, sports studies and more, concluding that liveness seems to matter greatly, but—as he somewhat polemically suggests—mostly to those who discuss it and for whom it is something to be 'concerned about' (2013, 57).

Regardless of these nuances and many meanings of liveness, an insight stands out across the disparate fields of study: *liveness is not necessarily bound to spatial or temporal co-presence*. Liveness does not hinge on bodily co-presence, but may also emerge through transmission, for example. Liveness through transmission emerges from temporal simultaneity, as we know it from live broadcasting. Transmitted and experienced through various kinds of technologically mediated processes, what happens in the moment is made available— in real time—to audiences who are not present at the specific place of the performance. Important here is the thrill of the game, the not knowing of the result and the possibility of things going wrong. The first being a basic pleasure of the audience of a sports event, the latter suggested by the anxiety often acknowledged by producers of live transmissions. This aspect of liveness is mostly discussed within television and media studies, including discussions of *online liveness* (Couldry, 2004), *eventfulness* (Ytreberg, 2009) and *live media* (Crisell, 2012).

Furthermore, liveness does not hinge on temporal co-presence; liveness may also take the form of a live recording. In itself an oxymoron, live recordings entail an evental aesthetic ideal of the recording in order to transmit a specific live performance, its situation, its atmosphere, its social interactions, typically with regard to music. The situational approach suggests that the quality of music relates to the specific circumstances in which it is played, live at this venue, in front of this live audience. All of which should be apparent in the recording. Hence, it points towards liveness as something that is produced through the recording and located in the ear of the beholder, as the recording seeks to pass on a particular atmosphere and sense of presentness to audiences who might or might not have been present at the specific event of which the recording serves as a documentation. This view is primarily developed within music studies, whether related to, e.g., the performing rites of popular music (Frith, 1996) or to screen adaptions of opera (Citron, 2000).

232 *Anja Mølle Lindelof et al.*

While these are clearly disparate approaches, they also point towards common features of liveness as it has been discussed within and across these specific domains. Even if liveness is not necessarily dependent on spatial or temporal co-presence, it is possible to see how elements such as thrill, anxiety, the possibility of failure, presence, absence, mediation and embodied experience are at stake in various ways, pointing towards the importance of a specific social situation, a sense of mutual engagement—a relationship among human beings, whether technologically mediated or not.

Live: Beyond Human Performance

Departing from this focus on human performers, there are in contemporary studies of live performance two parallel developments of interest to our purpose in relation to environmental performance. First, there is a general interest in exploring the notion of *performance* by expanding it into artistic fields and practices not usually associated with performance—as suggested by many contemporary performances using performing animals, organic material and generative processes in order to challenge fundamental theatrical terms such as dramaturgy, scenography and choreography as well as our common sense understanding of what a performer does. Second, the idea of what culturally counts as *live* changes over time in relation to technological change. This has been firmly established by Auslander, and he suggests: '[I]t may be that we are now at a point in history at which liveness can no longer be defined in terms of either the presence of living human beings before each other or by physical or temporal relationships' (2012, 6). He points out that the conventional understanding of live performance has expanded to include digital liveness. Digital entities, systems and processes, even computer vira and the movements of skyscrapers may be perceived as live.

In line with Auslander's inclusion of digital liveness into the discussion of live performance, we will explore environmental performance as live performance. Environmental performances are live in the sense that they 'act' environmentally and produce environmental effects. Environmental performances offer live experiences of environmental activity: of skies and water and weeds interrelating, connecting and disconnecting.

Experiencing Liveness: 'Being Involved with Something'

As it becomes evident that the quality of 'live' may be ascribed to a multitude of performances and entities, liveness increasingly is seen to have to do with experience. The stance is explicitly made in the title of this book, *Experiencing Liveness*, as well as in the emergent field of audience studies within music and theatre (e.g., Burland & Pitts, 2014; Reason & Sedgman, 2015) and a renewed interest in performance and phenomenology (e.g., Bleeker, Sherman & Nedelkopoulou, 2015). Liveness concerns the relation between 'human subjects' and 'the world', and in the debates about liveness the pendulum swings from

liveness being a quality of the thing (performance, digital technology, art work), to being a quality of experience, resting on human consciousness. Auslander draws up the positions quite clearly when he nominates '*the audience's experience* rather than the *properties of the thing experienced* as the locus of liveness' (2012, 6, our italics). Liveness thus becomes a specific form of intensified attentiveness on the behalf of the spectator, but also, simultaneously, a response to the object of the live experience. This is asserted by Auslander in a discussion of technological and social determinism where he points towards *interaction* and *interrelation* as central to understanding digital liveness:

> Digital liveness is neither caused by intrinsic properties of virtual entities nor simply constructed by their audiences. Rather, digital liveness emerges as a specific *relation* between self and other, a particular way of 'being involved with something'. The experience of liveness results from our conscious act of grasping virtual entities as live in response to the claims they make on us.
>
> (2012, 10)

Experiencing liveness is thus seen as involvement; a '*conscious act of grasping*' in '*response to claims made*'. Interaction and interrelation are central. Experiencing liveness is a sense of being involved with something. It may be seen as a kind of communicative ethos. Experiencing liveness seen as a process of grasping and responding suggests a distributed and relational approach.

Environmental Performance: Framed Flux

To further explore the question of experiencing liveness in 'the expanded field' (Krauss, 1979) in which oppositions like live/mediated, human/non-human are suspended, we unfold *environmental performance* as a type of performance that exceeds the actions and affections of the human subject often associated with both liveness and performance. We understand environmental performance as a milieu of commingling activities and material processes that emerge as performance without any regard to preferences, meanings and ideas produced by human subjectivity. Environmental performances focus on emergent environmental activity that is indeterminate or—to borrow a word from music—aleatoric in character, exceeding the anthropocentric realm of socio-cultural interaction, communication and organization. Things change, move and connect with other things without showing any sign of intention or goal. It takes time. And multiple temporalities coincide: fixed calendar time, clock time. Seasons and years, week and months. Dusk and dawn, day and night. As well as free time. My time, spare time, time investigated. Material, meteorological, zoological, organic and biological processes intertwine and interrelate in an emerging performance, taking place beyond any preconditioning and categorical organization of the human mind.

This, however, does not imply that no human intentionality is involved in environmental performance. Environmental performances are framed: they are

staged and organized for experience, for aesthetic appreciation, sensation and contemplation. By *framing* we understand the formal and perceptual process of drawing attention to a particular part of a living, dynamic environment without necessarily affecting its overall constitution or interrupting the ongoing processes that take place within it. Framing can—as in technical framings such as windows, camera lenses and microphones—simply take place as a formal differentiation that isolates a part of the perceptual environment as a particular event (Littlefield, 2013, 228). Or it can take place in a more direct physical sense as a containment and cultivation of ongoing environmental processes that are staged as performance (Grosz, 2008, 13). And finally, in line with Erving Goffman's sociological theory of the frame (1974), framing can be an organizing experiential perspective through which the physical and social environment is transformed into a meaningful aesthetic event. A window framing our visual field, a box in the forest framing a colony of ants in rigorous labour, an act of contemplation framing a group of distant trees swaying in the wind. Framing, in other words, is the set of different processes and actions by which the environment is produced, staged and viewed *as* performance. By framing a part of the world we are invited, or invite ourselves, to experience it as performance.

Environmental Performance: Some Examples

To illustrate and further investigate these ideas, we will first consider some examples before addressing questions of liveness and temporality in environmental performance in a broader perspective. The examples show framed environmental performances. They are from different artistic and aesthetic fields—field recordings; an ecological environment as a conceptual art installation; and a public sound installation with wind-driven music instruments. The examples are live in the specific sense that there is spatial and temporal co-presence between spectator and performance. This applies for James Turrell's *Skyspaces*, Pierre Huyghe's *Untilled*, and Pierre Sauvegeot's *Harmonic Fields*. Furthermore, in order to build on the insight that liveness does not hinge on spatiotemporal co-presence, two examples of mediated live performance are presented. The opening example, Francesco López's *La Selva* offers a technologically mediated live experience of environmental performance, as does James Benning's recordings of *Ten Skies*. The examples all relate to an art discourse, but we observe a similar orientation towards environmental performance in contemporary media practice.

Francisco López: *La Selva* (1998), James Turrell: *Skyspaces* (1974–) and James Benning: *Ten Skies* (2004)

Field recording, a leading artistic practice in sound art and sound design, is in its different expressions a profound example of environmental performance. The sound of animals moving and communicating in the forest, of ocean waves, of rain and wind—these sounds are transmitted to museums, living rooms and

headphones, and listeners are invited to immerse themselves in an apparently unedited flow of incessant, microscopic variations. As one example of this, consider sound artist Francisco López's *La Selva*, a continuous recording of a Costa Rican rain forest as a hypercomplex, ever-changing sound environment, which the artist has sought to free as much as possible of procedural, contextual or intentional levels of reference. As López himself describes it, *La Selva* is a 'natural sonic web created by a multitude of sounds from rain, waterfalls, insects, frogs, birds, mammals and even plants, through a day cycle during the rainy season' (López 1998).

The practice of sonic field recording is related to current practices in the visual arts. For example, the American artist James Turrell's works resemble the (field work style) attention towards the ongoing and unfolding acoustic world, but in a kind of atmospheric visual performance working with light and space. In this context his *Skyspaces* are particularly useful examples, as this group of works literally frames the sky architecturally by a cut in the ceiling of a room. These *Skyspaces* are more or less enclosed rooms inside which there are benches inviting visitors to sit and watch the sky, a dynamic and processual view influenced by meteorological circumstances and shifting daylight. In a similar way James Benning has framed skyscapes in *Ten Skies*, in which he has recorded ten different views of the sky, shown unedited and in sequence in ten-minute series. In some sequences the formations of clouds are dense, dark and rapidly moving; in others the atmosphere is brighter and lighter, with perhaps just one single almost stationary cloud. In contrast to Turrell's in situ framing, *Ten Skies* is a recording, shown in cinemas and gallery spaces, but they both equally serve as examples of environmental performances.

Pierre Huyghe: *Untilled* (2012)

Pierre Huyghe's *Untilled*, an installation of unfurling growth and insidious expansion at Documenta 13 in Kassel, is an example of environmental performance without the use of technical media. In this work Huyghe transformed a large compost-area in the baroque Karlsaue Park in Kassel into a balanced and self-supporting ecological system situated in one of the most renowned and prestigious festivals for contemporary art. A chaotic disarray of weeds, plants, sculptural and quasi-mystical objects and arrangements, a misplaced hive full of bees and eerie-looking puddles of mud, and stray dogs with coloured legs, *Untilled* resembles an unkempt 'garden' open for visitors to explore and move around in. The work depends on spatial and temporal co-presence but distinguishes itself from conventional understandings of live performance because of who is performing.

Pierre Sauvageot: *Harmonic Fields* (2010)

Pierre Sauvageot's *Harmonic Fields*, first performed in Martigues, France, in 2010, is a sonic environment built of huge wind-instruments. Inspired by wind chimes,

236 *Anja Mølle Lindelof et al.*

it consists of 500 instruments through which wind is transformed into sound. Vibrating drums, bamboo organs, gyrating musical boxes and propeller sirens mix to create a wind 'symphony' for a moving audience. As Sauvageot describes it, *Harmonic Fields* is 'a concert which goes beyond a performance, an original sensory experience, a stroll through the very heart of music' (Sauvageot 2010).

The reference to human-composed music is built into the work, as the instruments resemble the different sections of a philharmonic orchestra—brass, strings, woodwinds, percussion—and are arranged as a score with clusters of varying intensity and acoustic and musical colour. The listeners are invited to traverse their own routes, on the move or lingering in the loungers placed in the landscape in which the wind, the landscape and the materials of the instruments conjoin and add to a common understanding of a promenade concert. The musical composition thus becomes environmental as it is specifically produced and continuously (trans-) formed by circumstances in the natural environment where it is physically installed.

Characteristics of Environmental Performance

These environmental performances all share a number of characteristics: they are non-representational, unpredictable and durational. We will unfold these characteristics before engaging more deeply with the theme of temporality as being a central feature of that 'something' which spectators are offered involvement with and potentially respond to, when they experience environmental performances as live.

Non-representational

First, the environmental performances may be experienced as performances not because they represent existing 'real' environments, but because they constitute environments in their own right and affect us as such. Non-representational performance does not, in the words of Fischer-Lichte, 'yield to and dissolve into a sign but [evokes] a particular effect on its own terms and not as the result of its semiotic status' (2008, 18). Hence, environmental performances are performative in the basic sense of the word because they 'act' environmentally and produce environmental effects. They are not ideas or images of environmental principles, values or thoughts represented in a symbolic form. They are post-dramatic in the sense that there is no preplanned dramatic tension, and no plots leading to a reassuring narrative climax. There are no characters to identify with and no fictional scenarios to imagine. There is no detailed artistic control of the dramatic progression. Rather they are material manifestations of environmental activity: things, stuff, fluid elements, perpetually connecting, disconnecting and reconnecting, here and now in a performative framing of the material world. Consider, for example, the way in which a nexus of sound components become entangled when listening to the soundscape of *La Selva*, which is different from bio-acoustic recordings with the scientific goal of identifying each sound and its source.

Unpredictable

Without scripts and pre-planned dramatic intensity, one might say that environmental performances point towards things and actions that 'simply happen'. They are not composed but simply framed as performance. This framing gives the environmental performance an emergent and radically 'open' character. If nothing takes place according to a prescheduled plan, everything might happen—or nothing at all. Hence, unpredictability and randomness become unavoidable features in environmental performance. The framing of such emergent unpredictability is a central characteristic of environmental performance.

Huyghe's *Untilled* is a profound example of the framing of such emergent unpredictability. At first glance, *Untilled* resembles an unkempt garden of forgotten actions and lost intentions, now overtaken by processual entropy and nature's wild insurrection. This apparent lack of compositional order corresponds effortlessly with the precise meaning of the title 'untilled' as a description of unplowed soil that has not been cultivated by human hand. By exhibiting a self-generating micro-cosmos, a local biotope brought to life in the midst of the monumental baroque order, Huyghe has framed an entire ecosystem as environmental performance in the cloudy zone between natural and cultural being, between organism and artefact.

However, *Untilled* nonetheless brings forward mixed feelings and conflicting perceptions about the status of the environment. Despite its unorganized and rambling character, it is continuously framed not only as art (for example, as a work of contemporary art included in the Documenta-exhibition), but also as constructed, cultivated, man-made. 'Alive entities and inanimate things, made and not made. Dimensions and duration variable' reads Huyghe's description of materials used in *Untilled*. And at the same time, his detailed sketches for the 'installation' of the work indicate a carefully staged and choreographed work, mapping out the exact locations for the cultivation of plants as diverse as weeds, marijuana and toxic plants. Thus, while we walk the narrow, unkempt paths of *Untilled*, questions about what is staged and cultivated and what has grown 'wildly and naturally' of its own volition hover discreetly over the visit as a slightly disturbing atmosphere. This very atmosphere is the discreet sensation of environmental performance in all its heterogeneous unpredictability.

Durational

This non-representational performativity and emergent unpredictability puts a strong emphasis on the temporal dimension of environmental performance. What characterizes our examples with regard to time is their duration. The environmental processes are framed and acted out without any reduction, concentration, representation or displacement regarding the timespan of the act. Furthermore, they all persist over several days or weeks. This influences the here and now of the experienced live event and subsequently how the performance

is experienced in time—with regard to clock-time and calendar time, and with regard to how they intermingle with the rhythms of everyday life.

Furthermore, time passes beyond the perceptual and cognitive capacities of any one single human and into the non-reductive, undramatic and radically continuous duration of environmental reality. In the weather it is, as John Cage once put it, impossible to say when something begins or ends.

Hence, what characterizes our examples is their profoundly *durational* effect in experience. Following Henri Bergson, duration here refers to the sensation of an unbroken and direct flow of time in which 'an absolute heterogeneity of elements [. . .] pass over into one another' (Bergson 2001, 229), and where time 'refrains from separating its present state from its former states [. . .] but forms both the past and the present states into an organic whole' (Ibid., 100). Environmental performance not only unfolds its environing effect here and now. It sustains it perpetually, without a pause, break or cut in the continuous act.

One of the most remarkable effects of environmental performances as durational events is that they, along with other forms of durational performance, break with conventional dramaturgical models built around an economy of tension-building and a 'teleological' drive towards its final release. The difference—and therefore also the tension central in many conventional performances—between the inner, dramaturgical time of the performance and its durational time of presentation collapses in the framing of environmental performance as an act, an acting out, of continuous real time.

As everything passes with no apparent goal and without reference to a deeper, underlying meaning that needs to be teased out and comprehended, what becomes apparent is that time passes. Environmental performances might have a beginning and an end, and they may have passages with more activity and intensity than others, but such factors have no defining influence on the overall character and effect of the performance. The environmental performance simply continues, in an unbroken and potentially undramatic flow of duration.

Speaking of 'durational art' in relation to body-centered performance, Edward Scheer describes how it directly 'invokes the flux of temporal experience, the quality of time experienced in the doing of an action rather than simply the quantity of chronological time that a task might consume' (Scheer 2012, 1). By renouncing the use of conventional dramaturgical models, editing and artistic control of the unfolding process, the framing of non-reductive, undramatic and radically continuous flows of environmental time exposes the very act of experience as a durational event. This un-edited framing of durational processes directs attention to time passing as a striking perceptual effect when experiencing environmental performance—a sheer forceful duration that also creates a notion of linearity, as it continuously emphasizes that we can't go back.

Experiences of Flux

Experiencing liveness in environmental performance is the experience of time passing. Live experiences of environmental performance emerge where and

Liveness in environmental performance is first and foremost a question of a certain organization and experience of *time*. Experiencing liveness in environmental performance is an essentially temporal effect, not in the general sense that it *per se* emerges in time, temporally, but in the sense that it points to a *specific sensation of time passing*. What these works offer, we suggest, is a play with time and with the notion of time passing—exploring how (to paraphrase Henri Bergson) the present *is* not, but is constantly becoming.

We propose that these performances are perceived as live because they frame and give access to a sensation of durational time. The experience of liveness in environmental performance results from the spectator's perceptual act of grasping the framed environmental processes as live. This perceptual act emerges as a response to the non-representational, unpredictable and enduring processes which the works act out and which the spectator/visitor/participant is offered to be involved in. These works potentially offer genuine 'live experiences' of time: of the present, unfolding moment, of time passing, of emergent unpredictability.

They lead our attention towards the continuous variation of ongoing environmental processes. Our sensorium is tuned towards the world around as being in continuous process: fluid, in flux, on the move (Cresswell 2006). Through specific framings of the world, environmental performances potentially give us a heightened experiential awareness of the unpredictability of the world, of the radical uncertainty and potentiality of an open, unending and non-teleological mix of intermingling materials and entities. Environmental performances produce experiences of liveness because they frame the world as becoming. It and we are always at a point of no turning back. We can't undecay. Experiencing liveness in environmental performance is seeing *time pass* as theatre.

It is, however, not the durational qualities of the living world which produce effects of liveness. We may persistently attend to plants and flowers growing and blooming in our garden. We may notice the vibrations of the wind resonating in bodies throughout our physical environment, producing a fascinating cacophony of sounds vibrating all around us. We may watch the repetitive rise and fall of water in ebb and flow. And indeed, we will likely experience such situations as taking place, here and now and in real time. However, we will not likely experience and describe them as 'live'. Liveness, in other words, is not a product of the living world as such. Rather, it is the product of a certain framing of the world, combined with a certain heightened awareness and response, in a certain moment.

Live experiences of environmental performance emerge in specific moments where a framing of the world's unpredictable metereological, zoological and biological processes come together with a heightened awareness of the world as unfolding in the present. Liveness is not a product of the living world as such, nor is it the product of individual perception. The experience of liveness

is a relational event where a certain framing of the world combines with a heightened awareness and response to the enframed world. Liveness is a unique time-space of aesthetic exchange where the very relation between world and perceiver is accentuated.

References

Auslander, Philip. 1999. *Liveness: Performance in a Mediated Culture*. London. Routledge.
Auslander, Philip. 2012. 'Digital Liveness: A Historico-Philosophical Perspective.' *PAJ: A Journal of Performance and Art* September 34 (3): 3–11.
Barker, Martin. 2013. *Live to your Local Cinema: The Remarkable Rise of Livecasting*. Basinstoke: Palgrave Macmillan.
Bergson, Henri. 2001. *Time and Free Will*. Mineola, NY: Dover Publications.
Bleeker, Maaike, Jon Foley Sherman & Eirini Nedelkopoulou. 2015. *Performance and Phenomenology. Traditions and Transformations*. New York: Routledge.
Burland, Karen & Stephanie Pitts. 2014. *Coughing and Clapping: Investigating Audience Experience*. Surrey: Ashgate.
Citron, Marcia J. 2000. *Opera on Screen*. New Haven, CT: Yale University Press.
Cresswell, Tim. 2006. *On the Move: Mobility in the Modern Western World*. Oxford and New York: Taylor & Francis.
Crisell, Andrew. 2012. *Liveness and Recording in the Media*. Basingstoke: Palgrave Macmillan.
Couldry, Nick. 2004. 'Liveness, "Reality", and the Mediated Habitus: From Television to the Mobile Phone.' *The Communication Review* 7 (4): 353–362.
Fischer-Lichte, Erika. 2008. *The Transformative Power of Performance: A New Aesthetics*. Abingdon: Routledge.
Frith, Simon. 1996. *Performing Rites. On the Value of Popular Music*. New York: Harvard University Press.
Goffman, Erving. 1974. *Frame Analysis*. New York: Harper and Row.
Grosz, Elizabeth. 2008. *Chaos, Territory, Art—Deleuze and the Framing of the Earth*. New York: Columbia University Press.
Ihde, Don. 2001. *Bodies in Technology*. Minneapolis: University of Minnesota Press.
Kaye, Nick. 2007. *Multi-media: Video—Installation—Performance*. Abingdon: Routledge.
Krauss, Rosalind. 1979. 'Sculpture in the Expanded Field.' *October* 8: 30–44.
Littlefield, David. 2013. 'Installation and performance'. In *The Handbook of Interior Architecture and Design*, edited by G. Brooker and L. Weinthal, 226–238. Madison, Wisconsin: Bloomsbury Academic.
López, Francisco. 1998. 'Environmental Sound Matter' [Essay]. http://www.franciscolopez.net/env.html.
McKenzie, Jon. 2001. *Perform or Else: From Discipline to Performance*. New York: Routledge.
Phelan, Peggy. 1993. *Unmarked: The Politics of Performance*. London: Routledge.
Reason, Matthew & Kirsty Sedgman. 2015. 'Theatre Audiences.' *Special Section of Participations* 12 (1), May 2015.
Sanden, Paul. 2013. *Liveness in Modern Music*. New York. Routledge.
Sauvageot, Pierre. 2010. 'A Symphonic March for Wind Instruments and a Moving Audience.' Accessed at http://www.lieuxpublics.com/en/pierre-sauvageot/creation/8-harmonic-fields.
Schechner, Richard. [1988] 2003. *Performance Theory*. Revised edition. London: Routledge.
Scheer, Edward. 2012. 'Introduction: The End of Spatiality and the Meaning of Duration'. *Performance Research* 17 (5): 1–3.
Ytreberg, Esben. 2009. 'Extended Liveness and Eventfulness in Multi-platform Reality Formats.' *New Media & Society* 11 (4): 467–485.

Shorts

10 *Three Performances*

A Virtual (Musical) Improvisation

Mathias Maschat and Christopher Williams

▶ **Play**

Bearing in mind that there is no improvisation without the live, we—musicians and researchers with interests in improvisation, performativity and notation—came together to create a unique musical performance. Even if the here and now is nourished from the past and from future expectations, liveness is the primal paradigm of every musical improvisation, characterised by archetypal elements such as temporal continuity, real time action and reaction, presence, originality, immediacy, intimacy, indeterminacy, eventness, existence in the moment, and so forth. As Saladin and Guionnet write:

> Free improvisation is liveness taken to a radical extreme. Improvisation arises from an immediate and playful confrontation with the specific characteristics of a situation, whereby relationships between all the elements present—the instruments, players, space, public, whatever—acquire an intensity born precisely of an awareness that everything, at every moment, hangs in the balance.
>
> (2011)

This was our first musical encounter, an ad hoc session with no prior agreements about the musical instruments to be played, structural developments, etc. The temporal and spatial conditions, as well as our personal histories and dispositions, were the basis of performance. We happened to use a guitar, a trombone, a piano, a synthesiser, a home stereo with audio cassettes and CDs, and assorted objects found at the site of the performance. By including pre-recorded media, sometimes played in rewind or fast forward, we impurified the liveness of our original performance from the outset.

Occasionally, we moved around and out of the room, allowing bodily movements and positions to become part of the performance. The ensuing sounds, mixed with citations read aloud from books or CD booklets found in the shelves, constituted a live performance in which we were simultaneously actors and witnesses. In our experience no further audience apart from us two was necessary to implement a sense of liveness; as will be explored in the following pages, we consider liveness to be a feeling or state of mind enacted by an individual, independent of the object of his or her attention.

244 *Mathias Maschat and Christopher Williams*

Along the way, we recorded our actions to document the live event. That recording now serves as a memory and point of departure for the present chapter, in which we wish our improvisation to continue its transformed existence in another dimension of mediality, with potential for other sorts of liveness.

```
Take instrument out of case—you haven't done this in a
while. Place mouthpiece to lips, blow gently through the
          slide, opening and closing spit valve.
       Play a hot sloppy [F 4th line bass clef]
 and follow your broken lips up and down the overtones.
```

1 *The Original Performance is Past, this is its Mediatized Representation*

Following Philip Auslander's argument that '"[m]ediatized performance" is performance that is circulated on television, as audio or video recordings, and in other forms based in technologies of reproduction' (2008, 4), we also consider texts, books or scores to be technologies of reproduction. In this sense the transcription of the original performance beginning on your right could serve as documentation—or 'mediatized performance'—of the primary event, much as would an audio- or videotape, with a few obvious differences.

At the same time we also agree with Derek Bailey's critique of 'the loss during the recording process of the atmosphere of [improvised] musical activity—the musical environment created by the performance' (1992, 103). Clearly the score cannot be considered a comprehensive or transparent representation of the initial situation, as equally any audio- or videotape cannot. To begin with, its perspectives are strategic—they fail on a practical level to capture the action from every angle. Furthermore, the temporal and spatial co-presence of the musicians and the audience has vanished, radically changing the 'immediate' aspect of the improvised event.

Still, the possibility is given that it carries some of the (live) flavour of the initial situation by retaining and sharing with the reader some provisions for recreating its spirit and specificity; here we recall Paul Sanden's statement that '[l]iveness represents a perceived *trace* of that which *could be live*' (2013, 6). The score assumes the position of a listener who is *there*, in the performance, attempting to make sense of a music in its emergence as his or her focus bounces among disparate sounds, gestures, and temporalities. To this end, different events are represented with different kinds and degrees of detail—some include specific pitches and/or articulations, where others are simply assigned a general verbal description ('Rustling') or association ('Tristan') or a physical location in the room ('HALLWAY').

```
        Leave the room, following your lips.
     Shut the door. Resume hot slop. Knock.
            Open the door. Return.
                Join pianist:
```

1:00

MM | Rustling Gtr. Pf.. [Tristan] Gtr. —
CW | Tbn. blowing air → sloppy overtones **GROWL**

3:46

MM | Rustling
CW | spit values → **HALLWAY**

MM | Pf. marcato etc... → **Bookshelf** Rustling
CW | → **Pf.** 4 hands [Tristan] solo

246 *Mathias Maschat and Christopher Williams*

While temporal and/or spatial co-presence is traditionally the minimum requirement for the definition of liveness, in our case none is given in a direct sense. However, if we reflect on Auslander's claim that 'liveness can no longer be defined in terms of either the presence of living human beings before each other or physical or temporal relationships' (2008, 62), why couldn't liveness be experienced here in written form, as in other mediatized representations? Instructions in present progressive tense like 'blowing air' or imperatives such as 'GROWL' or 'insert Colorblind' might give a clue to the moment-related immediacy of the score. Or the informal memo-like quality of the handwriting might hold the potential to draw you into a more intimate connection with the virtual performance. While it is difficult to measure the effects of liveness in these cases, they do seem to substantiate Auslander's suggestion 'that thinking about the relationship between live and mediatized forms in terms of ontological oppositions is not especially productive, because there are few grounds on which to make significant ontological distinctions' (2008, 55).

2 *This is the Performance, you are the Audience*

<div style="border:1px solid">

TACET

</div>

The second performance is located in the accumulation and presentation of signs that you are decoding at the moment. Having characterised the score (and the present text) as the mediatized representation of the original performance, we should also articulate their *distance* from the event itself. The inherent limitations of the recorded reference and the human ear listening back can only capture a narrow slice of the original event. And just as 'script is not simply the graphic fixation of spoken language' (Krämer 2002, 341), a score is not the mere picture of the sounding music; any score—even a transcription—is an artefact used to *make* music, and thus by necessity omits certain details about its sounding result. For these reasons we can assume that a transcription of sounding music is always reductive. At the same time transcriptive notation produces new qualities not inherent in original performances. As Hartmut Möller states:

> Systems of written notation relegate a serial, temporally shifted stream of data to a visual field and thereby untether parts of the communication from the context of their origination. Notations accentuate, shorten, and abstract given the abundance of the real sounding event and *start a life of their own* as documents that allow or even provoke diverse versions.
>
> (in Ungeheuer 2011, 176, authors' emphasis)

MM | 6:42 cassette case clacking
CW | Pf. (a free hand)

MM | 7:48 8:00 RW cassette
CW | moog

MM | 8:24 – 8:38 Tape freakout "This music is respectfully Incns." clacking
CW | ⇒ Gtr. + Tape "I'm being censored."

MM | clacking
CW | insert Colorblind

The layout of the score, for example, in lines read left to right bound by page size, implies phrases or temporal units beyond those of the original performance. Likewise, the tools of inscription—ink pens and an idiosyncratic typewriter—create internal visual connections and disjunctions with no external sounding correlate.

A performative tension is produced by this triangulation of a 'factual' past live event, what is lost in its mediatized representation, and what is added by the particularities of the medium. You may imagine who 'Tristan' is, how the 'HALLWAY' looks, why its letters are capitalised, or what happens on the next page, even before you do anything with the score out loud. Following Martin Zenck, the score can thus be regarded as a performance even without its factual recreation in an event: 'A score, the music, becomes performative not only through the performance, but performative aspects are already found in the external tension between form tectonics and inscribed figure' (2011, 20). For historical precedents of scores whose performances require nothing more than the act of reading itself see Dieter Schnebel's *MO-NO: Music to Read* (1969), Yoko Ono's *Grapefruit* (1970) or Josef Anton Riedl's *Optische Lautgedichte* (see Ungeheuer 2011; Zeller 1998).

Such performativity and 'external tension' are by no means limited to our score or to musical notation in general. Indeed, there are many ways to comprehend the performativity of texts in and through themselves: 'self-referentiality, meaning the exhibition of processes of thinking and articulation, [. . .] simulated or factual orality, dialogical structure, plurimediality or the focusing on the embodied act of utterance' (Häsner et al. 2011, 76). Many such examples are to be found in this analytical text and elsewhere in this book (see for example, Dworkin). In this sense, the 'form tectonics' of the notation to your right are not limited to an autonomous score. It might be said that this entire volume is a stage and that you are following one act of the play upon it through the process of reading. You are attending our second performance as authors of this text and score, in the form of a 'performance-reading'—conceived here as the cousin of a performance-lecture—in real time with your own modes of reception.

TACET

3 You are the Performer, the Performance is about to Take Place

Taking this claim a step further, we would argue that you are not only the audience attending our performance—you are also the performer of these pages engaged in the 'act of reading,' as Wolfgang Iser (1976) has famously characterised the individual instantiation of a given text. This happens as you move along our thoughts and previous artistic acts, make temporal sense of them, shift your

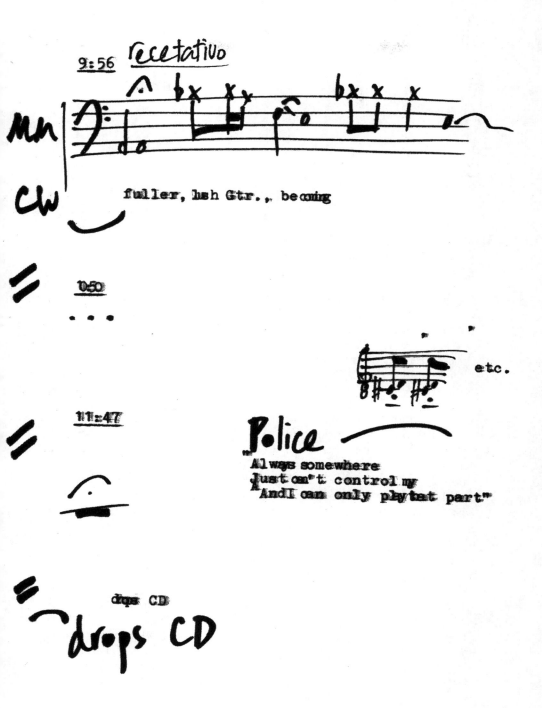

250 *Mathias Maschat and Christopher Williams*

attention from the verbal text to the score, or wander back and forth among the pages of the physical book. The third performance has been in full swing for a while then, but it still seems to hold potential for further development.

```
A few muddy long notes, gradually windier.
            [Whole rest—Fermata]
Remove slide, twirl in circles like a baton.
            Continue, announce:
   "I shall twirl until you are finished."
             [Pf fragment]
```

While the symbols and words on these pages may be nominally static, you actively choose when and how to navigate among them. This is a special case of what Iser has termed the reader's 'wandering viewpoint' (1976, 177–218), or 'the mode, by which the reader is *present* within the text' (1976, 193) in which:

> there is a potential time-sequence which the reader must inevitably realize, as it is impossible to absorb even a short text in a single moment. Thus the reading process always involves viewing the text through a perspective that is continually on the move, linking up the different phases, and so constructing what we have called the virtual dimension. This dimension, of course, varies all the time we are reading.
>
> (1972, 285)

While Iser prioritises the role of narrative memory and expectation in the reading process, the same principle of non-linear grouping applies to the counterpoint of the different elements in *Three Performances*. The numerical timeline in the score is only one layer of temporal understanding; the way you situate this unfolding within the chapter is another. Have you read the score on the right hand pages first, coming back to the analysis on the left hand pages, or viceversa? Have you read the chapter continuously from left to right in two-page episodes, interrupting the musical performance for theoretical clarification? Have you concentrated only on one element or the other? When, if ever, have you shuffled back and forth in search of a context for the unexplained instructions inlaid here between paragraphs of the analytical text?

However you have chosen to read, you are interacting with the text, and this, according to Iser, is what *produces* meaning (1970, 7). Meaning is not necessarily *there*, but it is co-created by an active reader dealing with the offerings and possibilities of the text. In our case this interaction can go beyond mere imagination, materialising in concrete action: to enhance this interactive experience of liveness in the reading process, you may even like to recreate the piece, preparing your own performance score for it, improvising with the material,

13:12 13:48

MM | Ped...

CW | Tbn. clankety clank muddy notes

MM | poco cresendo'____

CW | gradually windier

MM | etc.

CW | "I SHALL TWE UNTIL YOU AE FINISHED."

"Are you finished?"

252 *Mathias Maschat and Christopher Williams*

or adding more material. We have provided spaces in the score for this purpose. You could perhaps join with one or two friends taking over the different parts, integrating elements from the left hand pages into the performance material.

You will notice many 'blank spaces' that produce a high degree of 'indeterminacy' (Iser 1970, 15–6). These spaces aim to amplify your experience of how 'the more the texts lose determinacy, the more the reader is engaged in the co-construction of their possible intentions' (Iser 1970, 8). If this sounds like a hopeless vagary, focus on a few details in the middle of page 249. The first three dots might suggest a series of short soft sounds in a regular rhythm. Alternatively, they may be an ellipsis, or a continuation of previous activity. Below and to the right, the origin of the typewritten text below the word 'Police' is not clarified. Do you recognise anything about it—within or outside the score?

◄◄ Rewind / ►► Fast Forward

Iser compared texts to musical scores, stressing that the reader's individual skills are responsible for the instrumentation of the work (1976, 177). Meaning thus 'appears in individual form' (Iser 1970, 7) interwoven with the experiences, attitudes, knowledge, expectations, feelings and will that you contribute to these performances. In this sense we underline Auslander's thesis that the 'emerging definition of liveness may be built primarily around the audience's affective experience' (2008, 62). At the same time, we also expand this thesis by highlighting how this theoretical audience, in the act of reception, takes over the role of a performer. The reader performs and actively participates in the process of co-constructing meaning and individual experience and the seemingly separate entities of performers and recipients thus start to overlap and to permeate each other.

Our conception of liveness locates the recipient-performer's affective experience in direct action and interaction beyond temporal-spatial attendance. With Erika Fischer-Lichte we believe that texts and/ or scores are comparable to 'speech acts, symbolic physical actions and practices and performances [. . .]—characterized by the unpredictability of reading, ambivalences and transformative power, which is capable of changing the reader for the time of reading and maybe even enduringly beyond that'. (2012, 145) Ultimately, this is speculation: we cannot say if the experience of reading, hearing, and/or performing this chapter has indeed changed you. Neither do we know if it has reached any meaningful degree of liveness as we have characterised the term. Only you can confirm or deny if this is the case through your own empirical 'test' of having read, heard and/or performed it. The function of this speculative quality has thus been to invite you to explore relationships that might bear out our claims.

Should we have succeeded, the broader intention is that *Three Performances* move beyond these rarefied pages to help 'restore continuity between the refined and intensified forms of experience that are works of art and everyday events, doings and sufferings that are universally recognised to constitute experience' (Dewey 1980, 3). That is to say, we believe the experience of liveness can happen anytime anywhere: whether you are improvising your own performance,

reading and envisioning a score or analytical text, recreating a work seen through your own perspective, and therefore establishing a new reality. Or even just dealing with everyday personal activities, for as John Cage describes it '[e]ach moment is absolute, alive and significant'. (1973, 113).

References

Auslander, Philip. 2008. *Liveness: Performance in a Mediatized Culture*. Abingdon: Routledge.

Bailey, Derek. 1992. *Improvisation: Its Nature and Practice in Music*. Boston: Da Capo Press.

Cage, John. 1973. 'Lecture on Nothing.' In *Silence: Lectures and Writings by John Cage*. 109–29. Middletown: Wesleyan University Press.

Dewey, John. 1980. *Art as Experience*. New York: Perigee Books.

Fischer-Lichte, Erika. 2012. 'Literatur als Akt—Lesen als Akt: Zur Performativität von Texten.' In *Performativität: Eine Einführung*. 135–45. Bielefeld: Transcript.

Häsner, Bernd et al. 2011. 'Text und Performativität.' In *Theorien des Performativen. Sprache— Wissen—Praxis: Eine kritische Bestandsaufnahme*, edited by Klaus W. Hempfer & Jörg Volbers, 69–96. Bielefeld: Transcript.

Iser, Wolfgang. 1970. *Die Appellstruktur der Texte: Unbestimmtheit als Wirkungsbedingung literarischer Prosa*. Constance: Universitätsverlag.

Iser, Wolfgang. 1972. 'The Phenomenology of Reading: A Phenomenological Approach.' *New Literary History* 3 (2): 279–299.

Iser, Wolfgang. 1976. *Der Akt des Lesens*. Munich: Wilhelm Fink.

Krämer, Sybille. 2002. 'Sprache—Stimme—Schrift: Sieben Gedanken über Performativität als Medialität.' In *Performanz: Zwischen Sprachphilosophie und Kulturwissenschaften*, edited by Uwe Wirth, 323–346. Frankfurt on the Main: Suhrkamp.

Ono, Yoko. 1970. *Grapefruit*. New York: Simon and Schuster.

Saladin, Matthieu & Jean-Luc Guionnet. 2011. 'Going Fragile: Points of Resistance and Criticism in Live Musical Practice.' Paper presented at the *What is Live?-Symposium* of the *CTM Festival*, Berlin, 1–3 February. Accessed at http://archive.ctm-festival.de/archive/ctm11/day-program/day-schedule/02/going-fragile-points-of-resistance-and-criticism-in-live-musical-practice.html

Sanden, Paul. 2013. *Liveness in Modern Music: Musicians, Technology, and the Perception of Performance*. Abingdon: Routledge.

Schnebel, Dieter. 1969. *MoNo: Musik zum Lesen/ Music to Read*. Cologne: Studio DuMont.

Ungeheuer, Elena. 2011. 'Schriftbildlichkeit als operatives Potential in Musik.' In *Schriftbildlichkeit, Wahrnehmbarkeit, Materialität und Operativität von Notationen*, edited by Sybille Krämer, Eva Cancik-Kirschbaum, and Rainer Trotzke, 167–181. Berlin: Walter de Gruyter.

Zeller, Hans Rudolf. 1998. 'Schrift-Musik im Extrem: Josef Anton Riedls Optische Lautgedichte.' In *Positionen* 36: 29ff.

Zenck, Martin. 2011. 'Erzeugen und Nachvollziehen von Sinn: Rationale, Performative und Mimetische Verstehensbegriffe in den Kulturwissenschaften. Einleitung zu den drei Sektionen.' In *Erzeugen und Nachvollziehen von Sinn: Rationale, Performative und Mimetische Verstehensbegriffe in den Kulturwissenschaften*, edited by Martin Zenck, and Markus Jüngling, 13–26. Munich: William Fink.

11 Chronography

Craig Dworkin

> The only thing that is different from one time to another is what is seen and what is seen depends upon how everybody is doing everything. This makes the thing we are looking at very different and this makes what those who describe it make of it, it makes a composition, it confuses, it shows, it is, it looks, it likes it as it is, and this makes what is seen as it is seen.
>
> (Stein 1993, 497)

It has been one second since I began typing this text and one second since I began reading this text. It has been fourteen seconds since I began typing and now here at the second sentence of this text five seconds since I began reading. It has been forty seconds since I began typing this text and eight seconds since I began reading it. By the fourth sentence I find it has been one minute exactly since I began typing this text and twelve seconds since I began reading the same text. At the fifth sentence I discover it has been one minute and twenty-two seconds since I began typing and sixteen seconds since I began reading. Now in the middle of this sixth sentence I have clocked one minute and forty-four seconds since I began typing and twenty seconds since I began reading. This next sentence marks two minutes and two seconds that have transpired since I began typing this text and twenty-seven seconds since I began reading the self-same writing. Now at two minutes and nineteen seconds I am up to the eighth sentence on this page, although it has taken me only thirty-two seconds to read to this same point. A period of two minutes and forty-eight seconds has passed since I began typing this text and thirty-seven seconds since I began reading this text. It has now been three minutes and seven seconds since I began typing this text and I am finally at the tenth sentence, which has taken me forty-three seconds to attain by reading. By the start of the eleventh sentence I find I have been typing for three minutes and thirty seconds and have been reading for forty-nine seconds. I have been typing now for three minutes and forty-four seconds and reading for fifty-three seconds. Here now the stopwatch tells me I have been typing for three minutes and fifty-eight seconds but reading for merely fifty-eight seconds—three full minutes behind. At what I believe is the fourteenth sentence I have been

typing for four minutes and ten seconds, almost half a minute shy of John Cage's notorious 'silent' piece, and I have in fact kept quiet since I began typing except for the clatter of the plastic keys on the laptop keyboard, which I do not hear while reading, which I have been doing for one minute and nine full seconds. Fifteen sentences into this experiment I have been steadily typing for five minutes and seven seconds but reading for only one minute and fifteen seconds. I have now been typing for five minutes and twenty seconds and reading for one minute and twenty-two seconds. I have now, even with all the constant backing up to make corrections for spelling errors and poor dactylography, been typing for five minutes and forty-five seconds and reading, with all the inevitable saccadic jumps and distractions, for one minute and twenty-six seconds. Just over six minutes and seven seconds have elapsed since I began typing and exactly one and one-half minutes have elapsed since I set to reading. By the clock, I have now been typing for six minutes and twenty-eight seconds and reading for one minute and thirty-five seconds. This, the twentieth sentence, registers a duration of six minutes and forty seconds of typing, and one minute and forty-one seconds of reading. I have been typing now for six minutes and fifty-seven seconds and reading for precisely one minute and forty-seven seconds. I have now been typing for seven consecutive minutes and an additional thirteen seconds and wonder how this project would be different if I knew how to properly touch-type rather than pursue my practiced but erratic and error-prone forward and backward hand-waving haste. At seven minutes and thirty-seven seconds I am now at the twenty-fourth sentence and have been reading to this point for one-hundred and seventy seconds, surprised that I have not wondered yet about speed-reading or how this project would be different if I were not dyslexic or did not have all the retarding coping mechanisms to compensate. In all events I have now been typing for eight minutes and twelve seconds and reading for two minutes and one spare second. At this sentence I find the stopwatch clocks me at eight and one-half minutes exactly for writing and two minutes and five seconds for reading. I have now been typing for eight minutes and fifty seconds but reading for only two minutes and eleven seconds. Exactly nine minutes since I began typing I have come to this point in the text, which memorialises precisely two minutes and seventeen seconds since I began reading what I have written. It has now been nine minutes and fifteen seconds since I began typing and two minutes and twenty-seven seconds since I began reading, though I wonder if my typing is improving, that is, becoming faster, while my reading slows as I grow increasingly bored. In any case it has now been nine minutes and forty-nine seconds since I began typing and two minutes and thirty-five seconds since I began reading. At the palindromic ten minutes and one second I observe that I have typed about two and one-half pages and read for about two and one-half minutes. It has now been ten minutes and nineteen seconds since I began typing and two minutes and thirty-seven seconds since I began reading. It has now been ten minutes and thirty-four seconds since I began typing and one-hundred and sixty seconds since I began reading. It has now

been ten minutes and fifty-one seconds since I began typing and two minutes and forty-three seconds since I began reading. It has now been eleven minutes and five seconds since I began typing and two minutes and forty-seven seconds since I began reading. It has now been eleven and one-third minutes since I began typing and two and five-sixths minutes since I began reading. It has now been eleven minutes and thirty-one seconds since I began typing and two minutes and fifty-four seconds since I began reading. It has now been eleven minutes and forty-nine seconds since I began typing and two minutes and fifty-eight seconds since I began reading. It has now been eleven minutes and fifty-eight seconds since I began typing and I am wondering if I will stop at the bottom of the page or if I should go for a set period of time instead, though if I were a steady typist the space and time should equate according to a fixed rate—especially since the words I am using in this text are not very varied. In any event, this current sentence commemorates a dozen minutes and forty-seven seconds since I began typing, exactly the track-length of Vito Acconci's *Ten Packed Minutes* in the Electronic Arts Intermix reissue and since it has now been exactly thirteen minutes to the second since I began typing I will stop here, merely noting that three minutes and fifteen seconds have expired since I began reading and if you had been keeping track you would know how long you have been reading—even with all the skimming and skipping—too.

<p style="text-align:center">★ ★ ★</p>

In the late 1960s, Vito Acconci composed a series of works that took the typewriter page as a field for both recording and provoking performance. One of his poems from the period, for instance, begins: 'READ THIS WORD THEN READ THIS WORD READ THIS WORD NEXT READ THIS WORD NOW SEE ONE WORD SEE ONE WORD NEXT SEE ONE WORD NOW AND THEN SEE ONE WORD AGAIN.' (in Dworkin 2006, 111). Aligning the activities of writing and reading in this way, Acconci also underscores their inevitable, incongruous unassimilability. The critical gap between the moments of narration, inscription, and reading—even when reading writing about the act of its own inscription—had been a concern since modernism. Gertrude Stein, for example, directly engaged those discrepancies at the levels of grammar (with her mode of 'continuous present'), the sentence (by 'beginning again and again'), and the conceptual poetic project (in the self-reflexive performance of a 'composition as explanation' that actively enacts rather than discursively describes). Distinguishing with carefully modulated prepositions between 'composition and the time of the composition and the time in the composition' (1993, 502), Stein diagnosed a mortal arrhythmia audible in the inevitable, inframince delay between narrative time and the anticipated experience of reading—what Marcel Duchamp would call the 'inframince' threshold between two just barely perceivable states (cited in Sanouillet and Matisse 2008, 246).

Chronography 257

That irregular pulse is both articulated and recorded by the durational event of writing itself, so that 'the quality in a composition that makes it go dead just after it has been made is very troublesome,' as Stein remarks with signature understatement (1993, 502). Astrid Lorange argues that Stein's own experimental techniques, accordingly, 'attempt to account for the mobility and multiplicity of time both as it is experienced 'in the living' and as it is experienced 'in' composition' (2014, 67). Following Gilles Deleuze and Félix Guattari (1980, 385), Lorange identifies those dynamic tensions between the various temporal moments occasioned by texts as the fundamental source of Stein's poetic rhythm: 'rhythm "ties together" critical moments; it is the "in-between" that brings about a relation that is durational, heterogeneous and dynamic' (2014, 67). In contrast to the absolute measure of repetition, which might effect a strict metre, differential relations open onto the supple rhythms of composition. Consider, for example, Lawrence Giffin's *Ex Tempore*, which purports to record 24 hours of scrupulous chronometry with improbable accuracy. The book begins, 'it is now 12:00:00 AM on October 28, 2011. It is now 12:00:09 AM on October 28, 2011. It is now 12:00:18 AM on October 28, 2011' and continues with only occasional pauses and elisions, for over 160 pages (2011, 6).

A practice of reading attentive to the rhythms of its own discrepancies, including its own discontinuous visual stutters and continually repeated acts of 'beginning again and again,' reanimates the textual dynamic of composition's disjointed temporality at a further remove. We speak casually about 'live' recordings, an idiomatic phrase that implicitly invites one to imagine what recordings might *not* have been made live, as well as what recordings might ever be truly live: experienced in the moment and not merely as the still document of an already lost moment that arrives 'dead just after it is made.' One answer was posed in the form of participatory performances by artists such as John Cage and Grand Wizzard Theodore, who managed to revive recordings when they realised that the phonograph might be employed as instruments for generating new sounds rather than merely as the means of preserving previously performed music. But the moment of performance passes immediately into the condition of the performed, constituting a new text with all the same troublesome temporal dynamics identified by Stein.

On account of their fatal arrhythmias, the very inscriptive techniques that would seem to be a means of registering liveness may simultaneously obviate its possibility. However, such techniques of registration also inevitably open onto new possibilities, held open for the same moment they instantaneously, in turn, foreclose, in a series of deferred syncopations. Textual time demands that we must, like Stein, begin again and again. Texts like those by Acconci, Stein and Giffin illuminate an awareness of the very kinds of active engagement that can put the lost moment of recorded time back briefly into play; they attempt—at one and the same time—the auscultations and resuscitations which both register and construct textual rhythm.

References

Deleuze, Gilles & Félix Guattari. 1980. *Mille Plateaux: Capitalisme et Schizophrénie, tome 2.* Paris: Éditions de Minuit.

Dworkin, Craig, ed. 2006. *Language to Cover a Page: The Early Writings of Vito Acconci.* Cambridge: MIT Press.

Giffin, Lawrence. 2011. *Ex Tempore.* Buffalo: Troll Thread.

Lorange, Astrid. 2014. *How Reading is Written: A Brief Index to Gertrude Stein.* Middletown: Wesleyan University Press.

Sanouillet, Michel & Paul Matisse, eds. 2008. *Duchamp du signe, suivi de Notes.* Paris: Flammarion

Stein, Gertrude. [1925] 1993. 'Composition as Explanation.' In *A Stein Reader*, edited by Ulla Dydo, 493–503. Evanston: Northwestern University Press.

12 Memory, Time and Self

A Text Work based on a Conceptual Performance

Paul Forte

Pythagoras, when he was asked what time was,
answered that it was the soul of this world.

(Plutarch)

Remember that time is money.

(Benjamin Franklin)

In the autumn of 1977 I participated in a book fair held on the campus of San Jose State University, California. I set up a table in a large ballroom amongst other tables displaying books and art related ephemera. I designated this a *Time Table* and began selling a minute of my time for one dollar to those who approached and requested it. The transaction was noted on a 'timetable,' a simple two-page document listing the seconds, minutes, and hours in a day, which I then signed and stamped with the book fair's logo (see pages 264–5). My action at this event represented an explicit awareness of and involvement with time as a 'medium.' Many years later, the 'timetable' document, along with my recollection of the event, became the impetus for reflection on our need to find or make more time for ourselves in a fast-paced world. Selling nothing but a minute of my time was patently absurd, although, in thinking of time as a kind of medium (much like some consider ideas in conceptual art), I was reducing my activity to something essential. In retrospect, it may be that I didn't just use time reflexively (as a medium), rather, the action, or conceptual performance, in addition to its explicit engagement with time, may also have had a metaphorical aspect. Given the ever-intrusive and accelerating pace of the modern world, a pace increasingly set by our evolving technology, it seems that more and more people have less and less time for themselves. I contend that such time is crucial for personal development, perhaps now more than ever.

Memory, Time and Self

The *Time Table* performance came at the very end of the conceptual art movement and thus in some way signalled its culmination. That apogee was

260 *Paul Forte*

expressed through an action where my activity as an artist was reduced to recording and then selling a moment of my time. The conceptual performance in 1977 continues to reverberate in all its power and simplicity. The reductive and reflexive practice of my selling nothing but the time it takes to note the time gained, through hindsight and reflection, a new perspective. That perspective came to involve a metaphorical message about the value of personal time in a technological and market-driven economy and the imperative to slow down.

In 2000, the timetable document was given added meaning through its repurposing as textual ephemera in a new context at the 2000 *Academy of Management Meeting* in Toronto, Canada, something unimaginable in 1977. After learning that this institution had inaugurated a new category of submissions (Art & Poetry) and that the general theme was *A New Time*, I immediately thought of the *Time Table* performance. It was my good fortune that the organisers of the Art & Poetry Division had the foresight to, in their words: 'expand our domain in response to new ideas.' What I submitted was, after all, unorthodox: neither poetry nor strictly speaking, visual art. As a kind of 'conceptual memoir,' *Memory, Time and Self,* as the text work came to be called, may seem uninspired, insofar as the work merely documents and comments on the original event, rather than present 'an artwork in its own right.' It must be understood, however, that the *idea* here is the prime mover, the idea is the art.

As with this chapter here, the work had three parts: an original 'timetable' score; a written description of the performance; and a short text titled, 'New time for ourselves,' a subsequent reflection on the 1977 performance and a direct response to the theme of the meeting, *A New Time.* Through speculating on the value of personal time I sought to reveal the social dynamic involved in selling time and thus broaden the parameters of the original performance. Part of my intention with this text work—as again with this chapter—was to bridge the gap between academic paper and artwork, hopefully suggesting the dialectical value of an aesthetic approach to the former and a conceptual approach to the latter. I certainly did not put my work on the same rigorous footing as many of the papers presented at *The Academy of Management* meeting. However, imaginative engagement with ideas and an intuitive understanding of the results of that engagement can strike a chord with people in a way that exhaustive research and empirical studies often cannot. The experiential knowledge provided by the original *Time Table* performance served as a ground for the theoretical *and* practical innovations of the text work, *Memory, Time and Self.* This work was then germane to the first two ways of addressing time suggested by the submission guidelines, which included results of innovations and experiments with time; and work that explores similarities and differences between theory and practice in relation to time.

If nothing else, the conceptual performance piece that *Memory, Time and Self* refers to was based upon an experiment with time that anticipated a

future where an ever-accelerating pace of life would infringe upon one's personal time. In light of this, I felt that the event of October 9 1977, also required an interpretation of it to counter the freighting of time with economic value, something that even colours whatever personal time we do have (e.g., 'how are you going to *spend* your vacation time?'). In this way, just as the original performance drew attention to the wholesale commodification of time at the expense of personal time, the third part of *Memory, Time, and Self* envisions the growing importance of and need for a 'new time for ourselves' and the all-important cognitive focus that such personal time might make possible. My contention was that such personal or private time in the future would become indispensable to our development and well-being. The results of my original experiment were very encouraging. Many of those who bought some time all those years ago were intrigued, amused (or both) and mostly enthusiastic about their participation. This largely positive response was echoed in some of the comments by those who reviewed my submission for the Art & Poetry category of the 2000 *Academy of Management Meeting*: 'rather prescient!' said one, and, 'so much more than an art-piece,' said another. Such comments seem ironic in light of the theme of the meeting, *A New Time*, and the fact that the work I submitted was based on a performance art piece that happened in the past.

When I set up my *Time Table* I wasn't thinking about the relationship between (art) theory and practice. It was rather an intuitive sense of the relationship between time and space that motivated the work. Drawing attention to a moment in time and recording it involved a predetermined order of repetitious movements (noting the exact time, recording it on the timetable and then certifying and signing the document). The reductive and reflective practice of selling time thus makes the correlation of space and time more pronounced. Again, I was basically interested in extending a moment of time as my medium, transforming it into linear coordinates in the context of a conceptual performance. The performance had an implicit 'theoretical' quality. Put another way, the act of delineating time on a table of seconds, minutes, and hours was a kind of 'theory in action,' perhaps a useless practice but a practice nonetheless. Renee Turner, a Dutch artist and curator, has something to say about what this means, writing: 'it is [also] important to move away from classic constructs of theory versus practice by acknowledging the hybridity of each activity' (1998). In other words, we must remember that in any field there are always elements of theory in the prevailing practice, and vice-versa. Turner suggests that theory and practice always have 'mutual territories' where both are in play. 'By realizing where these mutual territories lie, a relation between art and theory can be created which is based not on a division of labour—the one who does and the one who thinks—but on common issues and interests.'

How does the text work, *Memory, Time and Self*, explore these mutual territories as well as differences between theory and practice in relation to

time? First of all, the format suggests a passage of time. The linear placement of its three parts: the memory of the event; the timetable itself; and the speculative text 'New time for ourselves,' symbolise past, present, and future. The 'Timetable' is of course a document *from the past that refers to the past*. The instant that I finished noting the time at my *Time Table* that day, the document entered the past or acquired a history. Yet, there is something about the document that paradoxically suggests the present. Perhaps its sense of the present is due to the fact that it is more an index (or score) than a text; it literally presents or contains the remains of an action and thus has immediacy about it. Or perhaps it is that the recorded moment is essentially like any other moment in time. Whatever, the 'timetable' captures a moment in time, something exemplified by the way the document itself is presented. Placed in the context of the written memory of the performance and the reflection on its meaning, it becomes evidence symbolically contained by both the past and the future. Suspended in time, the timetable document forever mediates between the past and the future.

The Time Table. A Conceptual Performance (1977)

The scene is a ballroom at a state university. Scores of folding tables occupy the space. Most are stacked with books and periodicals, the wares of small and independent publishers of poetry, artist's books, and other related literature. People are going from table to table, perusing the books and artworks on display and engaging those manning the tables, many of which are artists. Most of the publications are for sale. One table seems out of place, odd. A man with dark hair and a mustache sits at a little folding table. He is dressed in a white short-sleeved shirt and black trousers and wears the expressionless face of a chess player. He has placed a small placard on his table that reads: TIME TABLE. Along with the sign: an alarm clock, a stack of documents, a rubber stamp & ink pad, a pen, and a small glass paper weight. The man is busy selling approximately a minute of his time for one dollar. The protocol is simple: buyers approach the table and ask if they may make a purchase. Upon hearing the request the man takes a document from the pile. It is a two-paged 'timetable' delineating the hours, minutes, and seconds of the day (the document is also dated). The man picks up his pen, glances at the clock, and proceeds to circle the second, minute, and hour that he offers his time. The document is then signed and stamped with the logo of the publishers association hosting the book fair. A moment of time is noted and then signed, sealed and delivered.

New Time for Ourselves (2000)

What is a moment of our time worth? In strictly economic terms that value is determined by our position or status in society. I am not interested in the worth of time in this sense. Rather, it is the greater value of time in relation to personal growth that concerns me. So the question is not what is a moment of our time worth to others, but what is it worth to oneself? I once sold nothing more than the time it took me to note the hour, minute, and second I heard the request to purchase a record of that reflexive transaction (which involved noting or calling attention to time itself). As I was homeless and living on the margins of the culture in 1977, my time was of little economic value. Yet, what I was literally offering at my Time Table can also be understood metaphorically. In effect, I was saying to those who approached me: 'Buy some time for yourselves'. This message seems more relevant than ever. We need a certain amount of qualitative time for ourselves in order to deepen, indeed, to maintain our humanity. Quiet time, time to gather our thoughts, is not only essential to the enrichment of our experience; it may also be important to the further development of cognitive skills. In an ever-accelerating world our attention is divided and re-divided by life's demands. One of the greatest challenges facing us on the threshold of this new millennium involves remaining vital human beings in a profoundly changing world. This evolving world will be lost to us if we cannot take the time to find ourselves.

Reference

Turner, Renee. 1998. 'A Journey from Demode to Displacement: Some Reflections on the Relation between Art and Theory.' In *Think Art: Theory and Practice in the Art of Today*, edited by Jean-Marie Schaeffer, 157–161. Rotterdam: Wittte de With, Center for Contemporary Art.

TIME TABLE/STATEMENT

I _Paul Forte_ , hereby extend — as my medium this
day — a small increment of time: an instant past-the future.
Now close at hand:

Hour		Minute	Second
am	1:	00	0
		01	1
	2:	02	2
		03	3
		04	4
	3:	05	5
		06	6
		07	7
	4:	08	8
		09	9
	5:	10	10
		11	11
		12	12
	6:	13	13
		14	14
	7:	15	15
		16	16
		17	17
	8:	18	18
		19	19
	9:	20	20
		21	21
		22	22
	10:	23	23
		24	24
	(11:)	25	25
		26	26
		27	27
	12:	28	28
		29	29
pm	1:	30	30
		31	31
	2:	32	32
		33	33
		34	34
	3:	35	35

(table cont.)

(hour)	(minute)	(second)
	36	36
4:	37	37
5:	38	38
	39	39
6:	40	40
	41	41
7:	42	42
	43	43
	44	44
8:	45	45
	46	46
9:	47	47
	48	48
	49	49
10:	50	50
	51	51
11:	52	52
	53	53
	54	54
12:	55	55
	56	56
	57	57
	58	58
	59	59

"Time Table", P Forte
Book Fair, San Jose State Univ.,
San Jose, Ca. October 9, 1977

13 Broken Magic
The Liveness of Loudspeakers

Dugal McKinnon

This short chapter attends to the role of the loudspeaker in the creation and experience of liveness in electronic music, specifically in the context of immersive loudspeaker environments, such as the Hemisphere at the Institut für Elektronische Musik und Akustik (Graz, Austria), BEAST (Birmingham Electroacoustic Sound Theatre, UK) and 4DSound. These sound systems are typically used to create vibrant aesthetic experiences in the absence of live performers and any significant visual element. Such *acousmatic* contexts, while not conventionally live, use sonic immersion, spatial articulation of sound and the experience of sound as invisible matter to create a unique form of liveness. As a composer of 'loudspeaker music' (recorded electronic music composed for loudspeaker reproduction) working within the acousmatic domain, I find this enthralling and somatically powerfully, yet highly fragile as its (invisible) auditory objects are contradicted by the (visible) physicality of the objects that give rise to them—loudspeakers.

Loudspeaker listening is ubiquitous. More music is experienced via loudspeakers (including headphones) and acousmatically (without a visual element)—mediated in other words—than in any other form. In live contexts, irrespective of whether realised physically-acoustically (traditional performance) or quasi-physically (by operator-musicians, interfacing with electronics), most music is mediated by loudspeakers. Even performances of acoustic music in the Western classical tradition are often mediated, using sound reinforcement systems to compensate for room acoustic deficiencies or to simply increase acoustic presence.

Perhaps due to its ubiquity, this technologisation of music is rarely noted. In the case of sonic reinforcement of Western classical music, this is unsurprising as such sound systems are designed for visual and acoustic transparency. For other acoustic musics (e.g., jazz or singer-songwriter forms) such transparency is also desirable, but often rubs against the requirement of making intimate low amplitude music audible in larger spaces. In such cases, as the music is usually reinforced using stereo PA systems with speakers either side of the stage, a spatial division between visual source (musicians, the actual source of sound) and sonic source (loudspeakers) is introduced. For an alert listener, this schizophonic split (Schafer 1969) will be noticeable but equally the phenomenon of audiovisual

magnetisation (Chion 1994)—key to cinematic experience—tends to result in the perceptual gravity of the visual source drawing in sound such that listeners hear it as emanating from the visual source (see Blain in this volume). This phenomenon reaches an extreme in high amplitude performances in clubs or large stadiums, where loudness is often so extreme as to create a pervasive and directionless sonic field. Here the magnetisation effect still applies, often supported by large-scale video projections that create a virtual visual source which may not be located near the actual visual source.

The naturalisation of schizophonic listening in mediated live performance can be contrasted with the aural environments created by composers of fixed-media electronic music using the kinds of immersive loudspeaker systems mentioned above. In such systems, regardless of the technical approach taken (arrayed stereo, surround, ambisonic, wavefield synthesis), there is a concern to create a cohesive and credible sonic field or image that is heard as *not* projecting from the real source of the sound—loudspeakers. Here the *trompe l'oreille* (aural equivalent of the *trompe l'oeil*) is paramount, emerging not from a disavowal of loudspeakers (despite their obvious presence) but from the effort of the composer-engineer to render them perceptually transparent (Batchelor 2007). Such systems, where sound is encountered as a heterogeneous omnispherical field, are akin to real-world listening in which sound will be heard from many different spatial locations simultaneously (Ihde 2007). This affords immersive loudspeaker systems an environmental quality not encountered in mediated live performance (where audiovisual magnetisation is in effect). Sound is always immersive, to the extent that Tim Ingold (2007) describes sound as a medium in which we exist (we are 'ensounded'). Immersive systems intensify the ensoundment of the listener, deploying sonic space as a core parameter. Affectively, this intensification can be unnerving and/or exhilarating, as listeners encounter sound as *sound*, in forms of ambiguous provenance, heard in the absence of visual cues. This redoubling of sonic experience, exploited by artists working in the acousmatic domain (notably Francisco Lopez, who blindfolds his listeners), is also a feature of environmental audition in which the listener must actively make sense of audial experience that is not a sonic trace of visual events nor determined by musical conventions (Fisher 1998).

In mediated live performance, audiovisual schizophonia is barely noticed, while in the presentation of fixed-media electronic music—even when this offers a highly naturalistic sound-image—the non-liveness, introduced by its non-visuality and the temporal splitting of sound and source, draws attention. It appears that the fixed-media acousmatic *object* (for all its realism), in contrast to the live performance *event* (no matter how simulated it may be), represents a mode of aesthetic production and reception that falls outside normative understanding of what music is. (Object is used here to denote something concrete, fixed, in contrast to the use of event to denote something evanescent, in flux.)

It seems odd that loudspeakers, and acousmatic music made for them, place many listeners in an interpretative quandary. After all, loudspeakers long ago reshaped our expectation of how music should *sound* live, just as recording has

warped our expectations of live performance. (Katz 2004) The sonic presence, grain, balance and amplitude of music is now insuperable from its mediation via loudspeakers such that listeners are frequently disappointed by the sonic qualities of a purely acoustic music or insufficiently reinforced music. No one questions the magnification of sonic scale that takes place, for example, when an electric guitarist gently picks a string, exciting an acoustic response that is barely audible at 10 metres, but unleashing an electroacoustic object of enormous intensity (think of Pink Floyd's David Gilmour, or the even more gesturally restrained Fennesz).

A key observation to make here is that the performer-loudspeaker assemblage encountered in mediated live performance is entirely naturalised, remaining so even when the performer is not a physical agent, but a virtual one, implied in the music and understood as present by the listener (Emmerson 2000). The loudspeaker is granted liveness by the actual or virtual presence of the performer, presence which effectively renders the loudspeaker invisible. The performer, on the other hand, is always perceived as live, even when heavily mediated, as is the case in much simulated music (in which performance is fabricated). When no performer or performance can be readily perceived in mediated music, then the sense of liveness dissipates. When the human body is not heard as involved in the active production of mediated music, then the presence of technology is foregrounded. Thus, this assemblage is a tool that breaks when a central component—human agency—is not *perceptibly* present. Remove the performer and the assemblage is denaturalised, the music broken, the loudspeakers starkly apparent as inorganic technological things. By contrast, removing the loudspeakers leaves a less impressive performance which is nevertheless musical. Thus, the assemblage is asymmetrical, with unequally weighted components, for the loudspeaker alone has no liveness, despite its role in generating detailed and/or massive sonic presence (particularly when subwoofers are involved).

For the listener, when the ontological shift from performative presence to absence is noticed, there is often an accompanying epistemological shift: music moves towards noise or soundscape (environmental sound)—non-music in any case. Put coarsely, this means that for many listeners there is no music when people are not clearly involved in its sounding form. This is an understandably anthropocentric view. After all, until very recently music has been an exclusively human art, involving technologies that are more like traditional tools, which do nothing without constant human input. Listeners versed in music that is rooted in instrumental or vocal performance (and traditional musical materials and forms) tend to find technologically produced music lacks 'soul' or 'spirit,' or sounds 'like it was made by a machine.' This recalls the Memorex trope ('Is it live or is it Memorex?' i.e., technology), given contemporary expression in the high value placed on detailed simulations of human performance (e.g., in sample library-based film soundtracks,) and evident in the following: 'music which does not take some account of the cultural imbedding of [musical] gesture will appear to most listeners a very cold, difficult, even sterile music' (Smalley 1997).

This points to the ontological ambiguity of loudspeaker music, produced by a different form of schizophonia than found in live-mediated music, where live visual source and audial sound source are spatially split but temporally (more or less) synchronous. Instead there is sonic-spatial unity—the *trompe l'oreille* in which the listener is ensounded—but with a temporal split between sound and source. This is unavoidable in any fixed-media music as it involves reproduction of earlier events or simulated events without a correlate in reality (Dellaira 1995). This temporal split introduces a gap in which interpretation *must* occur, a necessity intensified by the fact that there's nothing to see (except loudspeakers). Audiovisual experience involves spatial magnetisation of sound to image and the warping of sound into visually *explained* forms (ontologically, epistemologically and affectively). By contrast, the monomodality of loudspeaker music, the hermeneutic gap it exists in, its intensification in immersive sound environments, creates significant uncertainty for the listener, focusing them on sonic experience and its multivalence.

Multivalence is of course a feature of any (musical) experience. '[What] horizons of experience might the musical work invoke? [. . .] these horizons are immense, numerous and heterogeneous' (Nattiez 1990). These horizons, when not visually-anthropomorphically determined (as most music is), are magnified still further. Loudspeaker music shifts the centre of gravity away from the performer and towards the listener, reconstituting liveness as *listener*-determined.

Figure 13.1 Gerriet K. Sharma performs using the ICO (icosahedral) loudspeaker developed by Franz Zotter (IEM, Austria). Izlog Festival, Zagreb, 2015. Photography Kristijan Smok.

270 Dugal McKinnon

By way of example, consider the following: the ontological dimension of music which, when detached from real or virtual human sources, becomes unsettled and labile, and can only be stabilised through listener interpretation. As Alva Noë asks: 'what would disembodied music even be?' (2012). Loudspeaker music complicates ontology through its profusion of unknown and unfamiliar bodies. There is also the somatic or corporeal dimension of sound and its physical-affective stimulation of the listener's body, often coupling sound with the resonant spaces of the body to produce affects which can be pleasurable (bass music), painful (see Goodman [2010] on sonic weapons), or stimulating, such as Maryanne Amacher's (1999) work involving the physiological response of the ear itself. Consider too the empathetic-affective responses of listeners to sonic corporeality. The involuntary response at hearing the noises of another person's body (Sewell 2010), or the sounds of physical bodies and processes, implicating the listener's body in the mesh of an acoustic hyperobject (Morton 2013) that is no longer limited to the musically performing bodies of human beings.

The liveness of loudspeaker music, particularly in immersive sonic environments, emerges in the interaction of sound, space and the somatic, affective, and interpretative activity of the listener. This can happen only in the absence of performer and performance, and in the presence of the loudspeaker. Such liveness is both singular and radical, particularly within a contemporary cultural context dominated by multimedia, whether spectacular or mundane. Yet the loudspeaker is always a broken tool, its visual-physical presence undermining the very audial-immaterial experiences it creates, even as this deficient object magically propagates qualitative abundance, ontological ambiguity and somatic presence.

References

Amacher, Maryanne. 1999. *Sound Characters (Making the Third Ear)*. New York: Tzadik. Compact disc.

Batchelor, Peter. 2007. 'Really Hearing the Thing: An Investigation of the Creative Possibilities of Trompe L'Oreille and the Fabrication of Aural Landscapes.' In *Electroacoustic Music Studies Conference Proceedings.*

Chion, Michel. 1994. *Audio-vision: Sound on Screen*. New York: Columbia University Press.

Dellaira, Michael. 1995. 'Some Recorded Thoughts on Recorded Objects.' *Perspectives of New Music* 33 (1 and 2): 192–207.

Emmerson, Simon. 2000. '"Losing touch?": The Human Performer and Electronics.' In *Music, Electronic Media and Culture*, edited by Simon Emmerson, 194–216. Aldershot, UK: Ashgate.

Fisher, John Andrew. 1998. 'What the Hills Are Alive with: In Defense of the Sounds of Nature.' *The Journal of Aesthetics and Art Criticism* 56 (2): 167–179.

Goodman, S. 2010. *Sonic Warfare: Sound, Affect, and the Ecology of Fear*. Cambridge, MA: MIT Press.

Ihde, Don. 2007. *Listening and Voice: A Phenomenology of Sound*. Buffalo: SUNY Press.

Ingold, Tim. 2007. 'Against Soundscape.' In *Autumn Leaves: Sound and the Environment in Artistic Practice*, edited by Angus Carlyle, 10–13. Paris: Association Double-Entendre / CRISAP.

Katz, Mark. 2004. *Capturing Sound: How Technology has Changed Music*. Berkeley: University of California Press.

Morton, Tim. 2013. *Hyperobjects: Philosophy and Ecology after the End of the World*. Minneapolis: University of Minnesota Press.

Nattiez, Jean-Jacques (1990). *Music and Discourse: Toward a Semiology of Music*. Translated by Carolyn Abbate. Princeton, NJ: Princeton University Press.

Noë, Alva. 2012. 'What Would a Disembodied music Even Be?' In *Bodily Expression in Electronic Music: Perspectives on Reclaiming Performativity*, edited by D. Peters, G. Eckel, and A. Dorschel, 53–60. New York, NY: Routledge.

Schafer, R. M. 1969. *The New Soundscape*. Vienna: Universal Edition.

Sewell, Stacey. 2010. 'Listening Inside Out: Notes on an Embodied Analysis.' *Performance Research: A Journal of the Performing Arts* 15 (3): 60–65.

Smalley, Denis. 1997. 'Spectromorphology: Explaining Sound-shapes.' *Organised Sound* 2 (2): 107–26.

14 Managing Live Audience Attention in the Age of Digital Mediation

The Good, The God and The Guillotine

Martin Blain

Picture this: six performers are on stage. Light, sound and bodies interact in the space. Three laptop musicians capture, manipulate and perform the voices of three theatrical performers. Simultaneously, foley sounds are initiated by the theatre performers in response to a text given to them by the director; the sounds are captured live and stored to be used as sonic material later in the work. Now, one of the musicians uses pre-recorded sounds to develop the audio texture; another manipulates a live audio stream with post-production software; a third sets up an external interface device and begins to mirror the bodily gestures of a theatre performer and this controls the parameters of an audio stream. Animation is projected onto two locations in the space and lighting helps to punctuate the scene.

This is one of many performance scenarios from *The Good, The God and The Guillotine* (2011–13), a collaborative performance project between laptop musicians MMUle (Manchester Metropolitan University laptop ensemble), Proto-type Theatre, a video artist and a lighting designer. The work takes Albert Camus's novel *The Stranger* (*L'Estranger*) as a starting point and is presented as an intermedial music-driven theatre work. In the early stages of the development of the work, the role, function and status of MMUle within the mise-en-scène became a key concern, particularly in relation to how a spectator might engage with the musicians performing through their computers on stage. A number of commentators (Cascone 2003a/b; Stuart 2003; Turner 2003) have identified some of the audience reception issues associated with laptop performance and these include: a dislocation between performative gesture and resulting sound; loss of connection between performance, gesture and spectacle; a general distrust of the relationship between musician and instrument; and a suggestion that the laptop performer could for all the audience know be entirely otherwise engaged and responding to email correspondence. Many of these issues remain unresolved and it is these issues in relation to the live experience that this project has attempted to address.

For MMUle, the intimacy of the interaction between human and machine is exposed through 'live' performance and this has resulted in the relationship between musician and interface device being in a process of constant negotiation.

Managing Live Audience Attention in the Age of Digital Mediation 273

Bob Ostertag, an experimental sound artist, suggests that one area to pursue in reclaiming mediated devices into the world of live performance is through the role of the body in performance. Pierre Hébert, a frequent collaborator of Ostertag, suggests that, 'the measure of a work of art is whether one can sense in it the presence of the artist's body' (paraphrased in Ostertag 2002). Notions of performer embodiment and in particular the proprioceptive relationship that is developed within the musician in relation to an interface device (be it computer or a conventional musical instrument) are not new (see Paine [2009] for a more detailed discussion). However, the computer as musical instrument continues to pose a unique set of affordance issues in relation to live performance. This short chapter will consider some of the technical approaches and performance strategies that have emerged from this collaboration with particular focus on performance codes that have attempted to manage the audience experience. The chapter will do this by considering three notions of liveness: spatial, audio and interactive.

Early academic constructions of 'liveness' (in the 1990s) were based on a simple binary opposition: the 'live' was associated with presence, value and skill; 'recordings' were seen as fake, undesirable and mechanical. However, more recent articulations of liveness consider the concept to be more fluid and one that embraces performance through a variety of technologies (see Dixon [2007] for a more detailed discussion on this subject). More recently, Paul Sanden suggests that spectators 'perception of liveness [. . .] often involves a negotiation between the recognisable demonstration of a performer's skill and the potential of mediating technologies to subvert performance as a skill-based art' (Sanden 2013, 27). For MMUle, enabling spectators to engage in the appreciation and evaluation of skill-based activities, as part of the live experience, has been one way of managing audience attention during laptop performances.

Spatial Liveness

So, let's return to our performance scenario and consider how 'liveness' has been constructed in *The Good, The God and The Gullotine*. My role in the design of the performance is as one of three composers working within the laptop ensemble MMUle.

Three musicians are located at the front of the performing area, allowing the theatre performers to work behind the musicians. Cormac Power suggests that '[t]heater and presence [. . .] are so connected as to seem almost synonymous' (2008, 1), and considers 'presence' to be manifest through a variety of constructed approaches. For Power, 'presence' can be located not only in the relationship between the physical performers and the spectators but can also be afforded to inanimate objects present in the performance area. The computers in this example are foregrounded and the interaction between the musicians and the computers has become a focal point of activity for the spectator. For the three theatre performers the presence of the computers became problematic as it appeared to restrict their ability to work playfully behind the

274 *Martin Blain*

technology. Part of the issue here, I would suggest, is that the musicians were interacting with their laptops but not with the three theatre performers. This was partly resolved in two ways. Firstly, each of the musicians was paired with a theatre performer so that any resulting audio, physical movements and gestures were synchronised throughout the performance; secondly, a further defamiliarisation strategy was introduced as part of the devising process where all six performers removed their shoes (somewhat radical for the laptoppers!), but this activity produced very positive results in terms of the performers developing an awareness of themselves in the space, connecting with each other and beginning to explore what performing as 'self' might mean in the context of this project—all six performers were now integral to the developing landscape.

Audio Liveness

Considering music within the context of electroacoustic performance, Simon Emmerson suggests that 'presence' might exist in the 'meaning of the utterance' of the work or in the 'aura' generated by the performer/performance and states that:

> Most music now heard appears to present little evidence of *living presence*. Yet we persist in seeking it out. From grand gesture to a *noh*-like shift in the smallest aspect of a performer's demeanour, we attempt to *find relationships* between action and result.
>
> (Emmerson 2007, xiii)

Whilst the relationship between performative action (cause) and resulting sound (effect) remains an issue for laptop performers engaging in 'live' performance, within the world of electroacoustic music performance the issue of causality that connects seeing to hearing does not appear to receive the same level of attention. In fact, Emmerson, more recently, when discussing cause and effect, directs his attention to the relationship between the 'hearing' of a cause and the 'hearing' of an effect (Emmerson 2011, 269). Within this particular tradition, notions of performative 'presence' are realised through what Emmerson defines as 'the sounding flow' (Emmerson 2007, 30): audio, contained within the 'sounding flow' is prioritised over any resulting visual stimuli that may result as a consequence of human or machine interaction taking place in the performance space at the same time. Retreating a little from this position, MMUle, working within an interdisciplinary context, has chosen to locate its musical practice within the wider context of contemporary art where the audio and the visual complement one another.

In an attempt to encourage the spectator to 'find relationships,' clues are planted at the beginning of the work so that the resulting audio streams develop a recognisable cause and effect relationship. For example, at the beginning of the work a theatre performer and a musician enter the space; both are then lit from separate lanterns; the musician encourages the theatre performer to 'test' the microphone; the theatre performer speaks into the microphone

Managing Live Audience Attention in the Age of Digital Mediation 275

and makes a physical gesture in recognition that their relationship has been established. The theatre performer's voice is 'captured' by the musician. This process is repeated until all six performers are in the performance space. The performance then begins with three audio looped samples of the spoken text just heard/recorded. Here, a causal relationship is established between all six performers.

This approach to developing gestural clues is further developed in *The Long Walk* section of the work. As part of the devising process and during a reading of *The Stranger*, a list of audio references in the work was collected. The text used to develop this section of the work contained reference to the sounds of buses, footsteps, matches, knitting. Some of these sounds were recreated live in the space by the theatre performers (the striking of matches; the clashing of knitting needles); some of these sounds were pre-recorded by the musicians (the sounds of buses and footsteps). For the spectator, the visual 'clues' performed live in the space with their resulting sound provided appropriate indicators for when the resulting captured samples of these sounds were used for musical effect both at the time of capturing the sounds as well as later in the work. The resulting sounds of knitting needles knocking together and matches being struck when used later in this section could be identified as sounds previously created 'live' in the space. The sounds of buses and footsteps may, therefore, be identified as mediated sounds.

Interactive Liveness

One approach MMUle has found useful in developing constructions of 'presence' and considering the relationship between the performance and the spectator for laptop performance is through Michael Kirby's work *On Acting and Not Acting* (1972) Kirby offers a continuum of states for acting with no values of privileges given to each condition. Kirby suggests that, '[t]o act means to feign, to simulate, to impersonate' (1972, 43). He goes on to claim that not all performing is acting and that it is possible (in fact encouraged) to move between states within a performance. I am not suggesting here that musicians (laptop or other) should consider their musical performance in terms of their ability to act, but when presented with bodies and inanimate objects in a performance space a spectator is likely to attempt to make sense of the complexities of the presented relationships.

Kirby's continuum for acting/not-acting contains five positions: non-matrixed performing, symbolised matrix, received acting, simple acting and complex acting. Kirby suggests that whilst 'the differences between acting and non-acting may be small [. . .] it is precisely these borderline cases that can provide insights into acting theory and the nature of art' (1972, 43). The application of Kirby's continuum to 'live' laptop performance practice as a way to better understand how bodies (human performers/spectators and inanimate objects) can work and interact in the performance space maybe a useful path to explore. Paul J. Rogers and Gillian Lees, working in the early stages of the devising process, explored the relationship between the sounds and movements.

Figure 14.1 The Good, The God, and The Guillotine. 2011–13. Photography Jonas Hummel.

An improvisation begins with Paul capturing the vocal sounds Gillian is producing and Gillian copies the physical movements Paul is making as he interacts with the computer to control and manipulate the captured audio. At moments during this particular session, it became evident that both Paul and Gillian were working in, or trying to find subconsciously, that space Kirby has defined as a 'borderline'. For moments in this improvisation Paul and Gillian reported that it was not apparent who was initiating material and who was reacting to the process.

Figure 14.1 shows MMUle and Proto-type Theatre developing 'interactive liveness' in *The Good, The God, and The Guillotine*. Here, Nick Donovan (MMUle) and Leentje Van de Cruys (theatre performer) are working together to generate, manipulate and present to a spectator vocal material. Leentje is singing into the microphone that is being controlled by Nick; Nick has come down stage right to locate himself physically close to Leentje; Leentje's physical gestures are being mirrored by Nick who is using his iPad as an external controller to manipulate and process the resulting audio stream.

Conclusion

Our approach to developing and constructing 'presence' in this work has been through a process of play and experimentation between all members of the collaboration (including, in addition, how the work of the animator and

lighting designer also impact on the perception of liveness for the spectator). In relation to the six performers on stage this has allowed each to choreograph (but not fix) specific performative actions through a process of collective and collaborative interaction with the sound materials at play. This has enabled a personal and spatial relationship to develop between the musicians and theatre performers in the performance space and in turn facilitated and encouraged a 'meaningful response' to develop between the six performers and spectators. Whilst the development of a Kirby-led performative continuum is ongoing, the development of this approach has begun to address the wider performative issues concerned with laptop performance. Kim Cascone once said: 'falling into neither the spectacularized presentation of pop music, nor the academic world of acousmatic music, laptop musicians inhabit a netherworld constructed from performance codes borrowed from both' (2000, 6). Power's thoughts on 'technological' presence and Emmerson's articulation of a 'sonic' presence have been useful starting points for this project not only in attempting to better understand how notions of liveness can help to build relationships with spectators, but how it can also begin to address some of the key issues that have challenged the spectator when attempting to engage with laptop performances. However, it is through MMUle's adaption of Kirby's paradigm that the apparent loss of connection between performative gesture and resulting sound has, to some extent, been regained; the level of technical and musical interpretive skill needed to perform on the instrument (machine) has been made evident, not only in the 'sounding flow' of the composition but also through the medium of the 'visual' performance; and the apparent distrust from spectators regarding the relationship between performer and machine in relation to laptop performance is being resolved as spectators are provided with more 'clues' as to how the live experience is working. From a spectator's perspective, Dave Cunningham has commented that it is 'ironic that a production in which loss of faith is a theme should renew your faith in what can be achieved in the theatre' (Cunningham 2014).

References

Cascone, Kim. 2000. 'Laptop Music—Counterfeiting Aura in the Age of Infinite Reproduction.' Accessed at http://www.itu.dk/stud/speciale/auditorium/litteratur/musik/Kim%20Cascone%20Laptop%20Music%20v2.pdf.

Cascone, Kim. 2003a. 'Introduction.' *Contemporary Music Review* 22 (4): 1–2.

Cascone, Kim. 2003b. 'Grain, Sequence, System: Three Levels of Reception in the Performance of Laptop Music.' *Contemporary Music Review* 22 (4): 101–104.

Cunningham, Dave. 2014. *The Good, The God and The Guillotine.* Accessed at http://www.thepublicreviews.com/the-good-the-god-and-the-guillotine-contact-manchester/

Dixon, Steve. 2007. *Digital Performance: A History of New Media in Theatre, Dance, Performance Art and Instillation.* Cambridge: MIT.

Emmerson, Simon. 2007. *Living Electronic Music.* Padstow: Ashgate.

Emmerson, Simon. 2011. 'Music Imagination Technology.' In *Proceedings of the International Computer Music Conference*, 365–372.

278 *Martin Blain*

Kirby, Michael. (1972) 1995. 'On Acting and Not-acting.' In *Acting (Re)considered*, edited by P. Zarrilli, 43–58. London: Routledge.

Ostertag, Bob. 2002. 'Human Bodies, Computer Music.' *Leonardo Music Journal* 12: 11–14.

Paine, Garth. 2009. 'Gesture and Morphology in Laptop music Performance.' In *The Oxford Handbook of Computer Music*, edited by R.T. Dean, 214–232. Oxford: Oxford University Press.

Power, Cormac. 2008. *Presence in Play*. Amsterdam: Rodopi.

Sandon, Paul. 2013. *Liveness in Modern Music*. London: Routledge.

Stuart, Caleb. 2003. 'The Object of Performance: Aural Performativity in Contemporary Laptop Music.' *Contemporary Music Review* 22 (4): 59–65.

Turner, Tad. 2003. 'The Resonance of the Cubicle: Laptop Performance in Post-Digital Musics.' *Contemporary Music Review* 22 (4): 81–92.

15 Enlivened Serendipity

Allen S. Weiss

Strange anatomy: the mute face of Novarina, the manifold voices of Whitehead, the electronic borborygmi of Migone, the cosmic hands of Sussman, the cruel eye of Paré, the hermetic ear of Weiss. Who's there? A monster, of sorts. No phantasms, but frozen mutations of language, following Novarina's declamation, 'articulatory cruelty, linguistic carnage.' Loosen the tongue, fracture speech, worsen the word through a logological proliferation, through an incantatory drunkenness, through an onomastic frenzy. Seek an impossible private language, and you shall find a universal expression.

When I re-read these programme notes to *Theater of the Ears*, written over 15 years ago, I wonder at the implications of the Shakespearian query, 'who's there?', an exclamation that conceals an entire philosophy. My discovery of the writings of Valère Novarina took place in the early 1990s. I specify writings, rather than theatre, for though I attended at that time several plays he staged and greatly admired the monologs performed by André Marcon, I especially relished Novarina's writing for linguistic and literary reasons. His writings instantiate the state of maximal flux, mutation and transformation of the French language, much in the lineage of Rabelais and Artaud: in works such as *Le drame de la vie* (1984) and *Discours aux animaux* (1987), every parameter of the text—orthography, lexicon, grammar, syntax, narration—is reinvented; and his reflections on theatre, as in *La lettre aux acteurs* (1989), offer instructions as to how his words could be made flesh on stage.

I had never imagined a theatrical destiny until the day I received a call from Richard Foreman, who unbeknownst to me had been reading my translations of Novarina and suggested that I produce some of his work at the Saint Mark's Theater, New York. I was intrigued by this possibility but hadn't the slightest intuition about staging a work, beyond my fascination with Marcon's readings. I thus contacted Gregory Whitehead, with whom I had already produced a radio documentary on dolls (*L'Indomptable*, Atelier de la Création Radiophonique, Radio France 1996), and suggested that we work together on this project. Inspired by Whitehead's radiophonic propensities (at that time centered on micromontage, noise interferences, circuit breakdowns and extended vocal techniques), and my literary ones (psychopathological manifestations of

280 *Allen S. Weiss*

glossolalia, aphasia, ellipses, musication), I imagined a similar form of monolog, a minimal staging of Whitehead's radiophonic virtuosity in a theatrical setting. However, not only did I not wish to simply reproduce an English version of Marcon's monologs, but I sought a more radical setting for such an extreme shattering of linguistic conventions. Given my preference for the literary over the theatrical, as well as the desire to avoid the theatrical monologue form, the logical solution was to reduce the work to pure orality as a *Theater of the Ears*, but then the problem became how to induce people to come to a theatre to listen to a CD!

So much art is in fact a matter of problem solving, as George Kubler rightly suggests in *The Shape of Time* (1962), and so much problem solving is a result of coincidence and serendipity, as we soon discovered. At that time theatre director Travis Preston, who knew my work on Artaud, was seeking a piece with which to inaugurate the Center for New Theater at CalArts, and was already in contact with the French cultural attaché in New York, who was committed to the work of Novarina and was also aware of my translations, which had been supported by a Centre National du Livre fellowship (1995). And, as such things happen, one evening my friend and soon to become co-director Zaven Paré and I were sharing a particularly lighthearted moment, and concerning my theatrical quandary we imagined a form of bowling where one of the pins would bear Novarina's face. *Theater of the Ears* was born at that moment, thanks to the extremism of humour: the voice would be staged by an immobile mute robot with the face of Novarina (sampled videos of the playwright, internally projected on a transparent life mold of his face) with the voice (Whitehead's vocalisations of my translations of a montage of Novarina's texts) emitted from seven speakers, three of them mobile. The staging was divided between Paré creating the robot and set and myself articulating sound and stage, such that the piece was generally described as 'a play for electronic marionette and recorded voice,' though this was after the fact. For it was not until our operator, the puppeteer Mark Sussman (one of the founding members of Great Small Works) sat down—mostly hidden from view behind a semi-opaque black scrim, like some Wizard of Oz—at the computer that controlled the robot's facial expressions, and began to operate the robot and the mobile speakers, that we realised what we had done as he exclaimed that we had in fact created a marionette theatre! An electronic marionette, without strings or wires, remote controlled. Soon afterward, we began to realise that the three mobile speakers—two on independent cars, one on a track—also had personalities of their own, and were thus a form of minimal marionette, and what's more, they spoke. *It was the live presence of the puppeteer that made the puppet.*

Novarina had originally been somewhat sceptical about the project, having up to that time refused to let his works be staged for puppets, marionettes, robots, or other non-human actors, but his trust in our efforts was warranted, and after the premiere he looked at me and proclaimed: 'Indeed, it's theater!' What changed his mind was the mysterious presence of Mark Sussman, whose manipulations gave a human touch to the electronic assembly. The most

minimal presence of human intervention—the crooked finger tapping on a computer key, the sideways glance following the progress of a speaker—gave sufficient flesh to the scene. Transpositions, distantiations, mutations. The speakers were the endpoint of a process, splitting into seven distinct channels a voice that suffered a series of distantiations: Novarina's authorial voice first set to written word by himself, thus cast into the world to follow its own destiny far from the author's body; these words then transfigured by myself (I do not say 'translated,' since for a writer like Novarina the act of translation is tantamount to writing in the manner of Novarina, rather than transliterating a text); the English texts synthesised as a montage, recorded in Whitehead's many voices and vocalisations, analysed by Whitehead's sundry audiophonic machinations, and finally staged within the robotic mechanism.

Live performance is most often related to a phenomenological metaphysics of presence. But just as phantoms take on many forms, so does 'liveness': as an existential state of being; as the act of observation in real time; as the temporality of coincidence and simultaneity; as a particular media genre; and as an aesthetic utopia. The present is the nexus of past and future, and liveness is the intersection of presence and absence, the very point where the ghosts of the past commune with the ghost that one shall become. Throughout this project, I felt that I was channelling the imaginations of all those whose interventions made the work possible, as well as others, notably Artaud and his 'theatre of cruelty,' who remains at the core of a certain modernist theatre of excess and transgression. For at every stage of a work—pre-production, production,

Figure 15.1 Theater of the Ears. Photography courtesy of Allen S. Weiss.

282 *Allen S. Weiss*

post-production—performance bears profound traces of absence and alterity, what in ancient times was called the muse. Inspiration proffers forms that work as constraints; these constraints are the very conditions of possibility of the work. They often escape our conscious grasp and are at times revealed with a jolt.

One performance of the French version, *Théâtre des oreilles*, at La Ferme du Buisson, was followed by a question-and-answer session with the spectators, who seemed genuinely enthusiastic. Quite frankly, we were bored and more than a bit fidgety, confronted with questions we had heard time and again and offering responses that were but echoes of our thoughts. Everything around us had become commonplace, and no poetry appeared. At one point I distractedly looked up at the stage, and the mechanism of boredom produced the shock of obvious recognition, as I realised that the weather balloon that was clamped into a huge vice stage left could be construed as a minimal marionette that does nothing for the entire length of the play except glimmer with light toward the very end, a sort of binary on/off signal of minimum communicability and austere iconography. A catatonic marionette!

That weather balloon-turned-marionette—a mysterious transformation that was most probably experienced by myself alone—was a lesson well learned. For when I organised *Poupées*, an exhibition on dolls at the Halle Saint Pierre (Paris, 2004, with an accompanying catalogue published by Gallimard), I posed as the epistemological precondition of the curatorial task the simple question, 'What is a doll?' (another manner of asking: 'Who is there?'). I had hoped that the spectators would enter the exhibition confounded by the vast range of dolls (artists' dolls, fashion dolls, ethnographic ritual dolls, found objects and so forth) and might at times look at a grotesque and nearly formless rag doll by Michel Nedjar, an Amerindian corn husk doll, or some nearly abstract modern-ist invention and wonder what these things might possibly be, yet by the time they left the exhibit would proclaim: 'Yes, indeed, that's a doll!' One must thus always ask, 'What is a puppet?' For if a simple husk of corn can make a beautiful blond doll, or if a puppet may be constituted by a clump of rags or a simple ball stuck on to the tip of a finger, as brilliantly evidenced by the great Russian pup-peteer Sergey Obraztsov, or even by just the finger itself, lasciviously enticing the viewers into an erotic spectacle, as in Philip Roth's novel *Sabbath's Theater* (1995), then why can't a blinking weather balloon be a minimal solipsistic marionette? What I learned, to my joy and my disquietude, is that *it is occasion-ally the animated puppet that creates the puppeteer*.

Such revelations often occur retrospectively, through the genius of the *ex post facto*. The twentieth century lives under the sign of a malleable temporal-ity, where the past is constantly transformed by present actions and intuitions, as attested to by Nietzsche, Freud, Eliot and Borges. Not only does a writer create his own predecessors, but in turn the writer will be transmogrified, even posthumously, by his own successors. Genesis and genealogy are one, such that liveness is always inhabited by the phantoms of our past and the spectres of our future. A single characteristic of a work, however minor—a gesture, a vocal inflection, a lighting effect, an insignificant part of the decor—may sug-gest new techniques, or inspire a new character, or even become characteristic

of a style. A balloon is reformulated as a puppet, offering a paradigm for future events. Furthermore, a particular work may well suggest the key to understanding an author's entire corpus and, in the case of *Theater of the Ears*, this occurred not despite but because of the collective nature of the work, where the specific contribution of each collaborator shed light upon conceptual and emotive traits that had remained latent and subsequently opened up new paths of endeavour. When asked by several theatrical journals to reflect upon this work, I distilled from the experience of both the collective production and my own intimate spectatorship a certain number of imperatives that had guided my part of the production: *multiply origins; neutralise technique; accept interferences; confuse genres; valorise polyphony; exacerbate paradoxes; exploit voids; condense givens; love mannerisms.* At first I thought these precepts were restricted to my relation to Novarina's work, but I soon realised they revealed the sense of my very own style.

The 'live' is constituted by a series of antinomies seeking resolution within a spectacle, that world of theatre and performance where the impossible becomes potential and the unreal realised: animate/inanimate; living/dead; present/absent. It is the successful staging, the inspired gesture that accomplishes this resolution. Above all else, the fundamental dichotomy of self and other is resolved within the magical scene of theatre and performance, where space is heterogeneous and time polychronic. Within these imaginary worlds one experiences, be it as creator, actor or spectator, Rimbaud's dictum: 'Je est un autre' ('I is another'). For what is most alive is not a unique subject but a community of writers and directors, composers and musicians, technicians and programmers, auditors and spectators. Life, in theatre and performance, is not the presence of an organism, but the sense of a communion.

Note

The text of the marionette play *Theater of the Ears* is a collage of works by Valère Novarina, translated by Allen S. Weiss and published as Valère Novarina, *The Theater of the Ears* (Sun & Moon Press 1996). Novarina is one of the most important voices in contemporary French theatre, whose work is frequently performed in France and around Europe, but had never been previously presented in the United States. *Theater of the Ears* was developed at the California Institute of the Arts, Center for New Theater (Valencia, California, November 11–13 1999), before being part of the Henson International Festival of Puppet Theater, LaMama, New York (September 13–24 2000). It was supported by an Association Française d'Action Artistique (AAFA) grant and a French-American Fund for the Performing Arts Étant Donnés grant. The production team was constituted as follows: text and visage: Valère Novarina; translation and adaptation: Allen S. Weiss; mise-en-scène: Zaven Paré and Allen S. Weiss; set and robot: Zaven Paré; montage and voices: Gregory Whitehead (additional sound: Christof Migone and Scott Konzelmann); puppetry: Mark Sussman; production: Carol Bixler at CalArts. The French version of *Théâtre des oreilles* was produced by the Institut International de la Marionnette, Charleville-Mézières (June 5–7 2001), and travelled to the Festival de la Marionnette de la Villette, la Ferme du Buisson, Noisiel (June 9–10 2001), and the Festival d'Avignon Off, La Caserne des Pompiers, Avignon (July 2001). Text and visage: Valère Novarina; mise-en-scène: Zaven Paré and Allen S. Weiss; set and robot: Zaven Paré; sound: Jon Gottlieb (based on the Whitehead version); voices: Leopold von Verschuer; puppetry and lighting design: Mark Sussman.

16 National Theatre Wales's *Coriolan/us*

A 'Live Film'

Mike Pearson

On 8–18 August 2012, National Theatre Wales (NTW) in collaboration with the Royal Shakespeare Company presented *Coriolan/us*, a version of Shakespeare's drama (1608–10) infused with elements of Bertolt Brecht's adaptation (1952–55). It was conceived and directed by Mike Pearson and Mike Brookes, with further design by Simon Banham and soundtrack by John Hardy.

Our principal ambition was to work at scale, with—after a previous rain-swept outdoor production for NTW of Aeschylus's *The Persians* (2010)—one proviso: to ensure protection from the weather for a perambulatory audience. As a consequence, the requirement was for 'a landscape with a roof on it.' And thus *Coriolan/us* was staged in a disused, Second World War aircraft hangar—90 metres long and 50 metres wide—at St Athan RAF station, close to Cardiff Airport.

In developing the production's dramaturgy and scenography—and in a conciliation of artistic desires and practical realities—we worked from both the text *and* the site, towards the creation of a *theatre machine*. That is, a set of conceptual approaches and technologies that were brought to the drama as much as emerging from or preconditioned by it. The result was a combination of live performance, video projection and audio broadcast.

Shakespeare's *Coriolanus* involves five strands of irreconcilable conflict: wars between the infant Roman republic and the neighbouring state of the Volsces; the intense personal rivalry between Caius Martius Coriolanus, Rome's greatest soldier, and the Volscian leader, Tullus Aufidius; the struggle for power within Rome between the patrician class, whose most intractable member is Coriolanus, and the plebeians, organised and manipulated by two Tribunes; the battle of wills between Coriolanus and his mother Volumnia over matters of political expediency; and the conflict within Coriolanus himself, who is torn between a desire for revenge on the city that rewards him with banishment and the affection he feels for his mother, wife and son.

Aggressive nationalism and acute social division; army and state; war and famine; conspicuous consumption and poverty; court and city—it's a complex and potent mix. The implications, effects and outcomes of their entanglements and of the conflictual clashes—for both individuals and states alike—are epic as much as they are personal and psychological. This is a world in turmoil in which events change rapidly: key perceptions in developing the eventual structure of the production.

National Theatre Wales's Coriolan/us 285

The overarching theme is politics: martial life versus increasing, though provisional, bureaucracy and the emergence of a world in which Coriolanus finds it difficult to situate himself. He is a battle-hardened war machine, an anachronism, the product of his caste, of his mother's ambition and of his own impulsive nature: a returning military hero out of his element in the new civic arena. He is unable—or refuses—to compromise, to temper his discourse, to perform a role for the plebeian public, to play a part, to act politically. Throughout *Coriolanus*, there is a key theatrical metaphor: of honour versus role-playing. He repudiates praise and distains compromise. His world revolves around himself; he mistrusts public estimations. He is preoccupied with his own inner integrity, his nobility. Yet his arrogance is as magnificent as his courage, and his swaggering charisma is attractive. Ironically, he is perhaps the only constant figure in the play.

Unlike other principal Shakespearean characters, Coriolanus is rarely alone: he has few private moments; little room or opportunity to go away, to withdraw in order to reflect on his own condition. He is always 'on camera,' his immediate, untempered responses on view. He can never be classically tragic. He has only two quasi-soliloquies but he is always the topic of conversation: an embryonic celebrity. A further important influence on the nature of the production.

In addressing the text, rather than preparing individual scenes, I configured it musically as an *overture* that establishes three conflicts—class, military and domestic—followed by three extended *movements*—war, politics, betrayal.

What of the play informed the dramatic and scenic concept? First, Shakespeare's world is crowded, and there are few empty spaces in it: in twenty-five of twenty-nine scenes, crowds are present. Secondly, of the multiple locations, many are nowhere in particular: camps, battlefields; streets, marketplaces; there are only two or three distinct interiors. Thirdly, there is a nascent public sphere, with political claim, argument and dissent in plain view. Characters appear for a moment from the crowd and are lost in it again in continuous comings and goings; in entrances, meetings, reunions and departures that foster the fluid, unstable situation.

The decision was made then to regard the audience, from time to time and unwittingly perhaps, as citizens, army, bystanders, film extras, etc., and to achieve the production—with only slight textual adjustment—with only two Citizens and two Tribunes, one of whom was female. No massed supernumeraries, no rioters, no foot soldiers to hinder the momentum of events, but with the few actors repeatedly emerging and disappearing. As Coriolanus begs approbation of the plebians, he stands on an oil drum in the market place, wearing a blindfold; unbeknownst to him, as he cannot see them, he is repeatedly quizzed by the same two Citizens rather than passing hordes.

And what of the site? In the immense, barrel-vaulted concrete structure, Brookes and Banham built two, two-metre high breeze-block (cinder block) walls across the space, with a two and a half metre gap between them and an opening at the centre, effectively creating three contiguous regions: Rome; a war zone; and Antium/the territory of the Volsces. They also installed three caravans, stripped of their fixtures, their interior walls rendered in plaster, as exclusive locations for Coriolanus's family, for the Roman patricians and for

Figure 16.1 Coriolan/us, 2012. Photography Mark Douet / National Theatre Wales.

Volscian leader Aufidius. A spare scenography in an open, unmarked landscape: in which it was the delivery of text and action that indicated and conjured precise locations, rather than fixed indexical scenic settings, with enough space here for staging different scenes at different locations, provisionally occupied and quickly deserted or erased.

Unobstructed, the building allowed the replication of performative phenomena of the city: ceremonial entries, victory parades, street demonstrations and riots. And the inclusion of traffic: the production also involved three moving vehicles together with several wrecks. The Citizens arrived in a silver Leyland van, Coriolanus in a Volvo estate, and Aufidius in an Audi, all from the 1990s, all slightly retro. At rest these became temporary settings, locations, enclosures, refuges, battlefield detritus; in motion they inserted kinesis into the dramaturgy, producing momentum, traction, drive and unpredictability as they drove into the crowd.

The lighting rarely pointed out where to look: it spilled from cars and caravans; from camera lamps; and from a series of vertical neon tubes standing around the hangar perimeter—drawn in from time to time, in an ad hoc manner, to illuminate a temporary scene. Amongst the few objects used were staves and wooden Japanese swords (little more than crude clubs) until one of Citizens finally produced a gun and assassinated Coriolanus.

All action was videoed and immediately projected—in black and white—on two large, suspended screens. Seven cameras were employed, with two news-gathering teams following the action at ground level: permanent systems

National Theatre Wales's Coriolan/us 287

rigged in the caravans and two overhead, radio-controlled devices on wires tracking events. The same event was observed from different angles, including from above; different scenes were screened simultaneously; the reactions of non-speaking characters were revealed in cutaway shots. And occasionally characters—making public announcements and declamations—spoke directly to camera. Scenes 'behind closed doors'—in privileged, inaccessible interiors, in the caravans and in vehicles—were witnessed on CCTV and glimpsed through windows. With some shots rehearsed for camera, others captured in an ad hoc manner, and all mixed live in performance, the juxtaposition of viewpoints reflected a contemporary, conjoined world of celebrity and surveillance: of constant media attention and intrusion; of embedded transmission; of low-grade recording, uploading and streaming; of covert monitoring.

The main practical problem was that the hanger had a ten-second echo, almost impossible and prohibitively expensive to control through conventional amplification. The solution was to equip all actors with radio microphones and all spectators with headsets through which they heard the voices merged with John Hardy's soundtrack. Consisting of long continua and shorter accents, the pre-recorded soundtrack was also mixed live, with the music following actors rather than *vice versa*. And from this technical solution, much else followed. Significantly, the actors themselves never heard the soundtrack in their own in-ear fold-back system, confounding any temptation for them to follow the rhythm and tenor of the musical composition in their exposition.

With no need to project their words or indeed their actions towards any particular audience, actors were able to use non-theatrical tones of voice, to engage directly in intimate conversations and interactions with their colleagues. All text—whispered thoughts, asides, personal commentaries—registered precisely in the ear of each individual audience member, however removed they were from the action, or how partial their view.

It also became possible to include pre-recorded characters, present only in the audio mix: Valeria was heard only as if on the other end of a telephone, the audience hearing both ends of the conversation; Aufidius was totally alone for long periods of the performance, although constantly on a cell phone to his lieutenants and advisors, in overheard conversations.

Both audio broadcast and video projection remained constant, however far—through personal choice or rapid shift of scene—the spectators found themselves from the action, however restricted their view, whatever the varying levels of dramatic rhetoric in play. Everyone in the room was—to varying degrees—'wired up.' And this lent a sense of complicity, of being addressed personally, of being immersed in events, of being an active agent in generating one's own degree of spectatorship: deciding to stand close or far off; to pursue the action or to watch events unfold on video; or, as in the battle scenes at the wall, to integrate close-ups on projection with distant spectacular views of smoke and light.

The play's open and direct setting—its lack of subplots, very few indoor scenes, yet ever-present crowds—made it a resonant counterpoint to current political events, with their unreliable leaderships, ad hoc factions and coalitions,

makeshift allegiances and fleeting loyalties, civic uncertainties and disturbances, military adventurism and fledgling democracies, as well as attendant round-the-clock news and social media. This was not *Coriolanus* in the Arab Spring or—as in the Ralph Fiennes film (2011)—in former-Yugoslavia, though the breeze-block walls might be redolent of Northern Ireland or Gaza or Aleppo. At the conclusion, as the Roman collaborators shoot Coriolanus we may recall the sudden, summary death of Saddam Hussein and that of Joe Pesci in the film *Goodfellas* (1990): 'And that's that'.

The shifting audience resembled an urban, plebian crowd at liberty to follow the action, to watch the film, to sit and listen on one of the 150 chairs stacked around the space. And without ever being choreographed they behaved as they might in a street performance, as scenes materialised, and then were lost, in their midst: negotiating their own presence; deciding where to position themselves; adopting circular arrangements around events; moving to see better; being distracted by parallel happenings; avoiding traffic and other people. However, although there was always something to listen to or look at there was never one place from which to see it all panoptically, *in toto*, as on the proscenium stage.

Crucially, the scale of the site and the use of technology facilitated instant shifts without pause from scene to scene, location to location, without the need to wipe and reset the stage: now Rome, now Antium; now interior, now war zone; now senate, now street; constantly segueing. One scene was always in preparation before the end of the previous one. The effect engendered was that the drama was all occurring in the 'here and now,' as sequential, 'real time' happenings: giving it forward momentum, and clipping its usual duration. Event followed event, wave upon wave, experienced and dealt with expediently, as they arrived.

Why *Coriolan/us*? Because it is always unsettling: seeming always to reflect the time in which we live, yet offering no easy solutions and demanding of us that we think politically. But our production referred largely unto itself: constituted as sordid events in back alleys; or tangentially, in its slight retro design—the actors barely distinct in appearance from the crowd—to recent Danish television crime dramas.

Coriolan/us as a landscape, flat and unrevealing—floor, walls, vehicles, people—with few permanent uprights to orientate the eye, without focused lighting pointing to or pointing out this or that. It was the actors who generated locales, drawing them out of the horizontal continuum through their words, actions and ad hoc scenic arrangements at sites identified and repeatedly revisited during rehearsal as the best location to achieve this or that. Always aware that their words and actions were being visually and aurally registered and amplified in a production that—in the immersion of the audience in events and their simultaneous mediation, in the instantaneous shifts in location, in the juxtaposition of close-ups and long-shots, in the integration of a variety of styles of exposition—eventually resembled a *live film* enacted on the equivalent of a sound stage. 'We are looking at the mix of cast, crew, spectators, structures, equipment and props as a specifically unified whole,' concluded Mike Brookes in a programme note.

17 Machines in Queer Gardens
Performance as Mixed Surreality

Judd Morrissey and Mark Jeffery

What is liveness within the performance of contemporary life; or equally within the life of contemporary performance? This inquiry has become increasingly complex within our collaborative practice, which is both interdisciplinary and deeply immersed in digital and algorithmic processes. As Anatomical Theatres of Mixed Reality, we experience liveness as a multi-threaded system of bodies and real-time processes in which human and non-human presences and temporalities are interruptive, simultaneous, and entangled. The artist cannot be present, or at least not live, due to conditions of liveness that multiply and divide attention, making one an asynchronous host to multiple flows of information.

Our most overt explorations of the complexities of mixed reality liveness demonstrate distance in the immediacy of mediated presence: a chorus sings our source code as it appears on screen, a performer repeats the live text-to-speech data streaming into his ear, an audience member examines the tattoo on a near-naked body through her smartphone camera, generating virtual content that comes between them. To rethink liveness within our performance work, it may be useful to begin with its definition in computing. As a computing term, *liveness* describes the condition of a system that must make progress despite the fact that it is executing multiple processes concurrently and may need to move between them. (Interestingly, at the time of writing, it is this definition which is provided by *Wikipedia*, rather than any discussions from within performance studies.) In this non-human sense, liveness is used to express a state of vigilance within a struggle of divided attention, a determination to be doubly present, to achieve, within classical computing, the quantum state of being in two places at once.

Who's live is it anyway? There is us (Judd and Mark), or performers Chris Knowlton and Justin Deschamps; our collective presence; the audience in the space. Or is it the involuntary long-distance performer whose tweet is captured by a live text programmed to complete itself. As in this writing, our voices are alternating but also mixed.

Where are we live? In the projected view of the roving augmented reality camera in our new work, *Kjell Theory*, we are surrounded by a virtual radius of words circling and stacked at different altitudes and delineating the permeable

290 Judd Morrissey and Mark Jeffery

boundary of our performance space. Indeed, recently, during a performance in Los Angeles, we lost the live stream of this poetic architecture and continued to perform in relation to an environment that was not present for the audience.

Anatomical Theatres (Judd)

We often find that our projects begin with historical, geographical or biographical research that acts as a spur to our practice-based enquiries. This involves an excavation, a reanimation, a way of being inside something and swallowing it up, filtering the past through ourselves into movement or writing while looking for the larger principles of a system. Our 2011 project, *The Precession*, started with a site trip to the Hoover Dam in Nevada two years earlier. Mark digested the material and emotional landscape, the scale of towering winged statues and miniature landscape dioramas, the ghosts of the builders who, like his father, fell while performing their labours. He drew an image of a man falling into another man's wings. I wrote: 'If men must have fallen from a great height, he wants them now to fall within his body.'

The systems of the dam include a permanent installation of two winged men seated in a celestial map that marks the positions of the visible stars when the dam was dedicated and illustrates the shifting identity of the polestar over 26,000 years, which changes due to incremental cyclical changes in the earth's rotation. The themes of labour and the celestial led to several experiments in mediated liveness on the way to creating a culminating work. In *The Labors* (2011), ten men performed a dance with shovels taking positional cues from a real-time visualisation of visible stars over the Museum of Contemporary Art in Chicago. In *The Living Newspapers* (2010), performers seemingly engaged in pedestrian conversation walked through the same museum but were actually vocalising real-time social media feeds received through ear buds, based on a form of theatre from the era of the dam's construction designed to address citizens' concerns. The scale of the dam and its identity, literally, as a generator, led to a monumental ten-screen panoramic installation of generative algorithmic text and image accompanied by a movement-based performance, choreographed by Mark.

Another work, *The Operature* (2014), began in 2012 with research relating to anatomy and forensics, including the architecture of early-modern surgical theatres and, Samuel Steward's STUD FILE, a twentieth-century autobiographical card catalogue which used a coded system to record (then-illegal) homosexual experiences. This work coincided with our formation of a collective, Anatomical Theatres of Mixed Reality (ATOM-r), to explore histories of technological augmentation and queer bodies, using the live medical operation as a metaphor for our performances. In this work, temporary tattoos on the performers bodies, based on Steward's designs, were scanned to reveal texts, videos and 3-D objects both within the performance and by the audience in an interactive intermission.

Now in 2015, we've embarked on a new work responding to aspects of the biography of British gay computing pioneer and mathematical biologist, Alan Turing, in conjunction with a 1917 gender-queer play, *The Breasts of Tiresias*,

for which the author, Guillaume Apollinaire, coined the word 'surrealism.' For crimes of gross indecency, Turing was infamously given forced estrogen treatment, which resulted in gynocomastia. While Turing described the chemical reactions of life, in his theory of natural forms, his own body was involuntarily undergoing a metamorphosis, and this led us to imagine him as the mythological prophet Tiresias, who moves back and forth between genders, subsequently guiding us to the discovery of Apollinaire's text. In initialising this new investigation with a research trip to the United Kingdom, we thought also of the artist and filmmaker, Derek Jarman, the trials of his queer body and his nuclear garden at Dungeness.

Inhabiting Research, A Pilgrimage (Mark)

This past January (2015), Judd and I took a research trip to the United Kingdom to inhabit specific sites related to our new project. We visited Bletchley Park, in Buckinghamshire, to study Second World War code-breaking and to walk where Turing had worked. In Manchester, we went to the Museum of Science and Industry to see 'The Baby,' the world's first stored–program computer and, in Dungeness, Kent, we paid homage to the home and garden of Derek Jarman. We explored Jarman's garden situated against the backdrop of Dungeness Nuclear Power Station, mentally placing radial arrangements of dead plants and sculptural wreckage in relation to Turing's theory of forms in nature, with particles reacting and diffusing in Fibonacci patterns of leaf spirals. Turing and Jarman together, their narratives cross-reacting: a preoccupation with flowers, Jarman blinded and Turing given breasts, forming a composite image of the seer Tiresias.

This particular research trip felt personal to me for many reasons and, although only seventy-six miles away from London, it took us four hours to travel via tube, train, bus, walking and taxi. In our work I think very carefully about order, structure, ritual, observing time, marking time, enduring time. For me, Derek Jarman was a childhood saint, a significant maker and marker in my own journey, helping me to understand my own sexuality as an extremely shy, anxious and awkward gay teenager. Jarman was anointed and canonised, as St Derek of Dungeness of the Order of the Celluloid Knights by the Sisters of the Perpetual Indulgence. The sisters were founded in 1979 in San Francisco to call attention to issues of sexual intolerance and gender-fluidity.

As a sixteen-year-old I had watched *The Garden* (1990), by Jarman, filmed on location in Dungeness, at his home and garden of Prospect Cottage. Its vivid image-making awakened a young artist. In watching the film, I was connected to its rich visual landscape of image and metaphor: beautiful, arresting, violent, and shocking. Jarman, in his poetics, created a screen of truth, of honesty; a place for not apologising; a voice of hope, a slither of light. This journey created a moment to reflect on twenty-five years passing and watching Derek's films on a 12-inch black and white television in my bedroom as a young sixteen-year-old. I was meant to be asleep when his films were on, at the time in the United Kingdom when there were only four TV channels. I would watch in the dark,

lights off, sound switched all the way down knowing otherwise it would be taken from my room; the television that gave me a place to see beyond the fences and walls of the rural, working class farm where I was born and lived out my childhood and adolescence. The pilgrimage to Prospect Cottage in Dungeness, Kent, on 15 January 2015, to inhabit this space of the artist and his home and garden, had been 25 years coming.

The hamlet of Dungeness is perhaps one of the bleakest, loneliest, most haunting spaces I have visited. This is a place of horror and beauty where the body and soul are caught in its wind and blue skies. Derek Jarman purchased Prospect Cottage in the 1980s: the house is wooden and built around old railway coaches and was owned by local fishermen, where their boats still lie on the shingle of pebble, cobble and flint. A home in the vicinity of lighthouses, a nuclear power station, and military training ranges, the site of the only desert in the United Kingdom. One looks upon graves of boats that are broken (from years past), brittle, bruised from being pushed out to sea, cast out with their nets. The boats now are markers in the shingle, characters in this place of theatre, broken by the harshness of the climate—that create a respite against the biting cold wind. As pilgrims in this play, we wait in the wings as we see the actors reveal themselves. They are photographers, kneeling with their lenses and eyes stationed behind the boats, scattered one by one in this brutal cold landscape.

Prospect Cottage is painted black with yellow windows and, stepping off the black tarmac road onto the property, you try to be careful not to make a mark with your shoe. It is hard to capture what is in front of you, in this site of history, this site of your youth. Careful in shingle where you tread, each stone is where Derek may have left his shoe, his foot marks. Stones are placed carefully around the house, composed stones of shingle, pebble, flint in circle formations, almost pagan in their worship and celebration of life; stillness still acts where perhaps the sun moves around them over the course of a day, changing their shape, their form, circles becoming more circles, becoming rocks and stones that embody shapes, a grouping, a placement of line and circle. Depth and height begin to form a contour, a pathway. I observe with care, try to embody all I see, and the winter sky begins to change from its serene stark blue. Telegraph lines near and far move electricity running volts of charge, creating beats in the landscape, while dark skies begin to come in and winds begin to run through you, cold and unanticipated by the clothing you are wearing.

There is unevenness in your tread as you move around the perimeter of the house; your hands shake from the bitter penetrating winds. Circles begin to form into lines, as rusted metal appears to have grown from the fertile ground. In the distance you see the nuclear power station, the sounds of military fire going off, men practicing for another war yet to come, war, a war, we are forever fighting a war.

> They're putting out the time to light the stars. The stars, the stars. F stars. G unsighted.
>
> —from *ATOM-r's* choral mutations of Apollinaire's play.

Shells are firing in the distance as we stand in his garden, piles of stones in forms collected from the beach in front of us, bits of rusted iron and steel, formed in patterns. This garden was tended to, with no soil, just stone, pebble, rock. Remember he trained as a painter at The Slade School of Fine Art. His film, *The Garden*, was made here, in this desolate desert. During the filming he became seriously ill from the disease in his body. The sound of war still goes on, the stone, the rust, the tar, the brittle wooden boards barely holding the boats. Rain arrives and runs its heavy wetness onto us as we begin to walk the single-tracked black tarmac road to the shelter of The Pilot pub.

Morphogenesis and Ossification (Judd)

We are preparing to present ATOM-r's new work-in-progress, *Kjell Theory*. The title is a reference to Alan Turing's biochemical explanation of dynamic patterns that generate natural forms including embryos, animal fur, and plants. In Apollinaire's play, a woman named Theresa transforms into a man, Tiresias, and longs to go off to war, while her husband gives birth to 40,049 babies. Apollinaire's feminist and queer plot, is, more normatively, a plea to the men of France to procreate, replenishing the population after the First World War.

Chris, Justin and I undergo a live transformation as Mark looks on. First, Chris becomes the image of Theresa as Justin blows on a long tube and inflates the two breast balloons in Chris's harness. The three of us together then embody the image of the Padstow Obby Oss, a human-operated horse used as a fertility symbol in Cornish Mayday rituals, the tube becoming the animal's genitalia. As the air is ejaculated from Chris' chest, the Theresa part of our body becomes Tiresias, the blind prophet 'with wrinkled female breasts' (Eliot 1922). I say, 'open your eyes' and Chris closes his. With my smartphone, I scan the flowers on Justin's chest and Derek Jarman's blue rectangle appears. A voice speaks: 'You say to the boy "Open your eyes." When he opens his eyes and sees the light, you make him cry out, saying "Oh, Blue, come forth! Oh, Blue, arise! Oh, Blue, ascend! Oh, Blue, come in!"' (Jarman 1993).

Mixed Reality Rituals

Our experience of the live could be described in terms of a ritual of doubled and divided presence. In *Kjell Theory*, Apollinaire's vision of male reproduction is manifested in choreographies influenced by rural folk traditions. In Cornwall, on Mayday, a man masquerading as a wild black horse, the Padstow Obby Oss, is symbolically resurrected and, accompanied by a female impersonator, attempts to trap women under his skirt, in conjunction with a precisely scored fertility ritual leading from morning into night. He is then led back to his stable to sleep for another year.

In our two-three year process of making a work, we repeat ourselves, moving through a precisely plotted space, until it becomes mechanical, and then organic again, in tandem with software that executes its evolving routines and

Figure 17.1 Kjell Theøry: A Prologue by ATOM-r. Performed at Rapid Pulse Performance Art Festival, Chicago, 2015. Photography Arjuna Capulong.

loops. We stare into a camera and letters stream out of our eyes. We gesture with a ceremonial paddle and see ourselves in another theatre made of words. It is only with continual practice that we can navigate this hybrid system, embodying history and the present, engaging the physical and virtual and re-enacting our memory of something that emerged fortuitously in a prior iteration.

Alan Turing, in his description of morphogenesis, explains: 'the investigation is chiefly concerned with the onset of instability' (1952, 37). It is a disruption of equilibrium that accounts for the tentacle patterns on hydra, whorled leaves, and the process of gastrulation. Just as Apollinaire sought to regenerate theatre by using Surrealism to destabilise its tired conventions, our mixed reality theatre evolves through its structuring of instability. For us, new forms of experience emerge from queer behaviours within the liveness of a system.

References

Eliot, T. S. 1922. *The Waste Land.* New York: Horace Liveright. Accessed via Bartleby.com, 2011. www.bartleby.com/201/1.html#219

Jarman, Derek. 1993. *Blue* (Part 1). Accessed 7 August, 2010 at https://www.youtube.com/watch?v=wVaC3XKSi5M&list=PLE84AA9A0EE81B48C&index=1

Turing, A.M. 1952. 'The Chemical Basis of Morphogenesis.' *Philosophical Transactions of the Royal Society of London* B 237 (641): 37–72. Accessed at http://dx.doi.org/10.1098/rstb.1952.0012.

Afterword

So Close and Yet So Far Away

The Proxemics of Liveness

Philip Auslander

In the 1920s and 1930s, the federal government of the United States included in its body of regulations concerning radio broadcasting an order that limited the amount of mechanically reproduced material that could be sent out over the airwaves. The Federal Radio Commission's *Annual Report* for 1928 states:

> By its General Order No. 16, issued on August 9, 1927, the commission, while not condemning the use of mechanical reproductions such as phonograph records or perforated rolls, required that all broadcasting of this nature be clearly described in the announcement of each number. The commission has felt, and still feels, that to permit such broadcasting without appropriate announcement is, in effect, a fraud upon the public. [. . .] The commission is inclined to believe that the use of ordinary commercial records [. . .] is an unnecessary duplication of service otherwise available to the public.
>
> (19)

Between 1927 and 1929 the commission would reiterate the demand that recorded materials be identified verbally as such over the air in four distinct General Orders.

The Radio Commission's policy is interesting for any number of reasons, beginning with the way it defines the cultural function of broadcasting in terms of its potential for liveness, since playing records is dismissed as 'an unnecessary duplication of service.' It also protected the interests of members of the American Federation of Musicians, who considered the use of recorded music on the radio to be a labour issue (Butsch 2000, 222), and the announcement requirement forced announcers for those stations that did use recorded music to morph into disc jockeys, thus paving the way for the emergence of that remarkable kind of performer. But my interest in this bit of broadcasting history here derives from the light it sheds on the concept of liveness. For one thing, even though a classical definition of live performance might propose that it is an event in which two sets of people (performers and spectators) are co-present in the same place at the same time, the Federal Radio Commission's ruling suggests that as long as we can believe that the music we are listening to

is being performed somewhere at the time we are hearing it, we will accept the performance as live. We do not actually have to be there.

I have argued frequently that liveness is not a stable ontological condition but a historically contingent concept, a moving target that is continuously redefined in relation to the possibilities offered by emergent technologies of reproduction. Broadcasting clearly effected a significant shift in our understanding of liveness and the experiences we are willing to count as live by suggesting that temporal co-presence, which it could produce, is essential to the experience of liveness, whereas spatial co-presence, which it could not produce, is nonessential. A further implication of the FRC's ruling is that liveness is something that exists primarily in the mind of the audience. The FRC's premise is that since I cannot tell just by listening to music on the radio whether or not it is being performed live I need to be told and the announcement is enough for me to understand what follows as live. Presumably, I listen to and value performance I believe to be live differently from performance I believe to be recorded. Our sense that something is occurring live is therefore a premise, not a conclusion, something we believe to be true of a performance rather than a characteristic revealed through the experience of the performance. In this sense, liveness is first and foremost a frame in Erving Goffman's (1974) sense of the term, an understanding of what is going on that allows me to define my relationship to it and to participate appropriately with it.

The idea that we can appreciate a performance as live without being in the place where it is occurring is fundamental, for I believe that the power of liveness is in fact a function not of proximity but of distance, or more precisely, the power of the live resides in the tension between having the sense of being connected experientially to something while it is happening while also remaining at a distance from it. The nature and degree of distance varies, but this tension is what all the experiences we call live have in common, whether live broadcasts or the experiences Nick Couldry (2004) describes as 'two new forms of liveness,' 'online liveness' and 'group liveness':

> [O]nline liveness: social co-presence on a variety of scales from very small groups in chat rooms to huge international audiences for breaking news on major Web sites, all made possible by the Internet as an underlying infrastructure [. . . G]roup liveness: [. . .] the 'liveness' of a mobile group of friends who are in continuous contact via their mobile phones through calls and texting.
>
> (356–7)

Whether we're watching a match on television or texting a friend from a mobile phone, it is our sense of the live connection that matters because it holds out the promise of compensating for our not being in the physical presence of the people to whom we feel connected, of bridging the gap. We would cry fraud, to use the FRC's language, if we were to discover that the thing with which we feel that connection was not live after all, if, for example,

we found out that that the supposed live Internet feed of Marina Abramović's *The Artist is Present* (2010) at the Museum of Modern Art in New York was actually a streamed video. We do not need to be there to experience it as live, but we do need to be able to believe that it is occurring at the same time we experience it.

It might seem that the sorts of theatre and performance art events we habitually think of when we consider live performance are different from broadcasting or live feeds because the performers and audience typically are physically present to one another. This is true, but physical co-presence does not obviate distance, and even when we are physically there the potential for fraud does not disappear. We might discover, for instance, that Milli Vanilli are not really singing even though they're right there, before us, or that the people we think are the flesh-and-blood Black Eyed Peas are in fact holographic projections, or that Vito Acconci was not actually under the ramp voicing his sexual fantasies during his performance of *Seedbed* (1972) but had placed a tape recorder there that played back his voice. Two of these examples are real; the third presumably is not, though how could we know for sure? I return to this question of fraud not so much to make an ethical argument as to suggest that the liveness even of events in which performers and spectators are physically present to one another is to some extent an article of faith, just as it is in broadcasting.

As the late Herbert Blau put it, 'Theater [. . .] posits itself in distance. [P]eriodically in the theater we want to reduce this distance, if not abolish it, modulate it for intimacy. [. . .] But something inviolable is required, an empty space—stage edge, pit, the space of consciousness itself' (1990, 86–7). As Blau suggested repeatedly in his voluminous writings, there can be no theatre (and I would say, no performance) without distance, without at least the minimal mutual distancing of performers and spectators that distinguishes them and is the inviolable precondition for performance, whether this distancing is enacted physically in the arrangement of the performance space or only in 'the space of consciousness itself'. (I have been suggesting here that liveness is primarily a matter of consciousness, of the spectators' belief concerning what is going on rather than physical arrangements).

As Blau implies, those performances that seek to collapse this distance inevitably reinforce it, if only by treating it as the fundamental question to be addressed. Live performance always holds out the promise of bridging this necessary distance, whether through technological mediation (for example, the use of Jumbotron screens at concerts and sporting events) or by other means (such as placing performers and spectators in very close proximity to one another, as in environmental theatre), but never succeeds in completely fulfilling the promise partly because it depends on distance for its very existence: 'Theater posits itself in distance'. Even in live performances, classically understood, where we are physically co-present with the performers, they remain at a distance simply by virtue of their being performers, our being spectators and the understanding of everyone involved concerning how these differential roles are to be performed. Our connection to the performers, our experience of their presence

298 *Philip Auslander*

and theirs of ours, is still a bridging over a distance that it never eliminates altogether.

This is what I mean when I say that the power of the live resides in the tension between our sense of being connected experientially to something while it is happening while also remaining at a distance from it. The distance can be physical, as in cases where musicians are performing at a radio station somewhere else, or a performance artist is sitting in a museum in a different city, or it can be a matter of consciousness, as in cases where my distance from the performers is a function of our relationship's having been framed as an interaction between two distinct groups—performers and spectators—with different roles to play. In all cases, liveness is the experience of having an active connection to an event taking place now, but somewhere else, whether that somewhere else is miles away or only inches away but distinguished from the space I'm in by virtue of its belonging to the realm of the performer rather than that of the spectator, the inviolable distinction on which all performance depends. In all cases, the live connection feels as if it could abolish distance but never actually does, and indeed cannot, since liveness, like theater, 'posits itself in distance'.

References

Blau, Herbert. 1990. *The Audience.* Baltimore: Johns Hopkins University Press.

Butsch, Richard. 2000. *The Making of American Audiences: From Stage to Television, 1750–1990.* Cambridge: Cambridge University Press.

Couldry, Nick. 2004. '"Liveness", "Reality", and the Mediated Habitus from Television to the Mobile Phone.' *The Communication Review* 7: 353–361.

Federal Radio Commission. 1928. *Second Annual Report to the Congress of the United States.* Washington, DC: US Government Printing Office.

Goffman, Erving. 1974. *Frame Analysis: An Essay on the Organization of Experience.* Cambridge, MA: Harvard University Press.

Index

Abramović, Marina 191, 193, 196–9, 202, 206, 207, 297; *The Artist is Present* 196–9, 297; *Luminosity* 207; *Rhythm 0* 115
absence 175, 188, 191–3, 195, 268, 270, 281–2; of audience 54; of the body 203, 210–11
Acconci, Vito 191, 256, 297
actors 4, 99, 285, 287–8
Adorno, Theodor 74
affect 9, 19, 83–95, 107, 153, 173, 184–5; autonomy of 85–6, 95; critique of 87–8, 95; and kinesthesia 107
affective 84, 87, 90, 95, 110, 115, 122, 173, 270; affective encounter 95, 107; affective meaning making 90, 93, 95; 'affective turn' 86, 88, 153
agency 174, 268; of artwork 40; and audience 111, 115, 287–8; and objects 153; of performer 106, 203–5, 207–8, 210; and technology 215, 217, 227
Alfred, Jarry 102
alive / aliveness 1, 5, 17, 22, 29–31, 77, 80, 100, 103, 125, 127–8, 174
amateur performance 74–5
Amos, Tori 48–59
amplification *see* loudspeakers
Anderson, Laurie 36
Apollinaire, Guillaume (*The Beast of Tiresias*) 291, 293, 294
archive 20, 119, 143–7, 149, 151; body as archive 119, 121–2; as detritus 143, 146–7, 150; performatic archive 144, 147
assemblage 89–90, 268
atmosphere 66, 114, 133, 141, 224, 237, 244
ATOM-r 289, 290
attention 12, 64, 93, 104, 234, 250, 272; divided 289
audience-performance relationship 2, 5, 19, 99–103, 105–6, 137–42, 189, 207, 295–8

audience research / studies 5, 7, 11, 18, 22–3, 24, 27, 48, 52, 61, 69, 83–4, 91; life history research 61
audiences 48–58, 60–9, 83, 87, 91, 195–8, 201–13, 216–24, 230, 272–7; absent/ remote 48, 49, 50, 51, 52–5; distracted 64, 83, 99; 'emancipated spectator' 10, 12, 93; expectations 11, 48, 61, 65, 75, 169; perceptions of liveness 1–5, 22–3, 216–17, 232–3; *see also* agency; community; creation of; fans/fandom; social media
aura 76, 191, 192, 198–9, 274
Auslander, Philip 4, 50, 164, 194–5, 215–17, 223, 225, 227, 231, 232, 233, 244, 246, 252
authenticity 4, 35, 67, 74, 79, 163, 167, 191–2, 195, 198, 199
author / authorship 42, 192, 198, 205, 283
Axelson, Tomas 24, 30

Badiou, Alain 163, 165, 175
Badovinac, Zdenka 197
Bailes, Sara Jane 41
Bal, Mieke 40
Baldessari, John 210–11
Banham, Simon 284–5
Barker, Martin 5, 6, 8, 231
Barthes, Roland 9, 110–11
Batson, Daniel 114–15
Beckerman, Bernard 3
becoming 20, 39, 73, 90, 94, 121, 176, 192, 217, 224, 239; becoming animal 124, 125, 127–8; 'collective becoming' 217, 226
Benjamin, Walter 191, 199
Bennett, Lucy 66
Benning, James (*Ten Skies*) 234–5
Benzecry, Claudio 24
Bergson, Henri 39, 238
beying 166–8, 174

300 *Index*

Biesenbach, Klaus 202, 204, 211, 213
Blair, Rhonda 85
Blau, Herbert 147, 297
Bleecker, Julian 227
body / bodies 9–10, 84, 89, 93, 104–7, 111, 115, 117, 121, 172–3, 190–1, 193, 197–8; animal body 151; bodily inscription 118; body art 201–2; as labour 203–4, 206; in performance 158–9, 201–13, 230; of the performer 118, 207, 268, 273, 276; on screen 4; spectator's body 117, 121, 272; surrogate bodies 202–4
Bourriaud, Nicolas 111
broadcasting / broadcast media 8, 67, 115, 231, 295–7
Broglio, Ron 125
Brook, Peter 2
Brookes, Mike 284–5, 288
Buber, Martin 2–3
Burke, Edmund 24–5

Cage, John 42, 253, 257
Calle, Sophie (*Last Seen*) 35–6, 42
care / care structure 75–6
Carter, Paul 159
Cascone, Kim 277
Chapter Arts Centre 143, 145, 146
choreography 121, 288
City of Birmingham Symphony Orchestra (CBSO) 63, 66–7
Clifton, Thomas 10, 179
co-creation / co-authorship 11, 20, 115, 137, 140, 141–2, 250, 252
cognition / cognitive 86, 87–8, 89
cognitive science 10, 115, 118
commodification 37, 201–4, 207, 209, 212–13, 216, 261
community, creation of 4, 23, 54, 67, 69, 111; fan community 50–2, 54, 66
completeness 28–30
computing 289–90
consciousness 9, 11, 85–90, 92–3, 94–5, 217, 223, 225, 233, 297; embodied consciousness 19; Kinesthesia consciousness 107; non-conscious 85, 89, 92, 93, 118; unconscious 37, 110, 132
control 137–41
costume / dress 127, 128
Couldry, Nick 296
creativity, creative 35, 37–40, 84, 132, 166–8, 174–6, 180, 183, 191; creative response 40–2
Crisell, Andrew 8

critique / criticism 35, 39–40, 42; cultural critics 24, 26; immanent critique 42; theatre critics 99–100
Csíkszentmihályi, Mihály 182
Cull, Laura 41
Culshaw, Edie 206–7
cultural capital 62–3
cultural value 1, 4, 60

dance 117–22, 290; and audience 7, 83–4, 86–95; and kinaesthetic empathy 117–18
deadliness 1–3, 12, 92, 99
Deleuze, Gilles 85, 90, 164, 168, 170, 172–5, 179–81, 184–5, 257; see also Guattari, Félix
De Oliveira, Nicolas 133
Derrida, Jacques 149, 164, 171, 172
Dewey, John 11, 88, 252
digital, the 215, 224, 225; digital liveness 216, 232–3; digital media(tion) 65–6; digital technologies 213, 233
disappearance *see* ephemeral/ephemerality
distance 246, 296–8
document / documentation 36, 94, 105, 115, 128, 144–7, 179, 184, 186, 192, 194–5, 212, 244, 262; *see also* archive
dramaturgy 284, 286
Duchamp, Marcel 256
duration 181–3, 237–9

ecstasis / ecstatic 26, 79
embodied / embodiment / embody 11, 84, 86–7, 89, 91, 118–19, 128, 133, 135, 144, 170, 225, 292
Emmerson, Simon 274
emotion 27, 62–3, 67, 85, 87, 89, 110, 134, 184, 190
empathy 19, 109, 110, 114–15, 207, 209; *see also* kinaesthetic empathy
encounter 3, 7, 17, 26, 35, 37–8, 61–2, 77, 86, 92, 106, 125, 149, 171, 191–2; affective encounter 95, 107; audience encounter 84, 87; historical 151; live encounter 5, 10–12, 84, 86, 151, 161, 192; musical encounter 243; participatory encounter 215; sexual 140
environmental performance 229–40
ephemeral / ephemerality 6, 37–8, 157, 179, 188, 192–4, 197–8, 230; eulogy writing 38
episteme 165, 169–70
essence 10, 168, 186

Index 301

Etchells, Tim 102
eternity 181, 184, 185–6
event / event-ness 37, 48, 73–6, 80, 100, 158, 163–76, 184, 193–4, 215, 226, 234, 267, 284; durational event 238, 257
everyday life 8, 62, 64–5, 78–9, 131, 133–5
excess 22, 86–7
experience 2, 3, 5–7, 9, 11, 17, 29–30, 73–81, 83–95, 121, 161, 167, 174, 178–86, 194, 197, 202, 225, 229, 232–3, 239, 252, 269; aesthetic experience 10, 36, 266; affective experience 90–1, 104, 107; authenticity of lived experience 77; commodification of experience 212; lived experience 4–5, 12, 18, 73, 77–8, 80, 84, 88, 93, 105, 107, 153, 164, 166, 167, 172, 182, 213, 239, 273; peak experiences 25
experiencing self 84; experiencing live / liveness 5, 8, 12, 86, 153, 230, 233, 239

fans / fandom 23, 31n2, 48–59, 66, 68
feedback loop 12, 117–18, 216, 223–5; autopoietic feedback loop 223–4
feminism 108n2, 193, 207
fidelity 163, 174
film 22, 27–8, 284–8
Fischer-Lichte, Erica 6, 223–4, 230, 236, 252
flesh 172, 173
flow 182; sounding flow 274
Forced Entertainment (First Night) 100–3
Foucault, Michel 119, 218
frame / framing 215, 234–5, 237–40
Frith, Simon 7, 231

Gabrielsson, Alf 24, 30
gaze 104, 108n2, 149, 205, 207
gestures 189, 272, 274; gestural inscription 117–19, 121, 122; musical gesture 268; performative gestures 126, 272, 277
Giffin, Lawrence 257
Goat Island 40
Goffman, Erving 234, 296
Goldmann, Lucien 30
Goleman, Daniel 110
Gómez-Peña, Guillermo 201
Grosz, Elizabeth 41, 118
Guattari, Félix 85, 90, 173, 179–80, 181, 257; see also Deleuze, Gilles
Guionnet, Jean-Luc 243

habit / habitual 12, 38–42, 61, 165, 168–70, 173–5
Hansen, Mark 215, 217, 221–3, 224, 226, 227
happening 73, 75, 80, 81n3, 163, 164, 165, 171, 174, 189–90, 237
Hardy, John 284, 287
Harvie, Jen 137
Hayles, N. Katherine 226
Heathfield, Adrian 37, 38
Hébert, Pierre 273
Heidegger, Martin 75, 77–80, 165–8, 169, 222
history 28, 149, 151–2, 189, 194–6, 199; embodied history 117–18, 294; life history 31, 61–2
Huyghe, Pierre (Untilled) 235, 237

immanent / immanence 89, 90
immersion / immersive 23, 49, 53, 55, 100, 125, 131, 133–5, 145, 220, 235, 266, 267, 270, 288
implication 159, 215, 217, 223, 226–7
improvisation 54, 119, 163, 165, 169–72, 178–9, 180, 243, 252, 276
indeterminacy 252
Ingold, Tim 157, 267
intensity 85–7, 131, 183–5
intentionality 217, 222–3, 229, 233–4
interaction / interactivity 6, 22, 49, 99, 110, 132, 135, 189, 205, 208–9, 211–12, 215–16, 218, 221–2, 224, 230, 233, 250, 252, 270, 273–4, 277, 287, 298; audience interaction 63, 65, 137–8; kinaesthetic interaction 121; online interaction 67; social interaction 61, 231
interactionist aesthetics 7, 10
interdisciplinary 6, 12–13
Internet of Things 216, 227
intersubjective 9, 117; intersubjective exchange 201, 204, 212
Iser, Wolfgang 8–9, 248, 250, 252

Jarman, Derek 291–3; Blue 293; The Garden 291
Jencks, Charles 26
Jonas, Joan (Mirror Check) 205–7
Jones, Amelia 108n2, 192–5
Jonze, Spike (Her) 225

Kaprow, Allan 189–90; Affect 190
Kay, Rosie (5 Soldiers) 87

Index

Kelly, Mary 191–2, 198
kinaesthesia 84, 107, 117–18, 121
kinaesthetic empathy 117–18, 121;
 kinaesthetic audiencing 119, 122;
 kinaesthetic intersubjectivity 117
kinesis 119, 286
Kirby, Michael 190, 275–6
knowledge / knowing 84–8, 92, 125,
 165–6, 168, 170, 180; embodied 122;
 involuntary 110; know-how 166, 169;
 knowingness 165–6, 169; practice-based
 157, 260, 261; tacit 84; visual 91

labour 203, 210, 212; body as labour 203–4,
 206
landscape 124, 126, 128, 284, 286, 288
language, to talk about experience 29,
 31, 67, 78, 84–6, 87, 91–2, 94–5, 107;
 ekphrasis 94, 95; outside of (ineffable) 84,
 85; performative writing 37, 38;
 technical 67
Lepecki, André 119, 121
Leys, Ruth 87
lighting 286, 288
Lima, Laura (*Man=Flesh/Woman=Flesh*)
 209
Lippard, Lucy 201–2
lived experience *see* experience
living sculptures 202, 204, 209, 212
López, Francisco (*La Selva*) 234–5, 236
Lorange, Astrid 257
Lord of the Rings project, the 27–9, 32
loudspeakers 157, 160, 266–70, 280–1
Lovink, Geert 215–16

machination 165–8
Malabou, Catherine 169
Marclay, Christian 180
marionette *see* puppets
Maslow, Abraham 25–6
Massumi, Brian 85–9, 95, 183, 184
materiality 157, 159
meaning making 9, 17, 49–50, 52–4, 57,
 84–90, 194, 250, 252; 'affective meaning
 making' 90, 93, 95; archival 147; meaning
 structure 75
mediated / mediation 3, 49, 50, 61, 154,
 161, 172, 188, 194, 231, 244, 246, 266,
 267–8, 273, 289, 297; technologically
 mediated 54, 232
Meireles, Cildo (*Through*) 34, 37, 41,
 42, 45
Melrose, Susan 119

memory 11, 17–18, 22, 34–46, 73, 92,
 93, 107, 121, 139, 259–63, 294; erratic
 memory 36; habit memory 39; narrative
 memory 250; transformation in memory
 35, 36–7, 41, 42–3
Merleau-Ponty, Maurice 9–10
Mia, Edie (*1993*) 138–9
Migone, Christof 279
mind-body dualism 87
mirror neurons 109, 110, 118
Mitchell, WJT 94, 153
mixed reality 289–94
modernism 191–2, 194, 196
Möller, Hartmut 246
mood 64, 76
music 7–8, 74–5, 119, 122; acousmatic 266,
 267; classical music 60–9; electroacoustic
 274; in everyday life 64; and
 improvisation 178–86; popular music
 concerts 48–59; 243–53; and technology
 160, 266–70, 273–7; tromp l'oreille 267;
 see also recorded music
music score 246, 248, 252
mutuality 2–3, 10

Nancy, Jean-Luc 171–2
National Theatre Wales 284
Nattiez, Jean-Jacques 269
nature 237
Needcompany (*Porcelain Project*) 83
Nell, Victor 24
Ness, Sally Anne 118
networked technology / networked
 performance 159, 215–27
Nielsen, Rosendal 133
Noë, Alva 270
Noland, Carrie 118
non-human performance 159, 176; animal
 124–5, 127–8; environment 229–30,
 233; puppets 280; technology 215, 218,
 224, 225, 289
non-representational 84, 86, 88, 92, 230,
 236, 239
Novarina, Valère 279–83
now / now-ness 79–80, 163–4, 168–70,
 172, 174–6, 188–9, 194–5, 198; *see also*
 temporality

objectification 108n2, 153, 207, 209,
 211–12
objects 149, 151–3, 190, 273, 275; living
 objects 207, 211; 'theoretical objects' 40
Obrist, Hans Ulrich 204, 213

Olkowski, Dorothea 39
O'Malley, Juliann (*Hive*) 139–41
one-to-one performance 137–42
ontology 44, 77–8, 163, 189, 192; of
 liveness 1, 3–4, 7, 216–17, 246, 296; of
 loudspeakers 269–70; of theatre 3
original, originary 193, 195, 197–9
Ostertag, Bob 273
otherness 124–5, 208

panoptic 218
Paré, Zaven 279–80
participation 12, 132, 138, 141, 189, 206,
 212, 221; aesthetic participation 11;
 audience participation 189; participation
 as research 138
passive creativity 168, 174–6
performance studies / performance research
 6, 10, 37, 86–7, 119, 179, 186, 230
Phelan, Peggy 3, 10, 35, 37, 115, 147, 164,
 192, 216
phenomenology 8–9, 78; of implication
 215, 217; of perception 89
photography 51, 104–7, 115, 191–3
pleasure 24, 25, 66–7, 125, 173
poetic self 130–2
Power, Cormac 273
practice-as-research 143, 290; practice-led
 research 117
practise 164–5, 169–70
presence 4, 11, 22, 49, 104, 115, 133, 145,
 164, 168, 188–9, 191–3, 195, 198, 268,
 273–4, 276–7, 280–1; co-presence 3, 10,
 117–22, 135, 208, 230–2, 234, 244, 246,
 295–7; mediated presence 4, 289
presentness 37, 231
preservation 37, 153, 170, 174
process 1, 6, 9–12, 21–2, 27, 29, 35–42, 73,
 95, 105, 113, 117–19, 121, 128, 135–6,
 145, 183–5, 217, 222–6, 231–5, 237–9,
 248, 250, 270, 289, 294; affective process
 88–93, 110, 115; creative process 11, 36,
 157, 179; devising process 274–5; and
 technological 48–51, 55, 57, 231
puppets 280–3

queer 290–1, 293–4; gender-queer 290;
 queer bodies 290–1

radio 60, 295–6
Rambert Dance Company
 (*Awakenings*) 94
Rancière, Jacques 10, 93

reading, the act of 128, 160, 248, 250, 252,
 254–7
real / reality 190–2; reality effect 195
real time (noun) 7, 61, 66, 75, 115, 216,
 229, 231, 238–9, 248, 281, 288; real-time
 (adjective) 19, 99, 289, 290
Reason, Matthew 35, 143, 146–7
recorded music 7, 22, 64, 65, 67, 231, 244,
 295; 'live recordings' 231, 257
re-enactment / re-performance 119, 121–2,
 145, 146–7, 193, 196, 197, 202, 205–6,
 207–8, 213
rehearsal 164–5, 169–70, 175
remembering 30, 34–46, 76, 168;
 misremembering 37, 41; remembered
 moment 41, 73; remembered response 36
repetition 39, 92, 122, 163, 168–70, 257
reproduction / reproducibility 170, 188,
 199, 266; technologies of 244, 296
responsibility 5, 10, 66, 115
Reynolds, Dee 84, 86, 91
risk 6–7, 22, 68, 115, 137–8, 140–1, 230;
 risk aversion and audiences 68
Roman theatre 151–2
Royal Shakespeare Company 284

Sacks, Harvey 74
Saladin, Matthieu 243
sameness 168–9, 174
Sanden, Paul 7, 231, 244, 273
Sauvageot, Pierre 235–6
Scannell, Paddy 8
scenography 284, 286
Scheer, Edward 238
Schilling, Chris 203
Schneemann, Carolee 207
Schneider, Rebecca 121–2, 203
Scottish Ballet 91
sensation 9, 90, 107, 109, 127–8, 152,
 172–5, 179–80, 222, 234;
 of time 238–9
Shakespeare, William 284; *Coriolanus* 284,
 285, 288
Sheets-Johnstone, Maxine 84, 107
Sierra, Santiago 208–9
Silverstone, Roger 49–50, 57
Simmons, Pip 145
simulacra 4, 170
simulcasting 22–3
site 163, 284–5, 288
Sobchack, Vivian 9, 89
social media 48–9, 51, 65, 217, 288, 290;
 audiences and social media 48–59, 65–6,

67, 69; blog / blogging 65, 131, 135; Facebook 48, 51, 52, 206, 219; Instagram 51; texting 48, 51, 52, 55–7, 296; Twitter / tweeting 48, 51, 52, 54–7, 65, 66, 68, 289; YouTube 56
sonic space 267, 269
Sontag, Susan 190
Soper, Kate 127–8
soundtrack 284, 287
space-time 168, 170, 189
spectacle 12, 24, 115, 201, 272, 282
Spinoza, Benedict de 181, 182, 185
Stein, Gertrude 256–7
Steward, Samuel 290
subjectivity 9, 78, 124, 191, 192, 216, 225, 227, 233
sublime, the 24–5
surprise 2, 29, 40–1, 56, 100, 171–2
Sussman, Mark 279, 280
sympathy 110
synaesthesia 29, 93

Taylor, Diana 144
techne 165–8, 170; technicality 166, 170; technique 166
technology 48–58, 165, 215–27, 268, 288; anthropomorphic 222; 'atmospheric' 215, 221–2; 'calm' 226; ubiquitous 215, 225–7; *see also* digital, the
television 8, 78–9, 296
temporality 5, 38, 79–80, 133, 158–9, 179–80, 182, 184, 188–9, 194, 229–30, 237–9, 257, 267–70; asynchronous 161, 215, 289; polychronic 283; simultaneity 4, 6, 12, 22, 50, 167, 231; *see also* now/now-ness; real time

Theater of the Ears (Théàtre des oreilles) 279–83
theatre 2, 3, 5, 99–103, 143, 145, 149–54, 190, 218, 221, 230, 272–7, 279–83, 284–8, 289–94
theatre machine 284
Theodore, Grand Wizzard 257
Thrift, Nigel 84, 85, 88
trace 20, 121–2, 143, 147, 153, 192, 244
Turing, Alan 290–1, 294
Turkle, Sherry 216
Turner, Renee 261
Turrell, James (*Skyspaces*) 235

unpredictable 236–7, 239
UVA (United Visual Artists) 215, 218–24, 226; *Rien à Cacher, Rien à Craindre* 215, 217–19, 221–5

Vergine, Lea 191
video 284, 286–7
virtual 289, 294
virtuality 172–4
virtuosity, perfection 7, 22, 74, 165
visceral 87, 115
voice 174, 275, 280–1, 287

walking 126–7, 291
Weiser, Mark 225–6
Wetherell, Margaret 88–90, 93
Whitehead, Gregory 279–81

Zenck, Martin 248
Zhen, Xu (*In the Blink of an Eye*) 209–10
zone of indetermination 39, 40